MW00636386

THE ART OF CENSORSHIP
in Postwar Japan

THE ART OF CENSORSHIP
in Postwar Japan

Kirsten Cather

University of Hawai'i Press
Honolulu

17 16 15 14 13 12 6 5 4 3 2 1

Library of Congress Cataloging-in-Publication Data
Cather, Kirsten.
The art of censorship in postwar Japan / Kirsten Cather.
p. cm. — (Studies of the Weatherhead East Asian Institute)
Includes bibliographical references and index.
ISBN 978-0-8248-3587-3 (hardcover : alk. paper)
1. Censorship—Japan—History—20th century. 2. Japanese
literature—20th century—Censorship. 3. Fiction—Censorship—
Japan—History—20th century. 4. Motion
pictures—Censorship—Japan—History—20th century.
5. Trials (Obscenity)—Japan—History—20th century.
I. Title. II. Series: Studies of the Weatherhead East Asian
Institute, Columbia University.
Z658.J3C38 2012
363.310952—dc23
2012014956

STUDIES OF THE WEATHERHEAD EAST ASIAN INSTITUTE
COLUMBIA UNIVERSITY
The Studies of the Weatherhead East Asian Institute were
inaugurated in 1962 to bring to a wider public the results of
significant new research on modern and contemporary East Asia.

Designed by Janette Thompson (Jansom)

Printed by Sheridan Books, Inc.

Contents

Preface

I begin by telling two stories: first, of the book that I didn't write and then of the one I did. Although both reflect my enduring interest in censorship, the present book has been shaped by the earlier, aborted attempt and its perceived limitations and pitfalls. By beginning in this admittedly convoluted way, I hope to explain both what the central aims of this book are and what they are not, as well as to recognize the people and scholarship that have informed its course along the way. And perhaps this roundabout manner of describing what remains on the page is appropriate to a book on censorship, which, after all, is about both the written and unwritten.

The first literary censorship trial I encountered was that of Ishikawa Tatsuzō's 1938 war novella *Living Soldiers* (*Ikite iru heitai*), based on his experiences with the military campaign in China leading up to Nanjing. The novelist was convicted under the 1925 Peace Preservation Law on charges of disturbing "public order and peace" for "writing a fabricated reality as if it was reality" and sentenced to four months in prison.[1] At first, I was intrigued by the novel's combination of politically seditious and explicitly sexual materials as well as by its ability to provoke the authorities, who, I thought, must have faced far more pressing matters in the late 1930s. The case seemed to promise a rare glimpse into the minds of the repressive wartime authorities and an equally rare moment of literary resistance.

I soon found, however, that the trial revealed less about Ishikawa's politics than I had expected. Although his descriptions of soldiers murdering Chinese civilians and Japanese prostitutes in cold blood first seemed to represent a clear case of resistance, Ishikawa's own statements suggested otherwise. At the trial, he denied any subversive intent, defending himself as merely "having recorded what he had seen as it was," and, when sent back to the battlefront for a second chance, Ishikawa subsequently wrote a prowar piece, *The Wuhan Operation* (*Bukan sakusen*, 1939). His response to the charges could of course be explained not as willing complicity but as reluctant acquiescence. But even after Japan's defeat, Ishikawa claimed to have written *Living Soldiers* as a more universal commentary on "what becomes of this thing called humans amid the extreme conditions of war" rather than

as a critique of the Japanese army or government.[2] I realized how tempting and problematic it could be to interpret censorship as evidence of political subversion, or, conversely, its absence as proof of complicity.

What interested me more were the ways that both the censor's attack and the artist's defense were predicated on similar notions of the roles of literature and the author in society. Each side subscribed to the notion that fiction should reflect reality. Most of all, I was struck by the paradox that a criminal trial designed to silence an unacceptable work was precisely what had ensured its survival. Eager to find more such examples I turned to Jay Rubin's comprehensive study of literary censorship during the Meiji period (1868–1912) and to Kyoko Hirano's work on film censorship during the Occupation period (1945–1952).[3] These seemed to invite the daunting task of writing a sequel and prequel, respectively, that would cover prewar and wartime literary and film censorship.

However, my early investigations yielded material that was significantly less interesting than the Ishikawa trial, a rare exception in prewar Japan. Although the titles were promising, such as the *Catalogue of Banned Books before 1945* (*Hakkin tosho mokuroku, 1945-izen*), these catalogues were frustratingly devoid of the links to questions of authorship, realism, and the relationship of politics to sex that intrigued me about the Ishikawa case. Instead, the records were just that: lists of the banned titles with only one or two lines of explanation. Moreover, the majority of the banned films were not extant. It seemed that these materials would yield only a description of the censorship process from a top-down approach more appropriate to the field of institutional history and that had already been dealt with in depth by historians and political scientists.[4]

Nonetheless, as the deadline for grant applications loomed, a clear and detailed research plan was required, so I plunged ahead compiling lists of lists. This ended up being the book that I did not write.

My current project on the landmark postwar obscenity trials began when, browsing in the library of the University of California, Berkeley, I stumbled upon a book—with the rather long title of *The Complete Record of the Trial of "Underneath the Papering of the Four-and-a-Half-Mat Room"* (*Yojōhan fusuma no shitabari saiban zenkiroku*)—centering on a short story by Nagai Kafū. Although jaded by then to any claims of being "complete" when it came to censorship records, I picked up the two volumes to find 670 pages of the verbatim transcripts from a 1973 to 1976 Tokyo lower court trial that reached the Supreme Court in 1980. With a bit more digging I

found several other high-profile postwar obscenity trials of literature and film and switched topics just weeks before beginning a year of dissertation research in Tokyo. While there, I was fortunate to work with Professor Oketani Hideaki, the author of books on two central figures in the trials, Nagai Kafū and Itō Sei, the translator of *Lady Chatterley's Lover,* and to meet Itō's son, the literary scholar Itō Rei, who kindly shared his childhood memories and otherwise inaccessible materials with me.

This revised topic on postwar trials proved more conducive to my vision of a censorship study written from the perspective of literary and film studies: a balanced consideration that would do justice to the complexities of both art and censorship. It could include close analyses of censored literary and film texts and at the same time consider how art is intimately shaped also by extraliterary (or extrafilmic) concerns: the state, laws, societal morality, and politics. What I most wanted to avoid was allowing the particulars of either the censored art or the concrete practices of censorship to disappear from the equation. If institutional histories of censorship tend to err on the side of the former, often invoking the censored art as if it were an almost irrelevant aside, literary and film studies all too often invoke the specter of censorship as if it were a monolithic and faceless entity. Instead, I hoped to bring to life the censor and artist in all their contradictions, resisting the temptation of a censorship study to become a "heroic narrative."[5]

Focusing on the postwar trials could also draw attention to the fact that censorship endures in Japan even into the twenty-first century, as became abundantly clear in 2002 with the first-time obscenity trial of a manga, the erotic comic *Honey Room* (*Misshitsu*). Although ultimately delaying the publication of this book, this approach gave me the invaluable opportunity to learn about a censorship trial from the parties directly involved. I thank especially Kishi Motonori, the defendant-publisher, as well as his head defense lawyer, Yamaguchi Takashi, and Nagaoka Yoshiyuki, the journalist who covered the trial, for generously sharing their time with me during a final research trip to Japan in May 2008.

An earlier, shorter version of a portion of Chapter 6 appeared in *Japan Forum* 19:3 (November 2007) and an earlier version of Chapter 7 appeared in *positions: east asia cultures critique* 18.3 (Winter 2010).

Finally, I'd like to express my deep gratitude to all those who have supported this project. Alan Tansman's generosity was boundless from start to finish, and without him the project would not have been possible. Jonathan Abel consistently offered incisive feedback, and his own archival work on

transwar censorship has been inspirational, recovering in the most fascinating way even those seemingly mute lists. Stefania Burk has always been the best of readers and the best of friends. Michele Mason never failed to offer the soundest of advice, and David Averbach generously helped with technical assistance, as always. Thanks to Aaron Gerow for pointing me in the right direction early on in the process and to Ann Sherif for sharing an early draft of her work on the *Chatterley* trial. I very much appreciate the generosity of the following individuals, who read and commented on early versions and chapter drafts: Carol Clover, Kathy Hansen, Tom Havens, Mack Horton, Mark Metzler, Jay Rubin, and Alex Zahlten, as well as the anonymous readers for Weatherhead East Asian Institute at Columbia University and for the University of Hawai'i Press. Their feedback improved the book immensely. I appreciate the unstinting support of Weatherhead, especially Kim Brandt, Carol Gluck, and Dan Rivero, and that of Patricia Crosby and her colleagues at the University of Hawai'i Press, especially Mike Ashby and Ann Ludeman. I thank Maeri Megumi and John Tallmadge for their sharp-eyed edits, and my former fellow graduate students at Berkeley and colleagues at the University of Texas at Austin for their moral support. I am most grateful for a University of Texas at Austin Subvention Grant awarded by President William C. Powers Jr., as well as research grants from the Japan Foundation and Mitsubishi Caterpillar Forklift America, Inc.

No amount of thanks suffices to express my gratitude to my family for their tireless support—my parents, Patricia and Joseph Cather, and my sisters, Cori and Danielle, for regular sanity check-ins and much-needed laughter and perspective; my mother-in-law, Mary Fischer, for cheering me on endlessly; my father-in-law, Miles Fischer, for his pro bono advice; and Granddaddy, whose advice "to apply the seat of the pants to the seat of the chair" remains the best I've received. Will, Sam, and Natalie—I love and appreciate you all more than I can possibly express. Thanks for making it all worth it.

Introduction

When Ayatollah Khomeini ordered a fatwa death curse against Salman Rushdie for writing the blasphemous *Satanic Verses,* V. S. Naipaul quipped, "Well, it's an extreme form of literary criticism." His statement provoked the anger of Rushdie's supporters and the literary world. If he had made the more obvious analogy of the fatwa to an extreme form of censorship, he likely would have been celebrated for assigning it a place in this universally reviled category. Images of the evil, scissor-wielding censor lurk in most narratives of literary and film history worldwide, from Comstockery and Hays Code Hollywood to Nazi Germany's Ministry of Propaganda. The censors' malevolence and ignorance have merited their villainous characterization in such novels as *Fahrenheit 451* and *1984* but are perhaps best epitomized by the real-life example of the former chief film censor in Iran who was, ironically enough, blind.[1]

Japan has had its own share of infamous cases of artists being persecuted by the official censors and their self-appointed minions. Perhaps, most notably, we think of the murder of proletariat writer Kobayashi Takiji (1900–1933) while in police custody for his treasonous writings; or the violent attack by a right-wing youth on the publisher of Fukazawa Shichirō's 1959 story irreverently depicting the severed heads of imperial family members rolling down the Imperial Palace steps;[2] or the brutal murder and mutilation of Rushdie's Japanese translator by a Muslim extremist in July 1991. Such incidents, and other, less-spectacular, acts of official censorship, are often cited to prove that art in Japan has been at the mercy of pervasive censorship throughout much of its modern history. According to this line of argument, the censor is imbued with the power to determine not just the fate of the artists' works but also that of their bodies.

This conception of censorship and art, however persuasive, fails to account for the complexity of the interactions between censor and artist in modern Japan. It depicts the censor as having the power to exercise a political or legal judgment on a work of art, and the artist as being either admirably subversive or unscrupulously complicit. Art becomes reduced to the status of a mere political indicator used by scholars to gauge artists' ideological

affiliations. In other words, the problem, as I see it, is that censorship is often used to write political, rather than artistic, history. Moreover, ascertaining an author's politics based on whether or not he or she was censored proves to be a futile project, as demonstrated by the case of Ishikawa, and is also true for an author like Tanizaki Jun'ichirō, who could be both lauded for writing the apolitical novel *The Makioka Sisters* (1943–1948) because it was suppressed during the war and lambasted for self-censoring his modern translation of *The Tale of Genji* (1939–1941). Instead, I would suggest that we take seriously Naipaul's flippant comment likening the fatwa to an extreme form of literary criticism. It suggests the complexity of artistic censorship by hinting at the often-overlooked connection between censor and critic, a link that is crucial to understanding the dynamic relationship of censor, artist, and text in modern Japan, and, implicitly, the nature of all artistic censorship.

In this study, I examine the practice of censorship in Japan by focusing on seven of the most celebrated obscenity trials of literature, film, and manga in the post–World War II period: the 1950s trial of the 1950 Japanese translation of D. H. Lawrence's *Lady Chatterley's Lover* (1928); the 1960s and 1970s film trials of *Black Snow* (*Kuroi yuki*, 1965; directed by Takechi Tetsuji) and of Nikkatsu Roman Porn, four soft-core pornographic films released in 1972–1973 by Japan's oldest studio, Nikkatsu; the 1970s trials of republished erotic Japanese literary "classics," the Edo-period *The Record of the Night Battles at Dannoura* (*Dannoura yagassenki*, ca. 1800), a pornographic adaptation of the canonical medieval text *The Tale of the Heike,* and Nagai Kafū's short story "Underneath the Papering of the Four-and-a-Half-Mat Room" (*Yojōhan fusuma no shitabari*); and, last, the trials of hybrid works combining text and image, including the late-1970s trial of *In the Realm of the Senses* (*Ai no korīda*), the book version containing the screenplay and still photographs from Ōshima Nagisa's infamous film of the same name, and the recent unprecedented trial of the manga (comic book) *Honey Room* (*Misshitsu*) from 2002 to 2007. I also more briefly consider the import of key successors or precursors to these, most notably the high-profile 1960s trial of the translation of Marquis de Sade's *Histoire de Juliette ou les prospérités du vice* (1797). All these landmark trials made it to the level of appeal, either to the Tokyo High Court or to Japan's highest court, the National Supreme Court. Each represents an influential judicial precedent, although not a binding one (as per Japan's civil, rather than common, law system), that swayed the course of both future legal controls of art and artistic production itself.

For each case study, I interweave an analysis of the works themselves with the trial arguments of the defense and prosecution lawyers, the judges' verdicts, and their coverage in both popular and academic presses in order to consider the relationship of modern Japanese art and the state from the second half of the twentieth century to the early twenty-first. For five of the trials, complete trial records from the lower court trials were available. For the others, I have relied on the verdicts and a combination of secondary sources including legal and artistic journals, mass media, memoirs and accounts of the trials written by participants, as well as interviews with the parties involved when possible.

Analyzing the lawyers' and judges' arguments demonstrates that censorship in modern Japan has rarely been simply a matter of the censor exercising an exclusively political or legal judgment on a work of art. Rather, the very nature of a literary or film censorship trial, or "artistic trial" (*bungei saiban*) as they are called in Japanese, required that the terms of debate be as much literary (or filmic) as they were legal. To argue that a text was subversive, censors had to rely equally on their interpretation of narrative (how a work of art signifies meaning) and on their predictions of reception (how a reader or spectator interprets that meaning). Censors thus acted not just as scissor-wielding book burners but also as narratologists, reception theorists, critics, editors, or even coauthors (or auteurs). Accordingly, the censor, like the critic, was obliged to work within the conventions of literary or film interpretation. That the censors in these trials engaged artistic theories demonstrates that just as art did not exist independently of legal institutions, censorship could not operate entirely outside the systems of art.

Thus, the title of this book is *The Art of Censorship,* rather than *The Censorship of Art,* which might suggest a disproportionate focus on censorship. This title is meant to suggest two possibilities. On the one hand, it is meant to be read as *The **Art** of Censorship* to stress the need to revive the art in question. Often, after being repressed by the historical censor, censored art is doubly repressed in subsequent accounts where the work's infamy as the object of a censorship incident is all that remains. Here I mean to highlight the often-paradoxical survival of censored works and to insist on a consideration of what remains of art and artistic discourse in the wake of censorship.

To flip the emphasis, the title can alternatively be read as *The Art of **Censorship*** to suggest the need to consider censorship as both a concrete legal and bureaucratic operation as well as an art form of sorts—a sometimes crude, sometimes elegant intervention on an artistic text that cannot

operate entirely independent of that text, or even more broadly, outside the conventions of creating, consuming, and interpreting art. As Dominick LaCapra has suggested in his study of the 1857 *Madame Bovary* trial in France, censorship incidents offer a "particularly fruitful approach to the study of reception," because they are based on "an index of conventions or norms of reading."[3] What I want to stress is that artist, audience, and censor alike must rely on these "norms" of interpretation.

In sum, this study attempts to avoid overgeneralizing either art and artist or the censor by closely reading the trials themselves and the objects on trial. What I have found is that although we may conceive abstractly of censorship as being a moment of the collision between law and culture that prohibits something, instead, it can equally be a moment of collusion that produces something.[4]

Although in the majority of these postwar landmark trials (five out of eight) the final court judgment upheld banning the work and convicting the defendants, their overall effect was nonetheless productive in many senses. First, the specter of censorship spurred artistic production in many cases. The sheer existence of censorship preconditioned these works' creation by encouraging censorship-dodging strategies, such as the use of exculpatory prefaces, opaque language, digital mosaics, creative mise-en-scène, and redemptive endings. In some cases, the very rhetoric of the censor (and the censor-dodging artist) has been incorporated into the work itself in an uncanny anticipation of its trial. Censorship, in other words, can offer fodder for the production, not just destruction, of art.

Second, censorship trials often influenced the subsequent critical reception of both the authors and the indicted works, as evidenced by the incorporation of interpretations offered at trial into critical scholarship. And the highly publicized trials invariably affected the trajectory of a prosecuted author's career, often spurring a boom in both the artist's creative production and sales. Finally, the spectacular nature of these trials alone refutes reading them as an example of the omnipotent, prohibitive nature of censorship. Contrary to the intents of the censors to consign a work to oblivion, the prosecution of a work paradoxically guaranteed its survival in both the literary and legal canons. In fact, these trials became mass media phenomena, with the help of flamboyant media-savvy defendants, and produced an amount of discourse far exceeding the original work.

Claiming that censorship, in general, is productive based on these cases alone might seem to risk overgeneralization, particularly since my study

includes only landmark trials that received sustained attention from scholars and the mass media. As I admitted above, the project attracted me from the very start because of the wealth of materials available, unlike other, more stubbornly silent censorship incidents. These trials do not, of course, typify all kinds of censorship; book burnings, bans, citizen-led boycotts, violent attacks on publishers and artists by the police or concerned citizens, self-censorship strategies like blurrings and maskings, and censorship trials in a democratic legal system cannot all be equated. Nor can these landmark censorship trials be said to encompass all types of judicial proceedings, which include many more obscure trials that were heard only in the lower courts and countless bans and summary fines quietly accepted without a fuss by other artists and publishers. Arguably only the most indefensible (or defensible, depending on your perspective) of works get charged and only the most irascible of defendants go to trial.

These trials offer instead an extreme limit case of one kind of censorship: a criminal judicial proceeding in a modern democratic society. They are public performances staged by both censor and artist alike—a purification ritual and object lesson of sorts conducted by the state censors and a platform for the sometimes earnest, sometimes carnivalesque pronouncements of the artist-defendants. Whereas the somber translator of *Chatterley*, Itō Sei, responded by publishing serious treatises on literary artists' moral responsibilities to society, the more iconoclastic artist-defendants responded by staging overt challenges to the state's attempt to silence them and to silence public discourse on sexuality. Director Ōshima Nagisa, for example, propagated the irreverent catchphrase "Why is obscenity bad?" (*Waisetsu naze warui?*); author Nosaka Akiyuki, the defendant who republished Kafū's story "Yojōhan" in 1972, staged a demonstration that he called an Obscenity Recital in Hibiya Park; and Nikkatsu Roman Porn director Yamaguchi Sei'ichirō arranged "Nikkatsu Porn Trial Tours."

Notwithstanding their status as limit cases, as highly public moments when art is censored, these trials can demonstrate also some generalizable truths about artistic censorship, its impetus, and its effects. Both inside and outside the courtroom, lawyers, witnesses, judges, as well as a wide array of commentators from legal and cultural spheres offered their competing conceptions about the proper role of art, artist, and audience in society. Contrary to what we might expect, the arguments made by the two sides were not always mutually incompatible but often inadvertently replicated one another, at least in their premises if not in their conclusions.

Considering how these censorship trials influenced and were influenced by artistic theories of authorship, reception, and medium specificity, as well as by notions of aesthetic value that define a canon, reveals the dynamic relationship between censor, artist, and text in modern Japanese history and, by implication, in any culture in which art meets the force of law.

Since the 1980s, there has been a debate among scholars in Japan and abroad over the nature and severity of censorship exercised at various points in Japan's history, especially comparisons of the prewar and wartime Japanese government with the Occupation officials. Works by literary and film scholars from both liberal and conservative camps have amply demonstrated that neither regime had a monopoly on repressing artistic expression, or, for that matter, on liberating it.[5] An unfortunate result of this vigorous debate, however, has been to occlude censorship conducted *after* the Occupation. Indeed, there seems to exist the impression that censorship ended with the end of the Occupation in 1952 in accordance with the postwar Constitution that bids quite unambiguously: "No censorship shall be maintained" (*Ken'etsu wa, kore o shite wa naranai*).

In fact, censorship endures, as is evidenced by the protracted and repeated obscenity trials (*waisetsu saiban*) over the past fifty years.[6] Although these are not of the same order as the overtly political or ideological censorship (*ken'etsu*) or bans on sales (*hatsubai kinshi*) of earlier periods, they are not devoid of larger political or societal meaning either. With censorship expressly forbidden by the postwar Constitution, it is not hard to imagine that police and prosecutors at times invoked the surviving obscenity laws that did allow for censorship in order to suppress undesirable politics. But, in these postwar obscenity trials, the indicted works often had no identifiable deep political or philosophical stance, notwithstanding the defense's strategic arguments to the contrary. Sometimes, a cigar is just a cigar. On the other hand, nor were the indicted works always pornography masquerading as politics as the censors would charge. And even for the works that do not expressly embody any overt political ideology, by pushing the boundaries of the acceptable limits for sexual expression, they too participated in a struggle to expand rights of free expression.

The trials were not only concerned with determining the proper relationship between art and law but also ventured into far-ranging debates about sex and society; the staying power of the liberal postwar Constitution in the post-Occupation period; the place of the classics and classical Japanese language in the canon and in the modern education system; the relationship

among sex, politics, and art; the state of the disciplines of science, medicine, and literary and filmic criticism; the affective nature of reading and spectating; and the relationship between native Japanese and Western conceptions of morality and art, as well as the effects of internationalism on cultural production and its regulation.

In the end, the debates generated by these trials both inside and outside the courtroom are the stories that Japanese society tells itself, and the international community, about its conception of the relationship between law, society, and culture. How these stories got told in each case was influenced by the trial's historical context, whether it was the early-1950s moment when Japan had just regained its sovereignty after defeat and the Occupation, the 1970s context of resurging interest in defining and preserving Japaneseness, or the twenty-first-century global society in which the soft power of Japanese popular culture reigns. Each trial was inflected not just by its present moment, however, but by the past as well, in large part because Japan's obscenity laws date back to 1880 when the nation was consciously modernizing (and Westernizing) all areas of society. Early modern and premodern Japan too played a key role, characterized as an idyllic model of a "pure" Japan that existed prior to contact with the West by both sides: as a bastion of liberal sexual traditions for the defense, and as an uncorrupted fount of native chastity for the prosecution.

Outside observers often remark that contemporary Japanese society itself embodies these two poles as a nation that is somehow simultaneously sexually uninhibited and deeply repressed. My project here is not to resolve this seeming paradox but instead to show how the trials demonstrate an enduring concern with policing sexual morality in art and in society, and to suggest what this may portend for the future of cultural regulation. In the chapters that follow, although I organize them chronologically, I am less interested in attempting to define obscenity or to catalogue what censors found objectionable over the ages than in tracing how key legal, moral, and artistic debates get reiterated, revised, or rejected over the course of these trials. That these debates often reappear in uncanny repetition, stretching from the 1950s to the twenty-first century, suggests both evolution and stagnation in equal measure.

Even more crucially for my project, this chronological organization lends itself to ordering the chapters by the artistic medium that is being censored: translated literature in part 1 (*Chatterley* and Sade in the 1950s and 1960s), film in part 2 (*Black Snow* and Nikkatsu Roman Porn in the

1960s and 1970s), native literary "classics" in part 3 (Kafū's "Yojōhan" and an Edo-period pornographic adaptation of a canonical premodern text in the 1970s), and finally hybrids of text and image (the book version of Ōshima's film in the late 1970s and the manga in the early twenty-first century) in part 4. The specific artistic medium on trial swayed the courses of each trial, both the contours of the debates and the verdicts. It mattered deeply to the lawyers, judges, and commentators alike whether the work on trial was purely words, as with a literary text like *Chatterley* or "Yojōhan," or a combination of word, image, and sound, as in the cases of the films, or just word and image, as with Ōshima's book and the manga. It mattered, moreover, what specific kinds of words and images they were: if words, whether they were textual or aural, translated Western literature or Japanese classical literary prose, the pillow talk and groans in a pornographic film or the speech bubbles of manga; if images, whether they were photographed, filmed, or hand drawn, still or moving. Such questions of form were paramount in these trials, suggesting that content or context alone cannot adequately explain these censorship incidents. Instead, the censorship of art, at its most fundamental level, represents an attempt to control the production and reception of text, images, and sounds.

The ferocity and persistence with which these issues were debated suggest that all parties involved were aware that the verdicts portended the extent to which cultural production and reception could be regulated by the authorities in the future. Moreover, they suggest that both sides recognized the powers (and dangers) of artistic representations, particularly those revolving around the ostensibly private realm of sexuality, to affect citizens in a very public and fundamental way. The ways the trials facilitated, rather than forestalled, such public debates over the ostensibly taboo issue of obscenity is what led director Ōshima to conclude, "The moment it gets involved in porn, politics has already been defeated."[7] Although the guilty verdicts in the majority of Japan's postwar censorship trials suggest this to be an overly optimistic assessment, the tenacity with which these works of art were defended and prosecuted are indeed a testament to the power of art.

EAST MEETS WEST, AGAIN

Trying Translations

And softly, with that marvelous swoon-like caress of his hand in pure soft desire, softly he stroked the silky slope of her loins, down, down between her soft, warm buttocks, coming nearer and nearer to the very quick of her. And she felt him like a flame of desire, yet tender, and she felt herself melting in the flame. She let herself go. She felt his penis risen against her with silent amazing force and assertion, and she let herself go to him. She yielded with a quiver that was like death, she went all open to him.

—D. H. Lawrence, *Lady Chatterley's Lover* (1928)

そして彼は純粋な優しい慾望に驅られて、その手のあの不思
議な氣の遠くなるやうな愛撫で彼女の腰の絹のやうな手觸り
の曲線を撫で、彼女の柔い暖い尻の間を下つて、彼女のあの
急所に次第に近づいた。彼女は彼を慾望のやさしい焰のやう
に思つた。そして彼女は、自分がその焰の中に融けてゆくや
うに感じた。彼女は自分がさうなるのに委せた。彼女は彼の
ペニスが不思議な力と確信で彼女の身體に觸れて起き上るの
を感じた。そして彼女は自分を彼に委せた。

—*Chatarei fujin no koibito,* trans. Itō Sei (1950)[1]

The obscenity trials of *Lady Chatterley's Lover* in Japan from 1951 until 1957 established an enduring legal precedent that would continue to be invoked with great success for over half a century in a series of judicial proceedings against literature, film, photography, art, and, eventually, manga (comics). Unlike the case in Britain and in the United States, where the equally high-profile trials of the novel marked the beginning of "the end of obscenity," to borrow a phrase from the head defense lawyer in the U.S. trial,[2] in Japan they marked only the beginning.

Translator Itō Sei and publisher Oyama Hisajirō were tried under obscenity laws for their 1950 translation of D. H. Lawrence's 1928 *Lady Chatterley's Lover.* As seen in one of its more explicit passages cited above, the novel describes the adulterous affairs of Constance Chatterley in rapturous prose that would lead the Japanese prosecutor to charge the novel with including "plain and detailed descriptions of the sex act . . . [that] will, for the contemporary average reader in our country, excite and stimulate their sexual desire . . . as well as provoke people's sense of shame and feelings of hatred."[3]

The course of the *Chatterley* trials was neither straight nor swift. After the chief public prosecutor's office lodged preliminary charges on June

26, 1950, the police seized all unsold copies. Despite a vocal and unified protest from the literary world, the defendants were formally indicted on September 13. The first Tokyo District Court trial ran from May 1951 through January 1952, when the publisher Oyama was convicted and fined 250,000 yen (approximately $700), while the translator Itō was acquitted. After both the prosecution and defense appealed to the Tokyo High Court, in December 1952, the court ruled to uphold Oyama's guilty verdict but to overturn Itō's acquittal and to fine him 100,000 yen (approximately $275). Finally, in March 1957, the National Supreme Court issued its influential *Chatterley* verdict, upholding both convictions with just one judge dissenting and another concurring in a minority opinion. It was not until after this Supreme Court verdict in Japan that the long-standing ban against the novel was reversed in either Britain or the United States.

The Tokyo District Court trial (hereafter *Chatterley* trial) would last for over eight months, meeting for a total of thirty-six sessions and producing over thirty volumes of records. The prosecution and defense called thirty-three witnesses from occupations as far ranging as Christian activist, high school student, farmer, and gynecologist. In retrospect, the idiosyncratic and somewhat haphazard nature of this first postwar obscenity trial seems an inevitable consequence of its timing, a period of tumultuous political, legal, and societal instability in Japan. The outbreak of the Korean War on June 25, 1950, just a day before the *Chatterley* charges, ensured the continuation of conservative policies that had been evident both among the U.S. Occupation (1945–1952) authorities after its so-called reverse course and among Japanese authorities, particularly after the installation of the powerful third Yoshida cabinet in January 1949. Beginning in late 1949, a wave of Red Purges swept over labor union activists and, after the outbreak of the Korean War, soon extended to the private sector, including the mass media and film industries. In a series of "train incidents" in July and August of 1949, striking Communist union members were falsely charged with causing unmanned train wrecks in McCarthy-like witch hunts.[4] All these events suggested just how hostile both the Occupation and the Japanese government had become by 1950 toward the provisions for freedom of expression and assembly included in Japan's new, postwar Constitution.

Most important, the *Chatterley* trial coincided with the moment when national sovereignty was being restored as per the San Francisco Peace Treaty of September 8, 1951. In anticipation of the end of the Occupation, censorship was transitioning back to domestic Japanese controls in the form of

newly established self-regulatory organizations. In June 1949, the film industry was the first to establish such an agency, Eirin (Eiga Rinri Kitei Kanri Iinkai, or the Motion Picture Ethics Regulation and Control Committee). In the interest of moving the publishing sphere also toward self-regulation, on June 19, 1950, just one week before the *Chatterley* charges, the Publishing Morals Committee (Shuppan Butsu Fūki Iinkai) was created at the urging of the National Police and in cooperation with the state prosecutor's office.

This committee's contradictory status as both a quasi-governmental and self-regulated organization reflects the uneasy state of free expression in the immediate postwar years. On the one hand, censorship had been unequivocally abolished by the 1947 postwar Constitution in article 21: "Freedom of expression is absolutely guaranteed. No censorship shall be maintained" (*Issai no hyōgen no jiyū wa, kore o hoshō suru. Ken'etsu wa, kore o shite wa naranai*). On the other hand, censorship was not eliminated in practice during the Occupation period or thereafter. In September 1945, General Headquarters (GHQ) established a two-pronged censorship system, with Civil Information and Education, the civil propagandist arm, taking a proscriptive role, and the Civil Censorship Detachment, the military censoring body, taking a prescriptive one. Many scholars have noted the hypocrisy of Occupation policies for conducting five years of intense, but invisible, censorship while vocally advocating democratic ideals.[5] Significantly, however, although the trial began during the tail end of the Occupation, it was run exclusively by Japanese authorities with a minor, yet contentious, role played by the Occupation officials (as discussed below).

With the disappearance of the Occupation censors, what legal and extralegal censorship mechanisms remained for the Japanese authorities? And what could the defense team rely on to make its case?

The newly formed Publishing Morals Committee may have had moral authority, but it lacked any legal authority. The committee included diverse members, both conservatives like Kanamori Tokujirō, first librarian of the National Diet Library, and Dr. Mori Atsuo, head of the Tokyo Medical Association, as well as liberals like literary critic Nakajima Kenzō. (All three of these men would play key roles in the trial as well, with Kanamori and Mori appearing as prosecution witnesses and Nakajima serving as special defense counsel.) The organization's mission statement declared,

> The trend of publishing obscene works is steadily increasing and editorial policies too have become shrewd, making the works increasingly

difficult to regulate. From the point of view of maintaining good morals and manners, we cannot allow this to be overlooked. . . . We will strive to sincerely and strictly enforce the appropriate regulations.[6]

Notwithstanding its stated zeal to stamp out obscenity, the role of this committee in the *Chatterley* indictment was secondary. At the trial, the prosecutor refused to disclose the precise sequence of events that led to the indictment but claimed that letters from concerned citizens and advertisements for the novel in newspapers and magazines had influenced the state's decision to investigate.[7] Apparently, however, the prosecutor's office had distributed copies of *Chatterley* with the objectionable passages underlined in red to committee members who were perceived to be amenable to advocating prosecution, excluding, for example, literary critic Nakajima.[8] The selective means of soliciting support and the alacrity with which the committee singled out and brought formal charges against *Chatterley* suggest a directed attack initiated by higher authorities.

Censoring the novel in the postwar period required a new form of censorship: an "artistic trial" for which the Japanese were lacking an established precedent. In the prewar era, censorship trials were rare when routine suppression of books and serialized works under the 1893 Publication Law and 1909 Press Law was common. And none occurred during the Occupation period. As such, only a handful of prewar literary trials could have served as models, and even these differed substantially because no corollary provisions for free speech existed.[9]

In all the postwar censorship trials, the prosecution and the defense appealed to two very different legal codes to make their cases. The state invoked article 175, the obscenity clause of the Criminal Code (Keihō). If guilty, the work was banned, and defendants were subject to imprisonment for up to two years, an increase from the maximum six-month term for prewar violations of the Publication Law, and/or fined; the prewar fine of a mere 500 yen was increased tenfold in late 1947 to 5,000 yen, and to a whopping 250,000 yen in February 1949 to increase the severity of the penalty and to accommodate rapid postwar inflation. Promulgated in 1880 and revised in 1907, the Criminal Code dates back to the Meiji period (1868–1912), Japan's era of modernization and Westernization. Modeled on French and Prussian law, respectively, it was not, by any means, a purely "native" document despite the lawyers' rhetoric in the trial. Although the code underwent revisions under the aegis of Occupation authorities in

October of 1947, at the time of the *Chatterley* trial (and even today) article 175 remained essentially unchanged from its Meiji version.[10]

The prosecutor's legal definition of obscenity (*waisetsu*) also dated back to the prewar period, having been adapted from a 1918 trial over nude illustrations and Western art to encompass "writings, pictures, or any other objects which stimulate or arouse sexual desire or could lead to its gratification, and, accordingly, such obscene objects necessarily are those that produce the sense of shame or disgust in human beings." This definition had been revised slightly in a 1951 ruling to establish what would become the famous three-prong definition of obscenity enshrined by the *Chatterley* Supreme Court verdict of 1957: obscenity was "that which wantonly stimulates or arouses sexual desire or offends the normal sense of sexual modesty of ordinary persons, and is contrary to proper ideas of sexual morality."[11]

To challenge the legality of article 175, the *Chatterley* defense counsel relied heavily on its interpretation of the barely three-year-old Constitution and on foreign models of censorship trials. The defense asserted that the constitutional ban of censorship (article 21) should take precedence over the Criminal Code, or at least should seriously restrict its applicability. According to article 98, the Constitution was deemed the "supreme law of the nation" under which five quasi-constitutional codes, including the Criminal Code, were to operate.[12]

The *Chatterley* trial raised a fundamental legal question of how to reconcile the obscenity laws in the 1880 Meiji Criminal Code with the new freedoms guaranteed in the postwar Constitution. This issue was given prime attention by legal journals at the time like *Jurisuto,* established in January 1952 with the intent of educating laypeople about postwar Japanese law.[13] The debate was not, however, a purely legal issue. Instead, it was heavily entangled with the larger question of the relationship of Japanese cultural, political, and legal institutions to foreign influence. The Constitution invited this controversy because arguably it had been imposed on the Japanese people by the Occupation authorities. Although GHQ authorities had initially left constitutional revision to the Japanese government, after receiving unacceptably conservative proposals, in February 1946 they took over and commissioned a constitutional convention consisting entirely of Westerners. The resulting draft was even originally written in English, necessitating a torturous translation into Japanese for consideration in the Diet. During this process, a Japanese cabinet minister accused GHQ of "trying to reinvent not merely the national polity but the Japanese language

as well."[14] Although this statement seems more polemic than truth, a reminder of the postwar Japanese Constitution's foreign origins undeniably remains imprinted on it. Just as *Chatterley* was a translated work, the new Constitution had largely been written by Westerners too.

The symbolism of this first post-Occupation trial that pitted the postwar "imported" Constitution against "native" obscenity laws, and as one that centered on the translation of a Western work no less, was obvious. At stake was the future of Western influence in both literary and legal spheres. Just as the verdict offered an important indicator of the freedoms that would be afforded to the arts in post-Occupation Japan, the trial would signal how the new Constitution would fare after a return to native sovereignty.

The successful conviction of *Chatterley* and subsequently of yet another translation—an abridged version of Marquis de Sade's *Histoire de Juliette,* translated by Shibusawa Tatsuhiko in 1959–1960—contrasts starkly with the prestige enjoyed by translations in Japan in the distant and recent past. Since the late nineteenth century, translated Western literature had enjoyed an esteemed position in what has been called the age of translation.[15] Western literature had initially been used to legitimate the modern Japanese novel. In what is considered the foundational work of modern literary criticism, *The Essence of the Novel* (*Shōsetsu shinzui*, 1885–1886), author and critic Tsubouchi Shōyō endorsed Western novels as a model for "immature" Japanese writers to emulate hoping to "bring readers to their senses and at the same time enlighten authors, so that . . . we may finally bring it to the point where it outstrips its European counterpart."[16] During the Occupation, translations were popular both with readers, who craved what they had been denied during what one literary critic called their "forced intellectual isolation" (*sakoku*) during the war,[17] and with Occupation officials, who actively promoted translations of foreign works as an instrument for democratizing postwar Japan. This policy was wildly successful; from November 1945 through April 1948, translations of 1,367 publications appeared, at the incredible rate of more than three translations every two days, and many making best-seller lists.[18]

With the *Chatterley* trial, however, a Western classic was being charged with tainting Japanese literature and society. The indictment of a translation of a foreign work at the very moment when Occupation censorship controls were waning is indeed suggestive of the ideological battles at stake. The *Chatterley* trial staged a very public struggle to define literary, cultural, and legal identity, engaging a far-reaching debate over the relationship of domestic Japanese and imported Western traditions.

Lacking a template for a postwar democratic censorship trial, both sides scrambled to devise new strategies. These strategies were informed by the immediate context of the *Chatterley* trial but would have an unexpectedly lasting effect in shaping subsequent trials as well. The prosecutor in charge was a young lawyer, Nakagome Noriyori, who had recently, in 1947, joined the Tokyo district prosecutor's office. The defense team was headed by the well-known radical lawyer Masaki Hiroshi, a 1928 graduate of Tokyo University, who had defended three earlier highly publicized cases: the Headless Incident (Kubi Nashi Jiken) of January 22, 1944, in which murder charges were brought against police after the severed head of a suspect who died while in police custody was secretly exhumed and autopsied; the Placard Incident of May 1, 1946, in which a protester at a Food May Day demonstration wearing a placard criticizing the emperor was charged with a crime akin to lèse-majesté; and the Mitaka Incident of July 15, 1949, one of the many postwar "train incidents." As Ienaga Saburō, a liberal historian who was involved in his own series of lawsuits against the government over textbook censorship from the mid-1960s through the late 1990s, noted, Masaki's involvement in an obscenity trial like *Chatterley* might seem a bit uncharacteristic in the context of his résumé but reveals a "fundamental link in the chapters of Masaki's life as it represents a fight against criminal coercion by the barbaric authorities [*yaban na kenryoku*] who try to oppress spiritual culture based on an outdated legal sense."[19]

The fact that *Chatterley* was being accused not of a political crime but instead of the sexual crime of obscenity obscured these connections for many. Writing early in his career in 1962, Japan's preeminent liberal legal scholar Okudaira Yasuhiro accused his colleagues of shying away from the issue because "the word obscenity . . . carries an unambiguously derogatory ring" that led them to respond by "putting a lid on the stench" (*kusai mono ni wa futa o*). He insisted on the inherent link between the repression of sexual and that of political expression, warning that "the scope and the legal logic of the authorities in cases when the state acts as the guardian of sexual morality is not, on further reflection, unrelated to its role as guardian of political order."[20]

This point was not, however, lost on all. In early 1952, just on the heels of the *Chatterley* lower court guilty verdict, revisions of the Subversive Activities Prevention Law (Hakai Katsudō Bōshi Hō) were proposed and eventually passed in July 1952 in response to the violent May Day Incident. The concurrent timing of the verdict and this proposed legislation led

author Abe Kōbō to insist tersely "these two things are not unrelated to each other" in a questionnaire conducted by the journal *Shin Nihon bungaku*.[21] Government clampdowns on political protests themselves suggested the intimate link between free expression in the arts and that in politics, as well as ways that the creative manipulation of language offered a powerful tool for political protest. For example, in the Placard Incident of 1946, the man protesting outside the Imperial Palace wore a sign written in a combination of archaic language traditionally reserved for the emperor and crude language and emphatics to denounce the emperor for letting the people starve while he stuffed his gullet: "Imperial edict: The nation has erred / I eat to my heart's content / Ye, the people, starve and die. The imperial sign and seal." Similarly, in the Kyoto University Emperor Incident of November 1951, students addressed hostile questions about war responsibility to the visiting emperor, whom they irreverently addressed with the confrontational and overly familiar pronouns *kimi* and *anata*. Later director-defendant Ōshima Nagisa, a young officer in the university's student association at the time, would later cite the incident as a formative politicizing event in his life.[22] Student activism revolved around antiwar protests in substance, but at the core was a demand for the rights of free expression and assembly ostensibly guaranteed in the postwar Constitution. The rights to protest, to address the emperor by whatever term one wished, to publish and to perform freely were people's new rights. But with the escalation of the Cold War, these rights were becoming increasingly precarious. Both political and artistic expression were targets, as evident in February of 1952, when an undercover policeman was discovered monitoring a leftist theater performance at Tokyo University in a surveillance tactic that disturbingly resembled prewar censorship.[23] In this context, the successful prosecution of *Chatterley* could serve as an important assertion of state rights over individual freedoms, or essentially as the reinstatement of prewar censorship mechanisms in a postwar democracy.

The trial attracted considerable attention from the literary and legal communities, as well as from the public. A prominent legal scholar writing just after the Supreme Court verdict in 1957 credited it for being the first postwar trial to captivate the Japanese press despite the fact that the issues at stake were largely ones of legal interpretation rather than lurid whodunits. Although another commentator writing in the late 1970s begins by warning against exaggerating its importance in retrospect, he nonetheless modestly credits it with having "seized the eyes and ears of the world."[24]

Why was the *Chatterley* trial able to captivate such a broad-ranging audience? Certainly, the sensationalized media coverage it received helped, not to mention the sensationalist potential of the taboo subject of obscenity. As the first censorship trial in postwar Japan, it held enormous implications as a legal precedent. Not only could it set a pattern for later trials but it could also establish a new pecking order for politics and literature and thus redefine the place of art in postwar society. Although the fate of literature had largely been subordinated to political concerns in prewar and wartime Japan, the *Chatterley* trial offered the artistic community an opportunity to assert the primacy of literature in the postwar period. For the legal community, it portended the fate of postwar legal reforms in the post-Occupation era. And for the state, it represented an assertion of the government's right, and even duty, to regulate cultural production in the name of societal morality. In sum, the *Chatterley* trial was to serve as a barometer gauging the degree of autonomy that art, law, and citizens would, or would not, enjoy in post-Occupation Japan.

Through the intense mass media coverage, the Japanese public was offered a crash course on postwar law, and on fields ranging from literature to psychology and mass communications. Depending on the testimony, the courtroom alternately resembled a lecture on constitutional law, a roundtable discussion on literary criticism, a debate on sexual morality, or a presentation of scientific findings. As one defense witness quipped to the newspapers after a lengthy day of testimony on the psychological effects of reading *Chatterley,* "courtroom no. 11 became classroom no. 11 that day."[25] The defendant-translator Itō Sei credited the trial with initiating the public into the world of literary criticism, including everything from the "new U.S. style" to the "traditional European style." In fact, the witness roster resembles a literati who's who, with even the rejected defense witness list including such luminaries as author Kawabata Yasunari and literary critics Nakamura Mitsuo and Katō Shūichi. In the preface to his published trial account, *Saiban* (The trial), Itō claimed that his book "quite unexpectedly provided a diagram of the state of Japanese intellectuals in the postwar period."[26] For us today, the trial offers a microcosm of literary and legal criticism and their relationship to each other in postwar Japan and a unique window on the state of these cultural endeavors at that time.

Lady Chatterley's Censor
(1951–1957)

In 1949, Oyama Hisajirō, owner of Oyama Publishing, approached respected critic, author, and translator Itō Sei about translating *Chatterley* as part of a planned series of Lawrence's collected works. His decision to ask Itō was a natural one, since Itō had already published two expurgated translations in 1935 and 1936 with other publishers. *Chatterley* was to be the first in the series, followed by Lawrence's 1926 *The Plumed Serpent* (*Tsubasa aru hebi*), translated by Nishimura Kōji, who had also previously published an expurgated version. Oyama would later make the improbable claim in court that this lineup was based solely on practical considerations of expediency rather than on a financially motivated desire to profit from the sensational reputation of *Chatterley* in Japan and abroad (*CS,* 1:59–60). This reputation long preceded the appearance of Itō's complete translation; many witnesses, for both sides, admitted to having read pirated English-language editions of *Chatterley* that were being passed around small circles as early as the 1930s.[1]

Based on the flurry of interest in *Chatterley* from publishers in the late 1940s, the work seemingly offered an especially attractive prospect in the postwar climate. The postwar constitutional guarantee of free expression encouraged publications previously unthinkable. In fact, other publishing houses had approached Itō as early as January 1946 to commission an unexpurgated translation. Another project planned to include *Chatterley* as part of a series called the Library of World Literature That Emancipates Mankind (Ningen kaihō sekai bungaku sōsho),[2] a name that itself suggests how *Chatterley* was perceived to accord with postwar democracy and liberation. As Itō Sei's son, Itō Rei, puts it, *Chatterley* was intended to be

"a publication in an era in which freedom of speech had become the new Imperial standard."[3]

The effect of this liberalized atmosphere on the publishing world was apparent almost immediately: whereas at war's end only 300 publishing companies existed, within eight months over 2,000 were in operation, and by 1948 that number had peaked at 4,600.[4] The publishing boom encompassed a number of genres, but the most relevant to the *Chatterley* trial are the pulp magazines (*kasutori zasshi*) at one end of the spectrum and translated foreign works that had been banned during wartime at the other.

Despite this climate of liberation, Itō worried that perhaps Japan was not ready for the sexually explicit nature of *Chatterley* and urged Oyama to make necessary revisions to avoid trouble with the authorities. Itō was well aware that the novel had encountered legal trouble in England and the United States (although postwar publishers there too would test these limits soon enough) and assumed this would be the case in Japan as well (*CS,* 1:55–58). Despite Itō's reservations, Oyama published the translation uncut in two volumes that were released on April 20 and May 1 of 1950. Oyama's business instincts proved correct: within two months, over one hundred fifty thousand copies had sold. His legal instincts were less savvy, however, as became obvious when the police initiated obscenity charges just two months later.

The Prosecution—Why *Chatterley*?

What about the novel motivated the state prosecutor to try Itō and Oyama over seven long years all the way to the Supreme Court, and what swayed the judges ultimately to rule in the state's favor? The *Chatterley* trial offers a particularly rich example through which to examine the prosecutor's motivations because, unlike his successors in subsequent obscenity trials, he expounded his arguments at length, calling a total of sixteen witnesses. His case tapped into familiar arguments made by censors through the ages in both Japan and abroad, revealing the censor's potential to display both a critical acumen that rivals the literary critic as well as occasional stupidity. To begin with the most obvious first question: why *Chatterley*? The simplest answer would be that the state found the novel's content obscene, although, as we will see, other less obvious and more complex reasons hold the key to the answer to this question.

In the indictment, the prosecution identified twelve particularly objectionable passages, which, in prosecutors' minds, rendered the entire

work obscene. These included examples of the "repeated plain and detailed descriptions of adulterous sexual intercourse" between Lady Chatterley (Connie) and two men, the writer Michaelis and the gamekeeper Mellors. The sex scenes with Michaelis focus on the impossibility of men and women achieving simultaneous orgasms, or "crises" as Lawrence euphemistically calls them.[5] The sex scenes between Connie and Mellors are rendered in even more explicit detail, as seen in the passage cited at the opening of part 1 that obliquely refers to anal sex.

Based on these passages, the novel seems indeed to have been indicted solely for its graphic depiction of sex that would "for the contemporary average reader in our country, excite and stimulate their sexual desire . . . and, in addition, provoke people's sense of shame and feelings of hatred" (*CS,* 1:38). Certainly *Chatterley* contains sexually explicit scenes, but whether they were of an extreme nature not seen before in Japanese works was debatable and was a point that was hotly contested in the trial, with competitors ranging from Edo-period erotic books (*shunpon*) and woodblock prints (*shunga*) by famed artists like Saikaku and Hiroshige to the lowbrow pulp magazines of the immediate postwar era. In any case, attempting to reconstruct the reasons for the work's prosecution by analyzing content alone yields only an elusive and circular definition of what is obscene based on what was considered so by the censors. In the *Chatterley* trial, the supposed obscenity of *Chatterley* was a central question, but it was not determined by a narrow judgment of content alone. Instead, broader factors of form and context, including literary, societal, and legal contexts, influenced the prosecution in its decision to indict *Chatterley* and the judges in their ultimate decision to convict both Itō and Oyama.

Immaculate Style and Maculate Contents and Marketing

Itō testified that he intentionally used the technique of "direct translation" (*chokuyaku*) to avoid accusations of sensationalizing the already sensational content of *Chatterley.* In the translation, Itō retains nearly every word and even the punctuation of the original, taking few liberties to naturalize the language. For example, he replicates almost every occurrence of "he" and "she" even though these pronouns are commonly dropped in Japanese. He also faithfully mirrors the diction of Lawrence's original, using Chinese characters, thus a more formal tone, for Lawrence's more euphemistic word choices, for example, *shikyū* (literally, "house for child") for the original's

euphemistic "womb" to refer to female genitalia, and more explicit collo-
quial options when the tone of the original is more explicit, such as *penisu*
in katakana script for Lawrence's "penis."[6]

But for the prosecution, Itō's literal translation style contributed to
rather than mitigated the text's obscenity. Indeed, prosecution witnesses did
not accuse Itō of mistranslating Lawrence but of translating him altogether
too skillfully and faithfully. Prosecution witness Mori Atsuo, for example,
asked, "Did he really have to describe it *this* skillfully?" and, "Couldn't Itō-
san have done something a bit more about the theme?" (*CS*, 1:137). For
the moment, we will leave aside the questions about authorship that these
critiques imply with their assumptions that seemingly confuse the translator
with the original author, or, alternatively, with the censor. In fact, Itō testi-
fied that he had advised Oyama to self-censor as necessary to avoid legal
troubles, noting that changing words like *penisu* to the more euphemis-
tic Chinese compound *dankon* (phallus, or, more literally, "root of male")
might have prevented the indictment (*CS*, 1:224–225). A defense witness,
psychologist Hatano Kanji, disagreed with this assessment, arguing in his
testimony that the use of literal medical terms like "penis" and "uterus"
mitigated the work's obscenity, because, unlike metaphorical language, they
did not stimulate the reader's imagination (*CS*, 1:199). For one judge, how-
ever, such immediacy was precisely what rendered the text objectionable.
During his cross-examination of Itō, Judge Tsuda questioned whether the
"use of a stiff style didn't conversely invite misunderstanding" (*CS*, 1:280).
Paradoxically, Itō's attempts to avoid indictment by faithfully translating the
work only encouraged it.

The work was also judged in terms of its context in both a narrow and
broad sense: its physical packaging as a book and its status in the canon
of contemporary and classical literature. The split verdict at the District
Court trial where the publisher was convicted and the translator exonerated
depended wholly on a distinction drawn between the book proper and the
commoditized product, suggesting how the book's form was equally, if not
more, important than content in the judges' minds.

Undoubtedly, the inexpensively priced Oyama edition at about fifty
cents per volume (180 and 200 yen, respectively, for volumes 1 and 2)
encouraged both its high sales and its indictment for "selling a large number
of copies to general readers" (*CS*, 1:38). In the trial, the defense argued that
Chatterley was unfairly targeted precisely because of its popularity and, as
proof, cited the two-month time lag between its publication and the charges,

which occurred only after over one hundred fifty thousand volumes had been sold.[7] As legal scholars commenting on the Supreme Court verdict remarked, the relationship between sales figures and indictments was circular: rumors of a possible indictment stimulated sales while increased sales fueled the state's decision to prosecute. In his memoirs, Oyama reports that after such rumors surfaced, he heard that copies of *Chatterley* were being sold on the busy downtown "corner at Sukiyabashi by newspaper boys wearing large lettered red ink signs carrying the mock warning, 'Danger! *Chatterley.*'"[8]

For the prosecution, the novel's widespread accessibility to an audience that included elites and the general public was at the root of the problem. Oyama's decision to publish the novel as the first in the Lawrence series was criticized as a cheap sales tactic: prosecution witness Sawanobori Tei'ichi, a high school principal and linguistics scholar, speculated that charges could have been avoided if *Chatterley* had been released as part of a collection of complete works despite the likely financial loss for the publisher (*CS*, 1:146). Its release in two separate inexpensive volumes only further encouraged the perception that Oyama aimed at titillating his readers rather than introducing them to the esteemed corpus of D. H. Lawrence. Not only was the second volume touted as the debut of a "complete translation!" (*kan'yaku naru!*) on the jacket cover, but the volumes were divided at a suspiciously titillating plot point as well. In the final chapter of the first volume, Lady Chatterley and the gamekeeper Mellors have an especially satisfying sexual encounter where they achieve simultaneous orgasms for the first time. The chapter ends with not just this climax but also a mystery centered on the question hinted at by the title of the novel: who is Lady Chatterley's lover? In its final pages, the Chatterleys' housekeeper discovers the identity of Connie's lover, which she considers revealing to Lord Chatterley.[9] Its tone invites reading the work as a combination of pornography, melodrama, and mystery instead of as the highbrow, philosophical work the defense would argue it to be in the trial.

In the initial split verdict, the District Court ruled the book itself not obscene but argued that it had effectively been transformed into obscenity by Oyama's sensationalist marketing strategy. Citing Principal Sawanobori's testimony, the judges criticized Oyama for "deciding to sell this translation first merely because the manuscript was completed first" and concluded that he "recognized that the majority of readers would interpret it as a vulgar novel about sexual desire and as pornography [*shunpon*]" (*CS*, 2:323). Oyama's commercialism was evident in his decision to release the novel in

two inexpensive volumes, unlike serious educational works of sexology like the 1946 translation of Van de Velde's *Perfect Marriage* (*Kanzen naru fūfu*) and the Kinsey report that Oyama had published as single expensive volumes.[10] Especially problematic in the judges' minds were Oyama's salacious advertising methods hyping the theme of adultery and including come-ons like "Lawrence never thought the work would see the light of day" (*CS*, 2:318–320), and the inclusion of a reader survey in the second volume, which asked readers provocatively, "Were you sexually aroused on reading the novel?"

In addition to objecting to the novel's physical packaging as sensationalist smut, in an apparent contradiction the prosecutor and judges objected also to its status as a highbrow literary translation. The defense had inadvertently fueled these objections by repeatedly pointing to the esteemed reputation of the original author, translator, and publisher in an attempt to secure an acquittal. By 1950, Oyama's company had established a track record for publishing highbrow classics, fictional works by Sōseki and Kawabata, as well as translations of Maupassant, philosophical works by Miki Kiyoshi, and even an encyclopedia.[11] In his testimony, Itō ranked, perhaps a bit optimistically, Oyama Publishing among Japan's top ten, and as one of Oyama's assistants testified, all thought that the publisher's reputation would save them from prosecution (*CS*, 1:344–345, 58–59).

The defense also pointed to more sexually explicit works that were readily accessible to the general public, such as the disreputable inexpensive popular magazines that flourished in the immediate postwar years. The Japanese term for these magazines, *kasutori,* refers to a potent, cheap rice whisky made from brewer's grains; just as one would be drunk after drinking three *gō* (about half a pint), the magazines usually went bankrupt after a mere three issues (*gō*).[12] In the hopes of convincing the court that *Chatterley* was less obscene than these magazines, or that both were acceptable based on contemporary community standards, the defense submitted a number of them, such as the best-selling *Married Living* (*Fūfu no seikatsu*) with a monthly readership of three hundred thousand.

In obscenity trials abroad as well, defense lawyers have often made similar claims—that the work they are defending does not qualify as obscene because it is comparatively innocuous. But, as noted by Charles Rembar, the defense lawyer in the U.S. *Chatterley* trial, such arguments generally fail as legal strategy: "To call attention to the currency of trash—to the availability of other publications of which a court might disapprove—would, in the

eyes of the disapproving court, prove nothing except that the government does not have time to prosecute everything that ought to be prosecuted."[13] In the case of *Chatterley,* this strategy was particularly ineffective because it served only to emphasize the novel's status as high translated literature and to bring attention to the impoverished state of the Japanese publishing industry, or the "currency of trash," which, to the courts, indicated not societal acceptance but the dire need for a corrective.

What was objectionable was precisely the appearance of lowbrow content in the sanctioned medium of high literature. A prosecution witness provocatively suggested that the impetus for indicting *Chatterley* was its "high" literary status rather than its irredeemably "low" subject matter: in his testimony, Komada Kin'ichi, a school inspector for the Ministry of Education, claimed to be unperturbed that students read pulp magazines because they were not respected publications but was quite worried that the first-rate author of *Chatterley* would have a worse effect on students (*CS,* 1:179).

Symbolic Strikes: Targeting Translations and Exempting Native Erotica

The persistent and ultimately successful prosecution of *Chatterley* contrasts sharply with the little to nonexistent regulation of domestic erotic publications. This begs a question perennially raised in censorship incidents: why this and not X, Y, or Z? Although ultimately an unanswerable one, the comparison is important here because it demonstrates how the novel's highbrow status and foreign origins worked against it and can suggest the ideological motivations behind the trial.

In the immediate postwar period, pulp magazines were occasionally charged with obscenity, but publishers merely received warnings to self-censor, fines, or temporary bans. A number of semigovernmental organizations, such as the Publishing Code Practice Committee (Shuppan Kōryō Jissen Iinkai), were created in the spring of 1949 specifically, as one witness described it, "to combat *ero-guro* [erotic-grotesque] publications that were undesirable from a moral standpoint."[14] But as another witness, Ishii Mitsuru, the chair of the Japanese Publishing Association, explained in his testimony, the reason this committee was dissolved stemmed from its members' realization that "although pulp magazines sold incredibly well initially, . . . after two or three issues, they would disappear."[15]

In part, the fundamental difference between the publications can explain why they were regulated differently. Unlike *Chatterley,* the pulp

magazines were not reputable. Moreover, they were ephemeral works, as indicated by the origin of their name, lacking both the financial resources and artistic merit necessary for publishers to undertake a defense in court. The discrepancy also reflects an important difference in their origins: a translated foreign novel versus domestic publications. Not only had lowbrow magazines been left mostly unfettered but also the police and prosecutors had not pursued charges against the provocatively named literary genre of "literature of the flesh" (*nikutai bungaku*). Author Tamura Taijirō pioneered the genre in September of 1946 and published his most famous work, *Gate of Flesh* (*Nikutai no mon*), in March 1947. The short novel depicts five prostitutes living together in bombed-out Tokyo in relative harmony until two of the group's members break the gang's cardinal rule by falling in love and having sex for free.[16] The work's sensational scenes of sex and sadism in which the gang brutally beats the scantily clad love-struck prostitutes appeared as a stage play in August 1947 and later as a film by director Suzuki Seijun in 1964.

As Jay Rubin argues, the Occupation authorities may have inadvertently set into motion the chain of events that culminated in the *Chatterley* trial when they urged the Japanese police to control lowbrow domestic publications in 1947 and again in 1950. The Japanese censors responded instead by embarking on a campaign against translations of highbrow foreign works that they suspected of being "a ploy to sell pornography with the false label of imported 'art.'"[17] Here the police articulated an objection clearly shared by the *Chatterley* prosecutor: the inclusion of "low" sexual material under the cover of the label of "high" art. In February 1950, their initial target was Norman Mailer's *The Naked and the Dead*, a top-ten best seller. When stymied in their attempt to prosecute Mailer's novel because liberal Occupation officials endorsed its pacifist theme, they targeted *Chatterley*, a work that was less likely to benefit from their protection because of its shaky legal standing abroad.

The successful *Chatterley* indictment symbolized the failure of the Occupation's early idealism and acted also "more indirectly to encourage the reawakening of a conservatism that had prewar roots."[18] For the Japanese authorities, it paved the way for the successful renewal of domestic censorship. Although the Publishing Morals Committee proclaimed its intent "to sincerely and strictly enforce the appropriate regulations" against obscene works in its mission statement, the committee pointedly noted it would "leave aside lowbrow erotic publications" and focus instead on rectifying

the overly "subjective" regulations for "literary works, medical texts, and translations."[19] Apparent again is the censors' concern with legitimate high-brow works covertly intermixing lowbrow content, rather than with overtly lowbrow texts.

In the eyes of the state censor, it seems the novel's status as a highbrow work of translated literature worked against it in two ways. First, as a work of high literature, the novel threatened to taint the literary canon with its discomfiting combination of highbrow style and lowbrow content, or as one commentator on the U.S. *Chatterley* trials has aptly put it, Lawrence's innovative technique of "literary fucking."[20] Second, as translated literature, its foreign origins were viewed as a threat to both domestic morality and the Japanese literary canon, suggesting that the targeting of a highbrow trans-lated work was highly symbolic.

A much more prosaic reason can also explain the tenacity and success of the prosecution: Oyama's litigious nature and his stubborn refusal to coop-erate with the authorities. After the *Chatterley* trial, Oyama also initiated lawsuits against the publishers of pirated editions of *Chatterley* and against the police for failing to return seized foundry proofs and other materials. And as Oyama himself admits in his memoirs, he refused to include the pro forma expression of contrition at the conclusion of his formal statement to police despite an officer's helpful advice that "it's what you're supposed to say in a place like this." Such apologies and even outright denials of author-ship often helped authors escape conviction or even prosecution (as we will see was the case with Nagai Kafū below), while Oyama's refusal caused the police to note that he was "one stubborn man" (*zuibun ganko na hito da na*).[21] The lower court's decision to convict Oyama and to acquit Itō may even have been influenced by the defendants' opposite dispositions. As the head judge noted in his memoirs, Itō "was a university lecturer who looked the part of a scholar and calmed the courtroom atmosphere with his mild demeanor. Oyama, on the other hand, had a stern bearing with an attitude that was rather stiff."[22]

To sum up the argument to this point, by exploring the style and con-text of *Chatterley*, I have tried to demonstrate how the book's style and its status as a material object and as a literary phenomenon fueled its pros-ecution and conviction. The novel's sexual content, its "plain and detailed" style, its large number of sales, its high literary status, and even the person-alities of the defendants clearly influenced the state's case. In the final analy-sis, however, such speculation fails to address adequately how the broader

historical and cultural context of the novel's publication in 1950 affected the course of the trial. As we will see in the next section, the content, style, *and* context of its publication converged to make it an attractive, and ultimately successful, target for the prosecution as a highly charged and symbolic strike against Western cultural and legal traditions.

But, as we will also see, these issues were never exclusively ideological. On the contrary, they were rooted in practices of cultural and literary interpretation. Determining the relationship between content, style, and context demanded that the censor, like the literary critic, consider also the aesthetic and material conditions of the novel's production and its reception. In other words, the censor had to ascertain both authorial intent and reader reception. In considering these aspects, the prosecutor and his witnesses engaged in literary criticism in a legal context. All parties involved were well ahead of their time, advancing such theories a decade before the emergence of reader response literary criticism in the 1960s by German scholars of the felicitously named Constance school.[23]

Why Prosecute *Chatterley* in 1950s Japan?

Impotent Veterans and Cheating Wives

Could, for example, *Chatterley*'s theme of a sexually impotent war veteran have touched a nerve in Japan in 1950? The theme did reflect an uncomfortable reality in a postwar Japan where large numbers of injured World War II soldiers had recently returned from the battlefields of Asia.[24] In the novel, instead of being rewarded with wifely devotion and war medals, former soldier Lord Chatterley is faced with an adulterous wife when he can no longer perform sexually. His fate mirrored the chilly homecoming for Japan's returning veterans, who were widely perceived as pariahs because of both the perceived ignominy of surrender and the public's aversion to their physical injuries, an all too visible reminder of Japan's defeat.

Itō himself recognized the potential parallels that could be drawn between the two, admitting his concern that the work would resonate unpleasantly with wartime readers. In an essay written in October 1941, Itō reported asking the publisher of his 1935 expurgated *Chatterley* translation to refrain from reprinting the work. He emphatically denied that his request was because of new wartime censorship regulations for translated works, explaining that

the reason is because a character appears whose lower half of his body is devastated after getting wounded in war and because it probes his internal issues at length. . . . My immediate motivation stems from my visit to an army hospital, where I heard about various injuries and treatments. But even more than that, I believe such "literary probing"—questions of the work's value or its treatment of ethical judgments—should be left alone at this time.[25]

Here Itō worries that Lord Chatterley's crises would echo Japanese soldiers' own bleak homecomings, which were proving to be the inverse of the propagandists' depiction of a celebrated and long-awaited return. Tragic stories of these "living war dead," who returned only to sometimes find their wives remarried even to their closest friends and relatives, circulated in the news and in fiction, such as the 1947 film *Between War and Peace* (*Sensō to heiwa;* directed by Kamei Fumio and Yamamoto Satsuo) and William Wyler's 1946 hit *The Best Years of Our Lives.*[26] If Itō was concerned about the novel's effect on readers as early as October 1941, when Japanese were incomparably more optimistic about the war's outcome, how would this depiction fare with postwar readers in 1950? The novel's dilemma of an injured veteran and his cheating wife hit perhaps all too close to home, particularly since the crime of adultery had just been abolished in 1947, nullifying prewar laws that had punished women more severely than men.

The question at the trial was also one that was implicit in the novel itself: was Lady Chatterley's adultery just that, or was it a justifiable and even commendable search for sexual satisfaction by a woman faced with the prospect of a life with an impotent husband? Although the defendants on trial were the publisher and translator (and implicitly also Lawrence), Lady Chatterley, both the character and the novel, served as their surrogate. The prosecutor blurred the distinction between the artist and character even in the grammar of the indictment, and the judges asserted that "a literary work was a manifestation of the author's character" in their verdict (*CS,* 1:42–43; 2:322).

The prosecutor seemed equally concerned with condemning the character Lady Chatterley for committing adultery as he did with indicting the defendants Itō and Oyama, and by extension Lawrence, for producing the work. Tellingly, the prosecution treated the fictional protagonist's actions as if they were real behavior that could, and should, be charged by law. In the

indictment, the prosecutor summarized the novel's plot as the "story of the immoral, adulterous Connie, who seeks sexual satisfaction from other men when her husband loses sexual functioning in a war injury, *despite* the fact that she leads a calm life, is educated, and enjoys the benefits of her father's property from better economic times" (*CS,* 1:37; italics mine).

For the prosecutor, at issue was not merely adultery but more specifically adultery that crossed class boundaries. Indeed, what was problematic was the fact that she has affairs with these lowbred men *despite* her advantaged upbringing. The prosecutor betrayed this concern with his repeated emphasis on the inferior class of Lady Chatterley's sexual partners. In the indictment, he introduced the objectionable passages with a damning plot summary, describing her adulterous affairs in lengthy, run-on sentences that rival Lawrence's own breathless prose: "Michaelis, a melancholy and gaunt antisocial writer of 'low birth,' pursues Connie, a married housewife, who, like a dog in heat, without a second thought, blindly becomes inflamed with animal-like bodily desire and readily assents to adulterous sex. . . ." After this affair ends,

> she discovers the married Mellors, a gamekeeper employed by her own family, uneducated, unpolished as a society person, and if anything, wild, rough, and unknowing of shame, and at the first opportunity, in a heedless encounter, without even a moment of critical reflection . . . , she is overcome by an impulse of entirely animal-like desire and immediately again blindly enters into an illicit union. (*CS,* 1:37)

As with its intermingling of "low" sexual content in the medium of "high" literature, *Chatterley* was objectionable because of its indiscriminate mingling of the lowborn and highborn. Ironically, this unacceptable crossing of class boundaries is precisely what Lord Chatterley himself objected to in the novel; although he tacitly endorsed his wife's extramarital affairs with other aristocrats, he decidedly opposed being cuckolded by his servant.[27]

In their verdict, the lower court judges agreed with the prosecution (and Lord Chatterley) on this point. During the questioning of Oyama's assistant in charge of advertising, Judge Tsuda criticized ads that hyped the theme of illicit love at the expense of deeper philosophical concepts. He cited one in particular describing the novel's theme as "the love between the gamekeeper Mellors, who was raised the son of a coal miner, and the noblewoman Chatterley," and asked why it emphasized the theme of the gamekeeper (*CS,* 1:346).

After the verdict, a legal scholar astutely noted that the *Chatterley* judges had confused the crimes of adultery and obscenity in a repeat of the nineteenth-century trial of *Madame Bovary* in France.[28] They had also similarly failed to distinguish between author and character as well as between reality and representation. In apparent recognition of the censors' tendency to do so, Flaubert was said to have remarked, "Madame Bovary, c'est moi."[29] In the *Chatterley* trial, however, rather than asserting the boundary between the two, the defense further contributed to this confusion by tackling the prosecutor's charges using legal, not literary, arguments. Instead of arguing that she was a fictional character and therefore not subject to the laws of the state, the defense argued that Lady Chatterley was innocent because adultery had been decriminalized in October 1947 (*CS*, 1:63). Oddly enough, this legalistic argument was offered by special defense counsel Nakajima Kenzō, an eminent literary scholar who had been added to the defense team specifically for his literary abilities. By pointing out the other ways the prosecution collapsed fact and fiction, however, the defense correctly implied that what was actually on trial was Japan's postwar sexual morality, with Chatterley—the character and the novel—as surrogate defendants.[30]

Reading Practices: Identification and Temptation

What concerned the prosecutor and the judges was that this theme of adultery across class borders would resonate with unscrupulous and susceptible readers, which included youths and women, or worse yet, young women. The prosecution's choice of witnesses certainly suggests that anxiety about a youthful readership fueled its attack: they included a high school teacher, a government official involved in youth protection agencies, the chairwoman of the Kanda Mothers' Society, and a former youth crime unit policeman. All testified to the dangerous effects a book like *Chatterley* would have on youths amid the deteriorating social conditions of postwar Japan. The high school teacher cited the current "age of instability" and the alarming increase in youth suicides to justify his desire to shield them from books like *Chatterley*. The police officer attributed the increase in sex crimes committed by youths to the prevalence of prostitution and sex books in postwar Japan and cramped living conditions. Another witness contrasted prewar sexual innocence with the "chaos of postwar sexual morality" evidenced by the increased number of pregnancies out of wedlock (*CS*, 1:147, 260, 357).

By characterizing young female readers as especially susceptible, the prosecutor was tapping into an enduring stereotype of the Japanese

schoolgirl corrupted by Western literature that can be traced back to the late
Meiji "age of translation" when a popular 1909 tune, "High-Collar Song,"
depicted her as suggestively holding the "poetry of Byron and Goethe in one
hand, and praise of Naturalism on the lips" while she causes "the rice shoots
of Waseda [to] rustle."[31] Ascribing an improper response to such readers
enabled censorship advocates to conjure an imagined and imperiled reader
without having to point to any concrete reader reception and also conve-
niently to exonerate themselves from being aroused.[32] In the *Chatterley* trial
as well as in later ones, the defense often strove to rebut the unsubstantiated
assumption that young women needed or desired protection from obscenity
by calling a "representative" young female witness. In the *Chatterley* trial, the
defense called a seventeen-year-old high school student; in the "Yojōhan"
trial, a twenty-six-year-old female author, Kanai Mieko, and a forty-four-
year-old "average housewife"; and in the *Realm* trial, a twenty-three-year-old
"average woman."[33]

Positing such dangers for a susceptible young and female audience is
in no way unique to this censorship trial. The censor often purports to pro-
tect the "young person," or the "vulnerable viewer" in the case of film. In
his seminal work *The Secret Museum,* Walter Kendrick provocatively argues
that the label "pornography" was not created until objectionable works were
secreted away in a "secret room," where access was restricted to educated and
elite men, excluding youths, women, and the lower classes.[34] Here too the
prospect of elite male literati reading the novel was not the problem. After
all, its unfettered availability in Japan—in both the original English as well
as in a French translation (since 1932)—certainly suggests that although a
limited and educated readership was to be tolerated, Oyama and Itō's inex-
pensive translation easily accessible to the general reading public was not.
In response to the defense's question asking why only the translation was
being indicted, prosecutor Nakagome explained that the original did not
warrant prosecution because of its small number of sales (*CS,* 1:277). But,
as suggested by a prior case in 1950 that was tried for only 314 copies, sheer
numbers were likely not the deciding factor.

Although the Chatterley prosecution overtly pointed to women and
youth readers, it seems prosecutors were also invoking the dangerous spec-
ter of a readership that included the "masses." Like the image of the young
vulnerable female reader, the elasticity of this term conveniently conjures an
imagined audience that is at once inclusive and unspecified but nonetheless
manages to capture the threat of unlimited access. In an article published

in the journal *Gunzō* in August 1951, a literature professor wrote that he did not object to an elite audience of a "few thousand art and literature lovers" reading *Chatterley* but could not endorse it if "it is getting a reputation among the Mii-chans and Haa-chans, and every Tom, Dick, and Harry devours it." His use of the phrase "Mii-chans and Haa-chans" is telling since it was coined in the Taishō period (1912–1926) as a derogatory term that implied the lowbrow tastes of the masses, especially young women.[35]

Such readers were considered particularly dangerous because they were deemed uncritical and liable to slide into an easy identification with unscrupulous fictional characters. Such an argument relied on a model of readership commonly used by censorship advocates: the imitative reader or spectator. Going back to the Edo period (1600–1868), Japanese censorship regulations had often attempted to inhibit audience identification and imitation. Strategies included strict sumptuary restrictions for Kabuki actors that presumed spectators would be less likely to identify with the actors if they were disallowed an opulent lifestyle.[36] Similarly, the common Edo-period plot device of *kanzen chōaku* (reward the good characters and punish the bad) was based on the premise that audiences would identify with evil characters less if they were punished at the end.

These devices resemble censorship (and censorship-dodging) tactics that span many nations and eras. To disrupt identification, film reformers in 1930s Hollywood initiated a program that strove to instill critical distance in spectators, especially youths, women, and laborers. In the 1857 French trial of *Madame Bovary*, Flaubert's defense counsel argued that the author's intent was "the incitement to virtue through horror of vice [*l'incitation a la vertu par l'horreur du vice*]." Likewise, Hollywood censors advocated the inclusion of "compensating moral values," such as "good characters, the voice of morality, a lesson, regeneration of the transgressor, suffering and punishment."[37]

In the case of *Chatterley*, however, the novel was utterly devoid of any such deterrents to identification, notwithstanding Oyama's testimony that claimed the book was meant to be a "warning for Japan today" (*CS,* 1:60). Instead, the novel ends happily with Lady Chatterley and Mellors expecting a baby, awaiting divorces from their respective spouses, and contemplating starting a small farm in the countryside. Lawrence's refusal to tack on a moralistic ending (and Itō's choice not to revise it) would have been celebrated as an achievement by the pioneer of modern Japanese literary criticism who had identified the insistent inclusion of moralistic endings as a major failure of the modern novel in Japan.[38] But for the 1950s Japanese censors,

"compensating moral values" represented a reassuring return to the conventions of nineteenth-century fiction. Failing to punish Lady Chatterley for her wrongdoings invited readers to identify with the protagonist. In fact, the reader survey included in the second volume of the novel had quite literally done so by asking, "If you were in a marriage like the Chatterleys', would you (a) continue the marriage as is, (b) take a lover, (c) get divorced?" with an overwhelming number of respondents (almost 77 percent) choosing divorce (*CS,* 1:352–353).

The judges sided with the prosecutor on this point and averred skepticism that the general reader would retain the proper distance from the characters, particularly from Lady Chatterley and her adulterous desires. In one of the final sessions, Judge Tsuda questioned Itō at length using a passage from *Anna Karenina* in which Vronsky's desire for Anna is palpable. Citing literary scholar Kuwabara Takeo's interpretation of this passage in his classic 1950 work of literary theory, *Introduction to Literature* (*Bungaku nyūmon*), the judge argued that the "prose has the power to coax the reader into becoming a partner in crime [*kyōhansha*]" (*CS,* 1:394). With this revealing choice of words, the judge suggests that adultery is a crime even in fiction. Kuwabara's text played an especially key role in informing the District Court judges' understanding of the process of reader identification. Of *Chatterley,* Judge Tsuda articulated his central concern as follows: "My worry is this: if [a reader] finds this translation fairly realistic and then starts feeling sympathy [toward the characters], is sublimation by philosophy still possible?" (*CS,* 1:393–398). Like the prosecution and its witnesses, the judge too suspected that the general reader of *Chatterley,* lured by the realism of the novel and its characters, would be unable to forestall identification and to sublimate his or her desire into the lofty philosophical and spiritual concepts that the defense would argue were at the core of the novel.

Reality and Representation

What made realistic literature so dangerous in the minds of the censors? In his testimony, star prosecution witness and Diet Library president Kanamori Tokujirō suggested that books were especially dangerous because of their unregulated availability to a broad reading public and also because of the private, individual nature of reception. In arguing that *Chatterley* was obscene, he first stressed that the novel's harmful effects would be undeniable if they occurred on the city streets: "If the things described in this work

went on in the presence of the public, for example, on the streets of Ginza in broad daylight, members of society would be able to judge [its obscenity]." Though Kanamori acknowledged a distinction between literature as a print medium consumed in private and a live public performance, he nonetheless asserted that literature was potentially more dangerous because reading involved "the general public's [*kōshū*] conjuring up those forms inside their heads." He concluded by articulating his concern that the novel's large print run facilitated both unregulated private accessibility and portability, allowing readers "to take it out at any time and see it" (*CS*, 1:126, 123).

Kanamori's testimony brings up three central points that are especially salient to the *Chatterley* verdicts and to the subsequent trials. First, as is clear from his failure to distinguish between fictional texts and live (or real) acts, the distinction between reality and representation was a murky one for the would-be censors. The conflation of the two realms would be enshrined by the *Chatterley* lower court judges with the introduction of the cumbersome and long-lived "principle of the nonpublic nature of sex" (*sei kōi no hikōzensei no gensoku*). In theory, this term referred to the fact that Japan and other modern "civilized" nations did not sanction public nudity or sex acts in reality, but in practice it was used to convict fictional representations of such acts. Second, the rhetoric of modernity and progress, as signaled by the Ginza, was often central to the arguments of both the prosecutor and the defense, but whether censoring sexual expression or promoting it constituted modernity depended on which side one was on. And third, the imagined, or conjured, images in one's head could be considered more dangerous than actual images (or words) on a page, an issue that would be of particular relevance to the trials of hybrid texts discussed in part 4.

To address Kanamori's first point about the relationship between representation and reality, what we can see in the *Chatterley* trial is a shared perception (or perhaps misperception) among all the parties that these two realms are largely indistinguishable for readers. Itō's wartime decision to pull *Chatterley* from its slated republication, the prosecutor's indictment of a fictional character for committing adultery, the defense's justification of her adultery based on its decriminalization, and, especially, the judges' introduction of the "principle of the nonpublic nature of sex" to convict representational media all depend on conflating reality and representation. The parties at the trial were insisting on the ties between art and real life, a position that is commonly held by censorship advocates worldwide but is especially entrenched in the case of Japanese letters.

The boundary between fact and fiction in Japanese literary traditions is especially porous, as is perhaps best represented by the prevalence of biographical literary criticism and by two genres: one, the ostensibly autobiographical modern "I-novels" (*shi-shōsetsu*) in which the identity of the author and the protagonist were understood to be the same, and two, the famed puppet plays of Chikamatsu Monzaemon (1653–1725) that were based on real-life love suicides but also influenced copycat suicides by lovers hoping to be memorialized in art. Not coincidentally, both these genres were the targets of censure and censorship. When a work of fiction was modeled on an actual person's life, either on the author's own or on a third person's, the charge that it exceeded the realm of representation was more plausible. An especially revealing indicator of the historical tendency of the censors to blur fact and fiction is the 1723 regulation by Tokugawa shogunal officials that simultaneously proscribed both the love suicides themselves and the plays concerning them. Similarly, during the early years of the Occupation period, GHQ simultaneously banned all "public displays of affection" between GIs and Japanese women in reality and in fictional or factual depictions of such "fraternization" in what has been called "the most systematically practiced distortion of postwar reflections of contemporary life."[39]

By manipulating such representations, the authorities hoped to control and thereby distort reality. In the case of *Chatterley*, the prosecution was seemingly attempting to stop adultery in reality via a ban of its representation. Even an avid prosecution supporter criticized the trial as an attempt to gloss over the real social problems of prostitution and class tension.[40] In other words, perhaps the trial was an attempt by the state to assert its authority in the realm of representation (fiction) to deflect attention from its lack of effective control in the realm of reality (society).

Healthy Literature, Healthy Society

It was especially imperative that the courts successfully deliver a guilty verdict because the postwar authorities had been stymied in their previous two attempts to indict literary works under obscenity regulations. In 1949, author Ishizaka Yōjirō was threatened with an indictment for his best-selling *Report on the Behavior of Ishinaka-Sensei* (*Ishinaka-sensei gyōjōki*). The charges were initially celebrated as a victory for the moral guardians; the police touted them as evidence that society had finally stabilized to the point where they could target "works that were not made an issue of in the heady, confused times of the immediate postwar period,"[41] a reference

to the free rein given to erotic works of the literature of the flesh and pulp magazines. But the ultimate failure of the Ishizaka charges (because of Ishizaka's contrition and an outcry from the Japanese literati) and subsequently of those against Mailer's novel (because of the Occupation's objections) suggested that the "heady, confused times," far from being over, were just beginning.

As the defense and its supporters clearly recognized, targeting *Chatterley* was an "all too clear attempt for the law to show its teeth" after its "double defeat."[42] Although the prosecutor did not specifically mention these previous failures, he did provocatively suggest in his closing argument that the *Chatterley* trial was indeed the final bastion. This was not because the novel *Chatterley* itself was egregiously obscene but because the verdict would portend the law's right to censor literary works and societal morality itself in the postwar period. He warned,

> If, because of the abolishment of the censorship system, we ignore the objective state of affairs and neglect to make arrests, not only will the standards for regulating obscene works be obliterated in this extremely troubled postwar state, but also the foundation for regulating these types of works will be utterly obliterated. Fearing this, we have brought decisive charges in the interest of drawing the final line.[43]

Significantly, the "final line" (*saigo no issen*) centered not just on a translated foreign novel but also on what the prosecutor would characterize as a foreign and imported legal document, the postwar Constitution. The need for the law "to show its teeth" in the *Chatterley* trial was especially pressing because of the abolishment of extensive prewar censorship mechanisms and the new provisions for freedom of expression.

Legal and Ideological Battles

The Meiji Criminal Code versus the Postwar Constitution

In their arguments, both sides referred to the "new" Constitution (*shin kenpō*), a designation that suggests the unstable position of the document at the time. Whereas the defense celebrated both its newness and implicitly its foreign authorship as guarantees of a clean break with Japan's militaristic past, the prosecution attempted to capitalize on these aspects to reassert tight control over regulating expression.

The prosecutor argued for the Criminal Code's continued validity, and even implied its supremacy over the Constitution, which he largely ignored. Only when pressed by the judges to clarify his understanding of its role in the *Chatterley* case did the prosecutor admit "even with the change from the old to the new Constitution, we do not think that the outlook with regard to obscenity has abruptly changed" (*CS*, 1:276). His only citation of the Constitution was its public welfare clauses (articles 12 and 13), which stipulate that the "rights to life, liberty, and the pursuit of happiness" are guaranteed, but with an important qualification: "to the extent that they do not interfere with the public welfare." In theory, the prosecutor cited this clause to argue that obscene works interfere with the public welfare and thus qualify as an exception to the constitutional guarantee of free speech. In practice, however, the phrase was a striking resuscitation of the legal caveats in the Meiji Constitution guaranteeing free expression only "within the limits of the law."[44]

The defense countered by arguing that the prosecution was trying to subvert the new Constitution by expanding the code's obscenity clause (article 175) to encompass the now-defunct prewar Publication Law that had been abolished by Occupation order immediately after defeat. Defense lawyer Masaki doggedly attempted to force prosecutor Nakagome to admit his intent to reinstate prewar censorship mechanisms:

> *Masaki:* In your list of applicable legal provisions, there is not the slightest mention of the Constitution. Regarding the difference between the eras of the old and new Constitutions, when you say that because the times have changed, the content of article 175 too has changed somewhat, should we interpret this to mean that although the law's application has evolved along with the times, the essence of article 175 has not changed?
>
> *Nakagome:* As I've stated, I think the crime of obscenity has not changed. Nonetheless, from another point of view, with the abolishment of the Publication Law, the violation of the Publication Law has also disappeared. In the past, the so-called corruption of public morals [*fūzoku kairan*] was punished by the Publication Law. But because that has disappeared, there are cases that, as a result, now infringe on the Criminal Code, which in terms of application has changed to some degree.

Masaki: If that is the case, can we conclude that there is a tendency for something similar to the prewar "suppression of sales" [*hak-kin*] to somehow find its way into article 175?

Nakagome: That is absolutely not the case.

Masaki: Perhaps not to the extent of suppression in the past, but is [what is now applicable under article 175] different from obscenity?

Nakagome: Although the concept of the crime of obscenity in the Criminal Code changes slightly based on a consideration of the times, it continually flows.

Masaki: In other words, even under the new Constitution, it is not subject to the waves of the law?

Nakagome: Yes, that's right. (*CS,* 1:51–52)

The water metaphors used by both lawyers are particularly provocative; by likening the Constitution to "waves" (*nami*), Masaki implied that Nakagome disregarded the new Constitution as a mere change in the tides. In contrast, by characterizing article 175 of the Criminal Code as something that "continually flows" (*shūshi ikkan nagarete oru mono desu*), Nakagome was defining it as an eternal fixture of the Japanese legal system.

By dismissing the Constitution as peripheral to the court proceedings, the prosecutor was echoing contemporary critiques that the Constitution had been single-handedly scripted by the occupiers in an attempt to impose a foreign legal foundation on postwar Japanese society.[45] Similar appeals to return to a pure, unadulterated native legal tradition had been made by conservatives during the process of constitutional revision, including key prosecution witness Kanamori, who had served as a member of the Constitutional Problem Investigation Committee (Kenpō Mondai Taisaku Iinkai) that had submitted to GHQ one of the most unacceptably conservative draft proposals. During deliberations in the Diet, Kanamori downplayed the substantial revisions to the Meiji Constitution required by GHQ, assuring parliamentary members that "the water flows, but the river stays" (*mizu wa nagaretemo kawa wa nagaremasen*).[46] With this phrase, Kanamori was conspicuously twisting a line from the premodern classic *An Account of My Hut* (*Hōjōki,* 1212) that emphasizes the ephemerality of all things: "The waters of a flowing stream are ever present but never the same" (*Yuku kawa no nagare wa moto no mizu ni arazu*).[47] Kanamori's deliberate misquotation mirrors a fundamental strategy of the conservatives—the willful

misinterpretation of both past (tradition) and present (change) in a way that allowed them to deny any fundamental difference between prewar and postwar Japan. In the *Chatterley* trial, Kanamori must have listened approvingly as the prosecutor asserted the precedence of the native Criminal Code over the imported Constitution in an echo of his own metaphor. For these conservatives, as the superfluous and artificial waters of Occupation personnel were flooding out of the nation in the early 1950s, it was high time to return to an enduring fount of Japaneseness.

Foreign Interference—The GHQ Letter

The only instance where the prosecution strayed from this strategy and chose to appeal to a foreign authority backfired dramatically. When the prosecutor presented a letter from an Occupation official as evidence, the judges balked at this incursion of a foreign authority into their courtroom. The letter touched off a tricky debate that hinged on the question of whose authority was to reign in the Japanese postwar courtroom. In the letter, solicited by the prosecutor, GHQ attested that Oyama had violated Occupation publication laws by failing to apply for the proper translation copyright with Lawrence's widow, Frieda, and by neglecting to submit a manuscript to GHQ before publication. Most damningly, in response to the prosecutor's question, GHQ insisted that even if Oyama had followed the proper procedure, it would have denied him permission (as it had other publishers in 1948) based on the existing bans of the novel in both England and the United States (*CS,* 1:236–238).

The defense refuted the accusation with the facts, producing receipts for translation rights and a belatedly signed contract. Oyama also claimed to have received verbal permission from Civil Information and Education, through a contact at the British embassy, a friend of literary critic and defense witness Yoshida Sei'ichi's, the well-connected son of the prime minister.[48] More important than these factual objections, the defense objected on ideological grounds. Head lawyer Masaki condemned the tactic as an unpatriotic attempt "to curb the power of Japan's courts by invoking the occupier's policies" and faulted the prosecutor with overestimating the benevolence of the Occupation, stating, "Although I understand that we are an occupied country, I have received no proof that the Occupation policies directly correlate with the public welfare of the citizens" (*CS,* 1:254).

It is important to note that this was one of the few moments when the defense's argument swayed the judges. The judges initially refused to

accept the GHQ letter as evidence and, according to Itō, were visibly displeased. In response, prosecutor Nakagome backpedaled furiously, denying any intent to apply pressure using another's authority and claimed to have "only reluctantly requested a letter from GHQ" and to have entered it as a matter of "fact," not as authority or law. The judges eventually allowed the letter to be introduced merely as evidence that no unexpurgated versions of *Chatterley* were allowed in England. Itō theorized that the prosecutor's tactic backfired because it was "reminiscent of ideological trials during the war" and reminded the judges of "wartime when militarists interfered with trials" (*CS*, 1:242–253 passim).[49] Perhaps the prosecution's enlistment of the GHQ authorities in the *Chatterley* trial even evoked an uncomfortable reminder about the lack of native judicial authority in postwar Japan's ur-trial, the Tokyo War Crimes Trial (1946–1948), for which not a single Japanese judge was empaneled.

In the case of the letter, when the prosecution advocated for the foreign authority of GHQ, it seemingly contradicted its own arguments insisting on the sovereignty of domestic law (the Criminal Code) and on the rejection of foreign law (the new Constitution). In contrast, the defense, which otherwise vociferously advocated the adoption of foreign models of law and culture, here emphasized the inappropriateness of introducing a foreign authority into the courtroom. Only in this instance did the judges side with the defense, suggesting the tremendous power the rhetorical positioning of Japan versus the United States had over the court. It seems the judges were intent on reasserting Japanese cultural, literary, and legal values and on rejecting the authority of imported foreign ones, whether in the form of the Constitution, *Chatterley*, and even the Occupation itself.

The lawyers' divergence from previous rhetoric in this instance suggests that their courtroom tactics were born not of rigid ideology but from flexible strategy. Such plasticity would be a characteristic of later censorship trials as well. What would largely remain from this first, however, was the organization of arguments along the axes of Japan/native/tradition and the West/foreign/modern, with the judges consistently ruling in favor of conservative domestic legal and cultural traditions. (The one key exception would be the manga trial, where conservative international laws would win the day.)

The framing of the trial arguments along these axes reflected a concern that was central to postwar Japanese discourse: whose authority would reign in post-Occupation Japan? The two options were symbolically represented by the "two ever-present 'ghosts at the historical feast,'" the emperor and

the United States.[50] These ghosts presided at the *Chatterley* trial as well with the defense threatening that "trials undertaken in the name of the emperor under the old Constitution" were being substituted with trials undertaken "in the name of the Occupation." The defense called instead for a postwar trial held "in the name of truth," as per the oath now sworn by witnesses (*CS,* 1:244, 72, 94). To the defense, this revision symbolized a shift from blind emperor loyalty, a relic of prewar ultranationalism, to a rational search for truth. In defense arguments, Japan was aligned with the irrational and antimodern, while the West was aligned with the rational and modern.

The defense strategically encouraged a perception of the trial in these stark terms. More specifically, the defense interpreted *Chatterley* and its trial through the lens of Japan's past attempts at Westernization and moderniza-tion, and the disastrous war to which these eventually led. An exploration of the defense arguments suggests how the shadows of war so significantly shaped this trial, coloring not just its legal defense but also its rhetorical strategies and even methods of literary analysis, which included scientific experiments. The strategies adopted by each side reveal the ironic reversals that could occur in the context of an "artistic trial." Most paradoxically, the censor adopted the mantle of artist while the artist adopted that of the cen-sor. If the state prosecutor and his witnesses, society's moral guardians, were forced to become ad hoc literary critics, then the defendants and their wit-nesses from the artistic community were forced to adopt occupations that were seemingly antithetical to art: scientists and censors.

Defending *Chatterley*: Shadows of the Past

From the perspective of the defendants, what motivated them to under-take such a passionate, costly, and prolonged defense? Their reasons varied from the practical to the ethical and ideological. Avoiding criminal prosecu-tion, heavy fines, and even possible jail terms were undoubtedly the primary motivating factors. Although the resulting fines of 250,000 and 100,000 yen (about $700 and $275) for Oyama and Itō, respectively, may seem pal-try because of inflated exchange rates, they represented a substantial amount of an average family's annual income, which was only about 120,000 yen in 1953.[51] Moreover, these amounts do not take into account the sizeable legal fees for three defense lawyers and expenses associated with the trial, includ-ing large entertainment costs for post-trial gatherings and thank-you money for witnesses.[52] Additional expenses were incurred by Oyama for printing up court documents, costing him almost double what he paid in legal fees.[53]

In fact, the case had dire financial consequences for his publishing company, which went bankrupt soon after the first trial when his bank refused him loans after the mass media's sensational reportage of an "illegal" (based on the GHQ letter) translation (*CS*, 1:242).

In contrast with Oyama, who courted the police questioning and charges with bravado, Itō was troubled by the stigma associated with publishing obscene works. As Itō's son notes, this stigma lingered even thirty years later when his childhood home was still being (mistakenly) called the Charetta-san house by the neighbors.[54] The charge of being a purveyor of obscene literature was particularly unsettling for someone like Itō with a reputation as a quiet and staid intellectual-scholar and author of such classic critical works as *The Methods of the Novel* (*Shōsetsu no hōhō*, 1947–1948) and a comprehensive history of the Japanese literati, *A History of the Japanese Literary World* (*Nihon bundan shi*, 1952).[55] Unlike the later iconoclastic artist-defendants, who would embrace the indictment as a badge of honor and even profess their disappointment when acquitted, Itō seemed genuinely appalled to be tried as if he were a "common criminal" and frequently noted the possibility of prison with trepidation in his trial account (*CS*, 1:20, 35; 2:46–49).

Aside from these practical concerns motivating the defense, the *Chatterley* trial also offered the perfect opportunity for both Itō and the larger literary community to assert their newfound postwar freedoms and to rectify their perceived failure to assert these freedoms in the prewar and wartime years. Without the ghosts of World War II, the contours of all the postwar censorship trials would have been significantly different, for the war and its end motivated both the *Chatterley* prosecution and the defense. For both sides, the trial offered the perfect symbolic opportunity to reform the nation, a moment when it could oust the barbarians once and for all. For the prosecutor, these barbarians were the departing Occupation army and the legal and cultural reforms left in its wake, whereas for the defense they were the ghosts of wartime militarism and nationalism.

The broader artistic community quite vocally and enthusiastically rallied to support the defendants (with just a few notable exceptions, such as Watanabe Tetsuzō, the former Tōhō studio president and Eirin head who would also condemn the defendants in the later Nikkatsu trial). Considering the precedent-setting implications of the trial for the literary and legal worlds, it is not surprising to witness overwhelming support from the civil liberties and art communities, such as the Committee on Freedom of Expression (Genron Hyōron Iinkai), the Japan P.E.N. Club,

and especially the Japanese Writers' Association (Nihon Bungeika Kyōkai), which established a Strategic Committee on the Chatterley Issue (Chatarei Mondai Taisaku Iinkai) immediately after the indictment. The trial offered a perfect rallying point around which to proclaim a unified artistic community that supported freedom of expression in accord with the new spirit of postwar liberation and democracy. Jay Rubin sardonically observes that the literati's enthusiastic response to the charges made it appear "as if they had been waiting for eighty-three years, since the Meiji government inaugurated censorship, to have their day in court."[56]

It was not just the future role of the artist that was in question but also its past. Japanese writers had not been particularly successful at resisting repression by prewar and wartime authorities. From the time of the murder of proletariat author Kobayashi Takiji by police in 1933 until the start of the Pacific War in 1941, leftists imprisoned by the police for being Communists often committed either a formal *tenkō,* a public renunciation of their political ideals, or an informal, less-public one. Many subsequently wrote semi-fictional accounts of their conversion (*tenkō bungaku*) and perhaps could even be charged with also profiting from their own complicity.[57] In wartime, members of the Pen Army and the Japanese Patriotic Literary Association (Nihon Bungaku Hōkoku Kai) had at least ostensibly, and sometimes rabidly, supported Japan's war efforts. And writers had also largely failed to support their fellow writers, as for example at Ishikawa's wartime trial, where not a single artist or critic came to his defense.

The desire to assert this new socially and politically responsible postwar artist was an inevitable response to the finger-pointing atmosphere of the times, in which assessing artists' responsibility was being hotly debated in the so-called debates over the war responsibility of artists. Nowhere was this atmosphere more evident than in the journal *Bungaku jihyō,* which, in 1946, "ran a regular feature titled 'Literary Prosecution,' devoted to exposing the war responsibility of well-known literary figures."[58]

For Itō at least, if not also for the larger artistic community, the trial offered an opportunity to atone for his own perceived failures during the war. Itō had served as a member of the military's Pen Unit and had written a number of short works, collected in *Mornings in Manchuria* (*Manshū no asa*), about his visits to China from April through June 1939. As a member of the Japanese Patriotic Literary Association, he published a vaguely patriotic piece celebrating his grandfather's participation in the Russo-Japanese war in the collection *Streetcorner Stories* (*Tsuji shōsetsu,* 1943). Itō was also

fairly complacent about the need to censor translated works in wartime, even, as we saw above, his own "literary probings."[59] Perhaps most damning were the nationalist sentiments he expressed in the newspaper in the days following Pearl Harbor celebrating the Yamato people as "the most excellent race on earth." Although such writings can perhaps be explained by government pressure and by the need of a writer to publish in a situation with no other outlets, his wartime diary, *Pacific War Diary* (*Taiheiyō Sensō nikki*), contains equally nationalistic sentiments that claim war with the "white-skinned peoples" will show that "we are the world's leading nation—this is our destiny."[60]

Itō's degree of complicity with the war effort is hotly debated among literary scholars, with some suggesting that his writings contain "some of the most xenophobic utterances to issue from the pen of any major writer," while others offer elaborate defenses of his subtle attempts at resistance.[61] For the purpose of this study, the more important question is how his own perception influenced his stance in the *Chatterley* trial. He certainly perceived himself as having been complicit. In his trial account, he confessed his chagrin at not having supported author Ishikawa during his 1938 trial, contrasting Ishikawa's lonely fight with his own experience of receiving the enthusiastic support of the literary world, including, embarrassingly enough, that of Ishikawa himself, who joined the Strategic Committee.[62]

In an essay published just after the Supreme Court verdict for *Chatterley,* Itō berated himself for his "cowardice," a cowardice that allowed him to escape three previous brushes with disaster: first, when he avoided involvement in the Marxist movements of the midtwenties that resulted in the mass arrests and occasional murders of Communists and Socialists; second, when he avoided the danger of losing his family by not following the self-destructive path of the so-called I-novelists, whose confessional fiction required that their lives be adequately dissolute to provide scandalous material for their art; and finally, during the war when he participated in a "battle of camouflage, trying to live as a writer but avoiding trouble or getting wounded." Equating the fate of I-novelists, whom Itō had designated as the "destructive type" (*hametsu-kei*) in earlier critical essays, with the weighty repercussions for prewar Marxist and wartime subversive writers would seem gratuitous. But all three groups of writers do share one thing: they practice what they preach, or perhaps preach what they practice in the case of I-novelists. Itō, on the other hand, lamented his own failure to defy conventional morality and authority, which made him an inauthentic writer, a "fake" (*nisemono*).

He wrote, "After the war ended and I turned forty-two, I was haunted by the notion that I was a writer who had never once led the lifestyle befitting a writer." Fighting the *Chatterley* charges offered him the opportunity "at least this once to follow through without avoiding what I thought as a writer."[63]

In sum, Itō's fight was fueled by a kind of survivor guilt over his literary and bodily survival. The trial offered him a chance to align with a tradition of resistant writers, "authors and philosophers exiled, burned alive, handcuffed, banned, and imprisoned because of their writings" (*CS*, 1:11). In 1948, Itō had famously coined the term "runaway slaves" (*tōbō dorei*) to characterize the literati as aloof, or at least separated, from society and societal issues and contrasted them with the "masked gentlemen" (*kamen shinshi*) authors in the West.[64] Punning on these terms, Itō's son credited the *Chatterley* trial with marking the moment when "instead of running away, he decided to become a gentleman." His father seemed to "grow a size as a novelist," while the consequences of bankruptcy for Oyama were somewhat less productive.[65] The trial was an undeniable boon to Itō's literary production, with three best-selling novels in 1954 alone, marking a turn in his writings from the narrow concerns of the literati to issues of broader social and political interest. For Itō and his supporters, unlike the cloistered and apolitical nature of the literati in the first half of the century, the postwar Japanese artist would doggedly fight for artistic and political freedoms, and the *Chatterley* trial offered the perfect stage for their debut.

Legal and Literary Imports as Antidotes to Militarism

According to the defense, the trial offered the ideal means by which to repudiate the prewar repressive regime that had led Japan into a disastrous war. Embracing Western influence in legal and literary spheres as symbolized by these imported texts—the new Constitution and translated novels like *Chatterley*—offered nothing less than antidotes that would ensure that Japan did not repeat its past mistakes. Whereas the prosecution implied that the trial represented a struggle for the cultural and legal purity of Japan, the defense insisted that without foreign influence in both literary and legal spheres Japan would be forever culturally backward and prone to ultranationalist leanings.

By framing the trial arguments in this way, the lawyers were participating in broader contemporary debates about the role of Western influence in Japan. The prosecutor echoed the conservative critique being articulated in literary circles in the "people's literature debate" of the early 1950s, which

called for a reinvigoration of Japanese literature with native traditions and a rejection of the "literature of colonialism" of the Occupation period.[66] The most vociferous critique of Occupation literary policies would be offered later, in the 1980s, by the conservative literary and cultural critic Etō Jun. For Etō, the Japanese had been force-fed a fundamentally foreign program of language and culture during the Occupation, which effectively created a "sealed linguistic space" (to borrow the title of his 1989 book) in which Japanese traditions had been irredeemably distorted. This critique interpreted the Occupation policies as physical and spiritual colonization, which could be traced back to the Western imperialism of early Meiji, when Japan had been forcibly opened with the arrival of Commodore Perry's ships in 1853–1854.[67]

By implying that Western cultural and legal influences were indispensable to ensuring Japan's future as a democracy, the defense, on the other hand, was echoing those leftist intellectuals who celebrated the Occupation as Japan's second "opening of the country" (*kaikoku*). The parallel drawn between Occupation policies and the opening of the country by Perry was a flexible one; it could serve either to critique the incursion of foreign powers as a distortion of native Japanese traditions or to celebrate it as a welcome introduction of political and cultural modernity.

Legal Salvation: The Postwar Constitution and Judicial Reform

For the defense, the Constitution represented the crux of a new start for Japan: in the trial, head defense lawyer Masaki declared it the "only pillar that can save our ruined country and people." While noting it originated from Japan's unconditional surrender in World War II, the defense here and elsewhere conspicuously evaded the fact that the Constitution had been scripted by a foreign occupying power: "There's no need to say who authored the Constitution, but it was not made by the bureaucrats who wrote the old Constitution, and we wouldn't have it without Potsdam" (*CS*, 1:78). Writing in 1954 while the case was under review at the Supreme Court, Masaki likened the new guarantees of human rights to an incomplete limb transplant to suggest the precarious state of these newly established freedoms in Japan. He warned, "No matter how fine the attached limbs, if the body does not clearly understand them, then even these fundamental human rights . . . granted at long last will fail to produce an understanding of why we should be grateful or why they are precious."[68] At stake was the

successful grafting of these slightly foreign, but still organic, rights onto the body politic of Japan.

As the defense proclaimed in court the first day, the *Chatterley* trial could also offer an ideal model of a "democratic postwar" trial that accorded with postwar judicial reforms (*CS*, 1:40). In his trial account, Itō painstakingly catalogues the newly revised procedures that protected defendants against bias, paying particular attention to the spatial rearrangement of the postwar courtroom (amusingly, Itō's model for a democratic trial was based on Hollywood movies where lawyers were free to roam the courtroom).[69] By distinguishing the "humanistic spirit of the postwar trial" (*CS*, 1:95) from its prewar antecedent, the defense strategically framed the trial as an indicator of Japan's emergence as a true democracy.

The trial was nothing less than a chance for Japan to declare a definitive break with the prewar era. In this respect, the defense was echoing a rhetoric of transformation and rebirth that was pervasive in the early postwar years among politicians, intellectuals, and artists alike. Editorials for the first postwar issues of journals in 1945 dramatically declared this break; the November manifesto for *Shinsei* stated, "The old Japan has been completely defeated. Completely . . . ," and in December, the former proletariat author Miyamoto Yuriko wrote in the inaugural issue of *Shin Nihon bungaku,* "Today, Japan has arrived at the moment for a comprehensive new start."[70]

The defense was thus participating in the broader attempt to reinvent the nation by defining the postwar period as what has been called the "fictive moment when the past ended and the present began."[71] The "past" was to become a catchall for the undesirable elements—militarism and repression—of Japan's history, and the "present" was to encompass peace and democracy, the ultimate symbols of modernity. Just how far back Japan's undesirable "past" extended, however, differed substantially depending on the interpreter. In the trial, the defense would side with progressive intellectuals by denouncing the Meiji Restoration of 1868 as containing the seeds of militarism and ultranationalism; the prosecution would align with conservatives, who agreed that Japan had gone off course but dated that derailment back to the 1930s when the militarists took over, and celebrated Meiji as a desirable first step toward modernization. In fact, one of the first conservatives to offer this kind of optimistic reappraisal of Meiji was literary scholar Kuwabara Takeo,[72] whose work of literary criticism figured so predominantly in the Tokyo District Court judgment, suggesting that literary and political conservatism often went hand in hand.

In order to discredit censorship as antimodern, the defense associated the prosecution with the irredeemably outdated politics of Meiji, or, as Jay Rubin summarizes it, with "the feudal, authoritarian, class-bound, anti-individualist, anti-human mentality that had suppressed thought and speech and the pursuit of individual happiness in prewar Japan and which had been, as they saw it, ultimately responsible for leading Japan into war."[73] This strategy echoed that of postwar intellectuals who denounced the Meiji Restoration as a period of "false modernization," or "deviant modernity."[74] In his opening statement, the defense attorney portrayed Japan as perched on the brink of destruction, threatened with an imminent backslide of legal, political, and cultural modernity. If *Chatterley* was found guilty, Masaki argued, Japan would become "an isolated provincial culture with absolutely no connection to Western culture and forever isolated from the mainstream."[75] A not-guilty verdict, in contrast, could herald the moment when "Japan too had become like the country of France," as one defense witness put it, rather than a superficially modern nation (*CS,* 1:162).[76] These threats of eternal backwardness if *Chatterley* lost resonated powerfully in the postwar setting, where Japan was striving to rebuild. By invoking a modernity critique and aligning the postwar moment with the failures (and missed opportunities) of Meiji, the defense suggested that Japan was in a sense back at square one of modernization.

Literary Salvation: Lady Chatterley, the Novel and Adulteress

The novel *Chatterley* was uniquely qualified to put Japan on the right course because it thematically and generically offered the perfect antidote to militarism. According to the defense, despite having been written in 1928 by an Englishman who had never even visited Japan, *Chatterley* somehow applied perfectly to Japan in its moment of post–World War II recovery, offering a much-needed balm for the "materially and spiritually poor, ruined country" (*CS,* 1:77). For literary critics as well, the novel offered a cautionary tale that was flexible enough to apply to both Japan's prewar and postwar moments. As Kawakami Tetsutarō noted in a 1950 postscript to an essay on *Chatterley* originally published in 1936, if prewar Japanese readers could relate to the "tragic age" of post–World War I Britain described by Lawrence in the novel's opening lines by virtue of the fact that Japanese had experienced the catastrophic Kantō Earthquake of 1923, then the novel was particularly relevant after the "truly tragic age" of the past fifteen years of war.[77]

How could a novel about the successive tawdry affairs of a highborn lady offer such a lofty alternative to the tragedy of war? Echoing the traditional

interpretation of the novel, the defense read *Chatterley* as Lawrence's attempt to elevate sex from an act of mere physical amusement to a philosophically and spiritually meaningful one.[78] As an act that synthesized body and mind, sex as depicted by Lawrence offered a remedy for the dehumanizing view that had transformed humans into mere machines in wartime. For example, defense lawyer Masaki argued that wartime Japan had prescribed an ascetic philosophy to encourage self-sacrifice so that "young men could be used as consumption goods for the country." He accused the militarists and their supporters of "fostering an atmosphere of scorn for life, body, and sex to obliterate people's humanity" (*CS*, 1:78). The ultimate, albeit unstated, evidence for this was the conversion of human bodies into actual weapons of war as kamikaze pilots and "human submarines." For the defense, if Lawrence originally wrote the novel as a statement against the mechanization of man brought on by the industrial age in the wake of World War I, in 1950s Japan the novel offered a cautionary statement about these dangers again in the wake of World War II.

The defense here echoes the defense of literature of the flesh made by author Tamura Taijirō in the late 1940s. When criticized for his works' profusion of sensational sex and utter lack of philosophy, Tamura defended himself in the essay "Flesh Makes the Man" (May 1948), in which he celebrates flesh (*nikutai*) and sexual desire as a crucial means of regaining Japan's lost humanity in the postwar period. He urges the people of postwar Japan to "build a glorious and strong humanity atop a foundation of flesh" and contrasts the authenticity and immediacy of flesh and physical desire with the false and empty abstractions of ideas: he asks, "Why did we undertake—and why did we lose—this great war? . . . I believe that our 'ideas' being divorced from the flesh was one of the major reasons."[79] Just as Tamura celebrated the inherently pacifist nature of sexual desire, the defense too asserted that Lady Chatterley's pursuit of sexual fulfillment would ensure the creation of whole-bodied individuals who would resist any future attempts at mechanization and militarization.

But claiming Lady Chatterley's adultery to be a woman's justifiable, and even admirable, search for sexual liberation was no easy task in the context of early 1950s Japan, as was obvious when the defense resorted to defending her by citing the postwar decriminalization of adultery. It was indeed a bit of a "delicate point" (*bimyō na ten*), to borrow literary critic Kawakami's phrasing. Much as the defense would in the trial, in his 1936 essay, Kawakami had defended the sexual improprieties of Lady Chatterley,

as well as Lawrence's depictions of them, as philosophically motivated: "Lady Chatterley knows humans and knows life not based on her eyes or hands but instead based on the sexual act. This is a delicate point, but Lady Chatterley is not acting solely animalistically. But neither is she, like certain members of the intelligentsia, consciously constructing a lifestyle only with the body."[80] Kawakami here presages the defense's own attempts to rebut the prosecutor's charges against Lady Chatterley for being blind and animal-like (*yaseiteki* or *dōbutsuteki*) by endorsing her sexuality as an integral (and integrity-filled) part of her life.

According to the defense, not only could the novel's theme of sexual liberation thwart the dangerous revival of prewar ultranationalism, but *Chatterley* could also save postwar society by virtue of its being a novel. In his testimony, Itō blamed the war on the unqualified validation of the sciences at any cost to people's rights and even lives, citing wartime medical experiments in Kyushu in which living bodies were dissected "in the name of science." He traced the blind valuation of science and concomitant devaluation of the arts back to Meiji's "biased culture that considered biology and physics useful to creating a 'rich nation, strong army' [*fukoku kyōhei*]" (*CS*, 1:153, 152). With this slogan, Itō and the defense implied that indicting *Chatterley* represented a repeat of Meiji instrumentalism and militarism.

In sum, the defense argued that *Chatterley*, because of both its humanitarian theme and its generic status as literature, which belonged to the previously undervalued field of the humanities, should be exonerated as an example of a new progressive postwar mentality that valued human beings and the humanities. For the defense, *Chatterley* was thematically and generically the ideal symbol ushering Japan toward peace, democracy, and modernity, and away from war and the false modernization of Meiji.

Science as Savior: Rationalizing Literature and Literary Criticism

Despite its grandiose claims that the newfound freedoms of the arts and humanities enshrined in the new Constitution were to be the foundation for building a progressive postwar society, throughout the trial the defense relied heavily on scientific discourse and methodology to legitimate both the novel and the law. Instead of defending *Chatterley* as artistic expression deserving constitutional protection, it justified the novel's inclusion of sex by likening it to a scientific, philosophical, or even medical text and by distinguishing it from sexually explicit lowbrow publications. Most provocatively, it relied on a series of "objective" scientific experiments as a means of

determining reader reception. In its attempt to scientifically prove the merits of *Chatterley* and the demerits of other, less worthy texts, the defense inadvertently abandoned its purview as literary artist or critic and as champion of free speech, instead adopting the mantle of scientist, and even censor.

The defense and its witnesses repeatedly called for the objectification of legal judgment. In his opening statement, defense attorney Tamaki Wataru demanded a legal judgment that was based on the "scientific analysis" of article 175 rather than one based on the judges' "feelings" or even legal precedents (*CS*, 1:29). Masaki called for legal interpretation that was based on logic, not emotion: "Because the Constitution is neither a poem nor a magic spell, when interpreting and applying it, the principles of logic cannot be ignored." Even the most humanistic and commonsensical arguments were rendered in the language of science. For example, in his concluding arguments, Masaki included a series of elaborate graphs with lines and points representing "humanity" and "the culture of humanity" intended to "mathematically" illustrate the adverse effects that regulating public morals has on the natural advancement of culture. In one, the vertical axis represents the natural upward progress and potential heights of cultural progress over time if culture is unfettered.[81]

Chatterley as Medical Text

To justify the novel's inclusion of sexually explicit material, the defense likened *Chatterley* to Western medical sexology texts they submitted for comparison, such as the best-selling 1946 translation of Van de Velde's *Perfect Marriage* and the 1949 translation of the Kinsey report. In his testimony, Itō argued that *Perfect Marriage* and *Chatterley*, which, not coincidentally, had both been published by Oyama, presented the "right" attitude toward sex and contrasted them with the frivolous treatment of sex in the popular lowbrow pulp magazines. He claimed that Lawrence's inclusion of sex in the novel was as essential as its inclusion in the fields of anatomy, biology, and psychology, and he even credited the translation with the groundbreaking status of Darwin's theory of evolution (*CS*, 1:215, 337–338, 244–245).

In court and in essays published in literary journals during the trial, Itō argued that literature deserved the same freedoms afforded to medical texts provided it aspired to the lofty aims of science. Authors were philosophers who, "like doctors, have the right to look directly into the physical whole of man and to consider its relationship to humanity." He argued, "If philosophy is one sphere of science, this has the same right to exist as

a medical text" and that *Chatterley* had "psychiatric usefulness" because it presents "sex as the only way to save man from being doomed to the isolation of hell by egoism." In one of his more creative interpretations offered at the trial, he explained that Lady Chatterley's first lover, Michaelis, ejaculates prematurely as an "expression of his egotistic ideas" and that his failure to satisfy Lady Chatterley "comes not from sexual deficiencies but philosophical ones."[82]

Itō's inspired, if slightly exaggerated, philosophical defense of the novel was undoubtedly dictated by strategic concerns. But it also stemmed from his deep-rooted critical stance toward Lawrence as an author. As early as 1935, Itō had defended the sincerity of the novel and of Lawrence's philosophy. Comparing his experiences translating Lawrence and Joyce, Itō had contrasted the purity of the former with the filth of the latter, noting that he "felt cleansed of dust, as if purified by water after contact with Lawrence, whereas with Joyce, he felt like garbage had been poured on his head."[83] What changed in the postwar context of the *Chatterley* trial was the way that Itō framed his defense entirely in scientific terms. The defense's methods of literary analysis too were based in the "hard sciences," spanning the fields of social science in the form of numerous reader surveys, of psychology with a newly pioneered technique of "psychological prose analysis," and of biology with what was the most bizarre of all the methods—the lie detector experiments.

The Questionnaire

The one reader survey that proved most controversial in court had been included in thirty thousand copies of the translation's second volume.[84] In his testimony, Oyama explained that the survey had been included in the interest of advancing scientific research at the request of the Association of Democratic Scientists. In his memoirs, however, Oyama reveals that when he read the questionnaire, he "recoiled quite a bit" in fear of vulgar responses, but he was reassured by the fact that the Ministry of Education had funded the survey.[85] The survey measured reader reception by asking the following five questions (responses given in parentheses):

1. If you were in a marriage like the Chatterleys', would you (a) continue the marriage as is (7.6 percent), (b) take a lover (15.6 percent), (c) get divorced? (76.8 percent).

2. Do you think love [*ren'ai*] is only spiritual? (a) no (71 percent), (b) yes (7.6 percent), (c) I would like to make it so (21.4 percent).
3. How did you feel about the work's sexual description? (a) beautiful (88.5 percent), (b) dirty (6.1 percent), (c) obscene (5.4 percent).
4. While reading were you sexually excited? (a) yes (79.1 percent), (b) no (20.9 percent).
5. If you were the censor, would you (a) ban the book (3.1 percent), (b) delete portions of the work (10.0 percent), (c) allow it to be published as is (86.9 percent). (CS, 1:352–353)

On the reverse side of the questionnaire, readers were asked to provide a number of personal details, suggesting that an individual's demographics were considered vital to their interpretation of the novel. This included their age, gender, place of residence, marital status (if single, they were asked if they were sexually experienced; if now or formerly married, whether separated, widowed, or divorced), occupation, level of education, monthly income, and political affiliation. Most telling was the question asking if they had suffered war damage (i.e., had been bombed out of their homes, injured, etc.) and if they had served in the war.

In his trial account, Itō affirms the indispensability of such research to the field of social psychology, explaining that it belonged to the field of "communication research [*komyūnikēshon risāchi*], as it is called in America, where it flourishes" (*CS*, 1:353). When the cocreator of the questionnaire was called by the judges to testify at the twenty-fifth session, he explained that he had created the survey "to measure objectively the reactions" to *Chatterley* and contrasted the advanced scientific research conducted in the United States with its lack in Japan: "In America, they frequently research what sociopsychological effect a work will have on readers, but such research has never taken place in Japan" (*CS*, 1:352, 351). Again here, the defense employs a thinly veiled critique that Japan lagged behind the United States. By aligning themselves with Western scientific research, the defense team implied their position was the more rational, progressive one.

Psychological Prose Analysis

Another, arguably less legitimate, scientific method called psychological prose analysis (*bunshō shinrigaku*) was offered by defense witness Hatano Kanji, a university psychology professor. Hatano began his testimony by quite rightly claiming that obscenity does not, objectively speaking, exist,

because texts change based on the context of reading and on the character of the reader. Soon enough, though, his testimony devolved into pseudoscientific jargon when he resorted to a mathematical formula to describe this concept: $B = f(P \cdot E)$, where B represents feelings of obscenity, P stands for the reader, E is the atmosphere when reading, and f is a mathematical function. Hatano then engaged in an endless attempt to quantify obscenity by defining seventeen criteria that were based on his statistical analysis of the "generally acknowledged obscene" European works *Balkan War* and *Gamiani,* which far from coincidentally had been translated into Japanese by a witness for the prosecution. Most of his criteria revolved around quantification: for example, Hatano deemed a work obscene if the majority of pages included sexual descriptions and exonerated *Chatterley* because "only twelve places, constituting forty pages, or 10 percent of the whole," are obscene. Similarly, he tautologically defined works as obscene if obscenity appeared in each chapter but exempted *Chatterley* since "out of nineteen total chapters, only half" included it. He further argued that obscene works include prolonged descriptions of a single sex session and again excused *Chatterley* since its longest sex scene is only five pages, and most are under one page (*CS,* 1:197–199).

The pseudoscientific language and statistical overload in Hatano's study cannot obscure the absurdity and futility of its purported aim, at least to us today. By the end of the list, Hatano struggled to classify obscenity based on the number of orgasms and how the orgasmic cries are described. But the defense repeatedly championed his "scientific psychological prose analysis" as the epitome of the kind of rational evidence the defense was using to define obscenity, and, as we will see, this evidence deeply swayed the Tokyo District Court judges in their verdict.

The Lie Detector Experiments

The most revealing scientific method used to determine reception involved measuring obscenity with a lie detector machine. The defense witness psychologist Miyagi Otoya and his colleagues at the psychiatry laboratory of the Tokyo Institute of Technology, where Itō had worked as a lecturer since 1949, used a biofeedback machine, or a lie detector, to compare the degree of sexual stimulation readers experience with *Chatterley* versus excerpts from pulp magazines and Western pornography. A prototype of the lie detector, a galvanometer that measured electrical currents, had been developed sixty years earlier, in 1890, by Jean de Tarchanoff, a Russian biologist interested in exploring the

links between body and mind. In Japan, the machine was created in October of 1950 with an Education Ministry grant for future use in criminal trials.

The *Chatterley* trial marked the first time that a lie detector was used for evidence in a Japanese courtroom. The defense testified to its widespread use in scientific, legal, and literary fields abroad and at the leading research institutions in Japan. Even when evaluating the validity of the machine, the defense witnesses resorted to statistics, testifying that its reliability, at 95 percent, compared favorably to the machine used by the Criminal Investigation Lab in U.S. military trials. The researchers asserted that the machine could measure a reader's sexual response by monitoring their physiological reactions. As Miyagi's research assistant explained to the judges, when an emotional stimulus to the body excites the inner brain, the body produces sweat; when we are shown a picture, a "biological expression is generated—the eyes twinkle, blood pressure or breathing fluctuates, or secretions of perspiration caused by mental agitation occur."[86] The machine, he explained, could objectively measure psychological response; with the lie detector, a reader's emotion became both visible and quantifiable.

In one test, twenty-four subjects (mostly college students) were strapped to the lie detector machine while they read the twelve objectionable passages from *Chatterley* and excerpts from popular pulp magazines of their choice. The results showed that only one in twelve of the subjects for whom valid data was generated was more stimulated by *Chatterley.* Another experiment measured the subjects' bodily responses when asked their impressions after hearing recordings of *Chatterley* and of "pure pornography." In all these tests, the lowbrow pornographic works generated a much higher physical response than *Chatterley,* results that the defense used to assert the novel's relative innocuousness.

The designer of the experiment, Miyagi, testified that he had previously performed a similar experiment comparing works of the renowned Meiji literary giant Sōseki to those of literature of the flesh author Tamura. Pairing these two authors seems strikingly odd since Sōseki's works from the early twentieth century are so vastly chaste compared to Tamura's postwar novels. But this detail was likely supplied to prove the purity of the results undertaken in the name of "pure science" as a continuation of previous research, rather than as a strategic defense tactic. The choice of pairings in both experiments also suggests the defense's tendency to categorize literature into high and low categories in order to privilege highbrow works at the expense of lowbrow ones.

In the early 1950s, this experiment seemed to herald a new mode of literary criticism that was to be based in the "hard sciences" instead of on unreliable subjective judgment. Contemporary news reports similarly championed this scientific proof, and Itō reveled that it would vindicate the novel, claiming that although "conceptually" one would perhaps conclude, as did prosecution witness Kanamori, that *Chatterley* was equally or even more stimulating than magazines on the market, when "measured experimentally," it was proven to be less so (*CS*, 1:327, 175). Even as late as 1962, Itō professed his faith in these scientific methods; in his review of the 1961 Japanese translation of C. H. Rolfe's *The Trial of Lady Chatterley*, which chronicles the British trial, Itō notes with pride the "superiority" of the Japanese defense testimony that relied on such scientific data.[87]

The Appeal of Science in the Postwar Trial

What impelled the defense to rely on science to such a degree in the trial even at the risk of undermining its own assertions of the inherent value that literature, as a discipline in the humanities, would have in rebuilding postwar society? The prevalence of empirical scientific evidence was, in part, encouraged by the nature of a legal trial that required objective proof and hard facts. More important, though, it was also a symptom of the historical moment of the trial. If the irrational rhetoric of the militarists had prevailed in prewar Japan, then what was called for in the postwar period was a dispassionate rationalization of society, including the fields of law and literature.

In the 1950s, Japan experienced a veritable science boom because it was thought science would guarantee both objectivity and progress. Calls for scientific rationality abounded in the mission statements of new, postwar publications: *Shin jidai* criticized "feudalistic legacies, irrationality, and antiscientific attitudes"; *Shin tsubaki* called "for the elimination of unscientific elements from scholarship and irrationality from all aspects of social behavior."[88] Its appeal was evident also in the "statistics boom," a spate of social science publications in the immediate postwar period.[89] Science and statistics were considered inherently neutral and ethical because they were based on fact, not ideology; the ostensible objectivity and neutrality of science would counter the emotional appeal of militaristic propaganda that had irrationally proclaimed the "Yamato spirit conquers material scarcity."

The broad-based popular appeal of science in the postwar era was a symbol of "'contrition' and the democratization of knowledge"; science and

rationality offered "the keys to national redemption."[90] Its explosive popularity was evident in the profusion of science research groups, including the one that had included the problematic reader survey of *Chatterley:* the Association of Democratic Scientists (Minshushugi Kagakusha Kyōkai), an organization whose name alone conveys the postwar tendency to conflate science and democracy.

Science and rational methodology were infiltrating every sector of society, even the arts and literary criticism. The novel that Itō wrote in the period immediately after the Supreme Court *Chatterley* verdict, *The Overflow* (*Hanran*, 1956–1958), would feature a molecular chemist as its protagonist who discovers an important bonding agent. Critics attributed its extreme popularity with readers to the fact that it "drew its material from the world of science,"[91] suggesting that the postwar science boom affected literary tastes as well as economic and political theory. In *The Methods of the Novel*, Itō created a gridlike classificatory system for Japanese authors based on a combination of a biographical and psychological analysis of the authors and a thematic/stylistic analysis of their works.[92] The first American film chosen by Occupation officials to be shown in postwar Japan in February of 1946 was Mervyn LeRoy's 1943 biopic *Madame Curie*.[93] Even a film like *Godzilla* (1954) that depicts both the horror of American atomic bomb testing and the salvation of Japanese scientific discoveries (especially when combined with a uniquely Japanese spirit of self-sacrifice) might be said to reflect the newfound popularity and promise of science in the postwar period.

In this context, it is not surprising that the defense used science in the hopes of legitimating literature and literary analysis. Far from advocating "art for art's sake," Itō and his lawyers were asserting the important contributions art could make to advance society. But it needed to be scientifically measurable, for only science, the beacon of progress and democracy, could save Japan from again following the irrational path toward war. By equating the role of literature with that of scientific texts and by relying on science to assess literary meaning and value, the defense also implied, however, that the right to free expression depended on an assessment of the novel's scientific and philosophical value and only secondarily its artistic value. In this respect, it subscribed to the very instrumentalist thinking it denounced. As we will see, the judges agreed wholeheartedly with the defense's premises, just not with its conclusions.

The Verdicts

At all three phases, the *Chatterley* judges agreed that someone was guilty of something. Where they departed from one another was over the question of who that was. In January 1952, the District Court judges ruled to convict Oyama and fine him the maximum but to acquit Itō in what many in the legal community deemed a "commonsensical but theoretically unsound"[94] verdict. Striving to correct this, in December 1952, the High Court reversed the not-guilty verdict for Itō and convicted him as well, albeit with a lesser fine in a verdict that was upheld by the Supreme Court in March 1957. Most surprising about the verdicts was the fact that the defense had inadvertently supplied as much, if not more, ammunition than the prosecution by subscribing to the modes of the scientist and the censor.

Judging the Messy Individuality of Literature versus the Tidy Rationality of Science

For the judges, the scientific experiments, as well as the broader question of the proper roles of literature and science, would figure prominently in their verdicts. The District Court split verdict held that the translation itself was not obscene but that Oyama's titillating paratexts, especially the questionnaire and salacious ads, had effectively transformed it into obscenity. They ruled that *Chatterley* was different from pornography "based solely on the psychological prose analysis research" (*CS*, 2:291). (Any terminological distinction between pornography and obscenity was not further clarified.) Particularly problematic was the questionnaire included in the second volume that had been submitted by the defense to prove that over 85 percent of respondents had both found the work's sexual description beautiful rather than obscene and disagreed with censoring the novel. But the judges fought numbers with numbers, citing the readers' responses to other questions from the survey as well as from other reader surveys. They were particularly disturbed by the overwhelming response of almost 80 percent of readers who found the work sexually arousing and concluded that the general reader was merely interested in the novel's graphic sexual depictions (*CS*, 1:140–144).

In citing these competing surveys, the judges demonstrated their own interest in gauging reader reception, but they also seem to have realized just how slippery and intangible that enterprise was. In the verdict, they too pointed to the promise of the lie detector experiments in line with the powerful rationalizing impulse in postwar Japan. Although the judges ultimately

dismissed them as unreliable indicators of reception, significantly, it was the methods used by the scientists that they criticized, not their premise. In the verdict, the judges devoted five out of six pages to the experiments in a section titled "The Relationship between the Translation and Obscenity" and stated their hope that the machine could be used in the future if the scientists just employed "more precise management" (*CS*, 2:291–297).

Of note, the judges cited these scientific studies because of their potential value in measuring literary reception not because they endorsed giving literature as much free rein as scientific and medical texts. For the courts, science and rationality should be the means for controlling literature, not for letting it loose. This distinction was very clear in the judges' minds: rational scientific method was needed to control irrational fictional works, their characters, and their readers, not to legitimate any of their "immoral" pursuits.

For all sides, this question of establishing the proper relationship between the spheres of science and literature was paramount. The judges at all stages unanimously upheld the prosecution's claim that *Chatterley* was of a different ilk than scientific texts and was not to be afforded the same guarantees of free expression. Prosecution witness Doctor Moriyama had contrasted the language of *Chatterley* with Van de Velde's "dispassionate and objective nature that appeals to reason" (*CS*, 1:358). Kanamori acknowledged both the artistic and the scientific aspects of *Chatterley* but specifically objected to the incursion of literature into the sphere of science, or what he called its "excessive" nature. Summarizing his three major objections to the novel, he concluded: "It exceeds the normal sphere of literature, becoming more like a biology or psychological textbook; it looks at humanity through a single lens; and it has excessive sexual description for literature or science" (*CS*, 1:118). The problem was that *Chatterley* treated a scientific subject using the style and form of a novel.

The judges concurred with this assessment and offered a lengthy comparison between sex education texts and literature that reveals how determining genre boundaries was at the heart of the matter:

> The defendants and their lawyers assert that if you accept that scientific books use frank sexual description in the pursuit of truth, then you cannot ban the same search for truth in literature. That assertion itself is absolutely correct. Nevertheless, as witnesses [psychologist] Hatano Kanji and [Doctor] Moriyama Yutaka pointed out, in contrast with most obscene literature that treats sex . . . with a frivolous and vulgar attitude

and that imbues fictional characters with individuality, depicting them as if they actually exist, sex education books treat sex innocently and objectively and use description that inhibits interpreting characters as emotional beings and instead makes them into abstractions of humans. (In other words, they can be said to be without individuality and lacking intimacy). Accordingly, if a sex education book instills an emotional attachment in readers by using description that imbues its characters with individuality, then there is a strong possibility it will become an obscene book. Similarly, if a literary work that is, at its core, meant to evoke the readers' interest aims to explore sex, it requires careful consideration as to what degree readers will become emotionally attached. (*CS,* 2:317–318)

Here the judges argue that fiction was potentially more obscene than scientific texts for two reasons: literature treats sex sensationally and invites readers to identify with characters who seem to "actually exist."

At the core of the guilty verdict was the fear that readers would uncritically identify with unscrupulous fictional characters. By virtue of being described in subjective novelistic prose, these characters transcended the page to become "living people," as the High Court judges claimed in their appeal verdict. For these judges, even when medical texts include sensational materials, they succeed at being educational because they "are discussed in terms of a universal principle that is based on objective observation and research." In contrast, even when literature strives to be educational, it is sensational because even when its "fundamental aim is to research and to explain philosophical concepts to the average member of society, it expresses this through the actions of living people."[95] In other words, literature's failure lay in its greatest strength: its ability to make its characters come alive for its readers. Here the judges credit *Chatterley* with the powers (and dangers) of realism in the crudest sense of the word; literary prose is transformed into a live performance akin to the one "on the streets of Ginza in broad daylight" evoked by Kanamori.

This very distinction between educational science and sensationalist literature had, in fact, been espoused by the defense itself in its quest to defend the novel as a scientific text. In the District Court trial, the defense lawyers had asserted that the definition of obscene literature "should exclude books or pictures if they depict genitals or the sex act objectively and if they appeal to human reason or to higher spiritual functions of culture. It

should include nonacademic or unethical books that are meant to produce curiosity or pleasure seeking based on an exclusively sensational or sensual description" (*CS,* 2:283). Significantly, the defense was not exempting literature based on the rights of free expression afforded to the arts but instead exempting *only* literature that resembled a scientific pursuit in its objectivity and "appeal to human reason."

In this respect, the defense had inadvertently replicated the arguments made by prosecution witnesses who contrasted scientific texts' "appeal to reason [*risei*]" with *Chatterley*'s "appeal to feelings [*kanjō*]" (*CS,* 1:358). That *Chatterley* advocated the irrational pursuit of sexual satisfaction at the expense of reason was central to the prosecutor's objections. As we saw in the indictment, the prosecutor had repeatedly characterized Connie's adulterous sexual encounters as lacking reflection (*muhansei*) and of being blind (*mōmokuteki*) and animal-like (*yaseiteki* or *dōbutsuteki*). With his use of run-on sentences that mirror the heedlessness of her actions and his use of words that liken her to a "dog in heat," the prosecutor was objecting to the bodily, irrational nature of adulterous sex depicted in the novel. Not only was he implicitly contrasting sanctified married sex with immoral adultery but he was also making a crucial distinction between rationality and sensuality and between the human and animal kingdoms.

Although the lower court judges did not overtly condemn Lady Chatterley for her irrational sexual abandon as had the prosecutor, they refused to endorse literature that itself incited readers to irrationality. The judges worried that readers would follow the example of the adulterous Lady Chatterley, noting their distress that 16 percent of the questionnaire's respondents reported that they would take a lover if they were in a marriage like hers. They cited approvingly the opinion of the Christian activist who had appeared as a prosecution witness and had commented, "Although we can sympathize with Lady Chatterley having to continue married life with a sexually impotent husband, she should get officially divorced. To continue married life while still doing 'those kinds of things' is not the right course of action" (*CS,* 2:325).

The claim that erotic literature was undesirable because it endangered sexual morality and order was made most explicitly by the Supreme Court judges, who concluded,

> Because an obscene writing stimulates and arouses sexual desire and clearly makes known the existence of the animal side of man's nature, it involves the sense of shame. It paralyzes conscience in respect to matters

of human sex; it ignores the restraint of reason; it comports itself wildly and without restraint; and it possesses the danger of inducing a disregard for sexual morality and sexual order.[96]

For the courts, the definition of obscene literature was to be based on whether readers "lost the ability to control sexual desire *based on reason*" (*CS*, 2:285; italics mine). And the conclusion that science was to be afforded greater latitude than the arts depended on the fundamental distinction drawn between the two spheres: like their predecessors, the Supreme Court judges averred that "artistic creations differ from scientific works, which describe matters objectively and dispassionately, . . . , because they appeal strongly to the senses and emotions" (*CS*, 2:12). This assessment became the definitive standard, cited by the Supreme Court judges in the subsequent Sade trial and in later ones without any further debate.

In their preoccupation with determining the relationship between science and literature, the *Chatterley* trials were participating in the long-standing conflict between the "two cultures," most famously debated by T. H. Huxley and Matthew Arnold at the turn of the nineteenth century and in the Leavis-Snow controversy of the late 1950s. Revisiting this debate in his 1963 essay *Literature and Science,* Aldous Huxley interpreted the central differences between the two spheres much as the *Chatterley* judges had: "The scientist examines a number of particular cases . . . and from these abstracts a generalization, in the light of which . . . all other analogous cases may be understood. . . . The literary artist's approach to experience . . . is to concentrate upon some individual case, to look into it . . . [as] a window opening onto the universal."[97]

Huxley's interpretation is instructive because it suggests why the judges in the 1950s *Chatterley* trial concluded that literature should be regulated by the court whereas science could be afforded the guarantee of free expression. Huxley describes the scientist's "ultimate goal [as] the creation of a monistic system in which . . . the world's enormous multiplicity is reduced to something like unity, and the endless successions of unique events of a great many different kinds get tidied and simplified into a single rational order," whereas for the literary artist, "outer reality is constantly related to the inner world of private experience, shared logic modulates into unsharable feeling, wild individuality is forever breaking through the crust of cultural custom."[98] If we accept that the "rational order" of science ensured order and the "wild individuality" of literature provoked chaos, the appeal of

science and the dangers of literature in the context of the political and social instability of 1950s Japan become clear.

Taking a Scalpel to Society: Healthy Literature, Laws, and Society

In the lower court verdict of 1952, the judges did not specify what aspects of society needed to be reordered, other than their brief criticism of the 16 percent of respondents who shared Lady Chatterley's adulterous predisposition. They did, however, state that their decision to convict was predicated on present-day social disorder and asserted this "social reality" by relying on scientific language, the authoritative lingua franca of the trial. In a graph included in the verdict (fig. 1.1), the judges represented society's "ideal" during "times of peace" as a straight vertical line with "natural" deviances, sometimes to the left and sometimes to the right, that are kept within bounds by "social controls." But, "when society becomes disordered

Fig. 1.1 Chatterley judges' graph asserting society has gone too far (Masaki 1983, 297). ① ideal state during times of harmony ② going too far ③ automatic social controls

and people's conduct becomes corrupt, the line veers outside the bounds and must be said to go too far . . . , resulting in a violation of public welfare." Here the judges were challenging the defense's own graph that had claimed leaving culture to regulate itself would lead humanity to its greatest heights. They complained that the defense lawyers' abstract constitutional claims about freedom of expression "failed to look squarely at the realities of present-day society."[99] Rather, society had gone "too far" (*ikisugi*) and was in dire need of a legal corrective.

The Supreme Court judges concurred and introduced also a sweeping precedent that asserted the courts had not merely the right but the obligation to correct society when it went awry:

> If a large majority of the people's ethical sense is paralyzed and even if they don't recognize something truly obscene to be obscene, the courts must protect society from moral corruption. . . . In all probability, the law and the courts do not necessarily always uphold societal realities but instead, taking a critical stance against vice and depravity, must perform a clinical role [*rinshōteki na yakuwari*].[100]

The Supreme Court is asserting here the courts' role is to take a scalpel to a sick society, like a physician charged with diagnosing and treating society's pathological immorality.

This point generated the most fervid discussion in the legal and literary communities. For the Japanese Writers' Association, the Supreme Court verdict represented an incursion of the judiciary body into the realm of morals, philosophy, and religion; in a petition they protested, "The judges have exceeded the sphere of judges and delivered a verdict from the perspective of moralists, philosophers, or religious leaders. This smells like a religious trial persecuting infidels or a thought-crime trial, and even raises suspicion that it violates the Constitution."[101] For the legal community, the question, as posed by one of the foremost postwar legal scholars of criminal law, Dandō Shigemitsu, was, should law have a moral or ethical basis or should it be a dispassionate, faithful interpretation of the written law? Some in the minority, like Supreme Court justice Mano Tsuyoshi in his vigorous dissent, scathingly criticized the *Chatterley* verdict for overstepping its bounds. Others, including Dandō himself, felt that morality must help guide the law, not the other way around. In a panel discussion published in *Chūō kōron* in May 1957, a former judge unequivocally asserted that "if judges merely interpret

and apply the law faithfully, dispassionately, and fairly, I believe they are not fulfilling their mission. . . . I want judges who will truly consider the state of the country one hundred years into the future." Even a more liberal legal scholar concluded by admitting that "this kind of verdict is very painful in today's era, but in the end, it is perhaps an appropriate compromise in terms of policy." In the minds of these legal scholars, the revival of censorship was justifiable in the interests of healthy social policy, "even if," as one scholar noted, "there were considerable doubts about its legality."[102]

CHAPTER 2

The Legacy of *Chatterley*
Sade (1961–1969) and Beyond

The *Chatterley* trial deeply influenced subsequent proceedings despite the many differences that divided them—from the objects on trial and the historical contexts of their production and reception to the individual personalities of the defendants. Before turning to these individual case studies, let us first consider how these later trials conformed to and departed from the template established in the *Chatterley* trial. On the one hand, there was a striking continuity in the kinds of structuring arguments over the legitimacy (or illegitimacy) of the medium; the contemporary state of morality among youths and females; the relationship of art to reality, especially with representations of female sexuality; the work's inclusion (or lack) of philosophy and politics; the question of authorship, ownership, and legal culpability; the role of the West in advancing or retarding domestic cultural and legal modernity as well as social morality; the relationship of science to art; and finally, the perennial taxonomic impulse of the censors.

On the other hand, the subsequent trials also diverged from this foundational model in important ways that suggest the necessity of making adjustments when a different medium—film, photography, and manga— was the object on trial, when the defendants had wildly different politics and personalities, and when conceptions of societal morality were rapidly shifting both nationally and internationally. Nevertheless, later defense teams were forced to contend with the *Chatterley* precedent. As the head lawyer in the manga trial acknowledged, when preparing his defense strategy, he avidly read the available records of the previous obscenity trials and even personally conferred with the head lawyer in the *Realm* trial.[1] At the

same time that the ultimate defeat of the defendants in the *Chatterley* trials provided the state with a successful template and powerful legal precedent, it also offered the later defense teams an opportunity to learn from the mistakes of their predecessors.

The Uses and Abuses of Science

In contrast with *Chatterley*, scientific evidence would be used only in an extremely limited capacity. Whereas in the *Chatterley* trial a total of nine witnesses (six for the defense and three for the prosecution) were medical doctors, psychologists, or social scientists, in the later ones, few to no such witnesses appeared and instead the overwhelming majority were literary or film experts. Scientific evidence would, however, resurface in the last two trials. The defendants and lawyers in the *Realm* trial (1976–1982) echoed the *Chatterley* defense with their claims that the screenplay's style was "dispassionate and objective, like a medical text"[2] and in the inclusion of the testimony of a witness specializing in communication theory and another who was a psychiatrist. They even relied on what was essentially an alternative form of the lie detector to gauge a work's arousal factor: a "peter meter," or machine that measures the erection of a male subject as he reads or watches pornography.[3] In the manga trial (2002–2007), two well-known scientists appeared as defense witnesses—the sociologist Miyadai Shinji and psychologist Saitō Tamaki—who cited a barrage of statistics and psychological theories to propose a unique and harmless mode of reception for manga readers.

Why was science invoked to such a degree in the *Chatterley* trial and why did it subsequently fade from view only to reappear in these later two trials? The currency science held among all parties in the *Chatterley* trial suggests that its use was largely a reflection of the historical moment. But its enlistment there, and its later revival, also reveal it to be an attempt to concretize reception, a slippery question even in artistic criticism but one that was especially pressing in the legal context where the definition of obscenity depended on a work's ability to move readers to states of sexual arousal or moral offense.

By using scientific language and methodology in the *Chatterley* trial, the defense was appealing to rationality, as implied by both senses of the word—scientific, that is, objective, and intellectual, that is, not sensual. In its arguments, scientific jargon certainly outweighed any concrete discussion of the novel itself. Suggestively, the novel's objectionable passages were almost always referred to numerically, by page and line numbers alone. And

the only time those passages were cited was during Itō's testimony when he quoted from Lawrence's original, English-language version. Both these strategies strove to desensualize and to intellectualize the language of the translation, either through numbers or through a foreign language. Both attempted to disrupt audience reception at the trial by requiring its members shift gears from a verbal language to a mathematical one and from a native language to a foreign one. (For later readers of Itō's testimony, which was published in literary journals and trial accounts, this entailed an additional shift from a vertical reading of the text to a horizontal one.)

The defense's scientific experiments not only aimed at rendering reader response innocuous under the cloak of rational language but also promised to render reception transparent and thereby subject to regulation. This was especially true of the lie detector experiments, which could ostensibly gauge the outward physical manifestation of a reader's internal reaction and lay bare the reader's "true" reaction. It seems the need to render the audience's response visible was particularly urgent when the object on trial was erotic *reading* material. As Linda Williams argues, pornography purports to offer a reader unmediated access to "real" sex. The unmediated and "real" quality of sex in pornography is attested to by the involuntary nature of both its content, orgasms or other bodily spasms/ejaculations, and its narrative structure, which often takes the form of a confession.[4] In the trial, the defense was attempting to counter the possible impression of the novel as possessing this involuntary quality in terms of either its content or form with an assertion of control at the level of reception—by measuring the reader's response in scientific terms.

This turn to science to determine reception was even more crucial in the case of texts because the act of reading was perceived to be a private, individual, and largely invisible activity. When prosecution witness Kanamori asserted that literature was potentially more dangerous than a live performance because reading involved "the general public's conjuring up those forms inside their heads" (*CS*, 1:123), he was expressing his concern that a reader's internal response to a work was invisible and therefore not subject to regulation. The defense's scientific experiments can be seen as an attempt to diminish this impression by depicting their responses as instead both measurable and visible and, most important, subject to the scrutiny of society and the courts.

The defense was also denying that *Chatterley* would evoke visual *images* for readers: as Itō claimed, the novel's description in the sex scenes

was "conceptual" (*kannenteki*), not "visual" (*shikakuteki*) (*CS*, 1:395–396). There were two seemingly contradictory things going on here. At the same time that the defense felt the need to refute the impression that readers were conjuring up *images* in their heads, they also needed to lay bare readers' reactions precisely because, in the case of a written work, those *images* were invisible and individual. In other words, perhaps the need to make reception both quantifiable and transparent was more pressing when the text was *nonvisual but invited visualization.*

Even when they did not submit the objective scientific results, the defense teams in the later trials did not, of course, dispense with arguing about reception. Instead, they offered the testimony of numerous witnesses recounting their impressions upon reading the book or seeing the film. In a sense, this testimony was also designed to render reception transparent and to counter the potential danger of readers' and spectators' being moved in a way that was invisible and unpoliceable. Significantly, though, these witnesses offered individual, subjective accounts of their feelings upon reading or viewing the work on trial, not charts and graphs that would objectively quantify their responses to a work of art. The adamant refusal to equate art with science or to subject it to its measurements was made abundantly clear by defendant Nosaka Akiyuki, who in the 1970s "Yojōhan" trial declared, "What is at issue here is undeniably words, not Pythagorean theory."[5] Even the return to science in the last two trials entailed a significant revision of the *Chatterley* defense strategy, invoking general theories of reception, not concrete scientific reception studies of the work on trial.

This general shift in strategy stemmed from a recognition by the later defense teams of the inherent contradictions of the *Chatterley* defense strategy. By arguing that only scientific, philosophically useful literary texts deserved constitutional protection, the defense had ceded the autonomy of literature to the authority of science. Although they objected to the mechanization of men's bodies through wartime conscription and sacrifice, in order to determine an individual's aesthetic response to a text, they subscribed in their methodology to just such mechanization. In the mid-1960s, the tendency to dehumanize bodies during both war and the postwar statistics boom was criticized by avant-garde artists in performance pieces, such as one entitled "Imperial Hotel Physical: Shelter Plan in Tokyo," in which participants (including Yoko Ono) were "subjected to various methods of bodily measurement . . . including such irrelevant data as finger strength, saliva production, length of extended tongue."[6] By offering the subjective

testimony of individual readers, the later defense teams implicitly rejected this earlier tendency and refused to translate reception into the cold language of statistics.

Censors and Taxonomies

The *Chatterley* defense team had also made the mistake of advocating censorship of other literary genres. In their arguments, they divided literature into reputable and disreputable categories: rational, scientific, or philosophical works like *Chatterley* on the one hand and emotional, unscientific, sensational ones like literature of the flesh and pulp magazines on the other. The defense was especially careful to distinguish *Chatterley* from literature of the flesh, likely because the defense recognized the undeniable similarities between them. This was especially evident in a bizarre open letter published in a literary journal during the trial that was ostensibly penned by the deceased Lawrence and addressed "To Itō Sei, from Lawrence in the heavens." In it, "Lawrence" professed to appreciate the attendance at the trial of the likes of literature of the flesh authors Tamura and Inoue Yūichirō but denied any affiliation with them, insisting that "their kind of literature of the flesh partakes of a literary spirit absolutely unconnected with me."[7]

By distancing less-respectable literary factions, the defense hoped to elevate the respectability of *Chatterley* and the defendants. But in doing so, it also participated in the categorizing push inherent to censorship, merely drawing the line further down the food chain. The battle to define and to distinguish between genres is an important goal of censorship, and one that was arguably more successful than the censors' attempts to remove a work from circulation. The power of censorship to create a taxonomy or classification that could symbolically purify a literary canon cannot be underrated.[8]

The sheer number of categories drawn by the prosecutor and defense alike in the *Chatterley* trial—rational/sensual, highbrow/lowbrow, human/animal, native/foreign, science/literature—evinces the taxonomic impulse that often lies at the root of the censor's endeavor. In his study of Meiji period censorship, Jay Rubin points out this tendency among early modern censors, noting their desire to concretize the borders of naturalism by subsuming everything obscene under this genre.[9] In part, the censor's ultimate success in defining and guarding such genre boundaries depended on the artists' own participation in these debates. By privileging science and dividing literature into highbrow and lowbrow categories, the *Chatterley* defense

team inadvertently replicated the censors' classificatory impulse. For them, literature, like science, was defensible only insofar as it was useful to society.

This contrasts sharply with the defense strategies in the later trials, which assumed the inherent value of all art and argued that an artistic work deserved protection regardless of its "value"—as determined by its content, theme, or the reputation of its author.[10] This is not to say that thematic readings or value judgments disappeared entirely. A striking continuity in the thematic readings at the trials in fact remained: like *Chatterley,* many were interpreted as antiwar, political statements, from the anti–U.S. base message of the 1965 film *Black Snow* to the Edo-period *The Record of the Night Battles at Dannoura* focusing on the sexual relations of men and women at night rather than glorifying the men's martial feats on the battlefield by day.

Despite the endurance of such politicized readings, the focus shifted from the decidedly utilitarian view of literature in the *Chatterley* trial to one that increasingly recognized and insisted on art's fundamental rights of expression. This shift can be attributed both to changing historical contexts and to the quite different personalities of the defendants. In the 1950s, the memories of wartime persecution and of artists' complicity may have compelled Itō and his supporters to defend the novel as a rational philosophical treatise that could save Japan, and to reject any emotional appeal that might uncomfortably call to mind irrational wartime propaganda. In the 1970s, however, the outspoken author Nosaka could confidently adopt the pose of a mere "scribbler" (*gesakusha*) and provocatively declare that "orgasms achieved through words are, of course, a fundamental right granted to the entire world."[11]

The later defense teams, especially in the 1970s trials, appealed instead to the traditional Japanese notion of the affective power of art that dated back to the tenth-century imperial poetry anthology *Kokinshū,* and to the eighteenth-century lectures on *The Tale of Genji* by literary scholar Motoori Norinaga. In the *Kokinshū* preface, compiler Ki no Tsurayuki celebrates poetry for its ability to move its audience: "Poetry moves without effort heaven and earth, stirs the invisible gods and demons to pity, makes sweet the ties between men and women, and brings comfort to the fierce heart of the warrior." In a pointed rejection of Confucian didacticism, Norinaga similarly advocated the aesthetic criterion of *mono no aware,* or "when the heart is deeply and genuinely moved in the face of some external event,"[12] for evaluating literature. In the context of 1970s cultural nationalism, the appeal of a defense that relied on such native literary values and that could

be dated back to the premodern canonical texts was immense. One judge, in his dissenting opinion in the Sade Supreme Court verdict of 1969, endorsed precisely this affective quality of literature, which he defined as "searching for the truth about man, trying to draw out from depths of anguish filled with bitterness what it is that will shake the emotions of the reader."[13]

In the final analysis, such assertions about art's considerable affective appeal failed to work in its favor in the legal context and were instead at the heart of the desire to police it. The ultimate irony of these trials was that to secure an acquittal, the defendant-artists were forced to emphasize not the powerful emotional affects of art but its inefficacy in the real world, while the prosecutor stressed its powers and dangers.

East Meets West, Again and Again

The one feature of the *Chatterley* trial that would endure in all the subsequent ones was the organization of trial arguments along the lines of East versus West, but not without a twist. As in the *Chatterley* trial, the later prosecutors continued to uphold the authority of the "native" Meiji-period Criminal Code and to ignore the "imported" postwar Constitution. And the defense continued to hold up the postwar Constitution and the West as models of democracy prizing free speech, eventually citing the "liberation of porn" in European countries that decriminalized pornography beginning in the late 1960s.

Whereas the *Chatterley* trial was characterized by the neat alignment of the prosecution with Japanese tradition and the defense with Western modernity, in the later trials this alliance was disrupted. Although the laws used to prosecute and defend the works remained the same, the defense downplayed the foreign origins of the Constitution and instead attacked the Criminal Code as a foreign import (which it undeniably was, having also been modeled on Western examples). The Criminal Code and especially its concept of obscenity were interpreted as Western imports that were incompatible with native Japanese traditions, a legacy of the forced opening of Japan to the West in the 1850s. The defense claimed that even the Japanese word for obscenity, *waisetsu,* was a translation consisting of such obscure Chinese characters (猥褻) that it was incomprehensible to most native Japanese.[14] Suggestively too, the orthography used by the defense for *waisetsu* in these later trials was most often katakana, a script reserved for foreign loan words. The defense explicitly blamed the Western imports of Victorianism and Christianity for introducing the stilted language and ideology of obscenity

into Japanese legal traditions. In the "Yojōhan" trial, special defense lawyer Maruya Sai'ichi remarked that Japan in the Meiji period

> became England's disciple, especially influenced by the Victorian court in terms of history, literature, and ways of thinking. . . . Victorianism was an age of hypocrisy of keeping up appearances. From this was born the customs that made sexual behavior taboo to the extreme point that men and women needed to cover their arms and legs, and even the legs of pianos had to be covered.[15]

In his closing argument in the *Realm* trial, defense lawyer Akiyama Mikio summed up this new position, calling article 175 "nothing more than something that was introduced to create an appearance of a Western modern state in our country. The extreme Victorian-period conception of sex did not originally exist among our country's people, or even in legislation . . . , but, in order to join the ranks of the West, Continental law was forcibly introduced."[16] The defense in the manga trial similarly charged article 175 with being a bald-faced policy "adopted in Meiji to nationalize subjects and to join the advanced nations."[17]

What can explain this realignment of positions? In the *Chatterley* trial, the defense argued that without legal and cultural imports, Japan would fail to become a truly modern civilized nation. In the 1960s trial of the translation of Marquis de Sade's *Histoire de Juliette,* these arguments remained largely unchanged, suggesting that the foreign origins of these novels facilitated this defense. However, when the works on trial were no longer translated foreign works but native Japanese literature and film, the defense abandoned its unqualified endorsement of Western imports and instead looked to native legal and artistic traditions to bolster its arguments. The defense continued to celebrate the West as a desirable contemporary model in which progressive free speech reigned but denigrated Western influence for having corrupted native Japanese traditions. With these accusations, the defense in these later trials was adopting the very rhetoric of the prosecutors in the *Chatterley* and Sade trials, who had implied that the introduction of the foreign-scripted Constitution and of impure foreign novels threatened to corrupt the legal and cultural purity of Japan. If this rhetoric was appealing to conservatives in the wake of defeat in 1950s Japan, it had potentially even broader appeal in the 1970s, during a period of resurgent cultural nationalism characterized by the

discourse of Nihonjinron, or the search for what constituted a uniquely Japanese identity.[18]

In the 1970s trials, the defense insistently turned to domestic traditions of free sexual expression. Such a depiction required the substantial rewriting of Japan's legal and cultural history, as well as its history of censorship. The revisionist impulse behind this project was evident, for example, in the convenient elision of the origins of the postwar Constitution, in the selective depiction of Japanese literary history as consisting of unremittingly erotic works (spanning from the eighth-century *Kojiki* to the seventeenth-century works of Ihara Saikaku), and especially in the characterizations of pre-Meiji Japan as a censorship-free society tolerant of sexual expression, and of Meiji, in contrast, as the moment when censorship began.[19] Since the Edo period was also notorious for being the time when censorship regulations were first formally instituted (in 1721, as part of the Kyōhō Reforms, and again in 1790, as part of the Kansei Reforms implemented by Matsudaira Sadanobu), this assertion required some finessing. To reconcile these contradictions, defense witness author Inoue Hisashi in the "Yojōhan" trial, for example, noted that although Matsudaira famously ordered author Santō Kyōden manacled for fifty days, after Matsudaira resigned, he asked for the author's autograph.[20]

Despite the willful distortion of the past that these assertions required, the defense celebrated the earlier periods as a time when Japanese legal and literary traditions were able to flourish unfettered by Western notions of obscenity. This defense suited the cultural nationalism of the 1970s but was also influenced by the fact that the works on trial in these later cases were themselves often either products of the Edo period, like *The Record of the Night Battles at Dannoura* (ca. 1800), or consciously adopted the Edo-period style of "light writing" (*gesaku*), like Kafū's 1924 "Yojōhan." The defense in these 1970s trials depicted the indictment of these classical and pseudoclassical works as an attack on Japan's premodern literary canon, on the classical Japanese language, and even on Japaneseness itself. In the twenty-first-century manga trial, the defense would again strategically draw parallels between the work on trial and Edo-period erotic woodblock prints in a bid to claim erotic manga also as a unique Japanese cultural treasure that was recognized both domestically and internationally.

Although the battle between East and West remained present in these later trials, any neat alignment was no longer operative. The *Chatterley* defense team had exhorted the judges to deliver a not-guilty verdict as a

symbol that would ensure the lasting influence of postwar reforms instituted by the Occupation and that would fulfill the long-awaited Westernization process that had gone awry in Meiji. The defense in the later trials, in contrast, exhorted the judges to acquit so as to eradicate the corrupting influence of Western thought from society for good. By the 1970s trials, the West was no longer simply lionized as the beacon of democracy and progress; it was now demonized as the corruptor of Japan's long-standing legal and literary traditions of open sexuality.

Notwithstanding the contorted realignments of defense and prosecution tactics that occurred over time, the *Chatterley* verdict itself endured. In 1952 after the District Court guilty verdict, legal scholars professed their hope that "the era when the *Chatterley* trial will be a laughingstock will come soon."[21] The succession of guilty verdicts at all levels of appeal and the high-profile Sade trial that followed on its heels proved otherwise, despite a close, eight to five split in the Sade Supreme Court verdict of 1969.[22] Fifty years later the *Chatterley* verdict remained firmly in place as evidenced by its verbatim citation in the first-time conviction of a manga. As the young prosecutor Nakagome rightly predicted in a newspaper interview in February 1957: "There are many incidents that kick up a fuss, but I believe that *Chatterley* alone will remain in the future. Not just as a mere record but as a historical fact."[23] If, as defense lawyer Masaki charged in his closing statement, the *Chatterley* verdict was to be the "starlight that tests freedom of speech and publishing [*genron, shuppan no jiyū o tamesu 'jikkenyō no hoshi no hikari'*]" in the postwar period,[24] then the future was dark indeed.

PART II

PINKS, PORNOS, AND POLITICS

Unlike their literary precedents, the objects of prosecution in Japan's film trials are less assuredly classics. *Black Snow* (*Kuroi yuki*, 1965; directed by Takechi Tetsuji) belonged to the burgeoning genre of Pink Film (*pinku eiga*), low-budget erotic B productions churned out in seven days. In the subsequent Nikkatsu Roman Porno trial, four films from 1972 to 1973 were simultaneously targeted, suggesting that they were chosen to represent a genre rather than for the singularity of their content. These films' notoriety as the objects of a censorship trial remains, however, with most commentators invariably devoting more lines to the trials than to the films themselves, which were not commercially available until the recent vogue for sexploitation films.[1] In fact, oddly enough, the original version of *Black Snow* that spurred the indictment did not exist even at the time of the trial. Despite the failure of the films to achieve the canonic status of the indicted literary works (or authors), during the *Black Snow* trial, director Takechi likened his indictment to an award, bragging, "To be indicted by the state authorities is the ultimate badge of honor for an artist. It beats getting the Order of Cultural Merit. With this, I've become a first-class artist."[2]

Censorship trials sometimes did have the unintended effect of catapulting a work and its creator into the artistic hall of fame. This was the case for *Chatterley*, especially for its translator, who prospered during the post-trial "Itō boom." But the works of D. H. Lawrence and Marquis de Sade have also long occupied a place in the literary canon,[3] and as we have seen with *Chatterley*, determining the relationship between a work's prestige and the likelihood of its prosecution is tricky. As we will see below, this was also true for the indicted films and for the short story "Yojōhan" by Nagai Kafū, an author who did, in fact, win the Order of Cultural Merit in his lifetime.

In the case of Japan's literary trials, the repute of authors and publishers often served not to inhibit but to incite charges. In contrast, in the film trials, the directors' or studios' so-called outsider (*autosaidā*) status (either real or self-proclaimed) often increased their tendency to be charged. In large part, this was because the self-regulating censorship body for films, Eirin (shorthand for Eiga Rinri Kitei Kanri Iinkai, or the Motion Picture Ethics Regulation and Control Committee), had a difficult time reining in these renegades during the preproduction inspection process. Eirin would play a critical role in both film trials, but not without a significant difference. Whereas in the Nikkatsu trial Eirin and the filmmakers, as codefendants, were necessarily united to a degree against the state censor, in the *Black Snow* trial, they were decidedly antagonists. Both trials, however, as ones

in which the targeted films had passed Eirin inspections, suggested that the fate of self-regulation and of Eirin itself was at stake. The trials would offer a barometer of the degree of constitutional protection that would be afforded to the medium of film, and also to Eirin in the eyes of the law.

Establishing Eirin: The Self-Regulatory Industry Censor

With the establishment of Eirin in June 1949, the film industry was the first sector to move toward self-regulation. Created at the behest of the Occupation officials and with the close cooperation of the major domestic studios and the newly formed Japan Motion Picture Union (now the Motion Picture Producers Association of Japan, Nihon Eiga Seisakusha Renmei, or Eiren for short), Eirin was designed to forestall the revival of prewar state film censorship and, more immediately, to replace Occupation censorship.[4] Initially, Eirin was tightly affiliated with the major studios both in its staffing and in its funding structure: at the helm was Shōchiku founder Ōtani Takejirō, and its top management positions were staffed by Daiei president Nagata Masa'ichi and Eiren chief (and former Shōchiku director) Ikeda Yoshinobu; it was subsidized by an annual fifty thousand yen contribution from each of the Big Five studios, as well as by a charge of ten thousand yen per film. The inspection process occurred at two stages, a script check (and sometimes also the synopsis) and then the completed film, and included attention to titles, advertising, lyrics, and dialogue. As of November 1949, approved films received an Eirin seal.

Its regulations were modeled closely on the 1930 Hollywood Motion Picture Production Code (or Hays Code), the self-regulatory U.S. system that had similarly been designed to stave off governmental censorship. As its mission statement emphasized, Eirin was charged with being the film industry's new guardian of morality:

> As entertainment and art, films have a large influence both spiritually and morally on the lives of our citizens, for which we feel responsible. For this reason, we have established ethics regulations for the production of films, and we will strive to prevent the production of films that will lower the moral standards of spectators. . . . At the same time films must aim at uplifting the moral outlook of spectators and must not disturb the maintenance of societal order, they also must not endorse words and deeds that violate fundamental human rights or ideals that run counter to democracy.[5]

At the time of its inception, Eirin was championed for marking the emergence of true democracy for the first time in Japan's history. As the head of Civil Information and Education, Lieutenant Colonel D. R. Nugent, somewhat condescendingly put it at the June 14 inaugural party at Piccadilly Theater, the occasion marked a "truly epochal moment for Japan's heretofore weak populace."[6]

Even though it was an industry-run voluntary organization, Eirin was championed because it would make prewar relics of state censorship obsolete. At the celebration, Nugent, for example, claimed, "If the regulations are followed faithfully, even article 175—the only regulation that presently applies to films—will be, for all intents and purposes, useless." The chief judge of the Supreme Court likewise lauded it as "an epochal moment fulfilling the spirit of the new Constitution and marking the starting point for new Japanese films." Eirin was to supplant the Criminal Code and to complement the Constitution. As some claimed, Eirin regulations were nothing less than "*the* constitution for the Motion Pictures."[7]

Eirin was clearly intended as a quasi-governmental organization, or at the very least as a "buffer zone" between artist and state, an ambivalent status that would engender much criticism from all sides over the years. Even at this celebratory occasion, some expressed pessimism about the fate of self-regulation: the state's chief prosecutor pointedly voiced his "expectation that the committee will develop healthily based on a deep understanding of art, proper morals, and a pure ethical stance"; and the president of the Diet House of Councillors warned, "The freedoms of the people protected by the Constitution need to be based on responsibility and duty."[8] Tension with state authorities would plague Eirin in a series of scandals that culminated in the unprecedented indictment of a film that had passed Eirin's inspections in the *Black Snow* trial and of its own employees in the Nikkatsu trial.

A Brief History of Eirin Scandals

From its earliest days, Eirin was perpetually dogged by accusations that it was either a front for the studios or one for the state. During the Occupation period, there were accusations that film studios were bribing Eirin inspectors and Occupation authorities with women and money, a relationship that was said to be no different from the alleged one between filmmakers and state censors in the prewar years. Later, during the *Black Snow* trial, Eirin employees were publicly accused of taking bribes from the studios to compensate for their pathetically low salaries.[9] In the eyes of the state and

the moral guardians, even if it was not actually taking bribes, Eirin was corrupted by its affiliation with the studios. In the eyes of many in the film industry, however, its role as a censor, "self-regulatory" or not, rendered it nothing less than a de facto state authority. Prior to the *Black Snow* incident, two major scandals prompted its successful reform from dubious industry insider to an authoritative and quasi-governmental organization: the 1954 *Pleasures of Vice* scandal and the 1956 Sun Tribe (Taiyōzoku) scandal.

In 1950, the prime minister's office established the Central Youth Problem Investigative Committee (Chūō Seishōnen Mondai Kyōgi Kai) and regional Youth Organizations (Seishōkyō), whose initial focus was on prohibiting harmful behaviors among youths, calling for "abstinence from bad habits" like methamphetamines. Soon followed a host of subcommittees, whose names suggest the government's concern also with the effects of books and films on youths: the Strategic Committee for Youth Culture and the Strategic Committee on Films, Books, and Other Media Harmful to Youths. (In fact, for one such committee, *Chatterley* defense witness Hatano Kanji conducted, in 1959, a study of the effects of sex and violent depictions on youths.)[10] Individual prefectures also passed their own Youth Protection Ordinances (Seishōnen Hogo Ikusei Jōrei), which were first designed to regulate youth behaviors (late-night carousing, drug use, etc.) but soon came to be used to regulate media consumed by youths by designating them "harmful" (*yūgai*) and off-limits to those under eighteen.[11] In effect, this designation represented Japan's first institution of a film-rating system, one that was assigned not by the film industry but by the state at the prefectural level and carried with it the authority to fine uncooperative local theaters.

The first major scandal revolved around the 1954 film *The Pleasures of Vice* (*Aku no tanoshisa;* directed by Chiba Yasuki), an adaptation of an Ishikawa Tatsuzō novel, which became the first work to be designated a "harmful film."[12] A Movement to Purge Vulgar Films (Zokuaku Eiga Tsuihō Undō), led by the powerful Mothers' Society, swept the nation and the Central Youth Problem committee appealed to Prime Minister Hatoyama to reinstate centralized governmental film censorship. In response, Eirin instituted the industry's own first rating system, slated to begin on the symbolically apt Children's Day (May 5) of 1955. It simultaneously established the Committee on Children's Film Viewing (Seishōnen Eiga Iinkai), whose members included child psychologists and mothers' organizations representatives from outside the film industry, to designate "films geared toward

adults" (*seijin-muke*), defined as eighteen and over, and other films as "recommended" (*suisen*) for youths.[13]

Albeit a successful temporary fix, this countermeasure failed to permanently quell the tensions between Eirin and the moral watchdogs, which soon peaked again in the Sun Tribe scandal of the summer of 1956. The Sun Tribe group originated with the July 1955 novella *Season of the Sun* (*Taiyō no kisetsu*) by the new twenty-four-year-old novelist Ishihara Shintarō, who would become Tokyo's controversial governor in 1999. The story features a doomed love affair between a nice girl from a wealthy family and a typical "bad boy," a bored high schooler who takes up boxing "to feel a kind of ecstasy mixed with shock" in the ring. Of particular note was the scene of her initial seduction, featuring his erect penis poking invitingly through the shoji screen. Critical and mass opinions were united: the story won the coveted Akutagawa Prize for new writers in January 1956 and the work was an immediate best seller, with over two hundred sixty-five thousand copies sold in its first year. (The critics themselves were not entirely united, however, with some of the prize committee members publicly disagreeing with the award decision.)[14]

The adaptation of Sun Tribe novels into films was swift and scandalous. In 1956, three of Ishihara's works alone were released: *Season of the Sun* (directed by Furukawa Takumi, Nikkatsu), *Punishment Room* (*Shokei no heya;* directed by Ichikawa Kon, Daiei), and the most notorious and critically acclaimed *Crazed Fruit* (*Kurutta kajitsu;* directed by Nakahira Kō, Nikkatsu). These works typically featured a twisted love story about the "seduction" (often by rape) and subsequent corruption of a young woman by a nihilistic antihero resembling the U.S. cult star James Dean in his 1955 *Rebel Without a Cause*. Theaters were filled five to six times their capacity, especially with young Japanese who were spurred to fashion themselves after the Sun Tribe leading man and poster boy, Ishihara's younger brother Yūjirō. Scandalized by the films' explicit sex and violence, the self-appointed censors lodged a highly effective campaign against Eirin. The films were widely criticized in the media as the "uncritical visualization of sex and violence" in articles with headlines complaining, "Enough already Shintarō." Social reformers labeled Ishihara's novels obscene (*waibon*) and denounced the Sun Tribe phenomenon as a "devil child of the postwar period." The powerful National Federation of Regional Women's Organizations demanded that Eirin protect young spectators by enforcing rating restrictions and by rectifying its overly lenient inspections. The *Asahi* newspaper declared Eirin

corrupt because of the subsidiaries it received from the studios and because it was staffed with former screenwriters.[15]

In a familiar formulation that echoed the prosecution arguments in the *Chatterley* trial (whose verdict was under review by the Supreme Court at the time), youth crime was again blamed on books, movies, and the sweltering summer season. In May of 1956, rumors spread that youths returning from watching Sun Tribe films would sexually attack female passersby now that prostitution had been abolished with the passage of the Antiprostitution Law in 1956.[16] On the eve of the preview of *Punishment Room* in late June, the *Asahi* newspaper ran the headline "Danger of Inciting Copycat Crimes. If You Screen It, Cut It!" and featured a scathing critique of the studios and of Eirin by film critic Izawa Jun (who would later, surprisingly, serve as a supportive defense witness in the *Black Snow* trial). After the screening of *Crazed Fruit* in July, public protest and prefectural bans under the "harmful film" designation ensued. Most important, the government intervened. In an August 13 meeting, the minister of education lamented, "Despite the fact that Eirin was created to shut down delinquent films [*furyō eiga*], in its seven-year tenure, it has established no track record whatsoever" and announced the establishment of an investigative committee "to establish laws to purge delinquent films."[17]

The Sun Tribe films provoked fears that youths would identify with and imitate the amoral behavior on the screen. What seems to have worried the reformers was that such works were corrupting not only youths' sexual morals but also their politics. Although these works featured protagonists who were apolitical, this stance in itself was often presented as a nihilistic rejection of politics, which helps to explain the Sun Tribe's popularity with antiestablishment youths. In fact, Ishihara's novella was said to be "the Bible" of student activists, who carried copies in hand to the 1955 antibase protests at Tachikawa Air Base.[18]

When threatened with the revival of government censorship, Eirin and the film industry again responded swiftly, this time announcing a significant restructuring.[19] No longer would Eirin be composed exclusively of insiders from the film industry. Instead it would be monitored by a committee of respectable outsiders, headed by the former minister of education Takahashi Sei'ichirō. The fee structure was also changed, eliminating studio subsidiaries in favor of charges based on the total length of an inspected film, initially set at twenty-four yen per meter. Eirin also promised increased protections for vulnerable youths by making its regulations for sexual depictions much

more detailed and strict, and by upgrading the Committee on Children's Film Viewing to a council. Subsequently, in 1957, with the establishment of the Japan Association of Theatre Owners (or Zenkōren, for short) in September and the subsequent passage of the Healthy Environment Law (Kankyō Eisei Hō), member theaters too were legally bound to comply with the rating system, all screenings requiring the Eirin seal of approval.[20] With these revisions, in essence the self-regulatory system of Eirin became national law.

Eirin's uneasy position as a nongovernmental, self-regulatory agency endowed with governmental trust and headed by former government employees was not without controversy. On the one hand, the countermeasures adopted by Eirin in the face of the Sun Tribe scandal were crucial to validating the organization in the eyes of the law and ultimately helped to secure not-guilty verdicts in both the *Black Snow* and Nikkatsu trials. On the other hand, this authority was accompanied by a high degree of responsibility and even criminal culpability, as would become obvious with the indictment of Eirin employees in the Nikkatsu trial. Nonetheless, unlike the host of relatively short-lived literary corollaries in the immediate postwar period that had been involved in the *Chatterley* indictment, Eirin would come to occupy a long-lasting position of high authority. It remains the oldest and most successful self-regulatory operation still functioning today, in fact in the very same building in the Ginza that it has occupied since the time of its inception.

CHAPTER 3

Dirt for Politics' Sake
The *Black Snow* Trial (1965–1969)

As the first postwar censorship proceedings against a film, the *Black Snow* trial established a revised template that took into account both the existence of a self-regulatory body like Eirin for film and the inherent differences between the media of literature and film. Although Eirin itself was not ultimately charged, the case against *Black Snow* marked an unprecedented attack on the authority of the self-regulatory organization.

When director Takechi (or Kawaguchi, his legal name) Tetsuji and the distributor chief at Nikkatsu, Murakami Satoru, were officially charged on December 25, 1965, the film in question no longer existed. The charges were based on a version that had previewed three times at the Tokyo Shinjuku Theater on June 5 for an audience of just 2,711 spectators, including a disgruntled member of the Police Safety Division who initially brought the film to the authorities' attention. This original version was retroactively pulled and reinspected after Eirin head Takahashi saw it and declared it "just too horrid" (*amari ni mo hidoi*).[1] After an additional eight-and-a-half minutes from fourteen scenes and sound in two places were cut, the film was rereleased nationally on June 9.[2] Because of Eirin's twofold censorship of the film, the evidence had to be reconstructed for the trial, prompting one commentator to dub it an "unprecedented, peculiar trial where the complete piece of evidence was nonexistent."[3]

The lower court trial ran for just under a year, from late July 1966 through mid-July of the following year, when both defendants were found not guilty, a ruling that was upheld by the High Court on September 17, 1969. The lower court determined that the film was not obscene and that

the defendants were not culpable because the film had passed Eirin. The High Court, in contrast, judged the film obscene but ruled to acquit on the basis of Eirin's seal of approval. Both verdicts depended on the judges' interpretations of three things: the place of politics and pornography in *Black Snow* specifically, and in the medium of film more generally; the differences between filmic and literary media; and, most centrally, the role of Eirin.

Black Snow, a politically and sexually explicit film about prostitutes set on the outskirts of a U.S. military base in Tokyo, engendered fierce debate about these issues. The film itself lodges a pointed critique of sexual and political censorship that sheds light on the oft-obscured connection between the two noted by legal scholar Okudaira Yasuhiro. The fact that this critique was lodged in the context of a low-budget Pink Film suggests that Takechi indeed took to heart Okudaira's plea to embrace the "stench" and "derogatory ring" of obscenity.

This trial illuminates the complex relationship between regulating sex and regulating politics, and also between state censorship and Eirin censorship. As we will see, the contentious preproduction censorship negotiations between Takechi and Eirin influenced both the production of the film itself and its postproduction censorship trial by the state. This case offers a unique glimpse into Eirin's role because of the wealth of available archival materials, including the original script, Eirin's initial objections at the level of script check, as well as Takechi's responses and revisions. What the *Black Snow* trial illustrates is the degree to which the existence of industry and state censorship could condition the production of a film and its reception in both artistic and legal spheres.

A Renegade Director, Pink Films, and the Self-Regulatory Eirin

Unlike the strong show of support for the defense in the *Chatterley* trial, the controversial outsider director-defendant in this first film trial rankled, rather than galvanized, most of his fellow artists. Takechi managed to antagonize the moral guardians, the industry and state censors, and the film industry alike. Over forty years later, Eirin employee Endō Tatsuo was clearly still riled by Takechi's antics, criticizing him for "dragging Eirin into a trial" and unfavorably contrasting him even with the notoriously contrarian director Ōshima, whom he praised as "the gentleman who even while frequently protesting Eirin's inspections and never one to lose in a heated debate, never failed to support Eirin."[4] After the police investigation of *Black Snow* began, even Takechi's sympathetic colleague, film critic Satō

Shigechika, admitted Takechi was largely regarded as a pariah: he noted, "There's no artist today who is as scorned by the public," although he also suggested that such disapproval was precisely what "the masochist" Takechi craved. Although Ōshima himself, along with other notable artists and critics, like author Mishima Yukio and film critics Izawa Jun and Ogawa Tōru, would come to his defense as witnesses, even the Directors Guild of Japan, whose English-language website today touts its status as "the only organization in Japan that promotes freedom of expression by raising social awareness of directors," indicated it would not support the film.[5]

In the film world, Takechi was doubly an outsider because his background was primarily in theater, and he had not undergone the requisite torturous crawl up the studio ladder under the tutelage of a senior director from one of the major studios. After over a decade spent creating experimental "Takechi Kabuki" theater, this independently wealthy son of a self-made industrialist turned to film and created the aptly named Daisan (Third Party, or more loosely, Outsider) Production Company in 1964.[6] His Pink Films, as low-budget erotic B productions, were also, by definition, marginal. Having produced a scant twelve films in over two decades, including both a remake and a sequel of his 1964 cult hit *Day Dream* (*Hakujitsumu*), Takechi never depended on the film community for either his reputation or his income. His wealth ensured that the maximum fine of two hundred fifty thousand yen was not much of a deterrent to attracting obscenity charges. Moreover, his future projects did not depend on outside investors who might be wary of financing a project by a director with a criminal conviction. In fact, though Takechi needed Eirin's approval in order to be able to screen his films in mainstream theaters as per Zenkōren regulations, his reputation as a Pink director could only be boosted by the threat of an obscenity conviction. Even the prosecutor's request for a ten-month jail term failed to ruffle Takechi's defiant bravado.

His outsider status combined with his penchant for making provocative films and statements to the media likely fueled the prosecutor to break with precedent and indict Takechi for *Black Snow* even though it had passed Eirin's inspections.[7] One of his earlier projects, *Day Dream*, loosely based on a short story by Tanizaki Jun'ichirō, a novelist famous for his combination of erotic themes and high literary style, sketches the sadomasochistic fantasies experienced by a male dental patient under sedation. Regarding this project, Takechi bragged to the media that the heroine would appear "totally naked" running around a department store, clearly contravening

Eirin's sex and morals regulation forbidding "vulgar depictions that would arouse the spectator's disgust, especially full nudity, mixed bathing, genitalia, and acts of excretion."[8] Despite protracted preproduction negotiations with Eirin, Takechi then further inflamed the watchdogs by claiming that Eirin had not demanded any cuts because it "acknowledged his artistry." He had also, in an unprecedented move, petitioned Eirin to have one of the less accommodating inspectors taken off the case, causing Eirin to insist that a representative from Shōchiku, the distribution company of his next film, act as the point person.[9]

When *Day Dream* became a big hit, especially by Pink standards, with three million yen in opening box office revenues, the backlash was intense. The Tokyo Mothers' Society initiated a phone and letter campaign against Eirin in an attempt to have the film pulled from distribution. Tokyo legislators proposed a Regulation to Nurture Healthy Youths (Seinen Kenzen Ikusei Jōrei), which prompted the film industry to apologize and promise, "We will not produce works that borrow the label of 'freedom of speech' and harm the quality of Japanese films. We will fully cooperate with Eirin's initiatives."[10] And lodging one of the more colorful objections against a film that reflects the commonplace belief that spectators consider film as a reflection of reality, the Japanese Dentists' Association occupied Eirin's offices in protest because the film featured a rapacious dentist who abused his patients while they were under sedation.

The following year, Takechi piqued both Eirin and the moral watchdogs again even before *Black Snow* was screened by announcing to the press that this time he would "have the female lead sprint fully nude around Yokota base."[11] *Black Snow* is the story of a group of Japanese prostitutes living on the outskirts of the Yokota Air Base filtered through the eyes of the morally and sexually dysfunctional teenage son of the whorehouse madam. Scenes of degradation suffered by prostitutes at the hands of American GIs are interwoven with scenes of cruelty committed by the teenage lead, Jirō, and his crew. Some of these cruel acts are inflicted against the GIs themselves; most notably, Jirō knifes and kills one black soldier whom he had earlier seen having sex with a prostitute and mischievously lifting the skirt of a young Japanese woman at a jazz club. But the most cruel and violent acts are inflicted on the Japanese women themselves in somewhat bizarre sublimated acts of retaliation: unbeknownst to his virginal sweetheart, Shizue, Jirō allows a friend to take his place during their first tryst, leading to her infamous stark-naked sprint around the Yokota base fence (see fig. 3.1).

Fig. 3.1 Shizue running along perimeter of Yokota base (Takechi 1965).

Most shockingly, Jirō and his crew steal $20,000 from his aunt, which she is temporarily keeping for her lover, the American "General-san," as part of his illicit deals with the black market. During the robbery, the gang proceeds to rape her by turns, with Jirō ultimately killing her with a bullet to the temple as she climaxes during their incestuous liaison. At the end of the film, Jirō is arrested and imprisoned by the base MPs, and after a forcible confession extracted by a pernicious American colonel, he is led off to his execution.

The Politics of Pornography

Black Snow: Antibase, Antiprostitution Film or Violent Youth Sex Pic?

The 1965 film combined many hot-button issues of the day into a single work: corrupted youths, antibase and antiwar politics, sex, violence, prostitution, and the death penalty. The film's depictions of sex and violence, it should be noted, are not particularly explicit. Breasts and butts appear in the sex scenes, and full frontal nudity is apparent in Shizue's naked sprint, but sexual acts are consistently very staged, with bodies clearly misaligned and clothing or bedding placed in between. The violence also remains off-screen for the most part. Rather than being targeted for explicit sexual or violent content, the film's highly politicized setting and theme fueled both the defense and the offense, in both senses of the word.

The defense's basic argument at the trial was that the film represented an ideological anti-American stance and that even its most erotic scenes served that purpose. Jirō's sexual and violent crimes were depicted as politically motivated: as many commentators have noted, he is invariably

(and not altogether accurately) described as "consumed with hatred for Americans and unable to make love unless playing with a loaded gun."[12] Although Jirō's impotence is not made explicit in the film itself, his penchant for substituting something else for the sexual act—first a friend and then a gun that fires in lieu of his own orgasm—certainly suggests sexual dysfunction. As with Lord Chatterley, here too appears an impotent male lead, and sexual impotence again exculpates immoral acts committed by the characters in the contexts of both the texts and their censorship trials. Just as Lord Chatterley's "physical devastation of his lower half" implicitly justified Lady Chatterley's adultery in the novel and explicitly in the defense arguments at trial, so too would Jirō's sexual dysfunction serve to justify his own acts of violence.

In many respects, the film represents an odd crossbreed between the disaffected youths of the Sun Tribe films and the postwar "prostitution pictures," most notably Mizoguchi's *Women of the Night* (*Yoru no onnatachi*, 1948) and *Street of Shame* (*Akasen chitai*, 1956). *Black Snow* also depicts the miserable lot of prostitutes, but filtered through the eyes of a damaged youth. It is almost as if Jirō were both a character in a Sun Tribe film—a disillusioned postwar youth who turns to sex and violence—and a spectator of the prostitution films, who is spurred to act in a cruel, twisted fashion after witnessing the hard life of prostitutes.

This time, however, the prostitutes (and by implication Jirō) were suffering at the hands of johns who were U.S. soldiers, which fueled the defense's elevation of the film to the status of an anti-American ideological critique. Like the prostitution pictures that were credited by some with spurring the Diet to pass the 1956 Antiprostitution Law, Takechi argued that *Black Snow* too could initiate positive reform. Despite the unseemly depiction of all sorts of vice—prostitution, sex, violence, and even murder—again in the tradition of *kanzen chōaku*, vice was shown only in order to advocate virtue. In this case, the film offered both a desired moral and a political model that condemned the corruptive presence of U.S. bases and servicemen on Japanese soil in the context of the ongoing Vietnam War.

In a sweeping condemnation of the United States, the film depicts Americans as both sexual and cultural predators whose presence corrupts Japanese traditions. This polemic is most obvious in the figure of the prostitute Yukie, who is temporarily off duty because of an outbreak of herpes acquired from her American clients, a disease that literalizes Japan's symbolic contamination. That we are to interpret Yukie's desexualized status, or

her hiatus from work, as returning her to a state of both sexual innocence and cultural purity is further emphasized by her attachment to all things Japanese. She totes around a traditional Japanese doll, loves Kabuki, and professes to have wanted to be a traditional Japanese dancer as a young girl. When she tries to share this secret girlhood dream with the madam, her hope to become a dancer (*buyōka*) is mistaken for a desire to be sick (*byōki*). In part, this linguistic confusion is a result of the deafening roar of American jets overhead and of a sore in her mouth that is caused, we are told, by her having "licked something strange" in accord with her American clients' tastes. But just as likely, the misunderstanding arises because of an inability to fathom such a dream in the context of postwar Japan. Indeed, it appears as if the madam is entirely unfamiliar with the occupation of traditional dancer, so much so that Yukie attempts to clarify by identifying it as "Japanese-style dance."

The scene that follows suggests an ironic and tragic situation whereby Japanese traditions survive only as exotic markers of what is considered "Japanese" by the Americans. As one prostitute explains to another who complains about having to attend Kabuki performances, "But you'll be in a fix if when asked by a foreigner you don't know Kabuki." Takechi here echoes a lament present in his own critical writings on the state of Kabuki in postwar Japan[13] and presages the neoconservative stance most vocally espoused by literary critic Etō Jun in the 1980s. In this scene and throughout the film, Japanese women and culture are cynically depicted as useful only insofar as they serve as erotic exotica for the occupying army. The prostitutes' familiarity with imported English phrases, like "don't know" (*dōnto nō*) as opposed to their ignorance of the Japanese traditional arts highlights the extent of the U.S. cultural occupation, calling to mind Etō's famous phrase "linguistic vacuum" to describe the impoverished and distorted state of Japanese language and culture in the postwar period.

Takechi repeatedly claimed that the indictment was an attempt to suppress antiwar and anti-U.S. ideology under the guise of public morals. In a statement to the press, he claimed,

> I made this film out of a desire to use an artistic form to appeal to the people about Japan's current political situation, the crisis in Asia over the issue of Vietnam, and as a call for democracy. At the same time that I released this film, Japanese public opinion about Vietnam and about the dangers of war have been on the rise. In that sense, I think the film

has fully met my intent. But precisely for this reason, it invited an attack by the reactionaries. By spreading the propaganda that *Black Snow* is obscene, they obscure the film's ideological assertions and are trying to displace the focus onto the issue of morality.[14]

When Takechi accused the prosecutor of engaging in the age-old act of political censorship, the prosecutor countered that Takechi was enlisting the equally long-standing censorship-dodging tradition of passing off pornography as politics, or, as he put it, "borrowing the label of anti-Americanism to disguise its eroticism." The prosecutor called for the judges to refuse the film constitutional protection, arguing, "While we must respect freedom of expression, when considered from the perspective of public welfare, it is by no means without limit. This work lacks any point. Claiming it has artistry or philosophy is nothing but a mere excuse. It panders to commercialism and caters to one segment of the masses."[15] As the prosecutor implied, Takechi's offense was exacerbated in his mind because the medium of film itself was suspect.

Similarly, the Tokyo Mothers' Society criticized Eirin for failing to be "contrite" and for instead appealing to a rhetoric of "freedom of expression" to protect "these kinds of bedroom pictures" in a reference to the explosion of Pink and adult films in the early to mid-1960s. In 1963, only 37 of the 370 domestic films checked by Eirin warranted adult ratings, whereas by 1965 the number had reached 233 of the total 503.[16] In a statement to the press, the association petitioned to have the film pulled from theaters and lamented, "If peeking into someone's bedroom and inciting vile sexual acts is freedom of expression, then we should scorn Japan's intellectuals." Tellingly, again here there is some confusion about who is committing exactly what kind of crime and in what realm. Is it the fictional character Jirō, who peeks into the prostitutes' bedrooms and is later incited to commit "vile sexual acts," or is it the film's spectator, who by peeking into bedrooms in these "bedroom pictures" would be incited to commit vile sex acts in real life? In either case, for the prosecutor and his witnesses, again immature spectators who were liable to uncritically copy amoral behaviors demanded protection. This time, however, the film was also charged with inciting copycat behavior that was harmful and prejudicial to women, in an echo of antipornography feminists. As the Tokyo Mothers' Society president testified, the film "was nothing more than one that will tempt youths to evil and to do insult to women."[17]

The prosecutor invoked these familiar arguments from the *Chatterley* trial, but his case was also much simpler because of the existence of a self-regulatory body for film like Eirin. Pointing to six objectionable scenes, the prosecutor tersely labeled them obscene by demonstrating how each clearly contravened Eirin's own regulations: the opening scene of a naked black soldier on top of the bored-looking prostitute Yuri making shadow puppets on the ceiling (fig. 3.2), a scene in which Jirō suckles at the prostitute Eiko's breast, and a petting scene between Jirō and Shizue set in a movie theater risked "stimulating spectators' base passions"; an S/M sex scene between a foreigner and the new prostitute Minako as well as the robbery, rape, and murder of Jirō's aunt violated the dictate against "depictions of explicit acts that are based on lust, sexual perversion, or perverted sexual desire" (and also incest in the latter case); finally, the extended scene of Shizue running around the base perimeter after discovering the switcheroo by Jirō (fig. 3.1) contained full nudity. According to the prosecutor, Eirin's inspection regulations themselves were "adequate, but we must say there was a problem with their application."[18]

In citing these regulations as authoritative guidelines for establishing obscenity, the prosecutor was acknowledging Eirin's de facto authority and even its criminal culpability. In fact, when the police filed documents with the prosecutor's office, they called for indictments for not just the director Takechi but also for over forty people total, including the actors, the president of Nikkatsu as the distributor of the film, and, most significantly, the Eirin inspectors themselves. When deciding whether and whom to indict,

Fig. 3.2 Yuri making shadow puppets on ceiling (Takechi 1965).

the prosecutor convened a small group of film critics and legal scholars, who uniformly agreed that the work was "vulgar and obscene." One of them, legal scholar Uematsu Tadashi, would subsequently appear as an eager prosecution witness in the High Court appeal trial and did not hesitate to publicly lambaste Takechi: he wrote that he "felt that it was a shame that the director would risk his reputation and make such a vulgar work."[19] Although the prosecutor ultimately decided against indicting Eirin employees, he loudly condemned Eirin in the press as culpable and criticized it for siding too closely with the filmmakers.

Recognizing its dangerous position, Eirin tried to make hasty amends by following its well-established pattern of retrenchment. Four days after the police announced it was launching an investigation, in a June 18 televised press conference, Eirin chair Takahashi expressed his heartfelt apology, publicized new "procedural bylaws" detailing Eirin's new inspection process for problematic films (and directors), announced plans to strengthen the inspection system, and had all domestic film inspectors submit informal resignations and temporarily confined to their homes "on best behavior." Just two months later, in August 1965, Eirin issued more detailed and stricter regulations. Takahashi, having handed over Eirin documents to the prosecutor, even appeared as a cooperative key prosecution witness.[20]

Eirin's eager cooperation with the authorities led many in the film industry to lambaste it as a quasi-governmental agency: Ōshima wrote in the *Sunday Mainichi,* "It'd be more appropriate to say that Eirin, as it is now, far from protecting filmmakers, instead strangles their necks." Nakahira Kō, the director of one of the early Sun Tribe films, fumed, "Eirin itself has no positive effect on films and lacks the power to prevent such movies as Takechi's. . . . It'd be best to abolish it as soon as possible."[21] Eirin's paradoxical failure stemmed both from its role as censor strangling filmmakers' necks and from its failure to censor the likes of Takechi, who was drawing unwanted governmental attention to the film industry.

Red Herrings and Political Paratexts

What led the Eirin inspectors to pass a film that clearly contravened its own regulations? In part, the failure was due to the fact that Eirin's job was becoming increasingly impossible. The explosion of sexually explicit adult films since 1962 rendered its organization overburdened and its August 1959 regulations outdated. It was also due to the nature of Eirin's inspection process and Takechi's own clever censorship-dodging strategies.

By the time of *Black Snow*, Eirin's standard procedure for checking films had evolved into a three-part check, first at the level of the script, then the "all-rush" print (a presound version prepared by the film editor based on the director's notes), and last the final cut. This multistep process requiring Eirin's attention to scripts differed importantly from the state prosecutor's own assessment, which was based exclusively on the final screened version. The prosecutor and the judges in the previous literary trials had carefully considered a number of paratexts—from D. H. Lawrence's and Itō's critical essays to the titillating ads and questionnaires included by Oyama—to gauge authorial intent and reader reception. In the case of a film, however, what is interesting is the way that a script could function like these other paratexts, particularly for the Eirin industry censors.

In the film and especially in the script, Takechi insistently inscribed a politics of pornography and also a politics of censorship that led the Eirin censors initially to pay undue attention to political offenses rather than sexual ones. At the script check, the two Eirin inspectors in charge, Arata Masao (a fifty-seven-year-old former screenwriter) and Yana Sei (a forty-nine-year-old former film producer), identified thirteen places that violated Eirin's regulations and demanded multiple revisions before issuing the Eirin seal. But they paid particular attention to the scenes that contravened Eirin's regulations under the category of "Nations and Society" that deemed films should "respect the customs and people's feelings of all nations . . . and aim for peaceful cooperation with all people. Avoid any expressions that disrespect foreigners or might cause prejudice against other peoples." They also focused on scenes where due legal process was not depicted accurately, particularly the seemingly unlimited judicial authority of the U.S. base police, which violated the "Law and Justice" regulations.[22]

Why might the initial Eirin inspectors have erred on the side of censoring the film's political content while leaving much of its sexual content intact? In the script, the fact that Jirō's crimes are politically motivated is made conspicuously more overt than in the film itself. For example, the script explicitly links Jirō's murder of an Occupation soldier to his witnessing Japanese prostitutes suffering at the hands of Americans. The script notes that upon hearing about the sadistic bent of one of the prostitute's johns, a U.S. soldier referred to as "that perverted old guy" (*ano hentai jijī*), and overhearing the prostitute's pained cries, "Jirō now begins to feel that killing the soldier was appropriate."[23] This retrospective justification of his homicidal act does not appear in the film version and is arguably impossible,

if not extremely difficult, to represent cinematically. (At this moment in the film, Jirō takes out his knife slowly and the screen tilts to suggest his disorientation, but this is not explicitly linked to his previous murder of the soldier other than through the symbol of the knife.) Rather than being included in the script with the intent to represent such a sentiment in the final film version, instead the notation was more likely a censorship dodge that could potentially deflect what was anticipated to be Eirin's criticism of the S/M scene.

More commonly, scriptwriters intentionally shorthanded their scripts and elided objectionable portions in an attempt to have these scenes pass by the censors unnoticed at the level of the script check. Takechi himself had adopted this tactic in his earlier 1964 films *Day Dream* and in another Tanizaki adaptation, *Red Chamber,* to little avail since the Eirin censors had become wise to this strategy by this time.[24] Indeed, this strategy was increasingly proving unsuccessful since the Eirin censor knew that the average Pink Film was about ninety minutes long. (Interestingly, in the later *Realm* trial, the terse script itself would be deemed obscene.) Here, the script's padded notation strives to exculpate both character and director alike; the potentially objectionable sex scene becomes integral to the internal logic of the story, politicizing and justifying the character's crime and the director's film. This strategy succeeded, at least with the Eirin inspectors who approved the otherwise objectionable scene, perhaps having unconsciously assimilated that textual information into their viewing of the film itself.

Politicizing the sex in the script and in the film was both an ideological and strategic move for Takechi. Many of his allegorical claims about the sex scenes were clearly valid: for example, the theme of an impotent young man whose mother (the madam, or "mama-san" of the whorehouse) fails to protect him and the prostitutes under her care from the abuses of the American soldiers, and the film's setting on the base's outskirts. But his rather creative interpretation of other scenes listed in the indictment was equally evident. Indeed, some of Takechi's claims rival those made by Itō on the philosophical depiction of sex in *Chatterley.* Even the highly sympathetic film critic Satō Shigechika criticized Takechi's strained symbolism, noting, "No matter how much it may be an era of reading against the grain [*urame yomi*], still, it's a bit much to read that much into images."[25]

For example, Takechi characterized the scene of Minako being deflowered by the sadistic soldier while the madam and others blithely listen on as pure allegory; he claimed that Minako represented Okinawa, the madam

stood for the Japanese government, and the soldier symbolized the United
States, citing the soldier's striped underwear as evocative of the stars and
stripes on the U.S. flag. The opening scene in which a prostitute hums and
makes finger puppets on the ceiling while having sex with a U.S. soldier was
credited with showing "the Japanese spirit was not sullied by contact with
America." Finally, the scene of Shizue running naked along the Yokota base
perimeter conveyed nothing less than "the bare-naked state of the people
of Asia."²⁶

This extended, almost four-minute-long scene of Shizue's escape was
cited most frequently in the trial and in subsequent critical commentary
to prove that the film included "dirt for politics' sake." Again, the script
spells out the scene's political symbolism more explicitly than in the film
by noting, "Shizue's body is beaten to the ground by the shock waves of a
jet taking flight, just as if she were falling leaves in a storm. Almost as if to
symbolize the fate of the small and weak populace."²⁷ The scene does sug-
gest an antibase stance by showing Shizue's vulnerable naked body (and also
inadvertently captured the real-life politics involved in shooting such an
unauthorized scene since it depicts a U.S. Army jeep with its siren blasting
alongside the sprinting Shizue). But, it is worth remembering that she is
running to escape from Jirō, who has betrayed her by offering her virginity
to his friend and accomplice in crime. Taken out of context, however, the
Japanese perpetrators are conspicuously absent from the picture. Not sur-
prisingly, these are the images that Takechi reproduced repeatedly in his sub-
sequent accounts with a running header of English-language typed text that
polemically characterizes the U.S. base presence in Japan as a continuation
of the Occupation: "United States Air Force Occupied Army Keep Out." As
his caption to the photos notes, "Submissive Japan (Shizue) is struck down
by the blasts from the American army jets taking off for Vietnam. Metal
fences and barbed wire—that is the 'occupying army' . . . in a nutshell. Of
the six scenes at issue in court, this is the most symbolic."²⁸

By excerpting these images, Takechi was attempting to rewrite the
film's narrative in conformity to his avowed anti-Americanism by suggest-
ing that Shizue's rape occurred at the hands of the Americans rather than at
Jirō's. Of course this is just what Takechi would imply—that Jirō is damaged
because of the American presence, and therefore the Americans are responsi-
ble for his twisted and cruel acts against Japanese women, including not just
Shizue but also his aunt.²⁹ Although Jirō's cruel victimization of the Japanese
women in his life refutes any such neat alliance of victimhood between him

and the prostitutes, such an interpretation conveniently subsumes all potentially objectionable sexual representation under political ideology.

The defense that dirt serves a political purpose would be evoked again with much success in the later *Realm* trial. With this film as well, a similarly politically charged scene has come to stand in for the rest of the film, displacing its ubiquitous sexual content as a mere adjunct to its political message: the scene of the male protagonist Kichi walking obliviously past a marching military parade, concerned only with the eponymous "realm of the senses" he shares with his lover, Sada. (Commentators invariably point to two other brief references to bolster their interpretation: one scene in which children poke at an unconscious drunk's genitals with the Japanese flag, and a scene in which carp flags fly in the background to commemorate the patriotic holiday of Boys' Day. They also cite the film's final voiceover that links the film's events to the failed military coup in 1936, which is said to have clinched the march toward a disastrous war.) That these scenes are weighted so heavily in subsequent interpretations suggests the extent to which politicized interpretations advanced in the context of a criminal trial have been adopted. This is not to deny the political message of these scenes or even of the films as a whole, but for anyone who has seen either *Black Snow* or *Realm,* characterizing these films as pure politics denies their equally erotic nature; indeed, the scenes that linger are not only the political ones, be they oblique or overt. We should note the ironic and enduring appeal for both the legal and artistic worlds of the "dirt for politics' sake" argument.

In the case of *Black Snow,* this type of politicized and desexualized reading was accepted by both the Eirin inspectors who initially passed the film and the judges at the trial. In fact, as we will see below, the base scene was the only one of the six cited in the indictment deemed not obscene by both the lower and appeals court judges. Instead, both verdicts cited it as a mitigating factor, suggesting how a defense that disavowed indefensible sex in favor of defensible politics was persuasive in the minds of the courts as well. Although state censorship of sex could disguise political censorship, as Takechi charged, what this incident shows is that the very existence of sexual censorship could precondition the creation of a script and a film and sway its future reception in legal and artistic spheres alike.

The Politics of Censorship

If this single scene and others like it could displace the film's sexual content, then, as the defense claimed in the trial, the film's indictment could

be characterized as motivated by its political content. The presence of U.S. bases on Japanese soil continues to provoke fierce debate in a nation that renounced its right to wage war in the controversial no-war clause (article 9) of its postwar Constitution. In many respects, Eirin's "Nations and Society" regulation resembles contemporary hate-speech legislation in the United States and in Britain designed to prevent racist utterances and acts.[30] But in the context of postwar Japan, it could also clearly amount to the censorship of ideological stances, particularly the kind of anti-Americanism embodied in Takechi's film. In fact, the lower court judges recognized this danger, noting their "fear that the application of Eirin regulations might be taken too far" in the case of its "Nations and Society" clause.[31]

By wedding sex to politics, Takechi drew a link between political and sexual censorship. He lodged an explicit critique against censorship conducted by the United States both during the Occupation and after. Implicitly, he also lodged an attack against the domestic Japanese censorship to which the film itself would be subjected: both "voluntary" self-regulation by Eirin and the obscenity charges by the state. By targeting censorship conducted by the Occupation, Eirin, and prophetically also the Japanese government in one fell swoop, Takechi cleverly inscribed multiple censors and censorship methods into the film. Again here, the nationality of the antagonists was conveniently blurred. Just as the base scene obscures whether Jirō and his crew or the U.S. Army is to blame, the censors in the film were explicitly represented by American bodies, but implicitly lurking throughout is also the shadowy presence of the domestic Japanese film censor. By incorporating both sexual and political censorship, as well as Occupation-period and domestic Japanese censorship, the film demonstrates a prophetic ability to "read" the trial, anticipating and even defusing many of the censors' eventual objections to the film.

Strategic Self-Censorship: Hitleresque U.S. Occupation Censorship

In the film, the overt target of Takechi's critique is not the Japanese government but the U.S. Army. In the penultimate scene, after Jirō has been arrested by the military police, he begins confessing his crimes, admitting to killing both the American soldier and his aunt. The confession is dutifully transcribed and interpreted by a second-generation Japanese-American soldier for the benefit of an American colonel named Roy S. Johnson. But when Jirō mentions the illicit involvement of his aunt's lover, "the General," with the black market, the colonel, who bears an uncanny resemblance

to Hitler, replete with the famous mustache and a poorly faked German accent, strikes Jirō to silence him and screams at Jirō and the translator, "Shut up! Shut up you fools! Shut up! Take out zat part. Vat fools you are. Recording everyzing you hear. Next time you make judgment before you make a fix! Do you understand?" The colonel then proceeds to rewrite the objectionable portion of Jirō's confession that implicates the U.S. general for profiting from the black market. When Jirō is reeling unconscious from the blows, the screen abruptly shifts from a normal black and white picture to a negative-image photo, a visual that further encourages the Hitler association by emphasizing his toothbrush mustache.

This scene is also where the film's title comes into play and where the film's allegorical message becomes most blatant, if not artistically crude: in the negative image, a shot of the falling snow outside the interrogation window turns to "black snow." The title evokes the term "black rain" for radioactive fallout from the atomic bombs on Hiroshima and Nagasaki and the title of the famous novel *Black Rain* (*Kuroi ame*) by Ibuse Masuji, which, not coincidentally, was being serialized in a literary magazine during the very period of the film's release.[32] This image signals the film's antiwar and antinuke stance, one that is further bolstered by the film's setting outside Yokota Air Base, which in 1965 became designated as a dispersal base for U.S. nuclear command and control aircraft during the Vietnam War, and by another scene of a group of youths petitioning against nuclear submarines.

The fact that the black snow occurs during a scene in which a U.S. military official performs an act of censorship designed to protect the reputation of the United States is a veiled gesture to the rigorous, yet invisible, Occupation censorship of discussions of the A-bomb in Japan.[33] By making manifest the covert, invisible censorship performed by the Occupation and by linking the censorship of Jirō's confession of sexual violence to the censorship of the A-bomb, the film asserts itself as a political allegory and implies that censoring it is akin to political suppression. With its inclusion of the figure of the über-censor, Hitler,[34] the film attempts to forestall its own censorship by implying that all censorship is part and parcel of fascistic dictatorships, not modern democracies.

Eirin "Self"-Censorship: Roaring Jets and "Coming" Soldiers

In addition to inscribing the figure of the Occupation censor into the film, Takechi insistently incorporates self-censorship techniques commonly advocated by the Eirin censors, especially the use of diegetic sound to cover over

potentially objectionable sexual dialogue. He does so by using a method that is distinctly political: the screeching sounds of U.S. jets overhead. The sounds permeate the film's sound track, imparting an almost "physical pain" to the audience, as one critic noted,[35] and maddening the spectator enough to make a persuasive case for the antibase position since we can only have sympathy for the Japanese prostitutes whose lives are so visibly and audibly dominated by the base.

This too is a clever double-pronged attack on censorship conducted by Occupation officials in the past and on the likely censorship of the film by Japanese censors in the future. The military base's glaring and grating omnipresence in *Black Snow* contrasts sharply with the forced invisibility of the U.S. occupiers in Occupation-period films per a strict censorship policy that required eliminating all traces of the base, personnel, English signs, and even the sound of airplanes.[36] The self-censorship technique of using sound effects had the economic advantage of allowing filmmakers to record sounds over the existing ones for the final cut rather than recording a sound track anew and was one advocated by Eirin.[37] During its inspection of the all-rush print, Eirin repeatedly advised Takechi "to cut dialogue by obscuring it with roaring sounds." For example, this was the strategy it recommended in the opening scene of a GI and Japanese prostitute's English-language dialogue that puns on the different words used for orgasm in Japanese and English:

> *Black man:* "Are you comming?"
> *Yuri:* "Nani?" [What?]
> *Black man:* "Comming! Comming?"
> *Yuri:* "Oh no! I Going, going . . . go . . . go . . . go."[38]

In his negotiations with Eirin, Takechi ultimately refused to cut this dialogue but reassured the inspectors by agreeing not to include Japanese subtitles and to obscure the man's lines with the sounds of jets. (In fact, the lines remain audible, with the deafening jet sounds covering only the prostitute's later cries of pleasure.) In his trial account, Takechi noted that ironically while Eirin objected to the man's lines, which refer to orgasm as "comming," in misspelled English, the inspectors failed to recognize the prostitute's line of "I Going, going . . ." was a direct translation of orgasmic cries in Japanese, "Iku, iku . . ."

In another prescient jab at the censors, Takechi foregrounds the absurdity of this strategic use of sound by using it for sexually provocative and

innocuous dialogue alike in the script. For example, during a bawdy conversation between a prostitute, Jirō's aunt, and his mother about the perverted sexual predilections of their American customers, the script notes, "The conversation becomes more explicit but it becomes inaudible because of the roaring sounds" of jets; and even in an innocent conversation between Shizue and her father when she dutifully hands him his *bentō* lunch box, Jirō is said to be unable to overhear "because of the roaring sounds."[39]

Takechi's strategy further calls attention to itself as a censorship-dodging mechanism because the sound effects are often completely implausible as diegetic sound. In a scene in an indoor jazz bar, the sounds of jets are abruptly introduced to cover Jirō and his friends' bawdy discussion about having sex with a dead girl's corpse. The use of such overt self-censoring techniques had the double advantage of sexualizing the censored content in the imagination of the reader or viewer and of politicizing that content. A somewhat circuitous logic encourages the equation of political and sexual subversion: if acts of censorship are essentially politically motivated, what is censored, be it sexual or political content, must be political. A film that inscribes its own censorship can therefore conveniently be cited as evidence of both its political nature in the legal setting of a censorship trial and its sexual nature in the marketplace of Pink Films.

Dirty Theaters and Dirty Spectators

One final example illustrates Takechi's prophetic critique of film censorship. In a pointed barb at the prototypical censor's rhetoric about the dangers of movies for the young and innocent, Takechi sets the location of the initial seduction of Jirō's girlfriend in a movie theater. Theaters were a perennial concern of the censors: prewar Japanese censorship focused less on film content and more on place, especially regulating theater safety, hygiene, and the spectators' bodies in that theater space; likewise in the United States in the early 1920s, the Motion Picture Producers and Distributors of America and the Hays office cosponsored Saturday matinees for children at "'preferred exhibitors'—theaters that were large, lavish, well-ventilated and well-lit . . . unlike the small, dark theaters that were seen as bad for both the health and the morals of the young."[40]

In this scene, Jirō initiates the fresh-faced and virginal Shizue into the dark world of sex and movies, luring her away from her innocent world of books and filial duties. When asked by Jirō how she spends her days since poor health keeps her out of school, she explains, "Usually I make my

father's *bentō* lunch or read books. We have tons of books in our house."
Echoing the early crusaders' criticism of theaters as dirty, contaminating
places, Shizue then explains to him, "Usually I'm not allowed to see movies.
Because they say the air is bad."[41] And in case these lines failed to register
as intentionally replicating the censors' critique of the movies, Takechi has
Shizue orgasm at the exact moment the film's theme song peaks in a boom-
ing crescendo during its final scene, subsiding only when the lights in the
theater return.

As if to further literalize the censors' fear that youths would commit
copycat crimes inspired by films, in this scene Jirō pulls out the pistol he has
stolen from the soldier he murdered only after he hears gunshots in the film
within the film. Pointedly, according to the script, the film they watch is "a
cheap Western" (*yasuppoi seibugeki*),[42] which, when considered in the context
of Takechi's avowed anti-Americanism, suggests that contamination origi-
nates from the evil influence of U.S. films, if anything. That the prosecutor
targeted this very scene in the indictment suggests that he may have missed
the meta-implications of this scene and that we may not want to overesti-
mate his critical acuity. Nor should we overestimate the artist, however. In
his negotiations with Eirin, Takechi further regressed the debate, defending
the sexual depiction in this scene based on the fact that the film within the
film was a Western with the sounds of guns and horses, not an erotic film.[43]

The Verdicts

The Filmic Medium: Pornographic, Philosophic, or Political?

For the court, the key question was whether politics were merely a cover
for sex, or if sex was essential to advancing a political argument. If the film's
overall message was political, then these scenes could be subsumed under
that message. The argument that the sexual parts were merely a means to
a greater end—be it artistry, philosophy, or politics—is a time-honored
defense, which, as we saw, was ultimately unsuccessful in the *Chatterley* trial.
In many ways, the arguments at the *Black Snow* trial were no different from
the debates about how to interpret "part versus whole" in the previous liter-
ary censorship trials. In the *Chatterley* trial, potential witnesses had been
given copies of the novel with the objectionable passages underlined in red,
a selective and directed reading method that the judges feared was being
employed by the majority of readers. This fear, in conjunction with Oyama's

titillating advertising that drew readers' attention only to the sensational parts of Lawrence's novel, led the lower court judges to find Oyama guilty. Even on appeal at the Supreme Court, although the novel as a whole was deemed to contain both philosophy and artistry, the judges asserted at issue was not the whole but only "whether or not there are included in the present work elements that fall within the purview of 'obscene writing.'"[44] Rejecting this, the Sade High Court verdict ruled that it was wrong merely to "excerpt the objectionable parts, mechanically cutting them off from the rest" of a work, and insisted instead on a "holistic" consideration.[45] Although the Sade Supreme Court judges affirmed this "holistic approach to interpreting the meaning of texts" in theory, they also reaffirmed the *Chatterley* Supreme Court ruling, which had insisted that an artistic or philosophic "whole" could not necessarily mitigate obscene "parts."[46]

What differed in the case of the *Black Snow* trial was the question of how spectators would judge the parts versus the whole in the medium of film. What was the relationship of the film's sexual content to its political content? And what distinguished the medium of film from literature? Disparate conclusions regarding these two questions led the lower court to rule the film not obscene and to exonerate the defendants, while the appeal court would rule the film obscene but still acquit based solely on Eirin's (misguided) stamp of approval.

The Sexual Politics of *Black Snow*

First, the question for the judges was whether this film specifically qualified as an abstract political ideology or merely as bodily sexual pornography. To answer this question, they assessed the effects of its legitimate political scenes versus its illegitimate sexual ones. The lower court judges cited three of the six scenes identified by the prosecutor and found that they conveyed political, not sexual, intent: the opening scene between the bored prostitute and the soldier, the S/M scene of Minako and the "perverted old guy," and the scene of Shizue running naked around the base fence. (The judges were hard-pressed to find justification for the robbery and rape scene involving Jirō's aunt, however.)[47]

Regarding the base scene, the lower court judges succinctly invoked the familiar parts versus whole argument to justify the "necessity of such depiction in the scene as relatively easy to understand in the context of the film as a whole."[48] The High Court concurred but clearly felt the need to argue at length in order to excuse the scene's illicit nudity:

Even if it is, of course, problematic from the perspective of Eirin's regulations, it is the image of a solo woman, and based on the fact that she is sprinting in a natural manner with an earnest expression on her face, it does not invite particularly lewd feelings. From the scene's composition, its artistry can be perceived relatively easily even if seen only in isolation. Even if it has a general lewd feeling as the image of a fully naked female, we cannot deny that it is sublimated because of such artistry.[49]

In affirming the scene's "artistry," the judges must have meant philosophy or ideology since the scene is filled with stilted acting and camera work, as well as an extremely crude graphic to represent the jet flying overhead. For both sets of judges, the base scene was not base but rather "dirt for politics' sake."

The judges' willingness to consider how politics mitigated dirt was even more obvious in their conclusions about the film's more explicit sex scenes. In the lower court verdict in particular, the judges repeatedly cited the film's markers of its politics as mitigating factors: the jet sounds that "make the spectator fully aware of the U.S. base presence," the perverted and sadistic American soldier, and the overall theme of Japanese prostitutes living around the base, which "conveyed a sense of pathos," so that "after watching, the feeling that remains is one of sadness or emptiness, not sexual pleasure or shame."[50] They concluded that the film was not obscene because it did not incite sexual arousal or sexual shame, two parts of the *Chatterley* three-prong definition of obscenity.

With this assertion, the judges echoed the famous ruling by Judge Woolsey in the 1933 U.S. trial of *Ulysses,* who exonerated the novel because its depiction of sex was "emetic, not aphrodisiac."[51] In the 1969 Japanese Supreme Court verdict for the Sade trial, one dissenting judge more explicitly echoed this logic when he deemed the translation of *Histoire de Juliette* not obscene largely because it was "grotesque in the extreme, and almost sufficiently filthy to make one vomit." Even the Sade justices who ruled to convict endorsed this reasoning in principle and claimed that the novel's "excessively frank sexual scenes" mitigated its obscenity to a degree because "those sexual scenes are joined with scenes of brutality and ugliness, or are portrayed immediately before or after such scenes."[52]

Author Mishima Yukio had offered just such a defense of *Black Snow* at its lower court trial. In his testimony, he contrasted his own controversial short story "Patriotism" (Yūkoku, 1961), which depicts a soldier and his wife's double suicide (and their torrid last sexual encounter) in the wake

of the 1936 failed military coup, as being about "the ultimate beautiful heights of sex in a certain political situation, while *Black Snow* was about ugly, warped sex in a different political context."[53] The lower court judges in the *Black Snow* trial agreed, ruling to acquit the defendants in large part because the film "depicted sex not for pleasure but in a negative way."[54] The definition of obscenity established in *Chatterley*, of course, intended to refer to the audience's reaction to a fictional text, not to the fictional characters' own reactions to the sex in the text. But again here, we can detect the censors' tendency to conflate the audience's response with that of the character: if the fictional characters were not enjoying sex, than neither would the spectator. For the judges, "bad" sex in both senses of the word—either perversion, like the S/M or rape scenes, or unsatisfying sex—was incapable of arousing spectators.

Although dubious, this logic clearly held currency in the legal context. Most important for the judges in the case of *Black Snow*, the bad sex was tied to a larger political context. Even the High Court judges, who deemed the film obscene, credited many of the scenes with admirably drawing attention to the pathos of those living by U.S. bases. Suggestively, they agreed with the lower court that the film's scenes failed to provoke "sexual pleasure but could not agree that it failed to provoke sexual shame."[55] For these appeals judges, the symbolic markers of the U.S. presence, like the jet sounds, successfully elevated the film to an abstract political ideology. But the more pervasive and bodily presence of these politics—in the form of U.S. soldiers' violating Japanese prostitutes—seems to have provoked a sense of sexual shame, and even perhaps national humiliation.

Lower Court Verdict: Film as a "Time Art"

What mitigated the film's obscenity was not just its politically loaded content or context but also its form. The lower court judges implied that the film medium itself as a "time art" was inherently conducive to philosophical meditation, not sexual gratification. This assertion was based on the explicit distinctions they drew between film images and prose, as well as between spectators and readers.

According to these judges, because spectators watch a film in its entirety its isolated scenes must be interpreted by spectator and judge alike in the context of the larger whole. As they reasoned, film "images are projected onto the screen at a fixed speed," and "each image is integral to the meaning of the whole."[56] The lower court judges were attempting to revive the

precedent established by the Sade High Court ruling that had called for a holistic evaluation of a work, but the argument they made also introduced crucial distinctions that hinged on the differing reception modes of film and literature. In fact, to make their case, the judges explicitly evoked a comparison with prose:

> Spectators are not allowed the freedom of choice of, for example, prose, which allows a single specific scene to be paused or repeated at will. In other words, they are compelled to watch it in its entirety just as it was created during a fixed period of time. . . . When judging obscenity, we must consider it as a whole and in the flow of time, not just its isolated parts.[57]

In a reversal of the common assumption, the judges characterized prose as a more dangerous medium than film, a harbinger of the guilty verdicts for literature in the postwar obscenity trials. The distinction made was based on the judges' understanding of film as a "time art" (*jikan geijutsu*), whose images are delivered "in the flow of time" (*jikan no nagare no naka de*). Not only would this ensure that spectators interpret the individual scenes in the context of the film's overall theme, but the fact that "images are projected onto the screen at a fixed speed" would also disallow any prurient lingering over those scenes. Put more bluntly, film images flit by too quickly to allow them to become masturbatory material in the same way that the "hot parts" of a novel might.

Though this argument would become moot with the advent of VCR technology in the mid-1960s, at the time of the trial, the ability to excerpt passages of literature but not film scenes was the most salient distinguishing feature between literature and film in obscenity determinations.[58] What often led the judges to convict literature but exonerate film in these postwar trials was precisely the spectator's lack of control over a film's exhibition, the fixed speed of film images compared with the reader's complete control over both the pace and place of reading.

The *Black Snow* judges were clearly influenced by the defense arguments on this point: in his closing arguments, the head defense lawyer contended that if, as the Sade High Court had ruled, it was inappropriate to judge obscenity based on excerpted passages of prose, this was "even more true of film because it is seen in a limited time and a limited place, and once one starts watching, it is projected without regard to the spectator's will."

Similarly, film critic Ogawa Tōru asserted, "Unlike literature, which can be viewed freely, film cannot be paused at will; it is an extremely coercive art form," and film critic Izawa Jun echoed this distinction, saying in film "the images are projected and disappear; it is a 'time art.' If we want to read literature carefully, we can pause or go back, but with films, we can neither pause nor rewind. This inability to rewind is both cinema's greatest flaw and its greatest strength."[59]

Notably, there was one defense witness who was not so keen to draw such black and white distinctions. In his testimony, author Mishima denied that film was any more of a "time art" than novels and, refusing to elaborate further, noted the debate could be traced back to Lessing's famous 1766 essay "Laocoön." Mishima's reluctance to ascribe to film the unique status of "time art," particularly in the judicial context, likely stemmed from his concern that the natural conclusion would be to judge novels as more potentially obscene than film. After all, the tendency to exculpate film by counterdefining it in relation to literature is obvious from the above testimony, which, not surprisingly, comes from the mouths of film critics. In his 1959 essay "How Far Should Depictions of Eroticism Go?" Mishima had advanced the opposite proposition: "The feelings we get from literature are ones that pass through the reason of our brains and are fundamentally conceptual things. Therefore, we don't receive a direct sensual feeling from prose but instead a conceptual sexual stimulus." After the lower court acquittal, Mishima complained in the newspapers that the verdict was "unfair because it recognized the wholeness only of film, although this is something that is shared by all artistic genres."[60]

Perhaps Mishima's disinclination to characterize film as a unique "time art" also stemmed from his recognition of the folly of making this claim in the context of *Black Snow*. The film is notable for its leisurely long takes and static camera, particularly in the scenes cited by the prosecutor. The opening scene of the prostitute Yuri with the black soldier is almost two and a half minutes long with just four cuts, and two of the longer shots (twenty-two and eighty-two seconds, respectively) depict mostly immobile bodies with a stationary camera; the scene of Shizue writhing her head back and forth in the movie theater is a single take of one and a half minutes also shot with a stationary camera; and the scene of Shizue running around the base perimeter is almost four minutes long, with a series of repetitive, fairly lengthy tracking shots.[61] Indeed, their prolonged duration seemingly

contradicts the judges' claims that the film's scenes are innocuous because of their fleeting quality. Far from disallowing "a single scene to be paused or repeated at will," the combination of extended long takes and repetitive content arguably stills the scene and allows for repeated "readings" of the image in a manner akin to prose.

Perhaps to preempt this potential objection, the defense offered an intriguing alternative interpretation of the intent and effect of Takechi's long takes, claiming them to be a political statement, and a uniquely Japanese one at that. In his defense testimony, Ōshima praised Takechi (and, with characteristic immodesty, his own films) for attempting to revive the one-shot/one-take method, a prewar aesthetic innovation by the "father of long takes," Mizoguchi, as a political statement in the postwar period. In Takechi's case, this was a deliberate reversion to the traditional Japanese folk arts and theater, especially the notoriously slow-paced Noh. For film critic Ogawa Tōru, such long takes represented nothing less than a return to the cultural forms of an "agricultural people," like samisen and *naniwabushi,* which are rooted in the earth with audiences "listening with their rear ends firmly planted on the ground." According to Mishima, they represented both a political and formal subversion of norms: "Despite the fact that we think of films as a realistic art, this film is brimming with artistic intent and uses extremely unrealistic methods. . . . By showing things for a long time, this film succeeds as a formalistic experiment and as a political statement. Most of all, it successfully gives time to transform the erotic elements into something else."[62] Here, realism was implicitly counterposed to artistry and to artistic intent. In other words, not only could long takes transform erotic images into political ones by employing an unrealistic method, but their use in itself was a political statement because it was a rejection of established Western norms of filmmaking.

These claims strove to counter the impression that films were either inherently "realistic art" or rapid-fire sensory stimulus. According to Ogawa, whereas the fleeting images of "modern" Western montage produced equally fleeting thoughts, protracted long takes encouraged a lasting contemplation:

> Takechi's use of long takes is based on his artistic outlook of national identity. . . . Until now, films have been characterized by superficial-ity—one's glances and thoughts flash by. Because films are made with cuts that are extremely rapid, jumping from one thing to the next, they

flit in one ear and out the other. If we understand this to be an especially modern way of making movies, then perhaps Takechi's works take the opposite tack; they make us wait for the image to disappear so that we will wait for the real thing to arise in its place.[63]

Rather than sexual gratification, Takechi's filmmaking was conducive to deep philosophical or political meditation.

The defense also offered an entirely more banal assertion about the long takes. As film critic Izawa put it, "because the sex scenes drag on and on, how can I put it, the sexiness in them disappears." And witness Ōshima claimed, "leaving the camera fixed in place produces an unpleasant feeling. It feels out of place, it repulses," whereas a glimpse might excite a spectator's sexual curiosity.[64] The lower court judges were seemingly persuaded by this interpretation, citing just this slow-paced lingering camera as a mitigating factor: in the film's opening scene, "Yuri's figure is depicted at length and slowly to an odd degree, so that the scene imparts a feeling of boredom or emptiness to the spectator."[65] Again for the judges, bad or boring sex would ensure that spectators were not aroused, but, notably, central also to their reasoning was film style.

It was not just the pace of *Black Snow* and film in general but also the place of viewing that guided the judges to deem the film not obscene and again to rank film as inherently less potentially obscene than other media. This time, however, the medium for comparison was not literature but the relatively new medium of television. The judges concluded that theatrical film spectators are more proactive than television spectators since "compared with television viewed inside the family home or ads and billboards glimpsed on the streets, theatrical films require the spectators' active participation and intent."[66] Commenting on this verdict in the legal journal *Jurisuto* in September 1967, a legal scholar wholeheartedly endorsed considering this distinction by reasoning that while theatrical films are "targeted at spectators who actively seek to watch a film," televised films are "pushy films aimed at passive spectators."[67] Television may have been contributing to the rapid decline in movie theater attendance and threatening the viability of the film industry, but its very existence also offered a mitigating factor when legally determining the obscenity of films.

In sum, the lower court judges cited two unique features of film that were seemingly contradictory in order to rank film as comparably less obscene than other media and to exculpate *Black Snow*. On the one hand,

the involuntary pace at which a spectator views film ensured audiences could not linger over the prurient parts. The voluntary nature of theatergoing, on the other hand, assured that only spectators who wanted to watch a film would be subjected to this inherently passive spectator experience. In other words, what made film less potentially obscene than either reading literature or watching television was the fact that film called for "active" (*sekkyokuteki*) theatergoers who "passively" (*shōkyokuteki*) watched a "pushy" (*oshitsuketeki*) film.

High Court Rebuttal: Film as Time Bomb and "Trigger to Action"

While the defense and many other artists heralded this recognition of the uniqueness of the filmic medium, many in the legal community, echoing Mishima, expressed skepticism that the need for a holistic evaluation applied only to film and other so-called time art.[68] On appeal, these two claims about the unique pace and place of film were most assiduously refuted by the High Court judges, who were disturbed by this lower court precedent that implicitly allowed the medium of film greater latitude than literature in obscenity determinations. Although the appeals judges agreed that film required a somewhat more proactive spectator than television or billboards, they summarily dismissed the proposition that the purchase of a book required any less active participation on the part of readers than that of a filmgoer. In fact, they would go out of their way to reassert a hierarchy of media that firmly ranked film as more dangerous than literature and suggest that it required even stricter regulation because of its passive, susceptible spectators and its realism.

To refute the lower court's assertion that film was a unique "time art," the High Court judges argued that film spectators too could repeatedly watch isolated sex scenes by going back to the theater multiple times, especially in the case of a film like *Black Snow* that had a "clear division between the sex scenes that occupy the first two-thirds of the film and what comes after."[69] Especially given the fact that such films had short runs in theaters, this logic strains credibility by treating films as if they were all-day Kabuki performances where spectators freely come and go, choosing to watch particular acts and to skip others. But, more plausibly, the judges were implicitly disputing the notion that spectators would interpret the entire film based on its *kanzen chōaku* ending that punished vice. By pointing to the first two-thirds of the film with its abundance of objectionable sex scenes,

the judges implied that the ending of the film—the imprisonment, forced confession, and ultimate execution of Jirō implied by the film's final off-screen gun shots—was insufficient to retroactively rewrite or sublimate the sex scenes into political ideology.

Though the High Court criticized the lower court's insistence that film be evaluated differently from prose based on inherent generic differences, in fact its own ruling depended equally on drawing a distinction between the two media. The only difference was that the High Court's logic relied on a more familiar and rarely disputed argument about film that can be traced back to the days of its inception: realism. The judges wrote,

> When judging the obscenity of film, the unique characteristics that must be considered, especially when comparing it with literary prose, are very simple and clear: the fact that animated films, just as they were called in the old days, are moving pictures—things that both move and are pictures—and recently include sound and color. . . . In other words, compared to prose, the psychological effect of film is extremely direct based on its reality effect and the deep impressions imparted on spectators. Moreover, the fact that even unschooled young people, who would be unable to understand difficult Chinese characters or phrases, can perceive film proves that film is not comparable to prose. For this reason, sexual depictions in film require very careful consideration.[70]

Significantly, instead of using the more conventional term *eiga* (literally, "reflected picture") to refer to films, the judges repeatedly used terminology such as "moving pictures" (*katsudō shashin*) and "animated films" (*dōga*) that conveyed a sense of motion. For these judges, film's reality effect depended primarily on its embodiment of motion.

Whereas the lower court had cited the moving images of film as a mitigating factor that ensured individual images and scenes would rapidly flit by the spectator and eventually be subsumed into the larger philosophical or political meaning of the film, the High Court judges implied that they would be lastingly imprinted on spectators. They agreed instead with the prosecutor, who, on appeal, had argued, "Even if you say that films have different characteristics than prose, this does not sway the essence of obscenity. Instead, are not films more intense and stimulating?"[71] The ephemerality of film images on the screen was no guarantee of their transitory effect on spectators.

When the judges noted that "watching a film is comparatively easier than reading a literary work,"[72] they were also claiming film was dangerous because of its accessibility to a broader audience that included "unschooled young people." The comparable ease and passivity of viewing a film was unfavorably contrasted with the difficulty of reading a kanji-laden text, a distinction that, as we will see in part 4, was also crucial to the not-guilty verdicts for Edo-period classical texts. The perceived danger also stemmed from films' realism, which would encourage these vulnerable viewers to uncritically imitate the actions depicted on-screen. As the High Court judges ruled, despite the fact that the film had an adult rating, this regulation was not uniformly followed by all theaters, and even the age of eighteen was no guarantee of sexual maturity, as evidenced by the preponderance of sex crimes by those eighteen to twenty years old. A legal scholar elaborated on this implied connection between realism and imitation:

> Because films are at the vanguard of the expressive arts, aiming at delivering the direct impression and effect of a living reality [*ikeru genjitsu*], they are not limited merely to being the "key of persuasion" but potentially become a "trigger to action." Even after a film is over, its psychological effects linger. It is difficult to know if spectators might be tempted to act in a manner that even exceeds the intent of the creator.[73]

Arguably, the fear of imitation was an especially worrisome prospect with a film like *Black Snow*, which combines explicit sexual depictions with violence. Just as the prosecutor and judges in the *Chatterley* trial demonstrated their anxiety about the prospects of readers' overidentifying with the adulterous Lady Chatterley, here the concern was that "unschooled young people" would identify with Jirō, the disaffected youth whose sexual violence converges with an antibase political agenda. After all, if even the apolitical rebellious youths in Ishihara's 1955 *Season of the Sun* made that novel the "Bible" of student protestors in the late 1950s, then perhaps the film *Black Snow* could become a "trigger to action" for disaffected youths in the mid to late 1960s in the context of growing student radicalism against both the Vietnam War and the renewal of the U.S.-Japan Mutual Security Treaty (ANPO). Just as in the film itself where Shizue is lured away from the safe and innocent world of books by the dirty world of the movies, the judges worried that young spectators of the film would be tempted and corrupted by its scenes of sex and violence.

The Future of Film Censorship after *Black Snow*

In the end, although the *Black Snow* trial introduced the new medium of film into the debate, the appeals verdict invalidated the legitimacy of any claims about the uniqueness of the medium that allowed film greater latitude than literature. Significantly for the future of film regulation, however, the verdicts engaged two other central questions that augured the degree to which film would receive constitutional protection: was the medium of film a legitimate vehicle for expressing lofty political or philosophical ideas, and was Eirin's approval itself sufficiently legitimate?

Clearly the courts disagreed about whether Takechi's film itself qualified as a legitimate political statement. In overturning the lower court's assessment and instead ruling the film obscene, the High Court judges concurred with the prosecutor, who had called to limit freedom of expression in the case of a film like *Black Snow* that "panders to commercialism and caters to one segment of the masses."[74] The two courts also fundamentally disagreed about whether the film in general was a capable or worthy medium of expression deserving protection. In their verdict, the appeals judges advocated a healthy dose of skepticism toward "the lower court's assertions that film, as a vehicle for philosophy and art, is protected as free speech under the Constitution." They instead reasserted the state's right to regulate all media, especially film: "As for theatrical films today we cannot, of course, deny their artistry, but on the other hand, we also cannot deny their qualities as entertainment and commercialist product [*gorakusei to shōhinsei*]."[75]

While literature's esteemed reputation as high art had worked to its disadvantage in the *Chatterley* trial, paradoxically here the lesser reputation of film also worked against it. Nonetheless, both verdicts reflected fears about the legitimacy or illegitimacy of the medium. If, in the case of literature, the fear was that an obscene work would tarnish the long-lived reputation of a highbrow medium, in the case of film, an obscene movie merely confirmed the long-held opinion that films were crass commercialism with mass appeal.

For the judges in all the postwar film trials, however, the fact that film was a newer and less-established medium relative to literature also worked to its advantage because the judges tended to defer to Eirin's expertise. As the *Black Snow* lower court judges admitted, they doubted their own credentials to regulate film and preferred to rely on Eirin's judgments since "as an art form, film evolved comparatively late and is still, in both theory and practice, at the stage of continued development. In light of the diversity and

fluidity of film's means of expression, Eirin's inspection process and decisions, which are based on its comparably rich experiences, can be said to offer a powerful standard."[76] Even though the High Court judges found Eirin's own standards to have been lacking in this instance, they ruled to exonerate the defendants based almost exclusively on Eirin's authority. They wrote that Eirin had gained the trust of both society and the government, and that Eirin's approval constituted "sufficient reason" (*sōtō na riyū*) for the defendants to believe that they were not violating the law since this was the first indictment of a film passed by Eirin in its illustrious sixteen-year history.[77]

As Eirin's secretary-general Sakata Ei'ichi recognized, the state's endorsement was not entirely good news, at least for Eirin: "Just because the verdict stresses society's high degree of trust in Eirin, it would be wrong to misinterpret Eirin as having some kind of censorship authority. Eirin is not a subcontracted state agency but a self-regulatory agency to the very end."[78] What Sakata recognized was that the judges were charging Eirin with the role and responsibilities of a quasi-governmental authority, which would only invite criticism from the film industry. More important, the more authority invested in Eirin by the state, the greater its chances of being held criminally culpable for passing films that violated the obscenity law. As a legal scholar noted after the *Black Snow* trials, Eirin was forced to maintain a tricky balance between two decidedly unattractive options: it was "reduced either to becoming a subcontractor, or proxy, of the bureaucracy's preproduction censorship, or to lapsing into the role of a sheltering organization for the film industry that promotes the commercialization of sex in the pursuit of profits."[79] From the perspective of the state authorities, it seems that Eirin erred on the side of the latter since just three years following the *Black Snow* High Court verdict Eirin itself would be put on trial alongside the directors and studio executives in the 1972–1980 Nikkatsu Roman Porn trial.

CHAPTER 4

Dirt for Money's Sake
The Nikkatsu Roman Porn Trial (1972–1980)

In 1971, amid a climate of increasingly liberalized sexual expression both domestically and internationally and a severe economic crisis for the Japanese film industry, Nikkatsu Roman Porn was born. It would prove to be the financial salvation of Nikkatsu studio and the most long-lived genre in Japan, lasting eighteen years, from 1971 until 1988, with some 850 titles total released under the brand name.[1] At the same time, it proved the ideal target for the state censors to make good on the threat issued in the *Black Snow* trial that Eirin's seal of approval offered no guarantee of immunity from future prosecution. Seizing on this caveat, the Nikkatsu prosecutors chose to target both films that had passed Eirin and to bring charges against the very Eirin inspectors who had approved the films. This engendered a very public debate about Eirin not witnessed since the Sun Tribe scandal of the mid-1950s. In the end, the threat of governmental film censorship was seemingly put to rest for good when the Nikkatsu judges, like their predecessors, ruled to acquit largely because they too recognized Eirin's important role in stemming, if not squelching, the rising tide of explicit sexual expression.

This unprecedented joint indictment of both the artists and the industry censors, or "self-regulatory inspection agency" to use a term preferred by Eirin, forced the Nikkatsu trial to diverge from the well-trod course of the previous trials that pitted the pure artist against the corrupt censor (or vice versa, depending on your perspective). The defendants totaled nine people: three directors, three Eirin inspectors, and three film studio executives. Unlike in the earlier trials, the object here was not a single work but

instead four films lumped together by virtue of their being Nikkatsu Roman Porn. Further complicating matters was the fact that the director of one of the four targeted films, Umezawa Kaoru, had not himself been indicted but instead appeared as a cooperative prosecution witness. Moreover, each group of defendants retained its own legal counsel, and one director appointed his own, resulting in an unwieldy total of four lawyers representing nine defendants. To make matters even more complicated, one of these defense lawyers was appointed by the Nikkatsu labor union, which lurked in the background of the trial as a not-so-silent player and aligned itself with the state prosecutor as well as with the Japanese Communist Party (JCP) by condemning the entire genre of pornographic film.

Fig. 4.1 *Love Hunter* (Yamaguchi 1972).

The defendants were charged under article 175 for "making male and female actors enact poses of sexual intercourse, raping women, girl-girl sex play, etc., accompanied by frank facial expressions, vocalizations, etc., and filming and recording this in detail" in four films: *High School Geisha (Jokōsei geisha,* 1972; directed by Umezawa Kaoru), *Diary of an Office Lady: Scent of a She-Cat (OL nikki: Mesuneko no nioi,* 1972; directed by Fujii Katsuhiko), *Love Hunter (Koi no karyūdo: Rabu hantā,* 1972; directed by Yamaguchi Sei'ichirō), and *The Warmth of Love (Ai no nukumori,* 1973; directed by Kondō Yukihiko). The first film was technically more of a Pink Film than Nikkatsu Roman Porn, having been produced by Purima and purchased by Nikkatsu for distribution. (Even for a Pink, its budget at 2.6 million yen was exceedingly low.) The latter two films were charged with the additional offense of including the "pose of a woman masturbating."[2]

Not surprisingly, the sprawling defense team provoked a fair amount of finger-pointing and infighting among the far from unified defendants. As a result, no truly coherent defense was offered, and the first lower court trial alone dragged on for close to five years. In an unexpected way, though, the major players in the trial offer a microcosm of the tensions involved in artistic production in general. Each faction represented the competing interests of the law (state censor), politics (the JCP and Nikkatsu labor union), artist (the three filmmakers), self-censor (the three Eirin inspectors), and patron (the studio representatives). The needs of this last group, the studio executives, played an especially key role. In stark contrast to the other landmark censorship trials, in which commercialism was depicted as an enemy of art and artist, the defense arguments in the Nikkatsu trial hinged on the commercial necessity of churning out porn to sustain an otherwise moribund domestic film industry. Rather than art for art's sake or even dirt for politics' sake, the defense of "dirt for money's sake" reigned.

That art and the artist largely disappeared from the equation is not altogether surprising considering the objects on trial: four films that generically and nominally declared themselves "porn." Advancing a defense based on their status as great works of art or as political statements was untenable, as even a cursory look at their plot summaries attests: *High School Geisha* features two geisha, a village priest, and a pornographic author named Kafū (蚊風) (in a thinly veiled reference to the famed author whose work was being tried contemporaneously in the "Yojōhan" trial) who have sex in varying combinations in reality and in their fantasies; *Diary of an Office Lady* is about an "office lady" betrayed by her boss/lover who gets revenge by first

seducing the boss's daughter's lover and by then getting them all to participate in an orgy together; *Love Hunter* centers on an upper-class twenty-eight-year-old woman whose loose sexuality is traced back to her witnessing an incestuous liaison between her mother and her grandfather; and *The Warmth of Love* focuses on the ruinous affair between a rebellious young woman and a Tokyo University professor whose wife plots revenge by sleeping with the woman's young lover. The boldly marketed "shocking [*shōgeki*] Nikkatsu Roman Porn"[3] demanded a new strategy; as one of the defendant-directors admitted, "Previous obscenity trials were fought by arguing artistic or political issues, but we have no such thing to turn to. We must directly tackle and fight from the issue of the works' mass appeal" (*NPS,* 127–128).

Indeed, the terms of debate needed modification, just as the 1960s U.S. censorship trials of Henry Miller's works had demanded a new strategy, for, as the head defense lawyer in that trial noted, "if *Tropic* [*of Cancer*] had no prurient appeal, it had no appeal at all."[4] But unlike the case in the United States, where the landmark "Brennan doctrine" had significantly expanded constitutional protection to all media provided it was not utterly devoid of "social importance,"[5] in 1970s Japan, there was little hope for such a defense based on the 1957 *Chatterley* and 1969 Sade Supreme Court precedents.

Unlike the other trials, in which the defense argued for the sanctity of the artist with a capital *A,* in the Nikkatsu trials, the lawyers enlisted two unlikely figures in their defense: the mighty censor and the equally mighty yen. Invoking the authority of the industry censor was not altogether surprising since three Eirin inspectors were codefendants and also because the *Black Snow* High Court verdict offered some hope that the fact that Eirin had passed all four of the indicted Nikkatsu films would be considered a mitigating factor here too. But invoking commercial necessity was striking. Most surprising was the degree to which this rationale was validated by both the lower court and High Court judges in their not-guilty verdicts of June 23, 1978, and July 18, 1980, respectively. Whereas the charge that art was being debased by commercialism had been successfully lodged against the previous literary and film works tried, here commercial necessity provided instead a viable defense.

The Nikkatsu defense team, and one director in particular, Yamaguchi Sei'ichirō, offered occasional glimmers of what would become a staple defense in the later trials, arguing that, in theory, erotica was equally deserving of the constitutional guarantee of free speech, or as they boldly put it, "What's wrong with obscenity?" (*Waisetsu naze warui?*). In practice,

however, they focused on characterizing all the defendants as victims of the times. Instead of the heroic artist championing art, here were young assistant directors cowering at the mercy of a studio system that itself was dying in the face of globalization and the rise of television. Far from the image of the all-powerful, malevolent censor, Eirin too was a victim criticized from every side, caught between the directors, who accused them of being handmaidens of the state, and the police and public, who accused them of being handmaidens of the film industry.

The Nikkatsu indictment represented an ambitious attack by the state censors, unprecedented in both its scope and severity. In this case, the prosecutor could indict not just a minor independent, renegade director and the distributor of a single film, as in the *Black Snow* trial, but instead an entire genre being pioneered by a major film studio and its endorsement by the industry censors. To ensure the significance of this indictment would not be lost on the defendants or on the industry as a whole, the prosecutors sought strict prison terms ranging from ten to eighteen months. In pursuing such a comprehensive indictment, the police and public prosecutors were attempting to nip in the bud the new genre of Nikkatsu Roman Porn, which was generating not just commercial gains but also critical support both domestically and internationally.

The Rise of Pinks and Porn

At the time of the charges, Nikkatsu Roman Porn was just two months old. Nikkatsu studio initiated the line as a desperate, and initially hugely successful, attempt to save its bankrupt company. By the early 1960s, studios were faced with an increasingly dire financial situation. In comparison with Japan's "golden age of cinema," when visits peaked at one billion in 1958 and a record 547 films were produced domestically in 1960, by 1962 attendance at theaters was almost half its peak, and major studio production was down 30 percent.[6] The decline was attributed to a number of factors: excessive competition among the studios that had overexpanded in response to the 1950s boom; inflexible studio block booking systems that required theaters to show all films made by its partner film company and directors to produce films at a regular rate, regardless of quality, to ensure distribution quotas; studio monopolies over their stables of stars and directors; and, especially, the loss of female audiences due to both the rise of television and their mass exodus to the suburbs with the advent of the *danchi* apartment developments. In a delicious irony, the *danchi* would provide Nikkatsu Porn

with its first, most successful series—the bored, dissatisfied housewife of the *Danchizuma* films, which reached over twenty in number and were recently revived in the February 2010 line dubbed Roman Porn Returns. In sharp contrast to the declining domestic industry, foreign films were enjoying a boom in the early to mid-1960s. After a postwar low of only 22 percent of the market share in 1960, imported films reached almost 39 percent in 1967 and 49 percent by 1971.[7]

Faced with this crisis, in 1962 independent production companies debuted the low-budget soft-core erotic Pink Films (*pinku eiga*). Officially labeled adult films by Eirin, they were typically called three-million-yen films or "eroduction." From the start, Pinks were extremely low-budget and low-tech affairs, evolving into quite standardized productions by the early 1970s: sixty to seventy minutes long with relatively tame sex scenes that carefully avoided depicting genitals, pubic hair, or sex acts explicitly; shot in 35 mm black and white film in three to four days on location with sound added afterward; and screened in specialty theaters on a triple bill. At the time, they were dismissed by many, such as film scholar Satō Tadao, as "the filming of some amateur actresses naked in a room of some apartment" and accused of "selling shabby eroticism."[8]

But these low-budget films would prove to be a huge hit with audiences, as well as an irresistibly attractive moneymaking option for the studios. In 1962, there were just 4 Pink Films produced, but by 1966 the number had jumped to 207 and peaked at 265 in 1968. In 1965, about 20 percent of the 4,600 theaters nationwide were screening Pinks, either exclusively or nonexclusively.[9] Moreover, Pink Films were increasingly being recognized as a legitimate genre by critics both domestically and abroad, with the leading film journal, *Kinema junpō,* establishing a distinct category for Pink Films in its annual Best Ten lists in 1965.

Internationally, censorship of sexually explicit films was waning. In the United States, regulations were shifting from outright bans and prosecutions to a policy of restricting access based on rating systems: the Hays Code, the template for Eirin's own original regulations, was significantly revised in September 1966; a comprehensive rating system (G, PG, R) was established in 1968; and the 1970 U.S. Presidential Commission on Obscenity and Pornography definitively rejected restricting sexually explicit materials from adults and instead recommended controls or legislative action only in the case of youths. (As we will see below, this report was invoked as a key defense witness of sorts in the Nikkatsu trial.) And in Europe, pornography

was legally decriminalized in Denmark in 1969, with other European countries soon following suit.

The Japanese film industry announced its desire to join this liberalized international community with the debut of its first international film festival in Osaka in April 1970. It challenged domestic film censorship policy by screening controversial European films like the Swedish *I Am Curious (Yellow)* (1969; directed by Vilgot Sjöman), a film about a young woman's sexual and political awakening that had helped to decriminalize porn in Europe. At the festival it screened with forty-five places blacked out to obscure genitalia and pubic hair and subsequently with additional cuts for general exhibition in Tokyo, with a record-breaking twenty-eight thousand plus spectators in a single week.[10] By the early 1970s, such imported erotic films had come to occupy a larger share of the Japanese market, up from less than 5 percent of total adult films in 1965 to 13 percent in 1970 and 19 percent by 1971.[11]

The appearance of these erotic films at festivals and in general theaters reflected both increasing audience demand and their acceptance (or at least resigned tolerance) by the film industry. For the Eirin and state censors, however, they presented a frustrating challenge. Until 1956, Eirin was largely powerless to regulate them unless Western film studios voluntarily agreed. And even Japanese customs had difficulty despite its lawful jurisdiction over imported films. An incident that brought this to the fore was the French film *The Lovers* (*Les amants,* 1958; directed by Louis Malle), which had provoked obscenity convictions in the United States and prompted U.S. Supreme Court justice Potter Stewart's famous (non)definition of pornography: "I know it when I see it." When customs officials insisted upon extensive cuts of its "overly thick" bed scenes in April 1959, they consulted with the Import Films Council and Eirin, which recommended cutting a hefty twenty minutes of the film. When the distributor balked, the debate even reached the Diet's House of Councillors, and the film eventually had only three minutes cut.[12]

By 1964, most of the majors themselves had entered the market in an attempt to secure a share of the profits. In 1963, seven out of thirty-seven adult domestic films were produced or distributed by the Big Five studios (Tōhō, Shin Tōhō, Daiei, Shōchiku, and Tōei), and by 1964, nineteen out of ninety-eight films.[13] Tōei was the first major studio to enter the market in earnest; in July 1967, it released films with titillating titles like

Secret Tales of the Inner Palace and a "Perverted Sex" series and, in July 1971, started its popular Sukeban Pinky Violence series about female bike gangs. In February 1968, Daiei launched new young actresses in a popular High School Student Sex series, introduced its Lemon Sex series in 1970, and finally a host of very low-budget *ero-guro* films in a final last-ditch effort at solvency before announcing bankruptcy in December 1971.[14] Even "the family-oriented Shōchiku studios joined the ranks of pink eiga producers" with the establishment of the subsidiary Tōkatsu (a name derived from their rival studios Tōei and Nikkatsu).[15]

As the most successful major involved in producing erotic films, Tōei at this point was also the authorities' primary target: in the summer of 1971, the Yokohama police confiscated an 8 mm "video porn camera" made by Tōei for rent at bars (for just ten yen a minute) that was advertised as a means of glimpsing otherwise invisible pubic hairs when viewers paused the silent film at will: "If you stop it, you can see hair"; in October 1971, the police searched Tōei studio, as well as some independent distributors, on suspicion of their violating article 175 after theater advertisements rejected by Eirin appeared in a magazine.[16] The following month, however, Tōei would be definitively displaced as the censors' main target when Nikkatsu launched Roman Porn.

Nikkatsu Roman Porn

In July 1971, labor union employees and Nikkatsu executives (including the defendants Murakami Satoru and Kurosawa Man) were embroiled in meetings to devise a revival strategy for the financially bereft studio. The studio had been in dire straits for a few years, selling off lots as early as March 1969 and its splashy Nikkatsu International Building in downtown Tokyo in 1970.[17] By July 1971, Nikkatsu was saddled with over two billion yen in debt after its failed joint venture establishing the distributing company Dainichi with Daiei. The end of the year 1971 represented a new low point for the industry, symbolized by the bankruptcy of Daiei, one of the Big Five studios, despite its desperate *ero-guro* film policy in its last days.

The Nikkatsu committees' recommendations were simple: focus on five to six feature films a year under the free-booking system, television and children's films, and most centrally, debut its own Pink brand—the Nikkatsu Roman Porn (*NPS,* 124). The highbrow "Roman" in its name was likely derived from French *roman pornographique* to suggest the inclusion

of novelistic story lines.[18] But by using "Porn" also in its branding name, Nikkatsu was boldly calling a spade a spade instead of employing a euphemism like the one used during its research phase, "small-scale production."[19]

The genre, at least initially, was less like the hard-core pornography that its name suggests in translation and more like the existing soft-core Pink and often screened on double or triple bills side by side with Pinks that Nikkatsu purchased from independent production companies, as was the case with *High School Geisha*. Where these films departed was in their glossy, high production values. Although still relatively low budget compared with regular thirty million yen features, at seven to eight million yen, a Roman Porn's budget was almost triple that of Pinks, and Nikkatsu's experienced filming crews were given ten days to shoot compared with the three to four days allotted for Pinks. The films were all color and sometimes widescreen, seventy-five-minute features. As the "Pink Queen" actress Shirakawa Kazuko, who starred in the first Nikkatsu Porn, noted, their studios seemed "like Hollywood" compared to the Pinks' low-budget facilities.[20]

The first two films—*Apartment Wife: Midafternoon Love Affair* (*Danchizuma hirusagari no jōji;* directed by Nishimura Shōgorō), the story of a neglected, adulterous suburban housewife who is blackmailed by a madam into becoming a call girl, and the period-piece porn *Castle Orgies* (*Irogoyomi ōoku hiwa;* directed by Hayashi Isao), about a young girl who gets caught up in political and sexual intrigue in the women's quarters at the shogun's palace—opened as a double feature on November 20, 1971.[21] The line's incredible financial success was touted by Nikkatsu executives in the press: by October 1972, the company had reached its target monthly income of 150 million yen, the number of Nikkatsu-owned theaters was almost at peak levels, up from a low of 50 to 800, and the films were screening in 2,700 theaters nationwide. Though somewhat hyperbolic, a film journal essay at the time claimed in its headline, "1972 Japanese Films Final Results: There Are Only Nikkatsu Roman Porn."[22]

The growing popularity of erotic films was not limited to Japan but reflected an international trend in the wake of the "liberation of pornography" in northern Europe that had been led by Denmark in 1969 and Sweden in 1970. In fact, the indicted films boldly marketed themselves as part of this international phenomenon. On January 23, 1972, an advertisement that appeared in the *Sunday Mainichi* proclaimed the advent of "The Eve of Liberation" (*kaikin zen'ya*) in Japan with a ten-page photo spread of the "new face of pornography."[23] These included several still shots from the

orgy scene in *Love Hunter,* which the Nikkatsu judges would deem the most explicit of the indicted films. For conservatives, Japan's aspiring to follow this trend was decidedly unappealing. As legal scholar Uematsu lamented after the 1969 *Black Snow* High Court acquittal, "Today's exhibitionist culture that began with miniskirts and the radical liberation of sex led by northern Europe would have been utterly disallowed a decade ago."[24]

The police's attention to the Nikkatsu Roman Porn line was piqued from the moment of its inception. A six-page photo shoot of stills from the first "period porn" *Castle Orgies,* which appeared in a weekly magazine just two days after the genre's debut, prompted the police to send a list of questions to Eirin that foreshadowed the indictment. The police asked, "(1) Do these photos include any that were not passed by Eirin? (2) What kinds of films are they and what kinds of scenes? (3) What kind of standard does Eirin use for this type of photo?"[25] Although Eirin attempted to reassure the police that its inspections were quite thorough and strict, Nikkatsu was clearly flirting with disaster. As one journalist commented, "There is a limit established by article 175, and if you exceed it, you face the clink of handcuffs. For the film industry, today is an era where a bandage is an indispensable item [used to cover up private parts] for filming, but when is the day that it will be officially ripped off?"[26] Nikkatsu might have initially been holding on by a single bandage, but the sound of handcuffs clinking was not far off.

The Indictment

Less than a month after the debut of its Roman Porn line, Nikkatsu was officially targeted by the state censors in a two-pronged attack. On January 19, 1972, the same day that three of the indicted films—*Love Hunter, Diary of an Office Lady,* and *High School Geisha*—were screened on a triple bill, Nikkatsu was charged on suspicion of violating article 175 for making and selling pornographic videos to motels and cafés.[27] Then on January 28, the three theatrical films were confiscated by the Tokyo Metropolitan Police in a raid of Nikkatsu's offices. According to the police, they were "no different at all from the blue films circulating underground."[28] Blue or underground films (*burū firumu, ura eiga*) were, in fact, quite distinct since they generally depicted genitals and real, not simulated, sex. But, as one prosecution witness pointed out, blue films also lacked the "force" (*hakuryoku*) of sound and color (*NPS,* 188). Most important, underground films were by definition illegitimate and associated with gangsters, not high-budget, glossy, and

Eirin-approved studio productions that were sanctioned by the industry and industry censor alike.

Indeed, the police clearly stated that their intent in targeting Nikkatsu was to issue "a warning to the sector of the film industry aiming to escalate pornography."[29] What the police meant by "escalating pornography" was undoubtedly the films' context and form, as much as their content. Their emergence signaled an undesirable attempt to legitimate erotic films by the domestic film industry. By targeting one of the oldest major studios, Nikkatsu (established in 1912), which had consciously adopted a company policy to produce "porn," the police were attempting to disrupt this trend and perhaps to confine it to less-mainstream and less-reputable channels. Unlike the cruder low-budget Pinks, here high style and lowbrow content mingled again uncomfortably, a combination that disturbed the censors' fundamental taxonomic impulses. If their context as stylish major studio productions could elevate these Nikkatsu films from smut to art, they might be accepted by the general public and critics alike.

In terms of sexual content, the Police Safety Division charged the films with exceeding previous limits: "Until now, scenes only suggested sex by showing just the legs or the upper half of the body. If whole bodies were filmed, the man or woman had underpants on. But in these three films, the sex act is clearly shot without underwear, and they clearly fit the category of obscenity." The police suggest here that the degree of nudity and the framing of bodies in full shots qualified them as obscene. But again, content and style alone fail to explain the charges. The police's stated rationale was undermined by its decision to add the 1973 film *The Warmth of Love* to the indictment three months later, despite the fact that this film contained no sex scenes of actors without underwear; when questioned on this point, the police employed its typically circular logic, responding, "Even with underwear, if it's sensational, article 175 applies" (*NPS,* 22).

In all likelihood, the decision to indict these four films was both less and more personal than the police's statements suggest. On the one hand, it was arguably because the films were representative, not unique, that they were targeted. Even the prosecutor's own witnesses admitted in their testimony that the films were "all the same" to explain their inability to recall which film they had seen, either specific titles or content. For example, a twenty-five-year-old securities firm employee testified that he "forgot the titles," and "although he watched three films, he couldn't tell which was which [*dore ga dore da ka wakaranai kanji datta*]." He concluded damningly,

"If you've seen one, that's more than enough." In contrast, a producer of educational films was able to recall the objectionable scenes in *High School Geisha* in detail and admitted that he had "read the script and watched the film repeatedly, eagerly, alone, and without distraction" in order to prepare as prosecution witness and was able to pinpoint the film's proportion of sex scenes to the precise mathematical figure of 31 percent! (*NPS*, 216–217, 222, 258, 262).

Newspaper articles at the time concurred with witnesses who professed bewilderment at the targeting of these Nikkatsu films since other, similarly, if not more, explicit films existed.[30] But this was precisely the point; as the police admitted, the indictment was meant to be "a warning," and these films merely offered an expedient target. The fact that three of the films charged had been released as a triple bill had the advantage of dispelling the impression that the charges were a witch hunt against Nikkatsu, because the prosecutor could call witnesses like the employee of the government watchdog agency Nihon Senbai Kōsha, who claimed he just "happened to run into a friend in the Public Safety Division of the Tokyo Metropolitan Police, Hosojima, at the theater" after seeing a double bill of *Love Hunter* and *Diary of an Office Lady*.[31]

The provocative photo spread of orgy scenes from *Love Hunter* heralding the "eve of liberation" in Japan had similarly declared the films as a forerunner of a larger trend:

> Try walking around the movie theater districts. The signs and posters that catch your eye and the advertising copy are unbelievable! If you enter the theaters, there are images projected on the screen that are very *cutting edge*. Scenes of skin touching shot from explicit angles that wouldn't have been close to getting okayed by Eirin a year ago appear everywhere. And the dialogue and sound effects only increase their degree of realism all the more. Things have gotten this way surely because of the strong support of "public opinion." After all, printed matter and even family room TVs have become increasingly pornographic. An astonishing escalation of pornography in the world as a whole![32]

Although the author's tone of mock alarm was designed to promote the films, it perhaps unwittingly invited the police to target them as indicative of a new trend pushing the established limits of sexual representation. Its rhetorical flourishes certainly echoed the tone of the moral watchdogs at

the time who were advocating the regulation of such films. In the *Asahi* newspaper feature "Considering Eirin" that appeared in the wake of the Nikkatsu indictment, the director of the Tokyo Mothers' Society similarly invited skeptics to "try peeking into the entertainment district of Asakusa sometime. Nudity, sex, fuck [ファック] . . . for a person of average nerves, it's entirely unacceptable. When I heard that Nikkatsu Porn had been indicted, I thought, 'Serves you right!' . . . But still Nikkatsu continues to churn out porn!"[33]

As a studio, Nikkatsu offered the perfect target, for its name was, for many, synonymous with violent and erotic films. The studio had always been an outlier in the film industry, with the Big Five studios actively organizing against it after Nikkatsu resumed production in 1954,[34] and the company did not even become a member of Eiren until June of 1957 after the Sun Tribe scandal. Roman Porn could be considered merely the studio's latest and boldest incarnation, a descendant of the mid-1950s Sun Tribe films. The "father of the Sun Tribe," Emori Seijurō, had clearly recognized the link between the two genres, declaring, "Sun Tribe films were the pornographic films of that time. From here on at Nikkatsu, let's again make pornography" (*NPS,* 163). The films were perhaps more accurately described as direct descendants of the late-1960s violent, quick-paced Nikkatsu New Action genre; as one reporter blithely noted, "The glory of 'New Action' has been revived by the transformation of a carbine into sex," or, "into a penis," as his title more bluntly put it.[35] The studio consistently tested the limits of acceptable sexual depiction even in the face of harsh criticism, as the Mothers' Society head had charged. Its unrepentant attitude was condemned by the prosecutor in the final lines of his closing arguments: "Although the films are clearly lacking in artistry or philosophy and are nothing more than lowbrow, obscene films playing to a certain segment of the population, they repeatedly spout the laughable defense that they are pursuing the essence of sex and such, and show no remorse. We cannot dismiss it as a light offense."[36]

The Nikkatsu indictment also offered an ideal opportunity for the state to rectify its previous failure to secure a conviction in the *Black Snow* trial. By including Eirin inspectors as defendants, the Nikkatsu prosecutor ensured that there would not be any finger-pointing at anyone *not* at the defense table this time. It could also make good on its threat that Eirin's approval did not guarantee immunity from prosecution and even target key individuals who had escaped prosecution in the *Black Snow* trial, especially

Nikkatsu, which had been the distributor of Takechi's *Black Snow*. The Nikkatsu indictment targeted both Murakami, Takechi's codefendant, and two of the very Eirin inspectors, Arata and Yana, who had been responsible for inspecting *Black Snow*. When cross-examining these witnesses, the prosecutor pointedly noted that, based on their roles in that earlier trial, the defendants could not claim ignorance of the *Black Snow* precedent. (Perhaps also not coincidentally, defendant Watanabe Teruo, the chief of Purima, the company that produced *High School Geisha,* had been involved in the planning of several of the Nikkatsu videos indicted in the contemporaneous Nikkatsu Porn Video trial, although he was not ultimately charged in that trial [*KWS,* 111, 145, 208].) By casting such a wide net in the indictment, the state was undoubtedly attempting to ensure that someone would be held responsible this time, but its targeting of three people who had ties to the *Black Snow* trial suggests that it was not merely strategic but also personal.

Authorship and Ownership

The comprehensive nature of the indictment also reveals much about the sense of who was responsible for a film in the minds of the law. The issue of authorship and ownership of films had, in fact, just been hotly debated in the legislature with the passage of the new copyright law in 1970. Much to the disappointment of the Directors Guild of Japan, the new law assigned copyright to the studios but the moral rights (and responsibilities) to the directors.[37] (Interestingly, when testifying before the Diet on this law the head of Eiren argued that since the Occupation authorities had banned only producers and not directors in the postwar Red Purges, the studios deserved the lion's share of rights and profits.[38])

In accord with this newly passed intellectual property law, the prosecutor asked for the strictest prison terms for the company executives: he sought eighteen-month sentences for both the Nikkatsu executives, fourteen months for the Purima executive, one year each for the three directors, and ten months for each of the Eirin inspectors. This suggests that the prosecution was crediting the studio executives with as much, if not more, authorial agency than the directors. And again, the commodified product as marketed by the studio was somewhat distinct from the individual works created by the artists. Echoing the split verdict in the lower court *Chatterley* verdict, here too the business side could be more culpable for the artistic product than the artist himself. In this case, the business executives were not only responsible for marketing the films but also had pioneered the genre. As

the prosecutor and judges were careful to point out, defendants Murakami and Kurosawa had served on the original committees that formulated the original plan to launch the line.[39] According to the prosecutor, the studio executives had even dictated the majority of creative decisions for individual works, from content to titles, charging, for example, Nikkatsu studio executive Murakami with "directing the story and frank sex scenes" of *The Warmth of Love,* rather than the defendant-director Kondō (*KWS,* 109).

That the directors themselves were somewhat exempt from responsibility in the prosecutor's mind was all the more obvious from the glaring omission of one of them, Umezawa Kaoru, from the indictment. Particularly damning for the defense was Umezawa's testimony as a cooperative prosecution witness, which effectively shifted authorial responsibility from the directors to the studios. He testified that Purima executive Watanabe had commissioned him for the project "to create a humorous local piece" and at the last minute asked him to add "lowbrow slapstick" scenes. During his initial questioning, he claimed that he did not want to shoot two such additional sex scenes and agreed only after "protesting passionately." He also fingered Eirin, noting that he was skeptical that the film would pass because of a few scenes, including one of the "69" position, and readily admitted that his film contained more sexual expression than *Black Snow* (*NPS,* 155–157). I quote at length this witness testimony because it suggests the tensions inherent in a trial that pitted artist, patron, and industry censor against the state censor and illustrates the finger-pointing nature of the trial:

> [Questioning of director Umezawa by prosecutor:]
>
> *Q:* What was this film's initial title?
>
> *A:* It was *Female Student Geisha* [*Jogakusei geisha*]. Before the Eirin inspection, I received word that it had been changed but don't know who changed it. Since it's about a female college student, the new title [*Female High School Student Geisha* (*Jokōsei geisha*)] doesn't reflect the content, but these kinds of title changes for business reasons occur frequently.
>
> *Q:* In the case of Pink Films, are there a determined number of sex scenes?
>
> *A:* It's not fixed, but usually about six.
>
> *Q:* Weren't you told by Watanabe to add crude, plain sex scenes?
>
> *A:* I was told to add a bit more sex. But that was my decision.

Q: What do you think about shooting sex scenes even though they're unnecessary?

A: Spectators expect sex scenes.

Q: I don't think it's necessary to add sex scenes to the point of forcing them to fit in. . . .

A: It's necessary to sell the work from a business perspective.

Q: In the initial investigation, you said that the reason additional scenes were requested was that your work was not as stimulating as Nikkatsu films. . . .

A: Well, that was also said out of my sense of rivalry with Nikkatsu directors.

[Cross-examination by Purima executive Watanabe's lawyer:]

Q: Are titles of films often changed?

A: Yes, on the request of the business side. . . .[40]

Q: Eirin did not inspect the final script?

A: I didn't know that the third draft was not inspected.

Q: Are you aware that the prosecutor has labeled four places in *High School Geisha* obscene?

A: Yes.

Q: What do you think about these so-called obscene scenes?

A: I never thought they'd be indicted.

Q: Have your works ever been evaluated by the critics?

A: [Film critic] Satō Tadao praised them in a film magazine.

[Cross-examination by Ogawa special defense counsel:]

Q: Your works are said to be those of a brilliant individualistic author, but do you think your individuality is apparent in this work?

A: I think it's characteristic of me, yes.

Q: Is it true that after the warning from police headquarters targeting twelve Pink Films, Eirin issued a directive to the industry to make comedies?

A: It didn't come my way, but comedies have become more prevalent. [At this point the prosecutor objects to the leading questions, and Ogawa backs down.] . . .

[Cross-examination by Eirin lawyer:]

Q: You stated that Eirin's regulations are confusing. Do you think they will remain so?

A: I don't.

> *Q:* It seems you were distinguishing between the inspectors and the administrative committee, but . . .
>
> *A:* There are times when something the inspectors passed was later reinspected by the administrators.
>
> [Cross-examination by directors' lawyer:]
>
> *Q:* Were you first questioned as a possible defendant?
>
> *A:* Yes.
>
> *Q:* Did you think you were potentially going to be indicted?
>
> *A:* I was worried that I'd run into financial problems if I was indicted.
>
> *Q:* Did you hear why you were not indicted?
>
> *A:* I didn't. I can only say it's incomprehensible.
>
> [Reexamination by the prosecutor:]
>
> *Q:* You stated that you make films based on your own limits for sexual expression. What are those limits?
>
> *A:* For example, the experimental French kiss scene stays within that limit.
>
> *Q:* You testified after watching *Love Hunter* that it had eight obscene places.
>
> *A:* I said that it had places that exceeded the limits. I was shown *Love Hunter* without music. The player was stopped and rewound at objectionable scenes, and I was asked my opinion about the scene.
>
> *Q:* This must have been because there were places that exceeded your limits.
>
> [Second cross-examination by the directors' lawyer:]
>
> *Q:* Isn't it odd to make the witness offer his evaluation based on something watched in that manner? [Prosecutor objects to the question.] (*NPS,* 158–161)

As is obvious from the extended back-and-forth, each lawyer was intent on exculpating his own client even at the risk of condemning his codefendants. The prosecutor strove to depict the studio as responsible for the majority of creative decisions that were dictated by "business reasons"; the studio lawyers, in turn, blamed Eirin for insufficient review and implied that Umezawa, as director, was responsible by noting that he was a critically acclaimed filmmaker;[41] the directors' lawyers attempted to disavow directors' authorship by instead suggesting that Eirin had a hand in the creation of the film with its directive to create more comedies; the Eirin lawyers

tried to get the director to blame inconsistencies in the Eirin organization as a whole rather than the individual inspectors; and finally, Umezawa himself was ambivalent, both trying to assert creative control over the product (for example, by asserting that it was ultimately his decision to add the sex scenes although the studio had requested them) while also trying to escape criminal responsibility by repeatedly crediting "business decisions" with the power to determine a work's content and style.

Umezawa was not the only one claiming that the directors were largely immaterial. The prosecutor repeatedly forced witnesses to admit that the generic imperatives of Roman Porn dictated the films' content choices. Defendant Murakami inadvertently suggested as much when he explained that the directors were picked only after the script and budget had been determined. And the prosecutor forced director Fujii to admit that his codefendant Kurosawa in the planning department at Nikkatsu had told him "to put in sex even before submitting the first draft" (*KWS*, 108, 118).

Even the defendant-directors themselves at times invoked this defense, albeit outside the courtroom. In a panel discussion in *Kinema junpō* in May 1974 during the lower court trial, Kondō admitted his impulse to deny responsibility for the films: at the time of the initial police questioning, he reported having thought, "The ones who displayed [obscenity] were the actors, not me. From the actors' perspective, the one who told them to do it was the director. Using that reasoning, the one who said to make it was the company. I didn't make it because I like it after all." He later noted his ambivalence about directing pornography: "Why do I continue to shoot it? To put it simply, in order to eat. When I was first asked by the company if I'd like to direct even though it's porn, I decided to because I didn't want my twelve years as assistant director to go to waste. . . . To tell the truth, I want to shoot normal films, not just porn. I don't like it at all" (*NPS*, 135). By suggesting that financial necessity and company policy, not personal artistic vision, drove the production of the films, Kondō essentially replicates the prosecutor's own charges.

Directors were understandably conflicted between their desires to assert artistic integrity and to escape criminal punishment. A reporter wryly noted the complications that arose because of the directors' presence in this case, "where the object on trial is the original work [*orijinaru sakuhin*] of the director who is the author [*sakka*]," and envyingly compared their plight with the comparable "ease" (*kirakusa*) of the contemporaneous "Yojōhan" trial, where "the object on trial was a 'classic' and the individual who wrote

it was absent" (*NPS*, 278). The unique challenge faced by the Nikkatsu defense team was not the presence of the directors per se, since director Takechi had stood trial before them, but rather the fact that the objects on trial were both nominally and generically labeled porn, as the prosecutor repeatedly stressed. In his cross-examination of director Yamaguchi, the prosecutor pressed, "Because it's a pornographic film, you necessarily need to shoot sex scenes, or it won't be pornography, right?" (*KWS*, 140).[42] Just as he had earlier cited the genre's fixed number of sex scenes, here too the prosecutor was implying that the films' content was predetermined by their genre in order to suggest that the director was immaterial, and the films therefore lacked any redeeming artistic, philosophical, or political intent. In his closing remarks, the prosecutor again attacked the genre as suspect based on its name alone: "Just as their name 'porn film' designates, the indicted films consist of a great many sex scenes that principally excite and stimulate sexual desire," and finished by labeling the films obscene "as per the characters" (*moji dōri*) of their name (*KWS*, 11, 14).

As a reporter who covered the Nikkatsu trial noted, calling Roman Porn artistic works (*geijutsu sakuhin*) was an oxymoron (*NPS*, 292–293). The defense was fully aware of the quandary presented by the genre. From the second day in court, they announced they would not argue for the films' artistry but would instead appeal to their value as mass entertainment: "Although they are not appropriate to debate in terms of artistry, they have a valid reason to exist: to satisfy as entertainment for the masses that suit the current cultural tastes."[43] Here we see inklings of a defense that would demand the constitutional guarantee of free expression be applied to works of dubious merit and even to obscenity. When the court deemed the films not obscene, some of the more outspoken artists claimed disappointment because the works' obscenity was a point of pride. Director Yamaguchi stated, "I'm embarrassed that I created something that didn't merit being called obscene,"[44] and actress Tanaka Mari (who starred in two of the indicted films and whose role in the trial catapulted her to becoming the darling of antiestablishment student groups) noted her incredulity (*KWS*, 252).

In sum, the simultaneous targeting of patron, artist, and censor provoked a fierce debate about the nature of film authorship and ownership. By holding all three parties—the directors, studio executives, and Eirin— responsible, the prosecutor was taking into account both the *Black Snow* debacle as well as the recently revised intellectual property law and the

collective nature of filmic production, especially in the case of works with such relatively strict genre conventions as Nikkatsu Roman Porn. The directors in particular were caught in a catch-22 between two poles: disavowing criminal responsibility and claiming authorial agency. In the eyes of the state, while the directors were culpable for agreeing to the studio's plan, the studio was most responsible because in the interest of profits alone it had formulated the genre and dictated the content, effectively becoming authors (or coauteurs) themselves.

The Communists and Commercialism

For the prosecutor, the criticism of pornography was necessarily one of commercialism and capitalism as well. One player in the trial that surprisingly took the prosecutor's side on this point was Nikkatsu's own labor union. In a memo released during the trial in April 1974, the union regretfully noted that it must criticize all "decadent culture" (*taihai bunka*), including pornography. Echoing the prosecutor's tautological definition, the union claimed that "a work made in the framework of Roman Porn cannot yield something that is distinct from pornography." The union was quite explicit that its critique was meant to place the blame squarely on the shoulders of the studio and to exculpate the defendant-directors, who they noted had all "stated that they would not want to make porn if they could make other works." But, in so doing, it also denied the directors any agency in the project; as the union bluntly put it, "It is a mistake to have the illusion that the directors have subjectivity" (*NPS*, 117).

The studio labor unions had traditionally voiced opposition to erotica. As early as April 1969, twenty-four assistant directors at Tōei's Kyoto studio had donned sashes with the slogan "Antierotic Films" in a quasi strike mode and issued a "Declaration of a Critique of *Ero-guro* Films" that read, "The Big Five film companies are devoting themselves entirely to the production of *ero-guro* vulgar films strictly out of their greedy pursuit of profits. . . . Films have lost their true essence and become vulgar spectacles, reduced to tools of Tōei's shameless commercialist capitalism." (Ironically, in an echo of the Nikkatsu defense, the Tōei president defended the director of one of these series—Ishii Teruo—because he was "merely an employee.")[45]

After the Nikkatsu charges, although the studio's labor union at first seemed to rally in support of the defendants with the establishment of a Strategic Committee against the Repression of Expression, its later statements suggest its ambivalence: "The Nikkatsu labor union is opposed to

today's decadent culture, including Nikkatsu Roman Porn films" (*NPS*, 36). In making this objection, the studio was echoing both prewar governmental censorship regulations against "Western thought, individualism, and decadent morals [*taihai fūzoku*]" and the contemporaneous critique of "decadent culture" being lodged by the JCP and the moral watchdogs.[46] Like the JCP, the labor union was advancing what was called a strategic two-pronged battlefront condemning both the state for suppressing pornography and pornography itself. But the irreconcilable contradictions of such a defense were evident in the testimony of a defense witness, a former *Mainichi* news reporter and member of Eirin's Advisory Council on Children's Film Viewing, who stated, "I don't support pornography, but I do support free expression" (*KWS*, 86).

Most damagingly, this critique of pornography in general, and of Nikkatsu in particular, was articulated by one of the defense's own lawyers. In his opening remarks, union lawyer Okada denounced the poor quality of the Japanese film industry. In an echo of Takechi in the *Black Snow* trial, he traced its decline back to the postwar Occupation film policy that had invited a "flood of coarse American films like Westerns and violent films" and a slew of poor Japanese imitations, from "decadent and sordid works like *Season of the Sun* that were born out of U.S. imperialism and Japanese capitalism" to Nikkatsu Roman Porn (*NPS*, 6, 28–32, 183). Although a strikingly odd argument from the mouth of the defense lawyer, he was blaming the various isms (monopoly capitalism and U.S. imperialism) for making pornography a necessary evil and for victimizing the directors. But in doing so, this lawyer too denied the directors any authorial agency; rather than attributing to them the lofty status of auteurs, they were instead reduced to assembly-line workers.

The prosecutor was not just echoing the JCP but also effectively turning the defense's own argument against it. In his closing, the prosecutor cited defense witness testimony that had admitted the commercial necessity of producing pornography: "The defense itself asserts that the majority of works originated out of sheer commercialism and are produced and sold only with the purposes of unduly stimulating people's sexual curiosity and profit making. They are no different from the so-called Pinks and porn that appeared in the context of the film industry's decline." He concluded, "The defendants' assertions are concerned only with commercialism. They have lost sight of the concepts of a healthy sexual order and good sexual morality that are fundamental to our nation's citizens' consciousness" (*KWS*, 12).

For the prosecutor, it was moral law not market law that should dictate film production.

Financial Need and International Norms (or the "But Everyone Else Is Doing It" Defense)

The defense was much more pragmatic in its arguments. What the prosecutor depicted as "sheer commercialism" it characterized as financial necessity. At times, the resulting defense seemed more like an attack. For example, film critic and special defense counsel Ogawa Tōru, who had also served as a defense witness in the *Black Snow* trial, argued,

> Sex is the staple of Japanese mass entertainment films. They are an imperfect art form that began as a means to sell sex. . . . Nikkatsu Roman Porn are commercialist entertainment films that are part of the larger trend of Hollywood film. . . . For the industry, this last gamble at making porn is the only path for survival for people whose lifetime careers have been in film.[47]

Although the same antagonists appear in Ogawa's rhetoric as in the prosecutor's (commercialistic sex and the evils of U.S. influence), the crucial difference between the two lies in his emphasis on the survival of the domestic film industry. Indeed, many of the witnesses candidly depicted the line's emergence as what it was: a desperate, last-ditch effort to salvage Nikkatsu amid an industry-wide crisis. Director Shindō Kaneto, for example, "paid his respects to Nikkatsu Porn, which revived the Japanese film industry when it was on its last legs," noting both its commercial appeal and its artistic and philosophical integrity.[48]

Significantly, witnesses also explained its emergence as a consequence of the increasingly explicit sexual depiction on the international film stage in the wake of the liberation of porn in northern Europe. Central to the defense's arguments was a linking of the question of financial need to international norms; it would argue that to compete financially and artistically in the global film market, Japan needed to revise its stringent censorship regulations. Defense witnesses repeatedly testified to the international trend to "liberate" sexually explicit material and contrasted this with Japan's stubborn adherence to outdated regulations. They called the Eirin inspector for foreign films to testify to the comparably explicit nature of imported films (*KWS*, 86–87). Constitutional law scholar Shimizu Hideo traced the history

of Western obscenity law from the Victorian period to its recent decriminalization in western Europe and in the United States and accused Japan of still applying the mid-nineteenth-century British Hicklin standard; he lamented that Japan ranked as "number two, right behind the United States in terms of GNP" but in terms of freedom of sexual expression was way behind, at number fifteen.[49] Notwithstanding his stated objections to the "shabby eroticism" of Pink Films, film critic Satō Tadao offered about four hours of testimony on the history of sexual representation in Japanese films to depict Nikkatsu Roman Porn as merely part of a natural and legitimate evolutionary process that included such groundbreaking films as Kurosawa's *Rashōmon,* which depicts rape four times over (*KWS,* 174). Since *Rashōmon* represented the moment of Japan's successful debut on the international stage after winning at the Venice International Film Festival in 1951, Satō was implicitly invoking the polemic that Japan repeatedly failed to recognize the value of its own cultural products until granted recognition by the West. These incidents dated back to the decline of ukiyoe prints until a Western vogue for them among *Japonisme* artists in the late nineteenth century and included *Rashōmon,* which had ostensibly received a less than warm initial reception at home.[50]

Other witnesses and commentators more explicitly blamed domestic censorship regulations for rendering Japanese films uncompetitive in the West. In response to the Nikkatsu indictment, *Black Snow* director Takechi surmised that the world would suspect that Japan suffered from a "laughable hair disease" because it censored depictions of pubic hair and noted that foreign film festivals were revealing just how behind Japan was. Others noted the need to bill exported Japanese pornographic films as comedies because so many cuts rendered them ridiculous.[51] Defense witness Ōshima blamed Eirin's strict, outmoded regulations for making domestic films "outwatched by foreign ones" (*KWS,* 79). And in an article published in the legal journal *Jurisuto* in June 1976, Satō Tadao most explicitly threatened the extinction of Japanese films entirely as the Big Five studios came to depend on foreign film exhibition to absorb losses incurred by domestic productions; he warned, "If this continues forever, perhaps they will stop making Japanese films and screen only foreign ones."[52]

This argument represented a curious reversal of the earlier trials, in which the prosecutor had cited the "flood of pornography" imported from the West to demonize the work on trial. Here the Nikkatsu defense was arguing that producing a flood of pornography domestically was the only way

to save Japanese film from a double threat: the bankruptcy of the domestic film industry and international ridicule. It stressed not just the financial necessity of turning to pornography but also the nationalistic stakes of doing so. Like in the *Chatterley* trial, the ghosts of the West appeared as part of an attempt to rouse nationalist proprietary sentiments. But this time international standards were used to legitimate the Japanese work on trial, not to condemn a foreign one.

The success of pornographic films in Japan was, as the defense stressed, part of an international phenomenon that included such hits as high-art porn like *Last Tango in Paris* (1972; directed by Bernardo Bertolucci), the infamous first mainstream hard-core *Deep Throat* (1972; directed by Gerard Damiano), and the French film *Emmanuelle* (1974; directed by Just Jaeckin). That some Japanese directors were aspiring to capitalize on this international trend was symbolized (albeit not altogether in the most favorable light) by the swift emergence of cheesy copycat porn pieces like *Tokyo Deep Throat* (1975; directed by Mukai Hiroshi), *Emmanuelle in Tokyo* (1975; directed by Fujii Katsuhiko), *Lady Chatterley in Tokyo* (1979; directed by Fujii Katsuhiko), and *Caligula in Tokyo* (1981; directed by Ohara Koyu).

In the early to mid-1970s, pornography was by no means as liberated in Japan as it was in western Europe. Nikkatsu Roman Porn films were, however, gaining critical acclaim in Japan and abroad in part because they offered one of the few avenues for new directorial talent during the industry's financial crisis. Domestically in 1972 and 1973, three films made the annual top-ten lists of film journals *Eiga hyōron* and *Kinema junpō;* in 1973, the Directors Guild of Japan awarded the New Director's Encouragement Prize to Nikkatsu Roman Porn director Tanaka Noboru; and also in 1973 another Nikkatsu director, Kumashiro Tatsumi, won the prestigious *Kinema junpō* screenplay award for his 1972 *Ichijō Sayuri: Wet Desire* (*Nureta yokujō*), whose lead actress, Isayama Hiroko, also won the magazine's best actress award that year.[53] Internationally, the line debuted at the 1976 Cannes Film Festival with an uncensored print of Kumashiro's *Street of Joy* (*Akasen tamanoi: Nukeraremasu,* 1974), which received rave reviews from the French press.[54]

The tension between the liberal international trends and the more conservative domestic Japanese film industry was especially apparent at international festivals. The first major scandal occurred in 1965 when famed Pink director Wakamatsu Kōji's *Affair within Walls* (*Kabe no naka no himegoto,* 1965) was unexpectedly sent to the Fifteenth Berlin International Film Festival. Eiren quickly sent a statement to the film festival organizers

disavowing any responsibility, "We don't recognize this film as a representative work of Japan," and pressed for its withdrawal. After Eiren expressed its concern to the Japanese consulate general that the film would "hinder Japanese-German cultural exchange," the consul wrote to the Cultural Bureau of the Ministry of Foreign Affairs to deny the film's status as an official submission from Japan. The Japanese Film P.E.N. Club joined the protest, demanding that the work be withdrawn and criticizing it as an "atypical work that was made in order to show sexual depiction." Notwithstanding the protests, the film was screened as an "invited" work, and Eiren boycotted the festival for the next two years. Tellingly, this episode became known as the "national disgrace film incident" (*kokujoku eiga sōdō*). As Eiren had put it, it was rejecting the film's right to "represent" Japan.[55]

Nowhere is film's role as cultural ambassador more apparent than at such international film festivals. Festivals offer an opportunity to authorize and to canonize one's desired version of a national film culture, which explains why they often become such hotbeds of controversy. For Japan, they often entailed an added layer of complexity about the relationship between international and domestic moral and aesthetic values. Censorship trials function in a very similar way: as an exercise in canonization and as a platform on which competing ideal models for cultural production are pitted against one another. What was perceived to be at stake at the trial was national cultural identity—the very representation of Japan to itself and to the West. Both the defense and prosecution were tapping into this rhetoric of national pride and identity, but with completely opposite conclusions. For the defense, explicit sexual depiction was a symbol of modernity and cosmopolitanism, a sign that Japan had shed its feudal roots and joined the international liberal community, and that Japan could compete culturally, economically, and in terms of human rights. For the prosecutor, such films had irrevocably tainted and retarded the illustrious history of Japanese film. In his closing arguments, he lamented,

> From way back when, films have been loved and enjoyed as art or mass entertainment by the people. Many great works have been left behind, and our country has made a great number of contributions to culture and art. The current flood of Pink Films and porn is truly deplorable, and the defendants' actions, which have led the situation to its current state, disregard the efforts of their predecessors and have left a large stain on the history of the film world. (*KWS*, 14)

In the prosecutor's eyes, to blame were the studio executives who formulated the genre in their crass "pursuit of profits" and the directors who blindly followed their lead. Also culpable was Eirin, which betrayed the trust placed in it by the *Black Snow* judges, who had praised its "effective role as the film industry's self-regulating body, highly respected by society."[56] The Nikkatsu prosecutor harshly censured Eirin in both his opening and closing remarks, accusing the organization of having "lost sight of our nation's healthy societal morals and film ethics under pressure from the film industry, which entrusts its fate to pornographic films, entranced only with a trend of flashy commercialism" (*KWS*, 13; cf. 197). Again ensued fierce accusations that Eirin was merely a front for the film industry. The impression that Eirin was a handmaiden was clear to all involved, but the question was to whom—the state, as the directors claimed, or the film industry, as the prosecutor charged?

Eirin—Industry or State Censors?

In the eyes of the law, the industry censor too was conceived as a coauthor, or at least an editor of sorts that was responsible for suggesting revisions and deletions. The Nikkatsu prosecutor technically charged the Eirin inspectors with being "accessories to the crime of distributing obscenity" (Criminal Code, article 62) because they "made possible the screening of the films in general theaters, and this facilitated the other creators' crimes" (*KWS*, 13–14). As evidence against them, the prosecutor cited the many places where the films clearly contravened Eirin's August 1965 regulations that had been issued after the *Black Snow* indictment, such as the requirement that filmmakers "avoid depictions that plainly suggest sexual intercourse, even if it is not directly depicted, that is, entangled legs, exposed lower bodies, . . . women's breasts, torsos, and the kissing or petting of these" (*KWS*, 194–195). That these regulations were hopelessly outdated in the context of the early 1970s and often ignored in practice was readily admitted by both an Eirin inspector and the Eirin chair in their testimony (*KWS*, 143, 169–170).

Nonetheless, since Eirin represented the official regulations, the state charged it with failing to uphold its role as industry censor and instead succumbing to commercial pressure from the studios. Ironically, this is precisely what the Nikkatsu studio representatives had themselves accused Eirin of in the earlier *Black Snow* trial: at the time, Nikkatsu executive director and "father of the Sun Tribe" Emori defended the studio for distributing

Black Snow, claiming, "It is only natural for a film company to seek profits. At the same time, we would ask that Eirin fairly and strictly regulate us without hesitation and without concern for commercial profits." (As former Eirin employee Endō Tatsuo noted, this statement was patently disingenuous, since Nikkatsu was notorious for fighting tooth and nail against every revision suggested by Eirin.)[57] The defendant-directors acknowledged the contradictory pulls of censorship regulations and commercial necessity both in their trial testimony and in the media: in a June 1973 interview in *Eiga geijutsu,* defendant Kondō complained that directors were impossibly sandwiched between "Eirin's regulations and the company demands" but squarely blamed Eirin's insufficient regulations for the indictment. In the *Asahi* newspaper feature "Reconsidering Eirin," director Kinoshita Keisuke noted that incidents like the Nikkatsu charges were inevitable when you "try to have the film companies that seek profits regulate themselves."[58]

For the defendant-directors, being lumped together with the censor was the ultimate affront to their artistic integrity. A cooperative relationship with Eirin was impossible, since Eirin was nothing other than an arm of the state in their eyes. In his testimony and in the press, director Yamaguchi railed against the joint indictment: "The viewpoint that champions Eirin as a buffer zone between us and the authorities or as a democratic organization is an illusion. For me as a director, Eirin's existence is nothing other than a representative of the censors [*ken'etsu daikō kikan*]. . . . As I've said before, Eirin is a complete hindrance. We should do away with it and confront the police directly" (*NPS,* 59). In large part, the tensions evident between the codefendants were a result of the indictment of the censor alongside artist and patron. As Yamaguchi astutely noted, the three parties were wildly incompatible considering "the oppositional relationship between Eirin, management [literally 'capital,' or *shihon*], and film directors."[59]

Was Eirin an arm of the state or a handmaiden of the film industry? As with the earlier scandals, in the Nikkatsu case both accusations were plausible. On the one hand, Eirin appeared to be firmly on the authorities' side since it again followed a predictable pattern of apologetic submission and retrenchment. According to one critic, Eirin revised its regulations in response to police threats over ten times between 1969 and 1973 alone. Here too, just a month after the fourth film was added to the Nikkatsu indictment, Eirin issued another "new" set of regulations, including the stricter than ever dictum disallowing even the suggestion of genitals or vocalizations during sex scenes. And again, Eirin responded by clamping

down on film inspections, causing a so-called chilling effect.[60] Accusations that Eirin had become an "arm of the police" were further fueled by the appearance of Eirin's director of operations as a cooperative prosecution witness who offered a scene-by-scene evaluation of the countless ways one of the Nikkatsu films violated Eirin's regulations, and also by the resignation of two of the indicted Eirin inspectors, Arata and Takei, in June 1973 just after the lower court trial had begun (*NPS*, 169–174).

On the other hand, the higher-ups at Eirin also sided with the defendants to an unprecedented degree this time by initially voicing their support of the individual Eirin inspectors. Eirin, in turn, was supported by Eiren, which established the Committee to Develop a Court Strategy in the Eirin Trial in September 1972 and even raised inspection fees to offer monetary support.[61] And a defiant seventy-one-year-old Eirin inspector, Kimura Sadao, willfully turned on the prosecution at the trial despite his seemingly complicit testimony during the police investigation, prompting the prosecutor to ask if he was nearsighted when he professed not to see ejaculate in a still photograph screen capture from the film *Love Hunter* (*NPS*, 180).

Eirin's official response to the Nikkatsu charges was to deny its culpability, since as a nongovernmental advisory organization it was not responsible for assessing violations of the law. By the nature of its very mission, the organization was forced to tread a thin line between the roles of regulator and advisor. From its earliest days, Eirin depended on nuanced semantic distinctions to distinguish itself from the state censor. Writing in the mid-1950s, one of the first appointed inspectors, Kobayashi Masaru, stressed that Eirin submitted "request opinions" to filmmakers, not "orders," and asserted, "We are not regulators of film. We exist in order to make films proper. In other words, we're not censors, but lawyers." Fellow inspector Sakata Ei'ichi similarly recalled that they were told to avoid the impression of being too "censorlike" in their recommendations and instead of calling for "deletions or revisions" to merely indicate places that were "desirable to cut." In 1956, after the Sun Tribe scandal, Eirin tellingly dropped the word "regulations" (*kitei*) from the organization's name. And again in 1970 when the police targeted twelve Pink Films, Eirin defended itself in a public meeting with police by arguing that Eirin regulations were not law but only suggestions to filmmakers to "take care with" certain items.[62]

For some, charging Eirin in the Nikkatsu trial was purely a legal strategy designed to defeat the directors and studio executives by disallowing them to blame Eirin in its absence, and many were forecasting Eirin would

be acquitted whereas the directors and executives would be found guilty (*KWS*, 236–237). But for others, the joint indictment was proof that Eirin was not a handmaiden of the state and constituted a badge of honor for Eirin; as director Onchi Hideo noted, "Eirin has been said to be a front [*kakuremino*] [for the authorities], but now we know that it's no front based on the recent indictment."[63] As we will see, any accomplishments in this direction were largely undone when the not-guilty verdict endorsed Eirin's role as "representative censor."

The Verdict

After five long years in court, the judges issued a not-guilty verdict for all nine of the Nikkatsu defendants on June 23, 1978, a decision that was subsequently upheld by the High Court in July 1980. Technically, because the verdict was based in part on the judges' assertion that the films were not obscene, its usefulness as a broad legal precedent that would expand constitutional protection to all media, including obscene works, was minimal. But in practice, the exoneration of self-designated "porn" films by the courts was momentous. In the verdict, the judges revisited two central debates raised in the *Black Snow* trial: one, the role of Eirin and its relationship to state censorship, and two, the specificity of the filmic medium as a "time art." The judges took into account the role of financial need and international norms as well, surprisingly agreeing with the defense that these constituted mitigating factors. The judges' conclusions on all these issues boded well for the medium of film, which would not again become the object of an obscenity trial. Most crucially, Eirin was definitively upheld as the ultimate arbiter of films.

On the Role of Eirin—State Censor or Studio Lackey?

As legal commentators noted at the time, the verdict was particularly momentous because it affirmed Eirin's quasi-official role as arbiter of the limits of sexual representation in films.[64] Both sets of judges were careful to affirm the courts' right to prosecute an obscene film even if it had passed Eirin; as the High Court judges asserted, "It goes without saying that the ultimate authority rests with the state institution of the courts, not private organizations like Eirin." Nonetheless, the courts endorsed Eirin, reasoning that "the goal of article 175 is to maintain the 'minimum degree of morality' [*saishō gendo no dōtoku*]," but the primary mechanisms for such regulation are "religion, education (defined broadly as not only school education but

also family education, societal education, etc.) . . . as well as other societal regulatory measures."[65] In other words, while the law was to be the last line of defense, Eirin and other societal organizations were deputized as the first.

The judges' optimism about Eirin's ability to police the film industry was boundless notwithstanding its failures in that "undesirable 'Black Snow' incident" in which Eirin had been chided by the High Court judges for "excessively weighing the creator's subjective intent and for relaxing the interpretation of its regulations."[66] According to the Nikkatsu lower court, Eirin's evaluation of a film was to be "respected as much as possible when determining obscenity" because "we recognize that it has society's approval and trust based on its track record in our country . . . and has come to occupy an established societal role in terms of preventing violations of sexual morality and mores in films."[67]

On appeal, the prosecutor objected to the judges' overreliance on Eirin, but the High Court also offered its unqualified endorsement. The judges cited as evidence of Eirin's integrity its laudable mission statement "to strictly suppress any films that would lower the ethical standards of spectators"; the unimpeachable character of its top committee members, such as former education minister Takahashi Sei'ichirō, who were not "mere window dressing" (tannaru kazarimono) but intimately involved in the day-to-day operations; its independence from the film industry, especially its revised fee system based on film length and its consensus-based inspection system; its policy of issuing revised regulations based on a consideration of police regulations, legal precedents, and the state of affairs in Europe and the United States; and finally, its response to the *Black Snow* incident—both the admission that an error had been made by inspectors, who failed to consult the Eirin Commission of Councilors, and its subsequent provisions for putting erring inspectors on probation.[68] Here we can see how Eirin's responses to previous scandals were crucial to gaining the endorsement of the state censors and to securing a not-guilty verdict in the Nikkatsu trial.

The judges seemed particularly impressed that Eirin had managed to maintain a "minimum degree of sexual morality" in light of the international trend to liberate pornography. In the lower court verdict, the industry censors were depicted as beleaguered by the flood of both domestic and international pornographic films. To explain why Eirin had not followed its own regulations to the letter, the judges noted that Eirin was in the process of researching new regulations at the time of the Nikkatsu charges. At fault, however, were not the individual inspectors who had sought consensus

among their colleagues and supervisors but rather "the increased production of adult films domestically and the so-called sex films imported in large numbers from abroad" that had made the existing regulations created in the wake of the *Black Snow* trial seem too strict and outmoded.[69] The judges demonstrated a keen interest in the state of films abroad, and the chief judge even traveled during summer recess to research sexual expression in foreign countries (*NPS*, 264–265). In the verdict, Eirin inspectors were praised for being "people who have general knowledge about films, societal education, and *international culture*," and for taking into account "the state of affairs in Europe and America" when revising regulations.[70] The judges also allowed both the 1970 U.S. Presidential (Johnson) Commission on Obscenity and Pornography report, which rejected restricting adult access to sexually explicit materials, as well as extensive testimony from the Eirin inspector for imported films and from Japanese legal scholars about the international trend to liberate pornography.

The admission of all this international comparative evidence in the context of an obscenity trial is striking. In previous trials, judges had proven to be completely unmoved by any argument that invoked international norms and instead proudly asserted the absolutist morals of "our nation" (*waga kuni*). Like their predecessors, the lower court Nikkatsu judges were clearly concerned that Japan not be tainted by international trends and definitively rejected the dawn of the "eve of liberation" in Japan: they wrote, "Nowadays, it is true that there are cries for the liberation of porn, but in our country, presently, because article 175 of the Criminal Code firmly remains, . . . Eirin must not become a so-called 'front' for the film industry."[71] At the same time, the judges also clearly admitted the necessity of considering what these trends were, especially in the context of the poor economic situation of the domestic film industry and the global nature of film production in the 1970s.

On Market Law—Crude Commercialism or Competitive Countermeasure?

The lower court judges rehashed the dire financial situation of both Nikkatsu and the domestic film industry as a whole. Although not explicitly identified as a mitigating factor in the verdict, this suggests that they were at least willing to consider its relevance and were perhaps even swayed by the defense arguments on this point. Suggestively, the essay by film critic Satō Tadao detailing these financial woes appeared not in a film journal but

in a legal one during the lower court trial. In the verdict as well, the judges framed the plan to revive the company with Roman Porn as an agreed-upon strategy between management and union employees that was taken only after "film production too temporarily was forced to stop" following the collapse of Dainichi. In addition, the judges noted that Nikkatsu's new line was modeled after Pinks, suggesting that the studio was merely adopting a preexisting survival strategy that "had inexpensive production costs and moreover offered a stable market,"[72] not pioneering an entirely new genre. Here we see the success of the defense's practical arguments about the economics of film production in an era of television and globalized film distribution. Equally important, we see also the success of an emotional argument with repercussions for national film preservation. Like the *Black Snow* trial in which Takechi had defended the film's content and form as a political anti-American statement, again producing pornography was a means of preserving national culture.

The ultimate success of the Nikkatsu defense should be attributed not solely to any nationalist motivations of film preservation but to the courts' recognition of the positive counterinfluence of Eirin, which only fueled the critique that the organization was indeed a front for the authorities. As one reporter put it, "The verdict offered proof anew from the authorities that Eirin, sure enough, is a repressive organ" (*KWS*, 237). In the verdict, Eirin was formally recognized as an insider censor, whose job was to apply "reverse brakes" to slow the internationally and commercially driven march toward the liberation of porn in Japan.

On the Particularity of Films—Fleeting "Time Art" or Realistic Impression?

In addition to establishing a precedent for the state's unqualified endorsement of Eirin, the Nikkatsu trial also offered an important precursor for later trials of other media because it revisited the debate raised in the *Black Snow* trial over medium specificity, albeit to a lesser degree. As a spectator at the Nikkatsu trial complained, it failed to truly become an "image trial" (*eizō saiban*) because the lawyers and witnesses engaged in little discussion of the nature of film as a distinct medium (*NPS*, 201). The Nikkatsu police investigators and prosecutors appeared unaware of the particularity of film, as evidenced by the artificial means used to exhibit films to witnesses— still shots of isolated scenes shown either in photographs or on a hand-cranked viewing machine, often without sound. As in the *Chatterley* trial,

where potential prosecution witnesses had received copies with underlined excerpts, Nikkatsu witnesses too were shown the objectionable scenes out of context.

In the case of film, however, the distortion was even greater because the isolated scenes appeared in a form utterly unlike usual exhibition practices. As we saw above in director Umezawa's testimony, he was asked to comment on scenes from *Love Hunter* shown without music after the player was "stopped and rewound at objectionable scenes," prompting the defense lawyer's objection (*NPS,* 161; cf. 180, 219–221). Defense witness director Shindō similarly criticized the prosecution's tactic and argued that "images and literary prose are different. Images cannot be judged in parts. Novels can be read over and over, but with images, once it gets dark, you must watch until the end" (*KWS,* 55). Here, the Nikkatsu defense team implicitly invoked the *Black Snow* lower court ruling that had claimed the fleeting images of film as a "time art" to be inherently less obscene than prose.

Despite the complaint that the Nikkatsu trial failed to achieve the status of a "true image trial," it too engaged in a debate about the hierarchy of media that contrasted words and images, as well as still and moving images. For the Nikkatsu judges, how spectators perceived the images in a film depended equally on their content and their form. The question was two-fold: First, did the films represent the "real thing" (i.e., sexual intercourse, genitals, etc.) or close enough that the spectator would apprehend it as such? Second, did the filmic medium encourage or discourage the perception of images as obscene?

First, in terms of content, both sets of judges agreed that if the images were the "real thing," actual sex or genitals that were depicted unambiguously like in blue films, the films would be deemed obscene. Where they departed was in their assessment of whether this was a violation of the "universal principle of the nonpublic nature of sex" established in the *Chatterley* trial. The lower court conspicuously omitted mentioning the existence of this principle in its verdict, an omission that provoked the High Court judges to accuse them of erring in "writing as if there has been a shift in the principle."[73] Both courts, nonetheless, claimed that Japanese sexual morality differed from that of other nations, an assertion that was not without a tinge of national pride. The lower court judges praised Japan for not following in the footsteps of the Western liberation of porn and for maintaining a higher standard of morality that forbade direct representations of real sex, while the High Court judges distinguished Japan from the third world, asserting that

"the principle of the nonpublic nature of sex" was universal among civilized nations including Japan but "excluded the case of primitive tribes."[74]

Like their predecessors, the Nikkatsu High Court judges upheld this principle without clearly addressing its failure to distinguish between reality and representation, despite the many calls by defense witnesses to do so. At the lower court trial, legal scholar Shimizu noted that the slippage between the two registers was apparent even in the Criminal Code, which juxtaposed real-life crimes of obscenity, like public indecency or flashing in article 174, with obscene representations in prose and pictures in article 175 (*KWS*, 41–42). As defendant Kurosawa Man complained in his opening statement, why did the prosecutor seemingly understand the difference when it came to representations of murder but not of sex? (*NPS*, 51; cf. *KWS*, 91).

For the Nikkatsu prosecutor, the rhetoric of realism was central to his charges. In his initial questioning of possible witnesses, the prosecutor asked, "Could you do these kinds of obscene things (shown on the screen) in front of your children? In the middle of the Ginza?" (*NPS*, 5; cf. *KWS*, 186). In trial too, the prosecutor persistently questioned witnesses about rumors that director Yamaguchi had an actress take drugs to loosen her inhibitions during rehearsals for a masturbation scene so that he could "get bolder acting." When cross-examined by the prosecutor, the antagonistic Yamaguchi did not help the defense's case when he asserted her use of drugs was a form of method acting, explaining "the actress herself wanted to enter into the world" of the protagonist.[75] In his closing argument, the prosecutor charged that the films "were created not only with the intent of mobilizing spectators . . . but also to impart to viewers a feeling just as if these sex acts were occurring before their eyes in public" (*KWS*, 11). This accusation that sex acts would come to life before viewers' eyes would become a central feature of the subsequent trials. It makes explicit the charges of realism that had been implicit all along in the notion of "the principle of the nonpublic nature of the sex act," a lofty-sounding phrase that the dissenting justice in the *Chatterley* Supreme Court verdict had criticized as nonsensical, although it has "a really grand ring to it."[76] For the prosecutor, it was not just that the films depicted the "real thing" (genitals and sex acts) but that film as a medium encouraged spectators to perceive representation as real.

In their verdict, the judges nuanced the prosecutor's position slightly. They admitted that the filmic depictions were not the "actual thing" (*jissai no mono*) since they did not clearly show either genitals or sex acts. Instead, they were "depictions that made one think of genitalia, the sex act, or

petting." While the former was undeniably obscene, in the case of the latter one must consider whether the degree of their depiction exceeded societal standards.[77] Here the judges were clearly acknowledging a distinction between simulated and real sex but not necessarily between representation and reality.

According to the judges, what saved the films' objectionable content—their many "depictions that made one think of genitalia, the sex act, or petting"—was the efficacy of Eirin's self-censorship techniques that lessened the reality effect, such as masking, abbreviating or darkening scenes, the comedic and theatrical performances or gaps between bodies, and the use of long shots. In their evaluation, the judges willfully discounted any obscenity in these scenes out of a seeming desire to endorse Eirin's efficacy as a self-regulatory organization. For example, the High Court judges concluded that *Love Hunter* "is the most problematic film among the four films, and if Eirin hadn't demanded abbreviations, etc., it might have been judged obscene. But in fact, as a result of Eirin's advice to make cuts and insert maskings, the effect and force delivered directly on the vision are weakened, and it narrowly avoids being obscene."[78] The judges were reassured by Eirin's censorship tactics but, like the prosecutor, feared that film had the unique force, or, literally, the "power to press in" (*hakuryoku*) on spectators.

This brings us to their second criterion for evaluation: did the medium of film encourage the potential obscenity of the images? The lower court judges devoted a large section of their verdict to "Things to Consider in Particular When Determining Obscenity Because the Object on Trial Is Film." This lengthy section reveals how the court subscribed to a hierarchical understanding of the powers of the respective media of literature, film, and photography:

> The special characteristics of films are that they are made from images and sounds, the images move, and moreover, the individual images change from one scene to the next at a fixed speed. In other words, because they appeal to vision based on images that move, they impart a direct and strong impression and, for this reason, are potentially very stimulating. On the one hand, in the screen image there is movement in the performances by actors appearing on-screen, and the scene is accompanied by color and voices, giving it a sense of presence. It becomes realistic and vivid and the impression on viewers has strong suggestive power. But, on the other hand, the image is not still like a photograph

but changes from moment to moment, so that it is understood in terms of what comes before and afterward. And based on the fact that the screen images move, they are experienced by the vision only momentarily, and there are cases where they don't leave a clear impression. In that sense, unlike photographs, where one fixates on a still image, in the case of film there are instances where the impression is weak or even almost nonexistent and so is the stimulus.[79]

Here the lower court judges were straddling two opposing views of film. On the one hand, film was especially dangerous because its moving images endowed it with a realistic "presence" (*rinjōkan*). On the other hand, film was innocuous precisely because its images moved; echoing the *Black Snow* lower court verdict that deemed film a "time art," the Nikkatsu judges stressed the mitigating effect of film's fleeting moving images, which ensured they would only momentarily enter the spectator's vision and would be contextualized as part of the film's whole. Whereas film was deemed innocuous based on this latter point, on both these counts photography was particularly suspect. After all, it was not a "time art" but instead allowed a viewer to fixate on an isolated and frozen spectacle.

On appeal, the prosecutor disputed the lower court's overdependence on the "film-as-time-art" argument and instead appealed solely to film's realism, its unique power to impress itself upon viewers. The High Court judges, however, insisted that the prosecutor had overestimated spectators' powers and called for a judgment based on "the limits of what can be understood by spectators with ordinary enthusiasm and ordinary powers of concentration, not based on a standard of a spectator with extraordinary powers of vision, hearing, or memory."[80] The judges were thus dismissing the implied model of spectatorship offered by the prosecutor and also the validity of the testimony of the eager prosecution witness who had calculated the sex scenes in one at a total of precisely 31 percent. They were also refuting the prosecutor's fundamental assertions about film's ability to impress itself upon a viewer in a particularly powerful way.

By relying on an explicit comparison between film and photography, the judges were asserting a ranking of the powers of media that placed photography at the apex and film and prose below it. The Nikkatsu verdict set a distinctly unfavorable precedent for the medium of photography, as we will see in the later trial of Ōshima's book, which included color photographic stills that captured the motion of the live film actors' bodies but lacked the

motion of a "time art." Although photography was rated as the most poten-
tially obscene medium, in fact this same argument would be used to convict
prose. As we will explore next in part 3, the ostensibly "unique" powers of
the moving image were not limited to images or film alone. Those very
"extraordinary powers" of memory, vision, and sound that the Nikkatsu
prosecutor had attributed to film spectators would be invoked quite success-
fully to convict prose and readers in the "Yojōhan" trial.

The Triumph of Porn and Eirin

Even after the trial ended, the problems were not over for Nikkatsu. After
hitting its peak annual income in 1982 at close to four billion yen, another
crackdown by the authorities in 1984, and in the face of escalating competi-
tion from the adult video (AV) market, the Nikkatsu Roman Porn line was
terminated in 1988 and the company filed for bankruptcy in 1993. The
inability to sustain the genre any longer was due in large part to competition
from the booming AV market with the increased commercial availability of
VCRs (by 1987, one in two families owned one).[81]

The end of Nikkatsu Roman Porn was also perhaps inevitable.[82] As
the belligerent prosecution witness who was accused of nearsightedness
noted, "Spectators have a metabolism. For the people who graduate from
pornographic films, a new successor will be born."[83] Pushing the envelope
was especially inevitable in the context of a continued industry-wide finan-
cial crisis for domestic film companies and increasing competition from
imported films but resulted in the end only in the saturation of the market
with porn. By 1975, Eirin's "recommended children's films" were down to
just four domestic films and twelve foreign features compared with a whop-
ping 239 adult domestic films and fifty-seven imported ones. By the late
1970s, Pinks and Nikkatsu Roman Porn would occupy over 70 percent of
the domestic film production market. In 1975, for the first time in his-
tory, imported films would occupy more of the market and make more
money than Japanese ones, so the war was lost in more ways than one.[84] In
addition to the succession of "Tokyo ladies"—*Chatterley, Emmanuelle,* and
Deep Throat—that appeared on the market in the 1970s, the 1980 Tokyo
screening of *Caligula,* albeit with 332 places censored,[85] offered the perfect
symbolic punctuation mark to the end of the Nikkatsu trial, a signal of
the successful absorption of international porn and defeat for the domestic
film industry.

PART III

THE CANON UNDER FIRE

A striking shift occurred in the kind of literature targeted in the 1970s landmark obscenity trials. Whereas in the 1950s and 1960s the translated works of Lawrence and Sade were the objects on trial, in the 1970s works with conspicuous ties to canonized Japanese classics and authors became targeted in two literary trials that reached the Supreme Court: the 1968 republication of the Edo-period *The Record of the Night Battles at Dannoura* (*Dannoura yagassenki*, ca. 1800), a pornographic adaptation of the canonical medieval text *The Tale of the Heike*, and the 1972 republication of Nagai Kafū's 1924 "Yojōhan," written in the style of Edo-period *gesaku* (playful fiction). The *Dannoura* trial, despite having reached the Supreme Court in 1976, remains largely unknown in part because the work was tried alongside four other obscure works: two translations of Western works and two Japanese publications.[1] As the defendant-publisher himself admitted, the four works were "not great artistic masterpieces" but rather "insufficient to occupy even the most marginal corner of culture."[2] (The trial did, however, garner the attention of the Nikkatsu defendants and Ōshima, who would adopt his catchphrase "What's wrong with obscenity?") In contrast with this relatively low-profile trial, the "Yojōhan" trial marked the last literary obscenity trial in Japan, reaching the Supreme Court in 1980 and becoming a full-blown media spectacle with the help of the media-savvy defendants, authors Nosaka Akiyuki and Satō Yoshinao, who were the editor and publisher of the journal in which the story appeared.

This was not the first time Kafū's story had been the object of obscenity charges. Back in the late 1940s, Kafū had denied authorship and narrowly escaped being charged when the police targeted and convicted a publisher, Matsukawa Ken'ichi, and a couple of booksellers for republishing and selling just 314 copies of the work in 1950. Although a far less influential precedent than the contemporaneous *Chatterley* trial, as a case against native literature the 1948–1950 "Yojōhan" trial offers an important counterpoint demonstrating that Japanese authorities did not target only translations of foreign works in the immediate postwar period. In fact, the publisher was simultaneously charged for selling another obscene native "classic," the Edo-period collection of bawdy senryu verse *The Safflower* (*Haifū suetsumuhana*, 1776). Likewise, the targeting of domestic and foreign works side by side in the *Dannoura* trial refutes any characterization of the 1970s as a time when the Japanese classics were exclusively targeted.

As the object of two trials, the first in 1948 to 1950 and the second from 1973 to 1980, "Yojōhan" offers an instructive case study that neatly

frames the beginning and, seemingly, the end of Japan's postwar literary obscenity trials. Suggestively, the work was consistently found guilty notwithstanding the relatively small number of copies sold in each case (314 and 28,000, respectively) and notwithstanding the undeniable changes in sexual morality and in the acceptable limits of sexual depictions during the more than two decade interim. Moreover, both "Yojōhan" trials offer examples in which other republished Japanese classics—*The Safflower* and *Dannoura*—were simultaneously or contemporaneously tried. For all three works, the original authors were absent, either because they were long dead or figuratively so as in the late 1940s "Yojōhan" trial, where Kafū denied authorship and was not himself charged. On trial in their stead were editors and publishers. As such, a comparison of these trials can suggest how anxieties about the appropriation of canonized authors and texts by irreverent modern publishers propelled the censor in these cases. They also suggest just how prominently notions of authorship and authenticity often figured in obscenity charges. In addition, the fact that each work employs classical language estranged from contemporary citizens—the comic verse (senryu, a descendant of Matsuo Bashō's *haikai*) of *The Safflower,* the mixed Japanese-Chinese (*wakan konkōbun*) of *Dannoura,* and the pseudoclassical style (*gikōbun,* an Edo-period revival of classical Japanese) of "Yojōhan"[3]— meant that the trials also participated in broader ongoing debates about the state of classical language and literary education in postwar Japan. While the defense would accuse the prosecutor and judges of attempting to sanitize the classical literary canon into an anodyne bureaucratized state version, the prosecutor and judges would accuse the defendants of sullying that canon beyond recognition. At heart, the trials staged a struggle to purify and to define the Japanese literary canon, language, and even the very definition of native cultural identity.

CHAPTER 5

Pornographic Adaptations of the Classics
The Safflower (1948–1950) and *The Record* of the *Night Battles at Dannoura* (1970–1976)

In late 1948, publisher Matsukawa Ken'ichi was indicted for the publishing, sales, and possession of 1,400 copies of *The Safflower* and for selling 170 copies of a privately published secret edition of Kafū's "Yojōhan." In the Tokyo District Court verdict of August 1950, although the publisher was acquitted of all charges relating to *The Safflower*, he was convicted on the "Yojōhan" charges and given a three-month prison term as well as an additional two-year suspended sentence. Two booksellers also indicted were similarly acquitted of all charges related to *The Safflower* but convicted for "Yojōhan," with the first receiving the maximum allowable fine of 5,000 yen for selling 147 copies and the second fined 3,000 yen for possession with the intent to sell for a mere two copies.[1] Significantly, the court found all involved guilty for selling just over 300 copies of "Yojōhan," while it acquitted them for selling almost five times the number of copies of *The Safflower*.

What can explain the huge disparity in these verdicts? Clearly not the breadth of distribution. Because the judges offered no explanation for their decision to convict "Yojōhan," instead devoting their entire verdict to justifying why they exculpated *The Safflower*, we can only speculate as to the reason.[2] But tellingly, the prosecutor opted not to put the author Kafū himself on trial while severely punishing the publishers and booksellers for republishing and selling "Yojōhan." The perceived gravity of the offense suggests that the sanctity of a canonized author like Kafū was at stake. A discussion on how such charges of authenticity and inauthenticity surrounding authorship figured prominently in the "Yojōhan" trials follows in the next

chapter. First let us consider how the concurrent trials of *The Safflower* and *Dannoura* staged a debate over the authenticity of the work itself and especially its archaic language.

The Safflower: Authentic Classic and Archaic Genre

Grabbing a pickled radish, the maidservant takes her leave.
The cheating man is frustrated and escapes grumbling.

takuwan o / nigitte gejo wa / sarete iru
mao no fushubi wa / koboshikoboshi nige

—*The Safflower (Haifū suetsumuhana*, ca. 1776)[3]

The Safflower is a late eighteenth-century collection of senryu, a genre of comic verse that was essentially a more vulgar and witty offshoot of Bashō's *haikai*.[4] In choosing the name of one of the most vulgar characters from a classic like *The Tale of Genji*—the large, red-nosed Lady Suetsumuhana—the collection can be said to insistently embrace the low within the high literary tradition. The association between the two works was limited mostly to its title, although some of its verses contain parodic sexual references to *Genji*, as well as to other classic Japanese premodern texts.[5] The work consists of primarily capping verses (*tsukeku*), seventeen-syllable verses that were originally created by adding a verse to the previous fourteen-syllable one (*maeku*) composed by another poet. As an exclusive collection of indecent senryu, or "last choice" verses (*suebanku*), the work is composed of the bawdiest of the bawdy. Its verses describing "instances of rape, illicit intercourse, streetwalking, [and] pornographic pictures" were originally gathered into this single volume from among those routinely deleted from published collections out of fear of censorship.[6] In the late eighteenth century, similar collections were published but were eventually discontinued as a result of the Kansei Reform (1787–1793) censorship regulations. In the modern period as well, *The Safflower* repeatedly encountered censorship bans, including, most notably, a 1928 annotated version by author and publisher Umehara Hokumei, who was often targeted by the censors for his erotic and proletariat writings.[7]

In the 1950 indictment, the prosecutor charged the publisher Matsukawa with "collecting old senryu verses that were vulgar into a pocket-sized edition [*bunkobon*] and adding footnotes" (*YS*, 1:146). Of significance, even in this terse indictment the prosecutor noted the addition of footnotes by the publisher and the choice of a portable and inexpensive medium. At

issue here was a question of access and accessibility, its republication into a comprehensible and portable form.

For the judges, however, making a lost Japanese poetic tradition available to contemporary Japanese readers redeemed the enterprise. In their verdict, the judges spent an inordinate amount of time lecturing about the importance of senryu in Japanese literary and cultural traditions, citing its origins as an "abbreviated and massified" form of humorous linked verse, a "recognized genre from old times" that probed "the underbelly of the world and the subtleties of human emotions." Although some of the verses about sexual love imparted an obscene feeling, the judges concluded that "rather than 'exciting sexual lust' they invited laughter at their wit and novelty" (*YS*, 1:146).

In sharp contrast with the parties at the contemporaneous *Chatterley* trial, these judges were not subscribing to a purely utilitarian or moralistic notion of literature but affirmed rather the essence of senryu: play. They endorsed the inclusion of sexual material because it followed the genre's original intent of generating humor: they concluded the verses "were not originally created with the intent of directly arousing sexual desire but merely as capping verses that came to encompass various aspects of sexual love as material to invite a reader's amusement" (*YS*, 1:147–148). In their verdict, the judges upheld the literary and cultural value of senryu as a bawdy, humorous genre and the authenticity of *The Safflower* as a literary and cultural artifact, leading them to affirm its importance as a worthy republication even (or perhaps especially) in the late 1940s.

What also seems to have swayed the judges to exonerate the publisher was the book's authentic and archaic genre and language:

> *The Safflower* is abstruse because it uses the specialized language of senryu, and there are many verses that cannot possibly be understood without the aid of a specialist in the field; moreover, based on the craftsmanship of the form and on the use of abbreviated words, there are many verses whose meaning can be understood only by readers possessing considerable knowledge and education. Therefore, even if these verses are fairly obscene, they lack the qualities of immediacy or arousal. (*YS*, 1:147)

Not only would the specialized language and form of senryu ensure a limited and educated readership but also the text was disqualified as obscene because it lacked "immediacy."

For these judges, transparent or immediate language was potentially more obscene than language that somehow veiled its meaning—through the use of an unfamiliar genre or diction. In other words, immediacy was defined as arousing whereas opacity was not. The judges in this case subscribed to what can be called the opaque language defense, an argument that was central in all the trials but especially in those of the classics. In the later, 1970–1976 trial of *Dannoura*, again at issue was the unauthorized republication of an authentic Edo-period pornographic classic that employed opaque and classical language unfamiliar to contemporary readers. Unlike *The Safflower*, however, whose ties to the classics confirmed its status as authentic, *Dannoura* was deemed heretic.

The "Night Battles" at Dannoura: Heretic Classic

> Yoshitsune announced, "Everyone pair up. . . . While together, enjoy. Men, forget the agonies of battle and women, let go of your despair."
>
> —*The Record of the Night Battles at Dannoura*
> (*Dannoura yagassenki,* ca. 1800)[8]

Dannoura, even more blatantly than *The Safflower*, asserts a tight affiliation with a Japanese literary classic, the twelfth-century *The Tale of the Heike,* the epic story of the medieval Genpei wars between the Heike (or Taira) and Genji (Minamoto) clans. Thought to be authored by the well-known historian Rai San'yō,[9] *Dannoura* offers a suggestive sequel to *Heike,* taking as its central protagonists the victorious Minamoto Yoshitsune and the defeated Heike empress Kenreimon'in. As its title suggests, *Dannoura* focuses on the "night battles" between the captured Heike women and the Genji warriors after the final major sea battle in 1185 in which the Heike are brutally defeated and commit suicide en masse when that defeat becomes apparent. In *Heike,* the battle at Dannoura occurs in the penultimate chapter and is followed by an account of the sad fates of the surviving Heike clan, or as the final line of the text puts it, "Thus the sons of the Heike vanish forever from the face of the earth." In the end, after being rescued from her suicide attempt, Kenreimon'in is reduced from one who "held the country in the palm of [her] hand" to a lonely existence praying for the souls of her dead husband and son in a remote convent.[10]

Dannoura begins just about where *Heike* leaves off with the failed drowning and rescue of Kenreimon'in by the Genji. The torrid affair of the

two tragic heroes—Yoshitsune and Kenreimon'in—begins in earnest soon thereafter. Below is an excerpt of one of the work's more explicit passages describing their affair:

> *Yoshitsune:* "Water or sake?"
>
> *Kenreimon'in:* "No."
>
> *Yoshitsune:* "Like this then?" mingling tongues, making slurping and smacking sounds. With his right hand on the empress' thighs, raising her knees all the way up to her shoulders and spreading her thighs like a winnowing fan, Yoshitsune draws the empress closer and tighter. Putting both thighs together, not a hair could fit between.
>
> *Kenreimon'in:* "Your body inside of my body still make two. If I could make a wish, our bodies would merge and forever become one."
>
> *Yoshitsune:* "Gradually melting and seeping further inside."
>
> *Kenreimon'in:* "All the way inside, I wouldn't be able to see you, oh how sad."
>
> *Yoshitsune:* "To be reborn as a baby girl and be loved by you all over again."
>
> *Kenreimon'in:* "You and a baby girl. I want just once to lie down together in the shape of the character for river [as three parallel lines]. Trusting you, do not abandon me."
>
> *Yoshitsune:* "Our urgent task is to make a baby girl."[11]

The above scene is rife with clichés that might appear in pornography today—from Yoshitsune's opening lines, when Kenreimon'in refuses his offer of a drink and he instead offers her his tongue, through his final suggestion that they get down to "business" and make a baby. As a work that puts such baldly pornographic words into the mouths of classic cultural heroes, including a member of the imperial family, *Dannoura*'s ability to provoke offense is somewhat understandable.[12]

But significantly, it was also the language into which those words had been put that rendered them offensive, especially for the High Court judges, who scathingly criticized and reversed the lower court's not-guilty verdict for *Dannoura*.[13] Although the book touted its authoritative status as "fine writing that should be called the most classic of the classics" in its preface, in fact the 1968 republication had been modified significantly

from its original form to include a number of reading aids to accommodate contemporary readers.[14] In the book, brief passages from the original Edo-period text appear in an old-fashioned sepia-toned typeface, followed by an intertext in black print that includes a modern colloquial translation, relevant background information, passages from *Heike,* as well as editorial comments. The sepia typeface of the original matches the coloring of four ukiyoe prints of scenes from *Heike* included in the book (fig. 5.1), adding to the text's aura of antiquated authenticity. The terse literary style of the original text contrasts sharply with the translation's colloquial, modern speech, complete with extensive glosses and feminine speech markers. For example, Kenreimon'in's desire "to become one body forever" (*nagaku ittai to naran*) is rendered "[I] want us to become one body for eternity" (*eikyū ni*

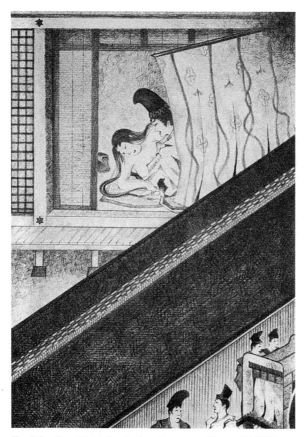

Fig. 5.1 The "Night Battles" at Dannoura (Kōmyōji 1968).

hitotsu karada ni naritai wa). The more abstract " 'Like this then?' mingling tongues" (*"Kaku no gotoki ka" to shita o majie*) becomes " 'Well then, would you like this?' sticking [his] tongue into her mouth" (*"Kore ga hoshii no ka" to shita o kanojo no kuchi ni irete*).

Disparate assessments of the function of this translation for modern-day readers led the lower and appeals courts judges to opposite verdicts. The District Court judges dismissed it as merely a partial translation, "an unpolished thing that concentrates on the colloquial translation of words and phrases and expository comments." Instead, they privileged the original text, whose "elegance of prose made it hard to deny its charm as an ephemeral lyric poem that unfolds between a hero and a great beauty of the day on the backside of a historical picture scroll." The High Court justices, in contrast, insisted upon considering the original and translation "as one unit" and concluded that the work was obscene as "the plain and detailed description of scenes of male-female sexual intercourse and related sex play."[15] Just as the lower court judges in the *Safflower* trial had claimed that the original text would have been indisputably innocuous "if only there had been no footnotes added to the text by the defendant" (*YS*, 1:147), the judges here too implied that *Dannoura* would not have been obscene if the translation and commentary had not been supplied.

Here, as in all the postwar trials, considerable weight was placed on the role of paratexts, both scholarly ones like footnotes and intertextual notations, interpretive essays, prefaces, and afterwords, and more commercial ones like advertising.[16] Such paratexts could be alternatively cited as a mitigating or contributing factor depending on how the act of reading was conceived. Would a paratext be read separately, or alongside the original as "one unit"? And would it direct readers to a sensual or an intellectual interpretation? On the one hand, commercialized paratexts—like the salacious ads hyping the illicit relationship between Lady Chatterley and the gamekeeper or the one on the book jacket of *Dannoura* that declared it "Japan's most unusual book! Complete edition published under conscientious censorship"—encouraged a dangerously affective or sensual response. On the other hand, scholarly paratexts—footnotes, translations, and explanatory intertexts—potentially offered the perfect insurance against obscenity charges if they encouraged an intellectual act of interpretation. But much depended on the content and placement of these paratexts. In the cases of *The Safflower* and *Dannoura*, these scholarly paratexts were deemed insufficient. Rather, by clarifying and facilitating the readers' understanding of

the primary text, they allowed for a potentially uninterrupted sensual experience of reading the original after internalizing the paratext.

Audience and Access: The Opaque Language Defense

According to the courts, the more legible a sexually explicit text was to the general populace, the greater its potential for obscenity. If a work was comprehensible to a general audience as the "plain and detailed description" (*rokotsu seisai byōsha*) of the sex act as the courts put it, it was more likely to be convicted. If it was inaccessible to a general audience because it used lofty, classical language, it might escape censure. On the one hand, this opaque language defense is quite prosaic. In a practical sense, it is a simple question of access, reflecting the censors' typical concerns about a mass readership not restricted based on age, class, or education level. But, as the consistent convictions of "Yojōhan" demonstrate, numbers alone cannot explain the impetus or ultimate success of these charges.

The opaque language defense involved not just a question of who was reading the work in question but also how the act of reading was perceived to affect those readers. This defense implied also a complex understanding of the reading process as encompassing both intellectual and sensual poles, as engaging both mind and body. For the prosecutors, reading was dangerous because the temptation to engage the senses, or the body, threatened to outweigh those of the intellect. The defense attempted to dispel this impression by asserting that an estranged language would engage the reader's intellectual faculties and thereby counter their sensual response.

In the trials of the classics *The Safflower, Dannoura,* and, as we will see, "Yojōhan," the fact that the original was written in a language that was estranged from contemporary readers facilitated this argument. But this debate over a work's transparency and accessibility was central in all the trials, not just those of Japanese literary classics. When the language of the text on trial was not classical Japanese, the defense claimed that the text employed other forms of opaque language, for example, abstract language, medicalized terms, a foreign language such as English or even Chinese compounds, or the more literary use of metaphor. In each case, the opaque language of the text was said to ensure a selective and intellectual readership.

For example, the justification for allowing *Chatterley* to exist in both English and French but not in Japanese hinged precisely on this reasoning. This reasoning had also guided a self-censorship strategy employed by Japanese translators: using the original English-language or katakana,

a script reserved for foreign loan words, for potentially objectionable passages. Itō Sei had used this strategy extensively in his 1955 translation of *Ulysses,* especially for Molly Bloom's salacious final monologue, and in his testimony at the *Chatterley* trial.[17] As we saw earlier, the fact that Itō had not adopted such a strategy for the translation itself and had instead used a direct-translation style concerned the lower court judges, although they ruled to exonerate him because it indicated his "sincere purpose."[18] After this not-guilty verdict for Itō was overturned by the Tokyo High Court, the defense again tried to argue for an elevated readership for *Chatterley* that excluded "adolescents, whose spontaneous powers of judgment are undeveloped," but the Supreme Court justices denied that the translation style proved either sincere authorial intent or limited readership. On the contrary, they ruled that "the existence of obscenity . . . is not something that can be influenced by the subjective intent of the author" and that "it is necessary that [a work's] influence on general readers throughout society be considered."[19] According to the judges, the use of transparent language was evidence not of pure authorial intent but of potentially corrupt and widespread readership and reception.

In the lower court Sade trial (1961–1962) as well, the defense cited the translator's choice of Edo-period elegant poetic diction (*gago*) as evidence of his scholarly intent and of the circumscribed readership for the work. In his testimony at the trial, the defendant-translator Shibusawa claimed that a translator could choose from three types of language: (1) medical terminology that had originated from translations of Dutch vocabulary into Japanese in early Meiji, such as "anus" (*kōmon*) or "vagina" (*chitsu*); (2) "vulgar language used by children"; and (3) poetic diction from Edo-period literature, such as "chrysanthemum seat" for anus. Shibusawa claimed that this last type was the only one that captured the lofty and remote tone of Sade's original work of "classical literature" set in an "aristocratic society." In contrast, Shibusawa denounced the censorship-dodging ploy of using English words like "Cant [*sic*], Prick" in recent translations.[20]

The use of such high-flown language not only attested to pure authorial (or, in this case, translator's) intent but also made reading the work into an intellectual endeavor. In the Sade trial, the defense pressed a high school Japanese language teacher to admit that his students would be unable to understand the difficult translated words used by Shibusawa. Another defense witness claimed that the "secret language" of the Edo period would not pique a reader's sexual curiosity but rather their intellectual curiosity by

prompting them to look up the word in a dictionary. As with the *Chatterley* trial, this argument ultimately failed to secure a not-guilty verdict for the translator and publisher in the Sade trials. It was, however, cited as a mitigating factor by one of the Sade Supreme Court justices in his dissenting opinion, in which he praised the translator for using the "dead language" of the Edo period and bluntly concluded that the "ordinary person cannot but find it basically something of a pain to read through the whole book."[21]

In sum, whether it was the direct translation style used in *Chatterley*, the Edo-period poetic diction in Sade, the specialized language and form of senryu in *The Safflower*, or the mixed Japanese-Chinese style of *Dannoura*, a work's opaque style could render it impervious to obscenity charges because it was, in effect, a foreign language engaging the reader's intellect rather than their senses. When the work on trial was a Japanese classic written in a pseudoclassical style, these debates over the artistry and obscenity of the text's language became embroiled in larger debates about cultural identity, particularly in the 1970s, when the place of classical language and literature education was being hotly debated. Claiming that classical Japanese was a foreign language for average Japanese readers did not lack political and polemical charge and was one that lodged most strenuously in the 1970s "Yojōhan" trial, where the defense criticized the modern educational system for rendering citizens illiterate in their native tongue. In the High Court verdict for *Dannoura*, there was a hint of this dispute when the judges refuted the defense's and the lower court judges' contention that the original text was incomprehensible to Japanese readers: they countered, "Phonetic [kana] readings are provided for the mixed Japanese-Chinese, and it is obvious that there are many readers for whom interpreting it would not be hindered based on the standard of present-day Japanese language education."[22]

This debate over transparency and opacity was not limited to language but loomed large also in the trials of visual texts, particularly those involving film and photography, since these media were generally considered more immediate and transparent and thereby potentially more obscene than textual media. In all the trials, transparency was equated with visuality, whereas opacity was associated with prose. In their decision to acquit *Dannoura*, the lower court judges suggested that what made the text innocuous was its difficult prose, which would impede the reader's ability to "imagine sex scenes."[23] In theory, if visuals were inherently obscene, language was comparably innocuous because it could potentially interrupt and intervene in this imaginary visualization process. In practice, however, in all the postwar

landmark obscenity trials, textual media were more often convicted on these terms than visual media. Prose was credited again and again with powers of immediacy and arousal that far exceeded those of images. As we will see in the following chapter, in the "Yojōhan" trials in both the late 1940s and again in the 1970s, it was the all-too-live words of the absent and dead author Kafū that would provoke the most consistent succession of guilty verdicts thus far.

CHAPTER 6

Kafū

Censored, Dead or Alive
(1948–1950, 1973–1980)

As she writhed her body in pleasure, her hair having become disheveled, I too was overcome, and once she started grinding on top of me, she collapsed forward, crying out in quick succession, 'Oh, oooh. I'm coming again, I'm coming again,' and for the second time in a row, I am drenched in her juices.

—"Yojōhan fusuma no shitabari" (1924)[1]

It is altogether fitting that the author Nagai Kafū marks both the beginning and the end of Japan's landmark literary obscenity trials. He is an author known equally well for his immaculate high style as for the rather "maculate contents" of his fiction, for dabbling with the debauched dancing girls of Asakusa, for antagonizing the authorities in the prewar and postwar periods alike, for introducing Western literary translations to Japan and for reintroducing early modern Japanese literary traditions in the fashion of an Edo-period "scribbler" (gesakusha), and for his avowedly apolitical sexual politics. Kafū remains one of the more confounding literary figures in modern Japan.[2] His uncanny ability to occupy simultaneously the highest and lowest of poles is perhaps best symbolized by his receipt of the prestigious Order of Cultural Merit in 1952 and by his posthumous appearance twenty years later as a fictional character in one of the indicted Nikkatsu Roman Porn films in 1972.

The struggle to reconcile all the apparent contradictions of a writer with such a long and varied career as Kafū's—many of which were embodied by

the story "Yojōhan" itself—understandably confounded the judges and led to verdicts that seemed somewhat contradictory. In both trials, the story was deemed obscene but Kafū himself was exculpated. In the first trial, although the publisher was convicted, Kafū was pardoned because the authorities seemingly believed his strategic denials of authorship. In the later, posthumous trial, while the judges acknowledged Kafū to be the author and deemed the story obscene, they also championed Kafū as a literary genius in the tradition of the Edo-period artist, confirming the honor bestowed on him by the cultural merit award.

These verdicts again suggest the inevitable vagaries that result when cultural production meets the force and logic of law. But they are also ones that haunt the critical reception of an author like Kafū, as evident in the divergent interpretations of him offered by literary scholars, ranging from incisive cultural critic (*bunmei hihyōka*) to a somewhat perverted, if talented, dilettante. His postwar publications, in particular, both his new fiction as well as republications of his salacious prewar works, engendered some of the fiercest attacks. One critic damningly concluded that when considering "Kafū as a novelist, it might not matter if the entire thirty-odd volumes of short works he wrote in the postwar period were entirely ignored."[3]

At stake in both trials and in literary criticism is the sanctity of canonized authors like Kafū. The fact that the lawyers and judges engaged in such literary judgments suggests how the trials were as much exercises in literary criticism and canonization as they were attempts to regulate social morality. In fact, the "Yojōhan" Supreme Court verdict of 1980 marked the introduction of a significantly expanded legal definition of obscenity that revised the long-standing three-prong definition established in the *Chatterley* trial to one that required consideration of not just a work's sexual content but also its proportions, prose style, and narrative structure. That the story's very same narrative devices would fuel the competing claims of the defense and prosecution alike suggests both the ironies that arise when literary interpretation is undertaken in the legal arena and the plasticity of literary criticism in general.

It is not difficult to imagine the perverse delight that Kafū would have taken in all the fuss over half a century later, especially since he was safely removed from any practical consequences of the verdict. A contrarian like Kafū could only have delighted in the fact that his slight, ten-page story would, on the one hand, garner a literary endorsement from the nation's highest court and prompt it to nuance the legal definition of obscenity into

one that rivals the interpretive methods of literary critics and, on the other, provide the makings of a 1973 Nikkatsu Roman Porn film adaptation that was daringly released during the "Yojōhan" lower court trial.[4]

The Story and the Indictments

"Yojōhan" is the story of a man in his fifties looking back on his youthful sexual profligacy and prowess with an equal measure of self-reproach and wistful longing. The story can be roughly divided into three sections: the first sketches the rise and fall of the protagonist from the height of his youth, when he was a self-assured connoisseur in the licensed quarters who devoted himself wholeheartedly to a geisha named Sodeko, to his later decline when he begins cheating on her once she has become his wife; the second section loops back chronologically to describe an especially passionate and extended lovemaking session from the early days of their relationship during which, by one defense witness's count, they orgasm no less than thirty-six times in a single evening (*YS*, 1:215); and in the final section, the protagonist launches into a sophistic defense of man's fickle nature and concludes by describing his own insatiable sexual desire, which eventually leads him to avail himself of the diverse pleasures offered elsewhere in Tokyo. In the story proper, the sordid first-person story of this man's life is presented as a found manuscript discovered by another man behind the papering on the shoji doors of the eponymous four-and-a-half-mat room of a former geisha house.

The story is undeniably an erotic one, if not obscene according to the *Chatterley* precedent. As Kafū himself admitted in 1916 when he had originally composed the work, it was "an indecent piece . . . that could by no means be read in front of saints or gentlemen."[5] The second section, describing the impossibly lengthy sexual encounter, is proportionally speaking about five times as long as the first and last sections combined. Although the existing records from the 1950 verdict reveal little about the prosecutor's motivations in that trial, the prosecutor in the 1973–1976 trial identified this second section as "particularly obscene." As he charged in his closing argument:

> The bedroom scenes occupy about two-thirds of the entire story. From those proportions alone, it is altogether clear that the purpose of this work is the depiction of sex acts. As for the content of those bedroom scenes, the male protagonist takes a prostitute as his partner, and there are plain and detailed descriptions of the repeated scenes of sexual

intercourse as they change from one position to the next. . . . In the end, there is even the description of fellatio. . . . Moreover, it clearly describes the woman's responses that accompany this kind of sexual intercourse and sex play—her sensations, her shifting positions, the appearance of her genitalia, the way she cries out when excited, and even her ejaculate—using a bold, realistic method and going into the most minute details. Here the female is depicted entirely as the object of male sexual pleasure, as a sexual plaything. The persistent bedroom description that continues in a long passage of just under six pages is of the type that cannot be read without shame in public. (*YS*, 2:204)

The prosecutor's objections run the gamut of the typical arguments made by the censor: he cites the story's sexually explicit passages to argue that its intent and effect as a whole is prurient, echoing the Victorian-period Hicklin obscenity standard, and he denounces pornography for being discriminatory to women by treating the female character "as a sexual plaything," prefiguring the arguments made by today's antipornography feminists.[6] The prosecutor focuses almost exclusively on objectionable content to make his case. Though he admits that the work's style—its clear descriptions, "bold, realistic method," and "minute details"—increases its obscenity, his primary preoccupation is with its descriptions of "repeated scenes of sexual intercourse."

Aside from a single error and omission (the female partner is a geisha, not a prostitute [*baijo*] per se, and eventually becomes the protagonist's wife), the prosecutor's charges of salacious content are not inaccurate. Based on the passage excerpted at the opening of this chapter alone we could rightly conclude that erotic content indeed propelled the indictments and eventual guilty verdicts. And, in fact, an expurgated version of the story published in 1917, which omits this middle section entirely, escaped any censorship charges and is canonized in the authoritative Iwanami complete collection of Kafū's works.[7] But the more pressing issue in the trial was the intent behind the work's creation and (re)publication and its effect on readers and on the Japanese literary canon—that is, questions of authorial intent, reader reception, and canon formation. To decide this issue, the defense, prosecution, and judges alike were forced to take on the role of a literary critic who considers not just the content of the story but also the intent and effect of its composition and its form—especially its language and narrative structure. In fact, much of the debate hinged on the story's anachronistic mode of

literary composition, particularly its use of pseudonymous authorship and the conceit of a found manuscript. For the defense, these aspects proved it was a valuable cultural artifact, a celebration of native literary traditions and a pointed rejection of imported Western literary values. Whereas for the defense these were evidence of the integrity of the text and of its author, for the prosecutor they proved that the text was corrupt in both senses of the word; the use of a pseudonym called into question its authenticity, while the device of the found manuscript resulted in an undesirably prurient reading experience. For both parties, at stake was the integrity of nothing less than the integrity of the Japanese literary canon.

Although the defendants in the contemporaneous Nikkatsu trial had envied the comparable "ease" of the "Yojōhan" trial, where "the object on trial was a 'classic' and the individual who wrote it was absent,"[8] both these factors—the authorship and authenticity (or canonicity) of the work— posed their own set of problems. In 1950, although Kafū himself escaped charges by strategically repudiating authorship, this only exacerbated the offense and the severity of the publisher's and booksellers' punishments. When his story was republished in 1972, Kafū had been dead for thirteen years, but his lifetime denial of authorship again figured prominently even in this posthumous trial. The fact that the story was a classic by a deceased national treasure would work against the defendants, the flamboyant author Nosaka Akiyuki, who had chosen to republish the story in July 1972 in the new humorous literary journal *Omoshiro Hanbun: Half Serious,* of which he was guest editor, and Satō Yoshinao, the journal's publisher. Both were consistently found guilty at all three levels, with fines amounting to one hundred thousand and one hundred fifty thousand yen, respectively, in the District Court verdict of April 1976, the High Court appeal of March 1979, and, finally, the Supreme Court in November 1980.[9]

At the 1973–1976 trial, the republication of this story was presented by both sides as an attempt to rewrite the career of a treasured national author. Whereas the defense proudly celebrated Nosaka's motives as a desirable step toward recognizing the importance of erotic writings in Kafū's oeuvre and in the Japanese literary canon, the prosecutor condemned him for sullying both. The implied question at the heart of the trial, which could be said to apply equally to Nosaka and to Kafū, would be, was the publication of the story the act of an intrepid cultural anthropologist or a perverted voyeur? The fact that this question is one that haunts the critical reception

of Kafū suggests the extent to which the trial both reflected and shaped the image of this literary giant.

1950 "Yojōhan" Trial: A Maze of Authors

During the 1948 police investigation of the publisher of the senryu collection *The Safflower* and "Yojōhan," Kafū was called to the Ishikawa Tokyo police station for questioning as the latter's reputed author. The story itself did not list Kafū as its author, but there were several hints that the work was indeed his. The story's byline identified it as "a playful composition [*gesaku*] by Kinpu Sanjin," a pen name that had been used by Kafū in the first decade of the twentieth century. In the postscript, his rumored authorship was hinted at again with a notation that "people say that this is the *gesaku* of the adult Hachisukaze," another pen name that obliquely suggested his name.[10] And most compellingly, in 1917 Kafū had published a very similar story, without the later version's more salacious middle section, with the suspiciously similar title of "Yojōhan fusuma no shitabari (1)."

This expurgated version had originally appeared in the journal *Bunmei*, a literary magazine started by Kafū and his friend Inoue Aa in 1916, under one of Kafū's many acknowledged pseudonyms, Koikawa Kanemachi.[11] This was the version subsequently canonized and acknowledged as one of Kafū's in his complete works. (The indicted version, on the other hand, is not included even in volume 26 under its "Authorship Uncertain" category). Literary scholars speculate that Kafū originally wrote this story in the form that appeared in the July 1917 edition of *Bunmei* and then revised it in 1920, and again in August of 1924, to produce a secret, privately published edition that included the extended sexual depictions in the middle section. To complicate matters further, this 1924 version subsequently spawned a number of both authorized and spurious manuscript versions that used variant characters for the pen name Kinpu Sanjin.

This maze of elaborate pen names and profusion of manuscripts facilitated Kafū's strategic denials of authorship when faced with police charges in May 1948. That Kafū had, in fact, written the story in question is clear from his posthumously published diary and from his private correspondence.[12] When summoned by the police, Kafū sent two colleagues instead. In his subsequent written statement, Kafū escaped the charges while poking some fun at the authorities by employing his characteristic playful and sophistic prose. In it, Kafū denied having authored the secret edition of the story. As proof, he claimed never to have used the pseudonyms Hachisukaze and

Kinpu Sanjin, or, more accurately in the case of the latter, to have used one with a similar pronunciation (金風山人) but not the same exact characters (金阜山人). Although he admitted to having written the 1917 "Yojōhan (1)," he claimed it to be "a work of pure literature, not a lewd one [*hiwai*], something you need only look at its contents to understand," and further claimed, "At that time, I submitted only the first part and did not write the rest due to certain circumstances."[13] With these claims he simultaneously makes a literary and a legalistic argument. He claims first his work to be well within the purview of "pure literature" (*jun bungaku*) and, second, emphatically denies any association with the secret version while hinting that a part two (or unexpurgated version) existed, at least in his own mind.

In his statement to the police, Kafū implied also that his work had been forged, an entirely plausible complaint that he made outside the courtroom context as well. One account describes an irate Kafū patrolling Tokyo bookstores in the early 1940s and urging patrons not to buy spurious versions of the secret edition of "Yojōhan."[14] In his 1944 novel *The Visitors* (*Raihōsha*), Kafū similarly depicted himself as the innocent victim of forgerers by liberally fictionalizing an incident with two disciples whom he accused of stealing and copying his manuscripts, including "Yojōhan."[15] His courtroom claims to be a victim of copyright infringement appear disingenuous when he proceeds to compliment the forgerers, writing, "I don't know who forged it, but I must say it makes one think it was written by an impeccably good writer."[16] Similarly playful assertions and disavowals of authorship characterize much of Kafū's work. For example, in the expurgated version of "Yojōhan," the frame narrator compliments the "author" of the found manuscript for his fine prose, saying, "I have to wonder if this author is perhaps a literary gentleman of the old style who has fallen behind the trends of the times. When I read it carefully, I can even vaguely detect the writing style of the Ken'yūsha writers."[17] Both statements of course invite one to assume that Kafū himself is the impeccably fine and old-fashioned stylist in question.

With such playful jabs, Kafū was thumbing his nose at the authorities and assuming they were too dense to get the joke. In fact, as the policeman in charge of the investigation later admitted, he and his colleagues did not actually believe Kafū's denials at the time but had opted to let him off because of his "lofty character."[18] Most important, with this ambiguous disclaimer, Kafū was simultaneously disavowing and claiming authorship. Here we see how the threat of criminal charges could lead an author to

disavow criminal culpability, which in turn could provoke a crisis of authorial integrity. For Kafū, navigating this tricky terrain entailed a playful and labyrinthine use of language, an altogether appropriate response from a literary author faced with the force of law. By maintaining that he was not the author of the secret edition, Kafū successfully escaped obscenity charges in the trial of publisher Matsukawa. In the 1950 verdict, the judges only tersely noted that "Yojōhan" was obscene but conspicuously omitted Kafū's name from the legal record. Ironically, although Kafū successfully absented and thereby exculpated himself in the 1950 "Yojōhan" trial, posthumously he would be at the fore.

The Posthumous Trial of Nagai Kafū

In the 1973–1976 trial, authorship and its repudiation would again be at the center of the debate, cited by the prosecutor, defense, and judges alike, albeit with altogether different conclusions. As we saw above, establishing the facts of the creation and publication of "Yojōhan" was a herculean task, one uncommon to modern literature; as special defense counsel Maruya Sai'ichi noted, although this kind of textual scholarship is often required in the case of premodern works, "such as *Genji, Man'yōshū,* and Shakespeare, it is rather exceptional" for a modern work of literature (*YS,* 1:121). While the 1948 version contained a number of hints that Kafū was in fact the author of the story, they were still oblique enough to allow Kafū to escape criminal culpability. When the story was republished in 1972, Kafū's authorship was indisputable, and the story was explicitly identified as Kafū's for the unknowing contemporary reader in an accompanying essay.[19] Nonetheless, in the 1973–1976 trial, the labyrinthine maze of authors and manuscripts would again be invoked by both sides; the prosecutor cited it to question the defendants' intent in republishing it, while the defense cited it to bolster its politicized claim that the story embraced native modes of literary production in a pointed rejection of modern Western conceptions of literature. To make their cases, both sides enlisted the deceased Kafū as a witness of sorts.

Channeling Kafū: Authorship and Authenticity

For the prosecutor, the question of authorship merited his one sustained argument, suggesting its centrality to the state's case notwithstanding its claims of being unconcerned with the original author's identity. Despite the repeated urgings of the defense and the judges, the prosecutor refused to state whether he believed the story was actually by Kafū; he claimed, "The

identity of the author is irrelevant. . . . I won't say whether we recognize Kafū as author," and in his closing he skirted the issue of authorship again, insisting on "leaving aside the question of whether it is Kafū's work" (*YS*, 1:38–39; 2:204). More important to the prosecutor than ascertaining original authorship was condemning the defendants' decision to republish the story even though it had been indicted previously by the state and disavowed by Kafū during his lifetime. In fact, one of the few pieces of evidence submitted by the prosecutor was the transcript of the 1950 verdict. He charged,

> The work in question is known as a work of phantom pornography. Despite the fact that it was found guilty a long time ago in 1950, and despite the fact that its obscenity is readily apparent even today, the defendants . . . included it in the mass entertainment and culture magazine *Omoshiro Hanbun* and distributed 28,000 copies to small bookstores nationwide.[20]

In an echo of the charges against Nikkatsu, the prosecutor implies here that had the story remained a work of "phantom pornography" (*maboroshi no shunpon*), detached from the broader channels of authorized distribution and from the name of the award-winning author Kafū, there might have been no criminal charges.

Although the prosecutor called no witnesses to the stand, he did enlist the deceased Kafū by citing his denials of authorship during the 1948 police investigation. Despite Kafū's playful and even contradictory statements, in the 1973–1976 trial the prosecutor interpreted these denials quite literally and cited them as proof that Kafū had been ashamed to claim the story as his own. During the two rare occasions when the prosecutor cross-examined defense witnesses, he forced literary scholars Yoshida Sei'ichi and Nakamura Mitsuo to admit that Kafū had not acknowledged the work during his lifetime and that it had never appeared in any collections of his complete works, to imply that the literary world had not recognized it either (*YS*, 1:305; 326). Rather than try to persuade the court that Kafū had not actually written the story—a difficult case to make by the time of the 1973 charges—the prosecutor impugned Nosaka and Satō for "being dazzled by the contemporary mass media trend extolling sexual liberation and for succumbing to the easy commercialism of the dirty publishing industry" (*YS*, 2:205). Republishing the story was a commercial ploy and an affront to Kafū's reputation.

If what had facilitated Kafū's denial of authorship in the late 1940s trial was the maze of elaborate pen names for the story, this same aspect would be interpreted by the defendants in the 1970s trials much more figuratively. Far from leading them to deny Kafū's authorship, his use of a pseudonym was cited as definitive proof of his pure authorial intent. Kafū's failure to sign his own name was depicted not as an indication of his reluctance to admit that he was the author of an erotic work but as a reclamation of an ancient native tradition of anonymous literature and as a rejection of the modern Western cult of the author. Special defense counsel and author Maruya claimed in his opening statement that the tendency to disparage anonymous or pseudonymous works originated from literary standards drawn from the West: "Just because a work does not record a proper author's name is not sufficient proof to judge that it belongs in a different category than works like *Madame Bovary.* This is clear if we consider the poems that are included in representative poetry anthologies from the very earliest moment of Japanese literary history." Kafū chose a pseudonym as a tribute to the traditional Japanese practice of unsigned poems seen in premodern poetry anthologies and to Edo-period *gesaku.* In so doing, Kafū evoked "works from a time when literature was a collaborative product, not the work of an individual author; when there were ties between religion and poets, who resembled spiritual mediums [*miko*]"; it was proof of "his desire to take after ancient literature . . . and to become a bard [*kataribe*] for the community" (*YS,* 1:109, 115; 117; cf. 168).

According to the defense, Kafū's reclamation of a Japanese mode of authorship and of the native genre of *gesaku* had both literary and political implications with strong nativist and even pacifist overtones. Kafū's use of a pseudonym proved that "he wanted to be a literary man for the sake of the community. Not signing his own name was an erasure of his individual existence, a ceremony of resistance suitable to one who was dissatisfied with feudalistic, militaristic Japan." The defense implied that *gesaku* had been rejected in the modern period in an attempt to emulate Western standards of literary evaluation and also Western models of nation building in the early days of Meiji modernization, when "*gebun* and *gesaku* that were popular in the Edo period were deemed vulgar and base, as well as useless and even harmful to fostering men of ability who would be useful to the nation" (*YS,* 1:120, 64).

In other words, the genre was likened to a neglected stepchild of modernity, the sacrificial lamb of Westernization. This point was most clearly

articulated by poet Tamura Ryūichi, who in his testimony noted the "radical nature of Japanese modernization, which in the span of one hundred years became a civilized country that caught up and surpassed advanced countries . . . but this, of course, entailed sacrificing something. What was sacrificed was laughter and play" (*YS*, 2:164). The defense held up "Yojōhan" as the perfect means to correct the instrumentalization of literature, language, and sex in the modern era and to return to a native tradition of play via the playful literature (*gesaku*) of the peaceful, isolationist Edo period. Far from being a work that would serve the interests of modernization or militarization, the story reveled in its playfulness. As the preface clearly stated, it was merely the "playful work of someone's brush" that provided a welcome diversion from the heat.[21]

By characterizing Kafū as an intrepid archeologist who had revived a distinctly Japanese literary genre and mode of authorship, the defense sought to convince the judges of the purity of Kafū's intent in producing the original work. But for the defense to succeed in its arguments, more important was convincing the court of the defendants' pure intents in republishing it. To accomplish this, it needed to successfully represent Kafū more convincingly than the prosecutor had when he cited Kafū's lifetime denials of authorship. Like in the *Chatterley* trial where the defense had claimed to speak for the original author Lawrence and had even claimed that Lawrence had spoken to them "from the heavens," the "Yojōhan" defense team needed to channel Kafū.

As the central defendant, Nosaka most actively sought to take on this role both inside and outside the courtroom, fearlessly channeling Kafū from beyond the grave. He repeatedly declared an affinity with Kafū, testifying that he decided to republish "Yojōhan" because it evoked in him "feelings of pity, akin to Kafū's feelings of nostalgia for the Edo period, for Japan's traditional culture that had been buried in the throes of frantic efforts to modernize and enrich the country and strengthen the army [*fukoku kyōhei*]" (*YS*, 1:68). If, with "Yojōhan," Kafū had revived the genre of *gesaku* in the Taishō period as a political statement against Westernization and the rising tide of militarism, then Nosaka would republish the work in 1972 at a moment of resurgent cultural nationalism to remind Japanese of the peaceful past traditions of the Edo period. The defense repeatedly stressed the parallels between the prewar period and the 1970s and warned that censoring sexually explicit literature like "Yojōhan" risked a disastrous repeat of the road to war: Nosaka cautioned, "True corruption is a world that swaggers with 'word hunting'

[*kotoba gari*], a world where the state meddles in the sphere of imagination. We need only look back thirty years to see the true corruption of the state"; defense witness author Itsuki Hiroyuki pointedly noted that "the similarities between the 1930s and 1970s are well recognized, but . . . we must not repeat the catastrophe of the 1930s . . . when Japan went flying into war. . . . The final destination has to be different" (*YS*, 2:314; 1:192).

Like the pacifist defenses of literature of the flesh in the late 1940s, *Chatterley* in the 1950s, and *Black Snow* in the 1960s, again here sex, the body, and sexually explicit literature are depicted as the antithesis of war, militarism, and censorship. The defense credited Kafū's story with a politicized literary purpose that was thematically and formally antiwar and anti-Western. Even the story's artistic flaws were blamed on the West, for example by Nakamura Mitsuo, who attributed the insufficient humor in the story to undue "Western influence" on modern Japanese literature (*YS*, 1:316). To advance this argument required again the strategic rewriting of literary and censorship history, not to mention Kafū's literary career, which had included many translated works as well as essays about his travels abroad early on.

By championing the politics of apolitical sex and linking it moreover to the isolationist and peaceful Edo period, the defense was attempting to capitalize on Kafū's reputation as one of the few writers who had resisted the militarist fervor of World War II and as one who had professed to take up the occupation of an Edo-period scribbler as a response to government repression in the mid-Taishō period.[22] Nosaka was even characterized as a modern-day scribbler himself. Although this was clearly strategic, if, as one witness claimed, dabbling in a variety of professions defined a *gesaku* author, this label was not unwarranted in Nosaka's case. The versatile Nosaka was well known as an author and television writer, as a popular singer who performed in his signature white suit and dark glasses, and as an aspiring politician who unsuccessfully ran for a seat in the Tokyo Diet in 1974 during the lower court trial. Most notable among his fictional works was his 1967 *The Pornographers* (*Erogotoshi-tachi*), about a small-time amateur blue filmmaker and his skirmishes with the police, presaging Nosaka's own belligerent stance when faced with obscenity charges. Nosaka even wrote his own quasi sequel to "Yojōhan," called "The False Charges of Sex in the Four-and-a-Half-Mat Room" (Yojōhan iro no nureginu), in 1977 that was advertised as a "Nosaka Akiyuki *gesaku* to rival Kinpu Sanjin's."[23]

The journal in which the story was published further encouraged interpreting Nosaka as a modern-day Kafū intent on reviving the Edo spirit of

play, as suggested by its title: *Omoshiro Hanbun: Half Serious.* As its first
editor, novelist Yoshiyuki Junnosuke, paradoxically put it in his testimony,
the purpose of the magazine was not to have a purpose, or to "do away
with this thing called purpose." According to its mission statement, it aimed
only to help readers "relax their shoulders and try to live in a natural state.
To rehabilitate the term and meaning of 'half serious' rather than scorn it
as it was beforehand" (*YS*, 1:227). In this respect, the journal was quite
consciously echoing its predecessor, the 1929 *Omoshiro Hanbun* edited by
Miyatake Gaikotsu, another iconoclast known for his frequent run-ins with
the censors:

> In *Omoshiro Hanbun,* the writers must take up the brush half in jest and
> the readers must attain knowledge half in jest. A person who lives always
> with a scowl on their face has a lifetime of misfortune. For what purpose
> indeed do we live in this world? . . . This floating world is about love
> and drink. . . . The interest of life lies in the enjoyment of passion and
> food and drink.[24]

When they claimed their goal was pleasure rather than didacticism, the edi-
tors of the 1970s *Omoshiro Hanbun* were also, perhaps not so coincidentally,
echoing an assertion made by Kafū in 1916 in the first edition of *Bunmei,*
the literary magazine in which the earlier, expurgated version of "Yojōhan
(1)" had appeared: Kafū "announced that he had abandoned 'the literature
of affirmation' for the 'literature of *shumi* [hobbies],' which we may take to
be the literature of hedonism or dilettantism."[25]

Nosaka, a "guerilla of the publishing world" as he was dubbed dur-
ing the "Yojōhan" trial,[26] would do Kafū one better, however. Nosaka's
overt defiance in the face of the authorities was evident throughout the
trials, especially when he audaciously staged an "obscenity recital" (*waisetsu
risaitaru*) in Hibiya Park just outside the Imperial Palace in September 1973
right after the start of the lower court trial. And in his closing statement,
Nosaka provocatively claimed "having an orgasm based on words" to be "a
fundamental right that is naturally guaranteed to all people of the world"
(*YS*, 2:314).

While Kafū had timidly, if artistically, denied authorship when faced
with charges in 1948, Nosaka hyped his own role in the story's republica-
tion in the 1970s to such a degree as to lead one commentator to note
her mistaken belief that Nosaka, not Kafū, was the story's author.[27] As the

Nikkatsu defense had enviously noted, defending a work was a lot easier when its author was dead. But channeling Kafū was not the purview of the defense alone, for as we saw the prosecutor too could invoke him by citing his official written denial of authorship in 1948. Moreover, the figurative or literal absence of the original author, particularly one who was as esteemed as Kafū, could also fuel charges akin to libelous obscenity for besmirching the reputation of a Japanese literary giant.

Although many scholars have pointed out how legal mechanisms, like censorship and copyright, heavily influenced the conception of authorship, and some have even argued that they in fact produced the concept entirely, here we see how they instead could also engender a more ambivalent notion of authorship. During his lifetime, Kafū's denials of authorship (both his literal one in the police records and his stylistic choice of pseudonymous authorship) were prompted by the threat of criminal obscenity charges. While this allowed him to escape obscenity charges, it left him at a loss in terms of intellectual property law, allowing the defendants (as well as their less-legitimate forger predecessors) to skirt copyright issues when republishing the story in 1972.

The act of republishing "Yojōhan" was, in everyone's eyes, a feat of preservation. Whether that was a desirable or an undesirable act of reclamation depended on one's perspective. Just as Kafū's labyrinthine maze of authors could be depicted as evidence of either the purity or the impurity of the text, so could the story's profusion of texts and especially its conceit of being a found manuscript. In this case, however, at issue was not merely the intent of the author or editor but also the effects on the reader. The question was how readers would interpret the story: would it intellectually stimulate them to reclaim their native literary heritage or physically stimulate them with its aura of authenticity? Was it evidence of the text's authenticity or of its obscenity?

A Maze of Manuscripts and Reader Reception
At its very start, the story declares its status as a found manuscript;[28] a preface identifies the work as an old manuscript that the ostensible author, Kinpu Sanjin, recopies as a diversion in 1924:

> While airing out my books this year, I happened to come across two or
> three of my old manuscripts in a worn-out box. Thinking it would help
> me to forget the heat, I copied them out and also took the time to copy

a smutty piece called "Fusuma no shitabari" in the hopes it would amuse me in my old age. Recorded by Kinpu Sanjin in Azabu on the day that marks exactly one year after the Great [Kantō] Earthquake.[29]

A second preface then introduces Kinpu Sanjin not as the author of the story but as a character who discovers yet another manuscript. After this "foolish old man" Sanjin buys an abandoned house that was formerly a geisha house, he discovers this manuscript. This second preface reads,

> In the sliding doors of a four-and-a-half-mat room, oddly enough, there is a finely written old text. Thinking it to be the fragments of some kind of manuscript, Sanjin, who is sharp-eyed when it comes to this sort of thing, takes up a wallpaper hanger's water brush. As he reads on and on while peeling off page by page, he suspects that this must be the playful work of someone's brush.[30]

This manuscript in turn then becomes the story proper—the first-person narrative of a man in his fifties recollecting his life of debauchery.

As with a Russian nesting doll, there are texts within texts. With its multiple manuscripts recovered from obscurity, the story thematizes the act of preservation and reclamation, a theme that is literalized by the figure of the narrator peeling page after page off the sliding doors. In the trial, the defense would capitalize on this feature of the story by depicting the defendants' act of republication as an attempt to recover and to preserve the text as a valuable and genuine cultural artifact. But in the minds of the prosecuting censors, the device of the found manuscript and the figure of the reader in the text peeling off page after page dangerously called to mind a prurient reading experience.

The defense celebrated this feature of the story as a tribute to Edo literature. As literary critic Nakamura Mitsuo noted in his defense testimony, the use of a framed tale in "Yojōhan" was a "conscious imitation of old love stories [ninjōbon] . . . and traditional Japanese pornography"; special defense counsel Maruya exhorted the court to "be grateful to Kafū, who left us this short story thanks to the tradition of Edo pornography." Kafū and the defendants were championed as archeologists who "had excavated and reprinted 'Yojōhan.'" Like the narrator, the defense implied that Nosaka, and Kafū before him, had unearthed what one defense witness called a national treasure (kokuhō) from a neglected native literary canon (YS, 1:316, 128; 2:20,

47–48, 256). If Kafū was a bard who had channeled the language of the ancient Japanese community, then Nosaka and Satō, in turn, had exhumed and channeled Kafū.

The unearthing of this national treasure was all the more admirable because its publication was not just about reclaiming a lost literary genre but also about reclaiming native identity. Defense witness and novelist Inoue Hisashi, for example, erroneously credited *gesaku* with being one of the few native literary products of Japan that were not influenced by China or the West. (Ironically enough, he cited the Chinese scholar Zhou Zuoren [1885–1967] to make this point.) He proudly labeled it "something that belongs to the Japanese that was made by Japanese hands" (*YS,* 1:204). In a familiar formulation that appealed to the rhetoric of 1970s cultural nationalism, the loss of native values was lamented and the Meiji period was demonized as a time of forced modernization and militarization; Edo, on the other hand, was the Garden of Eden, or "spring in an island paradise."[31] As an artifact of a lost language and culture that ostensibly predated Japan's contact with the modern world, the story was depicted as an attempt to repair this fractured linguistic and cultural identity.

According to the defense, the story's anachronistic features would effect a renewal of the ancient bond between author and reader in two ways. First, if pseudonymous or anonymous compositions were, as the defense claimed, collective enunciations, there was no rift to repair. This was doubly true of a pseudonymous *gesaku,* because the genre required the fusion of author and reader because of its high dependence on shared cultural references. Defense witness Inoue Hisashi asserted, "In the case of *gesaku,* it is essential that the one who writes and the one who receives become one." Second, the found-manuscript device would revive their connection because it purports to be an authentic and unmediated communication. As defense witness Itsuki, citing Walter Benjamin's famous essay on mechanical reproduction, argued, the inauguration of print culture destroyed the intimate bond between author and reader by introducing the intermediary step of distribution (*YS,* 1:201, 170).

Before turning to how the prosecutor interpreted these claims, we should step back to recall that the story was not actually an authentic found manuscript from the Edo period but was written by a modern author (and a cosmopolitan one at that) in the modern and cosmopolitan era of Taishō (1912–1926) and took full advantage of modern print technology. How then could the defense depict it as an authentic Edo artifact? Though the

defense's rhetoric was clearly strategic, the story did facilitate this interpretation in a number of ways, with its Edo-period pseudoclassical style and its byline identifying it as a *gesaku*. It was certainly an anachronism when originally written by Kafū in late Taishō, and all the more so when it was republished by Nosaka in 1972.

The story is further linked to the past by its preface's situating the act of copying as occurring "on the day that marks exactly one year after the Great [Kantō] Earthquake." Copying the story is portrayed as an act of commemoration undertaken on the first anniversary of the earthquake, which was said to have destroyed any trace of Kafū's beloved Edo culture. The reference to Azabu, Kafū's residence from May 1920 until its destruction in March 1945 in World War II air raids,[32] also conveniently dovetailed with the defendants' anti-Western, antiwar stance and fueled their polemic that the West was responsible for destroying Japanese culture. The story reinforces the conceit of being an authentic Edo-period text by referencing actual practices of the time that were designed to preserve texts—namely, the copying out of manuscripts by hand, the airing out of books, and the reuse of manuscript paper as wallpaper.

For the defense, these references to anachronistic practices bolstered its claims that the story was an important cultural document of the past and that indicting the story or anyone involved with its publication was tantamount to indicting native Japanese identity and culture. But significantly, these practices (and the reference to the earthquake) also hint at the threatened destruction of these texts by foregrounding the manuscript's precarious material quality. On the one hand, they facilitated the defense's case since the act of preservation was all the more valuable with the looming threat of the text's disappearance. On the other hand, they also fueled the prosecutor's charges of obscenity by calling attention to the fragility and materiality of the text.

Indeed, for the prosecutor the found-manuscript device created not only an aura of authenticity by offering readers access to Edo-period *gesaku* but also an aura of obscenity by threatening the termination of that access. The reader's access to the text ostensibly depends on the narrator's dexterity in peeling off the pages from the sliding doors without tearing the paper. That our access to the text is precarious is reinforced by the occasional panicky interjections from the frame narrator, Sanjin, who worries that the paper is fragmented and illegible. After his initial introduction, the narrator appears twice in the story to comment on both the fragile physical condition and

the salacious content of this discovered manuscript. In his first parentheti-
cal aside to the reader, he notes, "The first part is missing because it is torn
off."[33] The narrator's second aside to the reader, which occurs just before
the so-called hot parts, explicitly threatens the termination of the narrative:
"The first page of paper ends here, but where does the rest continue? Or
could it possibly be that it ends here with this passage? But when I try to read
on to the next scrap of paper—oh dear, how inexcusable and scandalous!"[34]
Like the narrator, we too are positioned as readers who finger the pages and
eagerly anticipate the "inexcusable and scandalous" story that follows.

This figure of the reader in the text is precisely the physically engaged,
rapturous private reader that the censors strove to regulate. Although
the prosecutor did not elaborate on this point, in his closing argument
he claimed one of his main objections was that "the persistent bedroom
description that continues in a long passage of just under six pages is of the
type that cannot be read without shame in public" (*YS,* 2:204). The pros-
ecutor was strategically evoking a public mode of reading as the standard by
which literature should be judged and implied that the good reader-citizen
would internalize the eyes of society even when reading alone and silently.

Although the prosecutor was ostensibly concerned with the fact that
the story could not be read in public, his likely concern was instead with
its reading in private, or more specifically, its potential for becoming what
Rousseau has famously called a "one-handed book," or masturbatory mate-
rial. In his cultural history of masturbation, *Solitary Sex,* Tom Laqueur has
noted the inherently somatic nature of silent, private reading and its ties to
masturbation in the minds of eighteenth-century critics: "Reading was a
physically powerful act, one that engaged the imagination, one that invited
the sort of pleasurable, secret, potentially addictive self-absorption that
contemporaries identified as the core of [masturbation]."[35] The perceived
threat of both reading and masturbation was that these physically engag-
ing and private acts would transport individuals to a self-enclosed and self-
absorbed world beyond policing. With its figure of the reader in the text,
"Yojōhan" presents the very model of reading that was feared by the censors.
The authenticity of the manuscript—its tactile, artifactual, even fetishistic
quality—and the confessional tone of the story transport the reader in the
text to imagine the sex scenes that occurred in the eponymous secluded
four-and-a-half-mat room in which he sits.

By employing a pseudonym and adopting the anachronistic device of
the hand-copied, found manuscript, the story also purports to be a private

communication to the readers proper that can transport us to a private and unregulated realm. After all, the use of pseudonyms, the endurance of manuscript culture even after the advent of print, and the practice of hand copying works whose printing blocks had been destroyed by the censors were all production strategies designed to circumvent censorship regulations.[36] Perhaps then the story's adoption of these very features creates the aura of a secret manuscript that is being circulated without the knowledge or sanction of the authorities. As we recall, though, the story itself was not published as a handwritten manuscript, but instead takes full advantage of print technology, setting off the narrator's comments in a smaller type size. (This led one commentator to complain that modern print technology had ruined the reading experience for him, noting his disappointment at receiving "a bland photocopy from the editors of the magazine" rather than "the hand-copied or underground versions read by people in the past."[37]) And despite the use of a pseudonym, the text contains a sufficient number of playful hints that suggest Kafū is the author. So it is not that the means of production remove the actual text, reader, or author from the purview of the authorities but that by adopting these conceits, Kafū attempts to transport the readers in their imaginations to a private space that puts them (and perhaps him) beyond the reach of the authorities.

The defense tried to dispel the prosecutor's charge that the story would excite readers sexually by depicting it as a "one-handed book" of an entirely different nature: employing the opaque language defense that had successfully led to the exoneration of *The Safflower* in 1950 and *Dannoura* at the lower court in 1974, the "Yojōhan" defense team argued that the difficulty of the pseudoclassical prose would force readers to have a dictionary in one hand and the story in the other. Author Kanai Mieko, who was twenty-six years old at the time of the trial, testified just that. Similarly, a linguist cited surveys he had conducted with readers ranging in age from late teens to eighties to prove the incomprehensibility of the story's vocabulary to young and old alike (*YS*, 2:46, 66–79; cf. 1:67, 217, 239; 2:77, 300).

The fact that the text was inaccessible to average readers facilitated the defense's polemical attack on the "conservative politicians" who had stripped the nation of its linguistic heritage, or as Nosaka put it, had deprived us of "our national character rich in the spirit of words [*kotodama*]" (*YS*, 1:69; cf. 64). Here the defense was participating in the call for a rehabilitation of the classics and classical language in the school curriculum and in the literary canon after being implicated as expressions of ultranationalist sentiment

in the early postwar years.[38] The very morning of the linguist's testimony, an NHK television program featured a discussion between concerned mothers (*kyōiku mama*) and the education minister, who agreed that the education system was lacking in all national language education, especially classical (*YS*, 2:55).

But the defense undermined its own claims about the text's inaccessibility and inadvertently fueled the prosecutor's case by repeatedly celebrating the sensual nature of the text. It claimed the act of reading was so powerful as to embody sensory dimensions. Inoue Hisashi, for example, credited the work with "rhythm" and the "proper use of a *gesakusha*'s pressure points [*tsubo*]." Kanai Mieko praised its rhythmic quality and "its mixed Chinese-Japanese-style prose, which is very rhythmical and easy to read . . . and sounds especially good if it is read aloud." And in his testimony, defendant Nosaka most clearly articulated this claim that the printed text somehow exceeded print, becoming an auditory, tactile, and even haptic experience for him: "After reading through it just once, the rhythm of its prose and its turns of phrases clung to my skin and body to the point that I could sonorously recite it aloud. Upon reading it again, I memorized the majority of it and on occasion would suddenly recall a line and sometimes even find myself whispering the lines softly to myself" (*YS*, 1:215; 2:44; 1:63).

The prosecutor turned this testimony against the defendants in his closing argument, concluding that "for these reasons, conversely we must say that the sexual stimulus is enhanced and exacerbated, and its obscenity strengthened all the more." In part, the prosecutor undoubtedly cited these witnesses' testimony to attest to the accessibility of the work to a broad audience. The fact that Nosaka could recall the story's lines after reading it and that Kanai found it "easy to read" suggested that the general populace (especially those susceptible women and children readers) might also. But the fact that he cited testimony celebrating the rhythmic prose for its aural and tactile qualities suggests that it was not just accessibility that was at issue. He pointed out that most of the difficult terminology appears in the introduction and therefore "fails to interfere" with the bedroom scenes, which can be read "without resistance [*teikō nashi*]" (*YS*, 2:205, 206). For the prosecutor, the immediacy of the story's language failed to restrict the potential readership *and* failed to impede the dangerously sensual, material, and embodied act of reading. Whereas for the defense its sensuality and aurality were proof of its artistry, for the prosecutor they were evidence of its obscenity.

In considering why aurality (and orality) in particular may have been linked with obscenity in the prosecutor's mind, an essay by literary critic Maeda Ai offers a suggestive explanation. In "Words and the Body" (Kotoba to shintai, 1982), Maeda criticizes the practice of silent reading to oneself as impoverished because it threatens to erase the gestural, bodily dimensions of language. He writes, "When our eyes glide over printed lines without stopping, we are hardly aware of sound. But when we slowly proceed to read a piece of poetry, we perceive the unique rhythm of the poem. . . . We move our lips, throat, and vocal cords. Or, perhaps those muscles only tense up slightly without actually emitting a sound."[39] For Maeda, only by reviving the reader's visceral connection to reading can language regain the power it has lost in the age of silent reading.

If this is the case then Nosaka's and Kanai's testimony indeed attests to the power of the story's language to reconnect readers with the physiological dimensions of reading. In the prosecutor's mind this power was of physiological consequence—sexual arousal—that qualified the story as obscene under the legal definition for obscenity, which required that it have the power to physically move a reader. For the prosecutor, perhaps the danger of the rhythmic prose was not just that it invited readers to connect physically with the story while they were reading it; rather, its alluring rhythm allowed the text to imprint itself on the reader and be transformed from something that exists outside the reader to something that exists internally. After reading it just once, it is both immediately comprehensible and portable, so that a reader like Nosaka could thereafter "sometimes even find [him]self whispering the lines softly to [him]self." The act of reading becomes doubly private—something that can be conducted both in the absolute privacy of one's home and in that of one's mind—two spaces beyond the censors' reach.

Far from the intellectually and culturally engaged reader posed by the defense, the prosecutor depicted the reader as apt to be lulled and ensnared by the rhythm, which he tellingly characterized as a textile of "exquisitely patterned prose" (bunshō no kōchi kiwamaru aya) (YS, 2:205). While the defense had credited both the text's producers (Kafū and Nosaka) and consumers (readers) as proactive archivists of the nation's heritage, the prosecutor characterized them as passive slaves to their base passions of sexual titillation and money, respectively. For the judges, the central question was whether the story's creators and its readers were active and thereby innocent, or passive and prurient.

The Verdict

Reluctant Authors and Rapturous Readers

When addressing the culpability of the author and publisher, the judges first dismissed any consideration of the producers' subjective intent, instead insisting on an evaluation of only the text itself. But they also repeatedly contradicted this New Critical approach by considering also whether the work has a "sincere purpose that is not sexual stimulation" (*YS*, 2:326, 327–328). The judges, like the prosecutor, focused their inquiry not on whether Kafū's original purpose in writing the story was sincere but on the defendants' purpose in republishing it, which was suspect since they had foreknowledge of the prior obscenity conviction in 1950. In the eyes of the judges, ignoring this precedent suggested their willful attempt to ignore domestic legal precedent and to impose Western legal and cultural standards on Japan:

> These days the words "liberation of pornography" are on people's lips everywhere, but we believe that adopting the mores, customs, and legal systems of northern Europe and America—which are different not just in terms of legal theory but also in terms of history, traditions, and social conditions—directly into our society today and applying them to the interpretation of our legal code without modification are not appropriate. (*YS*, 2:334–335)

By asserting the existence of an unchanging legal and moral code that was unique to Japan, the judges echoed the cultural nationalism articulated by the defense pitting domestic against imported legal and cultural values. But the judges insisted that Japanese legal and moral values, not literary ones, took prominence. Their citation of the 1950 conviction also suggested that the judges were effectively denying any changes in sexual morality over the past quarter of a century.

Again in this case, paratexts were central to the judges' determination of intent. In the verdict, they insisted on considering also "the method of sales in terms of printing, binding, advertising, and the inclusion of introductions and interpretive essays" (*YS*, 2:327–328). The judges noted that though the defendants had not unduly promoted the story by any "unusual advertising methods" or the inclusion of "conspicuous drawings or photographs," the three essays that accompanied the story "treat it entirely as

pornography [*shunpon*] and do not include a single reference to its literary or artistic values." One of the articles was specifically criticized for "introducing Kafū's diary entries as well as newspaper and magazine articles from the time that describe how 'Yojōhan' had been regarded as pornography or erotica and indicted as obscene writing." This article was also, however, praised for informing readers that though the story is today acknowledged to be an "authentic work" of Kafū's, Kafū had claimed the story to be a counterfeit during his lifetime. The judges implied that Kafū had the good sense to disavow this self-described "lewd writing" (*inbun*) and that it was to the defendants' credit that they informed the reader of this fact. Including contemporary commentary and Kafū's diary entries acknowledging his authorship of this "lewd" story, in contrast, proved their awareness that the story was "essentially pornography" (*YS*, 2:338–340).

Most important, the judges worried that Kafū's own comments, as well as those of the accompanying essayists, would direct the reader to read for prurient interest, not literary value:

> As is the custom, readers will read "Yojōhan" in combination with these articles. And when we consider also that the author himself has written that it is a lewd work, we must say that there is the potential risk that the average reader will get the impression that "Yojōhan" is a type of new pornography or amatory reading material, rather than be able to grasp the interpretation espoused by the defendants. (*YS*, 2:339–340)

Again, Kafū was not the focus of the judges' inquiry. In one sense, this is not surprising since the defendants, not the deceased Kafū, were on trial. But for that very reason the judges' investment in exculpating Kafū and distancing him from the story by noting his own denials of authorship is telling. Indeed, in the judges' formulation, Kafū was not even the author of the text on trial, for the text comprised not just the story itself but also its paratexts, especially the accompanying essays.

In fact, the story was praised by the judges as a testament to the esteemed Kafū's literary genius:

> In addition to the fact that this story is written in the particular style of *gesaku*, the sentences have a unique rhythm, and the shifting psychology and feelings of the characters are skillfully captured and expressed with a

fluid touch. From these, one can sense the breadth of the author's learn-
ing and the depth of his literary genius. . . . We recognize that "Yojōhan"
is reputed to be a work with literary or documentary value and that based
on its prose style, structure, theme, characterization, etc., it is presumed
to be a work written by the famous novelist Nagai Kafū. (*YS*, 2:336–337)

By claiming the literary aspects of the story as a credit to his reputation
while emphasizing Kafū's ambivalent stance toward authoring the obscene
text, the judges were effectively affirming his artistry and exonerating him
of obscenity. Just as Kafū's explicit denials of authorship in the 1940s had
allowed him to escape charges, here too they were invoked by the judges
to exculpate him, at least artistically, and to rehabilitate his reputation,
albeit posthumously.

Just as Kafū could be depicted as both a reluctant (or passive) producer
of the obscene text and an intentional (active) producer of the artistic text,
readers were also divided into two groups—those active consumers of the
text who would read for artistry and the passive ones who would be con-
sumed by its obscenity. While acknowledging the story's "value for literature
lovers and Kafū scholars since it has not heretofore been published in any
of his collected works" (*YS*, 2:337), the judges, like the prosecutor, charged
that the work was dangerously sensual, apt to lure the unsuspecting readers
into a passive and prurient reading experience. The metaphor used by the
judges to depict this experience was revealing. Rather than depicting readers
as susceptible eavesdroppers who would be lulled by the story's rhythmic
prose, as had the prosecutor, in the judge's formulation the reader was a
voyeur lurking in the shadows of the four-and-a-half-mat room who would
witness the sex act in reality: "For the reader, it makes the unfolding of these
acts vivid, just as if they appeared before their eyes, and evokes a sensational
atmosphere equal to that of seeing it and provokes their sexual curiosity"
(*YS*, 2:335). With this charge, the judges implied that the story invited an
entirely sensory, passive experience akin to watching visual media. Although
they did not explicitly note that the found-manuscript device was what cre-
ated such visual scenes for the reader, their adoption of visual metaphors was
likely fueled by the figure of the voyeuristic reader in the text.

In sum, by defining obscenity as something that was conjured in the
minds of readers rather than an objective attribute of the text, the judges
could affirm both the artistry of Kafū's authorial intent and the poten-
tial obscenity of contemporary reader reception. Thus the trial could

simultaneously work to sanitize Kafū's reputation while sullying that of the defendants and the reader.

Rapturous Readers or Peeping Voyeurs?

To return to the question posed at the start of this chapter: Were Kafū and Nosaka perverted dilettantes or incisive cultural critics? Intrepid archeologists or peeping voyeurs? In the case of "Yojōhan," claiming the story to be a pointed political or societal critique required some fancy literary footwork. Such an assertion was quite impossible at the level of content, for, as the prosecutor charged, over two-thirds of the story is the "plain and detailed descriptions of the repeated scenes of sexual intercourse." Instead, a discussion of content had to be deferred in favor of an appeal to literary form, just as in the defense's case. The award for fancy footwork goes to the judges in this trial, however, for they managed to demonize the defendants for republishing an obscene story while not just exonerating Kafū for his role as the original author but actually canonizing him. That such an unabashedly sexually explicit text could evoke such a paradoxical verdict is perhaps only fitting for an author like Kafū. Arguably, it is this hybridity of Kafū's works—the discomforting combination of high and low—that confounds the censor and critic alike.

The question raised by this trial, and one that comes to the fore in the subsequent *Realm* trial, was this: was the audience for obscene prose more of a rapturous reader or a peeping voyeur? When the judges in the "Yojōhan" trial strove to revise the legal definition of obscenity, they explicitly articulated the bias against visuality that I argued was lurking in the obscure phrasing of the "principle of the nonpublic nature of sex" as early as the *Chatterley* trial. In their general discussion of what constituted obscene literature according to article 175, the judges explicitly identified the visual quality of prose as a prerequisite for literary obscenity:

> Because we recognize that the principle of the nonpublic nature of sex applies even to prose, to call something obscene prose requires that the depiction of genitals or the sex act be plain and detailed enough to stimulate or excite sexual desire to the same degree as if genitals or the sex act *were actually seen*. (*YS,* 2:325; italics mine)

At this time what had been implicit in the prosecutors' cases—that the danger of a literary work lay in its ability to evoke visual images for the

reader—became central to the definition of obscenity. Most compellingly, the prosecutor in the subsequent *Realm* trial raised this objection not just to the photographic images included in Ōshima's book but also to the screen-play's prose. As the "Yojōhan" conviction as well as the guilty verdicts in all the literary trials suggest, in the eyes of the law, peeping readers of prose were even more dangerous than voyeurs.

PART IV

TRYING TEXT AND IMAGE

The cliché "a picture is worth a thousand words" suggests that images are inherently more powerful than texts. The perceived power of images, in turn, has encouraged their association with obscenity. As Frederic Jameson has provocatively put it, "the visual is *essentially* pornographic."[1] Stanley Cavell has claimed that the "ontological conditions of the motion picture reveal it as inherently pornographic."[2] But if these claims are true, the verdicts in Japan's landmark postwar censorship trials of literature and film make little sense. In these trials, spanning thirty years from the *Chatterley* trial to the Nikkatsu Roman Porn trials, literature was consistently convicted of obscenity whereas film was exonerated. Are we to conclude that, contrary to popular belief, words are more powerful and more potentially obscene than images?

In each of the landmark postwar censorship trials considered thus far, the objects on trial belonged solely to one medium, literature or film. In the final two trials of my study, instead hybrid media were the targets: Ōshima Nagisa's 1976 book version of his infamous film *In the Realm of the Senses* containing the screenplay and twenty-four photographic stills taken during the film shoot, and the 2002 erotic manga *Honey Room* (*Misshitsu*). Centering on hybrid media of both prose and images, these trials can facilitate our exploration of the perceived affective powers of text and image.

Because it involved a doubly hybrid work combining prose (if not literature per se) and photography linked to a film, the *Realm* trial offers an especially compact example to explore the nature of the relationship between words and images and between prose, photographs, and film. In tackling these debates, the trial foregrounded a fundamental issue that was implicit in all Japan's postwar censorship trials, even those dealing with only a single medium: What assumptions about the perceived powers and accompanying dangers of literature, as a textual medium; of photography, as a static visual medium; and of film, as a kinetic visual medium, informed the interpretation of obscenity? What about the acts of reading and spectating made the censors perceive them as dangerous, and which was more dangerous—a reader, a viewer of photographs, a spectator of films, or hybrid media that combined all three of these modes?

In these trials, each party advanced theories of the affective powers of the media of prose, photography, and film on readers and viewers. As Dominick LaCapra has suggested in his study of the *Madame Bovary* trial, censorship trials offer "a locus of social reading that brings out conventions of interpretation in a key institution—the judicial system," as well as "an

index of conventions or norms of reading in the larger public."³ By analyz-
ing the shared assumptions at work in the trials of hybrid media, we can get
a glimpse of possible answers to that ever-elusive question of reception in its
most fundamental sense: the ways words and images, both still and moving,
affect audiences.

Both trials also highlighted the key role that international perceptions
often had in Japan's censorship proceedings. Although the book *Realm* was
marketed to a domestic audience, the film was designed to be Japan's first
self-designated hard-core pornography aimed at an international art-house
audience. The manga too was marketed to an exclusively Japanese audience
and, according to the defense, to a unique subset of this group, nerdy young
males (*otaku*) obsessed with technology, anime, and manga, but these pop
culture media were also gaining the attention of the Japanese government as
designated export products. Again at stake was the representation of Japan,
both its culture and its laws, to the international community.

Compared with the earlier works, these two both escalated the degree
of explicit sex and violence significantly. *Realm* recounts the sensational Abe
Sada incident. In 1936, Sada strangled her lover, Kichizō, the married pro-
prietor of the inn at which she worked, severed his penis and testicles, and
escaped with his genitals in hand, only to be arrested four days later and ulti-
mately convicted of murder.⁴ A more extreme version of Lady Chatterley,
Realm's sexually insatiable female protagonist paved the way for an overtly
feminist defense of the character and of the work, an argument that had
greater currency in the 1970s context than in the 1950s, when defenses of
Lady Chatterley had been couched in legalistic rather than feminist terms.
Ōshima claimed "to stand in the courtroom with Sada by his side" in order
to "expand freedom of sexual expression for women," and film critic Satō
Tadao sanctioned Sada's castration fantasy as a natural response to patriarchy
(although he sheepishly admitted also that "of course we'd have a problem
if women indiscriminately went around cutting off men's penises").⁵ So too
would the manga encourage this kind of feminist defense in part because the
collection of eight stories includes depictions of similarly insatiable women
unabashedly seeking sexual pleasure. Because the manga also included bru-
tal depictions of the rape and torture of young women, however, it would
also engender a feminist attack, as well as age-old accusations of inciting
copycat crimes, this time among its vulnerable young male readers.

Whereas Ōshima's book won not-guilty verdicts from both the lower
and appeals courts in the late 1970s, the manga, at the start of the twenty-first

century, was consistently ruled obscene and the defendant guilty. These obscenity proceedings against a book version of an art-house porn film and, thirty years later, against a pop culture erotic manga suggest the censors' abiding concern with policing text and image, especially hybrid media that were gaining the attention of the international community. Whether in the context of the international drive to decriminalize pornography in the 1970s or to criminalize child pornography in the twenty-first century, the implications of these texts and their trials extend far beyond the borders of Japan and suggest a long-lived and complex relationship between domestic notions of obscenity and global trends.

CHAPTER 7

A Picture's Worth a Thousand Words
In the Realm of the Senses (1976–1982)

Kichizō's hand seems to have touched [Sada's] genitals. . . . The geisha
are surprised. Kichi turns toward the geisha and laughs. . . . Geisha 4
suddenly forces open [the young geisha] Osome's kimono and shoves
her hand up it. . . . Sada then approaches . . . and gets on top of Osome
and rubs against her genitals. Osome starts writhing, but Sada has no
pleasure. Geisha 4 gently pushes Sada aside, sticks a papier-mâché bird
inside of Osome's genitals and rides on top of her. Suddenly, Kichizō is
beside Sada. Sada: "Kichi-san"; grabbing him, she violently takes hold of
his penis. Kichizō's hand is stuck up Geisha 1's kimono. Kichizō's foot
rubs the ass of Geisha 4, who is on top of Osome. Geisha 3 is sucking
on Kichizō's lips. And Sada, who has just become aware of that scene,
desperately defends the penis.

—Ōshima Nagisa, *Ai no korīda* (1976)[1]

The book *Realm* is divided into three discrete sections: first, twenty-four
7-by-10-inch color still photographs; second, the original screenplay that
was distributed to the actors and staff prior to making the film; and third,
several essays of criticism by Ōshima. In the tersely worded indictment,
twelve of these photos and nine passages of the screenplay were identified as
obscene. The prosecutor's laconic style makes it especially difficult to deter-
mine what precisely was objectionable about the book. He merely identi-
fied the twelve "obscene color photographs taken of the poses of men and
women engaged in sexual intercourse and sex play" and nine passages of

"obscene prose from the screenplay that plainly describe scenes of male-female sexual intercourse, sex play, etc."[2] Again, a purely content-based analysis leads to a dead end. An evaluation of the prosecutor's choices can yield only the conclusion that the criteria used to determine which passages qualified as obscene were either extremely complex or extremely arbitrary. Instead, as Japanese-film scholar Aaron Gerow has aptly noted in an article on the *Realm* trial, "obscenity comes not from the text itself, but rather from the reception of that text."[3]

The book's hybrid form that overtly presents prose and still photographs and covertly evokes the moving images of the film lay at the heart of the prosecutor's objections. In his somewhat cryptic closing argument, the prosecutor implied that both the screenplay and the still photos were objectionable because they resembled moving images. He provocatively suggested that the book *Realm* was obscene because it was a visual and, even more important, filmic text. The coexistence of textual and visual components within the book, coupled with the fact that the book was a by-product of the film, undoubtedly facilitated the accusation that it was filmlike. And in fact the prosecutor likely *was* indicting the book as a substitute, or, as the defense charged, a scapegoat or payback for the film, which was not prosecutable because of Ōshima's innovative production strategy (*AS,*

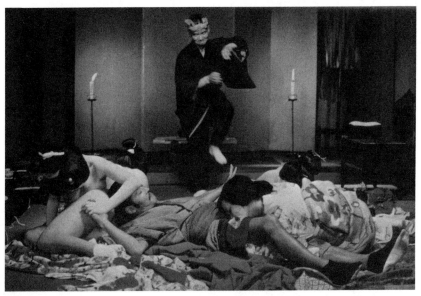

Fig. 7.1 The old man in the orgy (photo 21) (Ōshima 1976)

1:219; 2:294). He had imported the film stock from France, shot the film in Kyoto, and then exported the undeveloped film back to France, where he developed and edited it and finally distributed it internationally, including importing it back to Japan. This new strategy enabled Ōshima to avoid prosecution for the film under domestic obscenity laws, since the verdicts in the earlier *Black Snow* and Nikkatsu Roman Porn film trials had definitively ruled that Eirin was the trusted arbiter of morality for films and Ōshima had followed Eirin's (as well as the Japanese Customs Bureau's) regulations to the letter. This strategy also helped circumvent the strict domestic censorship regulations that would have allowed the film to exist only in the heavily cut form eventually screened in Japan and that many Japanese film directors felt were inhibiting their critical recognition internationally.

The perception that the international reputation of Japanese films was at stake propelled both the film's creation and the book's indictment. In his outspoken role as a defense witness at the Nikkatsu trial three years earlier (a factor that also likely encouraged his indictment), Ōshima had touted *Realm* as the first Japanese example of hard-core pornography made for an international audience:

> When I traveled to foreign countries, I felt keenly the poverty of Japanese sexual expression. Foreign spectators would laugh because in so-called sex scenes in Japanese films, the actors would be wearing underpants. I thought this was a national disgrace . . . and wanted to show the international community a film [that showed sexual intercourse and genitals] made by a Japanese director.[4]

With this statement, Ōshima was declaring his aspiration to join the trend to decriminalize pornography that had swept Europe in the late 1960s to mid-1970s. For the state censor, the prospect of hard-core pornography's being legitimated domestically was nothing to celebrate. Ōshima's stated intent to bring Japanese porn up to international standards and to the attention of the international community was undoubtedly even more troubling. Yet, significantly, it was not his infamous film but his book version that provoked the criminal charges. The indictment of Ōshima and his publisher in mid-August of 1976 occurred a full two months before the film was screened in Japan, while the film was stalled in Japanese customs' censorship. This suggests that the charges against the book stemmed not from any actual effects the film had on Japanese audiences but from the film's

sensational reputation abroad after it had been screened thirteen times to great critical acclaim at Cannes in May 1976. Of course the two works were not unrelated. The indictment of the book only served to hype the film in the Japanese media, with an estimated 70,000 Japanese traveling to France to see the uncensored version, compared with a paltry 12,524 copies of the book sold.[5]

While the indictment of the book was likely as much a response to the film as it was to the book itself, the prosecutor's arguments did not rely on a condemnation of the film but, more intriguingly, on a condemnation of the book *as filmic*. The prosecutor did not even claim that the book as a whole resembled the film. Instead, he made the significantly more improbable claim that each section—the screenplay and the still photographs—taken independently resembled moving images. This neat division of the prosecutor's case against the book facilitates our own investigation of the perceived powers and dangers of prose and photography. How each party at the trial interpreted the book's relationship to the film allows us to explore the tenuous relationship between moving pictures, or, more literally in Japanese, "moving photographs" (*katsudō shashin*), and still photographs (*suchīru shashin*).

Moving Words

In the indictment, the prosecutor accurately charged the screenplay with being composed of mostly "a succession of scenes of male-female sexual intercourse and sex play," whose depiction ranged from "plain and detailed" to "concise and intuitive." As seen in the opening to this chapter, one of the more graphic scenes cited by the prosecutor occurs during Sada and Kichi's mock wedding ceremony, which culminates in an orgy as they consummate their marriage for five onlooking geisha.

The prosecutor objected not only to the content of this and eight other such passages but also to their form, and particularly their visual quality. He began his closing argument by quoting Ozu screenwriting giant Noda Kōgo's dictate that screenplays should express themselves in a "visualized form" (*shikakuka sareta katachi*). He then revealed his basic criterion for judging obscenity: prose that described scenes of sexual intercourse was obscene if it satisfied one condition—did it arouse a picture in the minds of readers? In words that echoed those of the "Yojōhan" lower court judges, obscene prose created a visual picture of those scenes for the reader "just as if they were unfolding before one's eyes" (*AS*, 2:323, 324).

But how were words on a page transformed into a visual apparition that unfolded before the reader's eyes? The prosecutor avoided explaining how textual prose achieves this transformation by instead relying on a lengthy analogy to visual media. Again, photos or pictures of the real thing—genitals or the sex act—were "indisputably obscene." Even for less clear-cut, textual depictions, "if the depiction allows one to perceive or easily imagine scenes of male-female sexual intercourse, sex play, etc., then its obscenity is affirmed because it achieves nothing less than stimulating the viewer's powers of imagination and making them feel as if scenes of sexual intercourse or sex play are unfolding before their very eyes" (*AS*, 2:324). Notice that here even a general discussion of a written text's obscenity could occur only in terms of visuality. With these prolix and circuitous statements, the prosecutor was claiming that visual images and prose were obscene not because of *what* they contained but because of their ability to evoke an imagined visual scene for a reader.

As for the *Realm* screenplay, the prose was obscene precisely for this reason: "Because the screenplay is expressed in a visualized form that allows one to perceive it as a film screen [*eiga no gamen*], it makes the reader feel as if scenes of sexual intercourse or sex play are unfolding before their eyes [*kore o yomu mono o shite, atakamo seikō seigi no jōkei ga ganzen ni tenkai sareru yō na kan o idakashime*]" (*AS*, 2:324). With this repeated refrain, the prosecutor seemed to be suggesting a double risk: the visual unfolding (*tenkai*) of the sex act and the enfolding of the reader (*kan o idakashime*) by the scene. The prosecutor's rhetoric transformed readers into spectators who no longer control perception but are instead involuntarily consumed by the scene, which automatically unfolds before them on a virtual film screen as it enfolds them. In other words, the reader of the screenplay is transformed into a passive spectator who is immobilized by the power of the moving image.

In the prosecutor's formulation, when a text takes on a visual and kinetic form, the active work of reading is seemingly no longer required or even possible. The immediacy of the visual medium is implicitly contrasted with the opacity of written texts, which require mediation in the form of reading. For the prosecutor, it was imperative to depict the screenplay as filmlike because his case depended on this distinction between readers, who retain mastery over the reading process, and spectators, who are powerless in the face of moving images. A guilty verdict hinged on this rhetorical

transformation of the reader into a quasi spectator and of the text into a quasi-filmic medium.

Dazzling Screens and Bedazzled Spectators

In their defense of the screenplay, the defense lawyers and witnesses inadvertently played into the prosecutor's hands by admitting that interpreting the screenplay was a highly visual and imaginative act. In his opening argument, Ōshima's special counsel, Suzuki Seijun, the well-known film director, characterized the act of reading the screenplay in these terms. Suzuki differentiated screenplays from novels by stating, "Because screenplays are not novels, they do not require rhetoric, personification, detailed psychological description, or descriptions of settings. Indeed, what is most feared is that such things will impede the imagination. . . . The screenplay *Realm* requires reading straightforward things complexly. This work is what we call the work of reading by filling in pictures [*ga o oginatte yomu to iu sagyō*]" (*AS,* 1:147). According to Suzuki, though a screenplay is written in "vulgar letters and words," a reader inevitably creates a picture from the text.

Like the prosecutor, the defense depicted the act of reading as an ultimately visual enterprise. As literary critic Robert Scholes has noted, while readers must concretize or visualize a written text because it lacks images, spectators must supply the conceptual abstractions absent in the medium of film: "The reader's narrative processes in dealing with printed fiction are mainly oriented toward visualization. This is what the reader must supply for a printed text."[6] Although arguably not all printed fiction requires visualization, the compulsion to visualize a text is particularly strong in the case of a screenplay like *Realm.* As the defense claimed, the screenplay, a template for the film, was designed to invite its own visualization for its intended readers—the film crew. Its other target audience was Eirin, whose inspection process required a script check as the first step. Paradoxically, screenplays had become standard industry practice back in the 1930s at the insistence of the Japanese censors themselves in an attempt to standardize and to police film texts.[7] Why, in this case, was a script unable to perform this function and even itself deemed objectionable?

By claiming that the screenplay was an open-ended and fluid text intended primarily for those readers who created the film on the set, the defense raised the specter of secondary readers of the book who would be invited to actively construct the film in their minds. Just as the filmmakers

were forced to use their powers of imagination, so too were secondary readers of the screenplay. Such readers were no longer strictly readers but spectators visualizing a film in their minds' eyes. In his testimony, film critic and defense witness Matsuda Masao admitted that the screenplay could appeal to the more imaginative and susceptible readers of this secondary audience, those "people with a very rich imagination, who from a single line of even simple and very dull stage directions of a screenplay imagine a personal kind of screen that is dazzling. I think that, in many cases, depending on the reader's general outlook, this can vary quite a bit" (*AS*, 2:34). What worried the prosecutors was precisely the imagining of this "personal kind of screen" (*jibun nari no sukurīn no gamen*), all the more dangerous for its invisible, interior, and individual nature.

The problem with the screenplay, according to the prosecutors, was not just that readers *could* visualize any number of "dazzling personal screens" but that they *would be forced* to do so. While the defense had attempted to characterize the visualization of the screenplay as active "work" (or in Suzuki's terms, "the work of reading by filling in pictures"), the prosecutor depicted it as passive and even involuntary, positing the susceptible spectator unintentionally evoked by Matsuda.

The Presence of a Text

According to the prosecutor, the passivity of the screenplay's reader was a result not only of its visual quality but also of its palpably physical and even kinetic form. But how can a written text achieve a visual and even mobile dimension?

To explain the transformation from text to image and reader to spectator, the prosecutor next introduced the concept of "presence" (*rinjōkan*). Citing Sada and Kichi's orgy scene with the geisha, quoted above, he argued, "Because the description of the scene is plainly expressed in an extremely direct and visualized form, it has, as a result, presence for readers and presses in upon them. As a consequence, more than the detailed description of an average novel, it strongly excites and stimulates the sexual desire of readers" (*AS*, 2:324). The prosecutor thus credited the screenplay with both a visual and a physical dimension, or imminence, that can "press in upon" readers. The screenplay was dangerous because it was visual and kinetic, or in other words a "moving image," the very definition of a film. With this characterization, the prosecutor was condemning the screenplay by likening it to

film, and unwittingly evoking a model of early film spectatorship described by film scholar Tom Gunning as an "aesthetic of astonishment."[8]

Gunning recounts the apocryphal stories that appear in standard Western film histories of early film spectators in Paris running en masse from the screen in fear that they would be run over by the train speeding toward them in Lumière's 1895 *Arrival of a Train at the Station.* Notwithstanding its mythic status, this was the model of spectatorship implied by the prosecutor. The director, Shinoda Masahiro, a defense witness, recognized this and ridiculed the prosecutor for implying that the visually savvy modern citizens of Japan resembled "the natives in the heart of the African jungle, who upon being shown a hygiene film by their British colonizers were seized with panic when suddenly a close-up of a fly appeared, since they had never seen so big a fly" (*AS,* 1:346–347).

As Shinoda perceptively noted, the prosecutor invoked this model of the naïve spectator to insinuate that readers would be unable to differentiate between sexual depictions in fiction and those in reality. With his charge that the screenplay's "visualized form . . . allows one to perceive it as a film screen" (*AS,* 2:324), the prosecutor relied on a cinematic metaphor. This was likely because the medium of cinema had been long championed as the apotheosis of realism. According to his logic, if the prose was sufficiently cinematic to imbue the depicted scene with "presence," the reader of a text was transformed into a spectator at a live sex act. Accusations of obscenity often went hand in hand with charges of realism, as seen in the "principle of the non-public nature of sex" dating back to *Chatterley.* Nor were such charges limited to Japan; Attorney General Meese's 1986 Commission on Pornography report, for example, cites the eminent realist film theorist André Bazin.[9]

To bolster his assertion that the description of the sex act in writing was as dangerous as a live sex act, the prosecutor cited the precedents of the earlier literary censorship trials of Sade, *Dannoura,* and "Yojōhan," which deemed, "As for the expression of the sex act in prose, based on the way it is expressed, it has a psychological effect on viewers that is either equal or greater than if the actual sex act had occurred. . . . Based on the nature of prose, there is the danger that the effect will extend to an even wider sphere than the actual sex act" (*AS,* 2:318–319). The courts were claiming that the mimetic powers of language somehow exceeded reality itself and should be policed accordingly. Of particular note, the prosecutor even referred to what were indisputably *readers* of the screenplay as "viewers" (*miru mono*) without acknowledging any distinction between the two. Only by collapsing textual

and visual media as well as the acts of reading with those of spectating could the prosecutor convince the court of the dangers of a written text.

Moving Images

By likening the screenplay to a moving image, or as he put it "a film screen," the prosecutor was attempting to convince the court of both the visual and kinetic qualities of the screenplay's prose. The visual component was seemingly not enough to convince the court of the work's obscenity; a semblance of motion was essential. This was also true of his case against the photographs, for which he made the equally, if not more improbable claim that the *still* photos resembled *moving* images.

Gunning's concept of an "aesthetic of astonishment" suggests why the prosecutor conflated not only text and image but also static and kinetic media. Gunning criticizes popular and critical accounts that rely on apocryphal stories of early spectators fleeing from movie screens to depict them as unable to distinguish between reality and representation. He is especially critical of realist, psychoanalytic, or apparatus theories of cinema (i.e., those of Balázs or Bazin, Metz, Baudry) that depict spectators as entranced by the image on the screen because they confuse it with reality. Gunning claims rather that early cinema fascinated spectators because of its power to impart motion to the image. Based on the early film exhibition practice of projecting a still photograph onto the screen and only gradually making it move before the spectator's eyes, Gunning suggests that the attraction of early film was less about "a simple reality effect" and more about its ability to enthrall spectators with the "moment of movement."[10]

In his arguments in the *Realm* trial, the prosecutor's case rested on establishing a link between obscenity and the power of this moment of motion to enthrall spectators. Although at times the prosecutor blurred the distinction between representation and reality, we should take Gunning's cue and be careful not to underestimate the prosecutor's understanding of the "reality effect." He was strategically likening the screenplay and the photos to moving images in order to evoke the rhetorical power associated with this moment of motion. In doing so, the prosecutor could tap into what was perceived to be cinema's unique power, its capacity to capture movement. This ability was also what made it the medium of choice for pornography, a connection that would facilitate the obscenity charges against *Realm*.

Indeed, the fact that the work on trial depicted naked "bodies in motion" was not at all incidental to the prosecutor's accusations that the

work was a "moving image." As historian and censorship scholar Francis G. Couvares writes, the power of cinema lies equally in its ability to capture motion and to move spectators: "From the start, moguls and moralists alike recognized that the moving picture deserved its adjective in a double sense: it seemed to mimic the real world of people and things in motion, and it moved viewers to states of feeling that could be difficult to control and difficult to resist."[11] Pornographic film was doubly dangerous in the moralists' minds because its ability to elicit an involuntary response that was "difficult to control" in the viewer was mirrored in the film itself, which captured bodies involuntarily in motion.

The conceit that the movie camera is uniquely able to capture this spectacle is, as Linda Williams points out, central to both the invention of cinema and the essence of hard-core pornography: "to register the previously invisible hard-core 'truth' of bodies and pleasures in a direct and unmediated fashion."[12] Citing Eadweard Muybridge's experiments in the 1870s with instantaneous photography and his invention of the zoopraxiscope, a prototype of the motion picture projector, Williams notes that cinema exhibited a preoccupation with depicting naked bodies in motion from its inception. She interprets these early examples as a harbinger of what would become an abiding interest of cinema in general and of hard-core cinema in particular—the scientific and prurient desire to produce the illusion of capturing bodies (especially women's bodies) involuntarily in motion: "Thus, with this ability to induce and photograph a bodily confession of involuntary spasm, Muybridge's prototypical cinema arrives at the condition of possibility for cinematic hard core." Another example that suggests this early desire was Edison's 1893–1894 short test film of a sneeze, *Fred Ott's Sneeze.* Like the orgasm of later hard-core films, the sneeze offered an involuntary bodily spasm and emission to be captured by the new technology. Although the journalist who proposed this idea of filming a sneeze to Edison reported in his article in *Harper's Weekly* that he had seen the sneeze through the Kinetoscope, in actuality he saw it only as a series of printed still photographs. Nonetheless, he offered unqualified praise for the realistic illusion that makes "you involuntarily say, Bless You!"[13]

This incident offers a suggestive explanation for why the Japanese prosecutor made the improbable claim that the still photos were actually moving. The journalist's false claim that he had seen the film version of the sneeze can perhaps be dismissed as artistic license, but his need to mobilize the images to

impress his readers resembles the prosecutor's need to claim that the still photos in *Realm* moved in order to convince the court of their obscenity. In both cases, still photos were likened to film because the rhetoric of moving images was considered powerfully persuasive in the minds of moguls and moralists alike; without a moment of movement, images alone were seemingly insufficient to garner either the customers' or censors' attention.

It is striking, nonetheless, that the prosecutor implied the still photographs of *Realm* resembled the early exhibition practice described by Gunning since they resonate more with the prototypes of cinema seen in Muybridge's and Edison's early experiments. In fact, the photos represent the reverse trajectory of Gunning's example; for Gunning, early spectators were entranced by the image because a still photograph gradually began moving before their eyes. In the book *Realm,* moving images from the film (or more accurately, rehearsals for the film) were frozen into static single shots.[14] The question, then, remains: How could the prosecutor make a case that the *still* photographs in *Realm* were *moving* images?

Detecting Motion in the Stills

The prosecutor charged the photos with motion in two ways: the first was the explicit claim that the photos themselves embodied motion because the actors' arms and legs were moving in the still photos; the second, more implicit charge was that the photos would come to life before the viewer's eyes. In the indictment, the prosecutor singled out twelve of the book's twenty-four photos that depicted men's and women's bodies with their genital areas visibly aligned in the frame of the photograph (or, as in the case of two of the photos, showed Sada's head aligned with Kichi's genitals).[15] According to the prosecutor, these twelve photos were "clearly scenes of sexual intercourse, or at the very least scenes of the pubic regions of the man and woman in close contact with each other. . . . Because their positions make one clearly perceive that they are actually having sex, the photos have an extremely high degree of obscenity" (*AS,* 2:322). In other words, these photos were objectionable because they captured the actors "in the act."

For the prosecutor, the fact that the photos simulated the sex act both in their presentation style, showing genital areas aligned, and in their production process, having been produced during the film rehearsals, contributed to their obscenity. He formulated this claim explicitly in his closing argument:

> The photos are scenes of mutual entanglement of either totally naked or partially clothed men and women photographed either during rehearsals or immediately after the shooting of the film *Realm* with the real film actors and actresses who appeared in the film *Realm*. Although they do not directly depict the genitals themselves, in any case they are scenes that allow one to easily perceive the fact that men and women are engaged in sexual intercourse . . . or sex play. Moreover, the fact that the still photos were taken during the process of filming the movie in any case strongly produces a very real feeling and, consequently, excessively stimulates sexual desire. (*AS*, 2:322)

Because the viewer was aware that the photos were taken during the shooting of the film, they would effectively restage the film's live sex acts by "real actors and actresses." By portraying the photos as liable to being mobilized in the imaginations of viewers, the prosecutor was rhetorically transforming the photos from a collection of stills into a frenetic, kinetic live sex act.

Of course the fact that Ōshima had advertised the work as "Japan's first hard-core film" invited precisely this line of attack. Although the police officer who questioned the actors during the investigation asked if sexual intercourse had actually taken place (*AS*, 1:396), the question of whether the sex act was simulated in the film or in the photos was not explicitly raised by the prosecutor in the trial, likely because it would have been impossible to prove, just as in the previous Nikkatsu Roman Porn trial. While the designation "hard core" certainly suggests that the performances were real, in the trial Ōshima wisely skirted the issue entirely, although in press interviews and in an essay that was included in the book *Realm*, he proudly claimed that the film included a "scene involving real sexual intercourse."[16]

Of the twelve photos identified as obscene, the prosecutor explicitly charged seven (nos. 8, 9, 10, 11, 12, 16, and 18) with embodying motion, claiming, "The actors' expressions and the movement of their arms and legs increase the sense of presence" (*AS*, 2:322). The images of the actors are not, of course, actually moving in these still photos. So, what could the prosecutor have been indicating with this charge? When the frame cuts off part of the actors' bodies, the actors and the action seem to escape the parameters of the cameraman's frame, heightening the illusion of a moving subject that cannot be fully captured. In both photos 16 (fig. 7.2) and 18, for example, the heads of Sada and Kichi extend beyond the frame as if the camera just barely managed to capture them "in the act." In other photos, the postures of

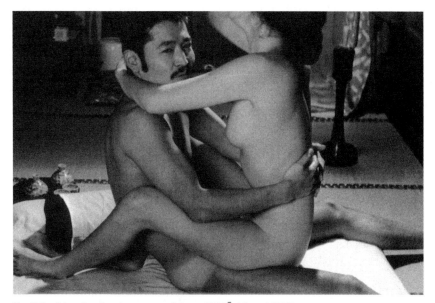

Fig. 7.2 Mugging for the camera (photo 16) (Ōshima 1976).

the actors seem unsustainable for any length of time, furthering the illusion that the photo was taken during a brief instance of stasis. One depicts Sada arching her neck and back, and in another Sada suspends her leg in midair with her foot arched in a tense pose.[17] In others, the out-of-focus quality of some body parts gives the impression that the actor was not entirely still when the photograph was taken; in photo 9, the seated figures of Sada and Kichi having sex in the left foreground and a geisha playing samisen in the background are less sharp than the candle occupying the right foreground, and in photo 18 the figure of Sada is blurred, giving the impression that she is being jarred about by Kichi's thrusting on top of her. For the prosecutor, it was this aroused, moved female body of Sada in particular that rendered the book obscene, but the figure of the immobilized male body of Kichi also likely factored into his objections.

Moved Female Bodies and Immobilized Male Bodies

The prosecutor identified seven photos as obscene because both the actors' kinetic postures and their facial expressions heightened the photos' presence and consequently increased their obscenity. For each of these photos, the prosecutor did not specify if it was the man's or woman's face, but their content suggests his preoccupation was with Sada's ecstatic self-abandon caught

in the midst of an ecstatic moment. Significantly, it is the actress Matsuda Eiko who conveys rapture and ecstasy, as well as her seeming unawareness of the camera.[18] The male actors, especially Fuji Tatsuya, who plays Kichi and appears in the majority of these photos (except for two that feature her elderly patron), in contrast, retain a remarkable control and mastery over their bodies even in the midst of the sex act. Kichi's calm self-possession begs a comparison with Sada's seemingly involuntary displays of sexual pleasure and begs a consideration of how gender factored into the prosecutor's objections to *Realm*.

In each of the photos cited as objectionable because of the actors' facial expressions, Sada's eyes are either almost or entirely closed, and her lips are slightly parted. In sharp contrast with her apparent ecstatic abandonment, the expressions on her male partners' faces convey an extreme measure of self-control. In photos 8, 11, and 12, the men exhibit their solicitous concern (and even distress) at Sada's extreme displays of pleasure, and, in photo 16 in particular, Kichi's self-possession is such that he mugs for the camera. Interpreted in the context of Williams' argument, the photos indeed seem to offer the promise of hard-core film: "incontrovertible proof that a woman's body, so resistant to the involuntary show of pleasure, has been touched, 'moved' by some force." As she notes, because a woman's orgasm is not visually verifiable in the same way as a man's, the much-touted representational capacity of cinema (and photography) must confront its limitations when depicting female pleasure.[19] Like Western hard-core films, such as the classic 1972 *Deep Throat*, which featured a female lead whose clitoris was inexplicably located in her throat, the film *Realm* similarly attempts to overcome these limitations by introducing medical explanations in the narrative for Sada's extremely visible and audible demonstrations of her sexual pleasure. In the photos as well, her self-abandon, especially in contrast with her male partners' self-possession, attempts to convince the viewer of the authenticity of her involuntary display.

But despite the prosecutor's myopic focus on representations of female pleasure, arguably male pleasure was also at issue and was perhaps even more central to his objections and to the theme of the film. Suggestively, the one photo (no. 14, fig. 7.3) for which the prosecutor specified that he objected to the female's facial expression is the only photo in which the man also exhibits signs of arousal (*AS*, 2:322). This omission suggests a willful disavowal on the part of the prosecutor to acknowledge the representation of male pleasure, especially one that is masochistic and submissive.

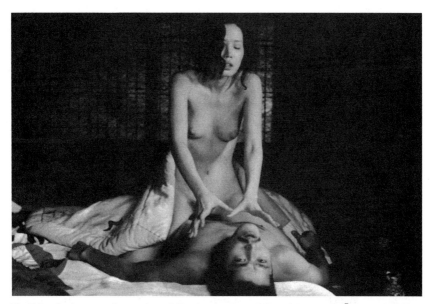

Fig. 7.3 Sada strangling an immobilized and unbound Kichi (photo 14) (Ōshima 1976).

In this photo, we see the front of Sada's naked body straddling Kichi, who is lying on his back with his head tilted backward so that his face is fully visible to the viewer; Sada's outstretched hands are poised hovering over Kichi's neck, as if to begin (or resume) strangling him. His hands lie motionless at his sides, with no binding keeping him from moving, suggesting that he willingly submits to Sada's desire out of enjoyment of pleasure or pain. The prosecutor's singling out of Sada's facial expression and his utter neglect to mention the expression on Kichi's in this photo is telling. Undoubtedly, the theme of the work—a dominant, homicidal, and castrating female and an increasingly submissive male—factored into his objections. (It also suggests how the film subverts conventions of the Western genre of hard-core pornography at the same time that it declares itself as part of that tradition.) That the man in this photo was clearly moved, but not moving himself, was perhaps as equally unsettling to the prosecutor as the many photos of Sada writhing in pleasure.

Judging the Stills: Absorption versus Distraction

In their verdict of October 19, 1979, the lower court judges rejected the prosecutor's charge that the moving words and images of the screenplay and photos would immobilize an unsuspecting reader-cum-viewer.[20] In

exonerating the book, however, they too gave careful attention to the question of whether the photos in particular, as well as the book as a whole, constituted static or kinetic media, suggesting the centrality of stasis and motion to their conception of obscenity.

Mugging for the Camera

Although the judges did not address the prosecutor's contention that the arms and legs of the actors moved, they did adopt his terms by using the criterion of stillness to exonerate the photos. In the verdict, they stated, "In photos 8, 10, 11, 16, 18, and 21, the actors' facial expressions are uninterested [*tanpaku*], especially the smile seen on the man's face in photos 16 and 18. The pictures as a whole impart a feeling of stillness [*seishi shita kanji*]." This results in "the impression that the actors are not actually having sex but are just acting as if." Consequently, the photos, "as scenes of sexual intercourse, lack a high degree of verisimilitude" (*AS,* 2:422). By claiming that the photos' staged quality stilled them, the judges were also implicitly linking kinetic realistic images with obscenity. Unlike the prosecutor, however, the judges denied that the photos involuntarily captured bodies involuntarily in motion and instead asserted that the photos contained frozen and posed bodies.

In contrast with the prosecutor, who had professed concern with Sada's expressions of rapture, the judges were concerned only with Kichi's. In photo 16, Sada's face is not even visible; Kichi, however, self-consciously mugs for the camera, a slight grin visible on his lips as his gaze steadily and knowingly meets that of the camera/viewer, as if to say "cheese."[21] In fact, this could have been the case, for as Ōshima testified, when taking photographs after rehearsals, the still cameraman could ask the actors to adjust their poses slightly (*AS,* 2:273). In photo 18, Kichi's bemused grin, emphasized by the many smile lines around his eyes, coupled with his pose—his upper body is propped up as if to maintain his distance from and mastery over Sada—contrasts sharply with Sada's abandonment. In another photo (13), Kichi's "quiet and even serious expression" was similarly cited by the judges as not realistic or arousing (*AS,* 2:423). The judges' privileging of Kichi's facial expressions for determining the photos' potential to arouse suggests that representing male pleasure was potentially more problematic for them than depicting female pleasure, perhaps because the representation of female bodies and pleasure is such a staple of both erotic photography and the cinema.

The fact that Kichi retained control over not just his bodily movements within the photos but also the bodily image he presented to the camera was central to the judges' not-guilty verdict. If the appeal of hard-core pornography lies in its ability to capture bodies that are moving involuntarily, the photos that contain traces of Kichi's, or, more accurately, of the actor's performance, do not qualify: Kichi's smiles, his serious, even blasé, expressions, and especially his deliberate mugging for the camera all negate the impression that he is either convulsing involuntarily or being caught on camera involuntarily. His expressions, in turn, signal to the viewer of the photographs the presentational nature of the poses and of the publication.

The Old Man in the Orgy

For the judges, the photos further signaled their staged quality to viewers by including a host of distracting and distracted images. For example, the judges ruled that the photo of the wedding orgy with Sada, Kichi, and five geisha was not arousing largely because of the presence of a disinterested spectator in the photo, an old man dancing on a quasi stage in the background. The judges claimed that "the photo also includes the figure of the merrily dancing old man just beside them, so it cannot be said that the scene of sex play is conspicuously sensational" (*AS,* 2:423).

Two other photos listed in the indictment also conspicuously include an elderly bystander in the background who is seemingly oblivious to Kichi and Sada's sexual activities: a geisha playing the samisen (no. 9), and a maid sweeping the garden (no. 12). Although the judges did not cite the presence of these spectators in the photo as a mitigating factor, they did suggest that the profusion of images in these two photos disallowed, or at least discouraged, viewers from focusing on the sex act, noting that "the actors' bodies occupy a relatively small proportion of the photographs and lessened their potential to arouse" (*AS,* 2:422–423). In all three photos, the third party is invariably depicted as unaroused by, and perhaps even unaware of, the sex scene before his or her eyes. The fact that the spectators in these photos are elderly, and presumably asexual, was not coincidental to the exoneration of these photos. Moreover, the fact that these figures were often also performers themselves heightened the performative quality of the photographs and thus likely further mitigated their obscenity in the judges' minds. All three figures—the dancing old man, samisen-strumming geisha, and sweeping maid—offered a distracting image for us the spectator proper to look at and also a model of the distracted, unabsorbed kind of looking we should adopt.

As many critics have noted, in the film scenes of voyeurism abound, and the act of looking is foregrounded again and again by the inclusion of a spectator in the film who doubles our own position as spectators proper.[22] Often these spectators in the film display the prurient looking feared by the censors. For example, in scene 35 (photo no. 6), a maid walks in on Kichi and Sada having sex and "sucks in her breath and watches totally still for a while," and later in that scene, five geisha breathlessly watch Sada and Kichi consummate their marriage.[23] In contrast, in the photographs cited by the judges in their verdict, both the actors and spectators appear to be utterly unabsorbed by the spectacle of sex. Like the 1930s Hollywood censorship-dodging strategy that required films include a morally righteous character to defuse the potential immorality of a scene, the inclusion of these distracted and distracting images ensured that viewers would be able to maintain the proper distance from the spectacle presented in the photos.[24]

According to the judges, not only could the composition of these individual photos have lessened the impression of the actors' having been "caught in the act," but the arrangement of the photos in the book as a whole likely also mitigated this impression. The photos echo one another in both content and composition. In addition to the three photos that include elderly spectators, the one with the maid sweeping in the background also echoes the first photograph of the collection, particularly its overhead angle and gray-toned color scheme with a red accent in the foreground. Such resonances among the photographs hint at an organizing consciousness behind the compilation and further attenuate any sense of spontaneous and kinetic sex being captured by the camera. Like Kichi's provocative mugging for the camera, here too the orchestrated nature of the poses and publication are foregrounded at the expense of kinetic and realistic representation.

Fleeting Film Images versus Fixed Photographic Images

In the judges' view, the form of the photos also rendered them innocuous. In their verdict, the judges articulated a crucial distinction between the media of film and photography that led them to rule the photos not obscene:

> Accordingly, if we compare the photos to depictions of uncensored scenes of sexual intercourse and sex play in the film, which is based on moving images, we recognize that the photos' degree of sensationalism is attenuated because they are not accompanied by successive motion. Moreover, because we think that the photos are different from the film's

single scenes and that the photos easily produce an unnatural quality and gaps between the actors' body positions, the sensationalism of the sex scenes in the photos is consequently reduced. (*AS*, 2:421)

Because a photograph as a frozen image allowed viewers time to study an image, its artifice was easily apprehensible and its obscenity thereby mitigated. In contrast, film as a "time art" glossed over these traces of artifice with its rapid succession of images.

In ruling that still images were less potentially obscene than moving ones, the judges were actively rejecting the 1967 lower court ruling in the *Black Snow* trial. As we saw, the *Black Snow* judges were concerned with film becoming a masturbatory tool and were reassured by the momentary nature of the film as a "time art" that disallowed any lingering perusal of its sensational content. Defense witnesses in the *Realm* trial implicitly endorsed this logic; they repeatedly testified that they casually flipped through the photos, using onomatopoeic expressions like *parapara* and *zatto* to convey a quick and casual pace, and that they "skimmed through" the screenplay (*AS*, 1:291, 313, 323–330 passim). It seems the defense witnesses understood the importance of characterizing the act of reading the screenplay and viewing the photographs as activities that were characterized by distraction, not absorption.

For the judges in the *Realm* trial, however, what could mitigate an image's obscenity was not the momentary impressions of film but instead the fixed quality of a still photograph. In their minds, viewers would study the still images not for their prurient value but to determine their resemblance to reality. Photography was therefore less susceptible than film to charges of obscenity because it was more susceptible than film to the charge that it failed to capture reality adequately. This represents an interesting revision of film theorist Jean-Louis Comolli's assertion that the cinema, unlike other visual media, must contend with its inability to achieve realistic representation because it is the medium that most closely approximates reality.[25] According to the judges' logic, whereas film, as a kinetic medium, encouraged the confusion of reality and representation, photography, as a static medium, drew attention to the inevitable gap between the two; what would be invisible to the spectator of a film would be apparent to a discerning viewer of a photograph.

In sum, the judges ruled that the photos' compositions—their distracting images, distracted actors and spectators, and their highly orchestrated

arrangement both as individual photos and as a collection—stilled the photographs. Moreover, because these images themselves were static, rather than "accompanied by successive motion," viewers would detect these traces of artifice and the obscenity of the images would be mitigated. The photos were not obscene in the judges' minds because they were unlike a film both metaphorically and literally: they were not "moving" in any sense of the word.

The judges were equally firm in their rejection of the prosecutor's comparison of the screenplay to moving images, or to "a film screen that unfolded before one's very eyes." The judges insisted that the script was a textual, and even literary, work that should be evaluated like other prose: "The screenplay must be considered as unrelated to the film—the acting, actors, etc. The assessment must not be based on what kinds of images the film will use to depict the screenplay. . . . Its evaluation must be the same as that of a novel" (*AS,* 2:424). Instead of focusing on the visual images the screenplay might evoke, the judges paid careful attention to the materiality of the screenplay's language and rejected the prosecutor's call for it to be evaluated as a quasi film.

Judging the Book: The Intimacy of Images and Words

According to the judges, when considered as independent units, the screenplay and the photos did not constitute moving images. But when text and image were combined as a single unit, as in the book version of *Realm,* was it transformed into a quasi film as the prosecutor charged? As their verdict shows, in the judges' minds, even when the book was considered as a whole, it differed from the film enough to warrant an acquittal. They reasoned that whereas the film integrated words and images, the book separated these two components into two distinct sections, the screenplay and the still photographs, thereby lessening their potential to arouse. Though they admitted "the photos do seem to correspond to places in the script," they were reassured by the fact that "there are many photos where it is not immediately clear to which specific scenes they correspond. And even in the cases where the correspondence between photo and screenplay is clear, it is not as stimulating to readers as in cases where illustrations are inserted into the text" (*AS,* 2:426). In other words, had the pictures been interspersed among the words of the screenplay, the resulting "intimacy" (*kinmitsusa*) between image and text would have made the book more arousing and obscene. As we recall, in the earlier *Dannoura* appeal verdict, the judges reversed the lower court's

not-guilty verdict because they insisted on considering the original text and the translated intertext as one unit since the two texts were interspersed. In the *Realm* case too the judges asserted that such proximity exacerbated obscenity, whereas physical separation could mitigate it. They also implied that a multimedia text, like film or an illustrated book, which integrates word and image, is potentially more obscene than one that separates the two components, as in *Realm,* or one that is composed of either text or image alone. This assertion did not portend well for the defense in the subsequent manga trial, as we will see in the next chapter.

To return to the question that began this chapter, was the audience for the book *Realm* primarily readers (of the screenplay), viewers (of the photographs), or spectators (of the film), or a hybrid of all three, and which was the most dangerous? In their verdict, the judges suggested that consumers of the book would be forced to alternate between the roles of reader and viewer, thereby keeping them from becoming quasi spectators. They speculated that consumers would likely follow the arrangement of the book, first looking through the photos and then reading the screenplay, or would possibly flip back and forth between the two. Although readers would naturally try to draw a correlation between the two sections, the lack of an intimate correspondence between them saved the book from being too arousing and obscene. For the judges, the order of reading the screenplay and viewing the photos was unimportant, but some barrier between text and image was essential to keep the acts of reading and viewing separate from each other. A not-guilty verdict required the interruption of both the photos' narrativization and the screenplay's visualization. In the case of *Realm,* it was both the physical separation of the images from the text and their interpretive remove from each other that effected this disruption and allowed the book to escape the obscenity charges.

I would add that the perceived lack of clear correspondence between the photos and the screenplay resulted not only from the book's organization into two distinct sections but also from the arrangement of the photos. Although the judges did not mention this aspect in their verdict, the fact that the photos were not interspersed in the text as in an illustrated book also meant that readers did not have to follow the chronology of the narrative presented in the screenplay. One film scholar, Yomota Inuhiko, has lamented this tendency of still photographs to rewrite films because they "interfere with the natural processes of memory and forgetting" and are "nothing other than a remake screened in the fantasies" of the cinephiles

Fig. 7.4 A happy ending (photo 24) (Ōshima 1976).

who collect them.[26] But in this case, the ability of the still photographs to rewrite (and to prettify) the Abe Sada story may have been crucial to securing the acquittal. Indeed, if one were to compare the photographs with the screenplay, a very different story can be told. In contrast with the screenplay's unremitting and repetitive progression toward Sada's murder and castration of Kichi, the photos present a prettified and romanticized version of their affair. Unlike the final scene of the screenplay and the film, which ends with an overhead shot of Sada clutching Kichi's severed penis next to his bloody corpse, the final photo (fig. 7.4) depicts a smiling Kichi and Sada huddled under a translucent beige umbrella in the pouring rain that effectively rewrites the ending from one of an unremitting march toward death into a happy end.

A Hybrid Goes Free

The assumption that kinetic media (i.e., film) are inherently more obscene than static media (i.e., still photography) and that images are more potentially obscene than texts was a powerful underlying current in the arguments of both the prosecution and judges. In fact, the defense also often relied on this very same assumption: moving images were potentially dangerous because

they threatened to absorb the viewer, or, as one defense witness phrased it, "to get lost in the screen" (*AS,* 1:302). The assumption most clearly dictated the prosecutor's strategies, compelling him to argue that the work on trial was actually *something that it was not:* that the screenplay was visual (with scenes appearing before the reader's very eyes) and filmic (like "a film screen") and kinetic (it "pressed in upon readers"), and that the still photos, despite what their name might imply, were also kinetic (containing the "moving arms and legs of actors"). The fact that there was a film version of *Realm* fueled the prosecutor's tendency to collapse these distinctions among the various media of prose, photography, and film. But paradoxically, the existence of a film version also contributed to the book's ultimate acquittal.

In the minds of the judges, the book version of *Realm* benefited from the comparison with the film. When the judges ruled that it was inappropriate even to compare the prose of the screenplay with the film, they were implying that the text was nowhere near as potentially obscene as cinema. When the judges ruled that the still photos were less sensational than the "moving images . . . accompanied by successive motion" of film, they were asserting that the still images of photos were less potentially obscene than the moving ones of cinema. Although the prosecutor and judges disagreed about the outcome, the terms of their arguments were the same: static, textual media are inherently innocuous and kinetic, visual media are inherently obscene.

The question remains as to whether the Japanese example supports theorists' claims about the inherent obscenity of the image. On the one hand, the rhetoric of the prosecutor and the judges in the *Realm* trial would seem to support this conception of the visual or cinematic basis of obscenity since the screenplay and photos were condemned only by likening them to cinematic texts and acquitted only by distinguishing them from film. This rhetoric certainly implies that the visual arts are inherently obscene and, conversely, that obscenity is inherently visual. On the other hand, the not-guilty verdict in the *Realm* trial—as in the two preceding film censorship trials—seems to refute this premise; works that include a visual component, like *Realm,* or films themselves like *Black Snow* and the Nikkatsu Roman Porn escaped conviction, while literary works were consistently judged obscene.

What can explain these disparate verdicts? The book *Realm,* as a hybrid of text and image, offers a suggestive explanation. In its case, the existence of visual versions of the screenplay (in the form of the film and the photos) and of actual spectators and viewers prevented the prosecutor's slippery

assertions from going by unnoted. Paradoxically then, perhaps the book's inclusion of a visual component, in the form of the photos, saved rather than doomed it. Rather than increasing the obscenity of the screenplay, the existence of photos served to restrict the visualization of the textual version in the minds of both judges and readers. In the literary trials, in contrast, because there was no visual component and there were no actual spectators, the judges agreed with the prosecutor who conjured a hypothetical spectator who was very much the apocryphal naïve spectator of early films. For Japan's postwar courts, it seems an obscenity conviction depended more on likening written texts to filmic ones and readers to spectators, rather than on the object on trial itself. Unlike Roland Barthes, who has confounded many a critic with his famous pronouncement that still photographs, not films, possess "the filmic,"[27] the Japanese censors granted literature or prose with the dubious distinction of being the most filmic medium.

Why then were the terms of condemnation always visual? Could it be that the perceived danger lay not with actual spectators who watched an actual film in the theater but instead with readers of written texts who created a "private film" in their minds? When the prosecutor accused a written text, like Ōshima's screenplay, of "unfolding before the eyes of a viewer," was he objecting to the fact that the so-called visual text was invisible, conjured only in the reader's mind, and therefore impervious to being policed? The reader of a text was not, after all, subject to the regulations of a theater space, for both the place and pace of consumption were outside external controls.

I would suggest that the censor was exploiting the perceived dangers of both media: literature, as a private, individual activity, threatens to remove readers from any external social or institutional controls, and cinema, as a moving image, threatens to paralyze a spectator's internal controls. As we will see in the next chapter, a manga as a printed and bound text that includes a laconic series of erotic images would be suspect on both counts. Despite the rhetoric in the trials, the legal judgment of obscenity in Japan depended not on the visual or visible but on the invitation to imagine an invisible, offscreen space, a "dazzling personal screen" that was beyond the reach of any control.

CHAPTER 8

Japan's First Manga Trial
Honey Room (2002–2007)

In 2002, after a twenty-year lull without a single notable obscenity trial,[1] a manga (comic book) was tried for violating the obscenity law, going all the way to the Supreme Court in June 2007. Despite the consistent guilty verdicts at all three phases, the outcome was not entirely a defeat for the defense, which managed to get the initial one-year suspended prison term reduced to a fine of 1.5 million yen (approximately $13,750). Notwithstanding this slight victory, the unprecedented case against a manga marked the introduction of a new artistic medium as a candidate for successful prosecution by the state. This trial represents at once the natural conclusion to the preceding obscenity trials in the second half of the twentieth century, as well as a departure portending those that may follow in the twenty-first. As suggested by recent movements led by conservative Liberal Democratic Party (LDP) politicians and powerful citizen groups, popular cultural media—manga (including the burgeoning genre of erotic cell phone manga), anime, video games, and the Internet—will likely be the new targets of legislation and regulation. While literary and film obscenity trials have faded from view, the manga trial may mark the first in a long line to come.

Spanning precisely half a century, the trial of the highbrow *Chatterley* translation and that of an unabashedly erotic manga would appear to have little in common, but they exhibit surprising similarities at their core. The manga trial rehashed many of the earlier debates: the constitutionality of article 175; the roles of authors, editors, and publishers; the efficacy of self-censorship; the publishing industry's moral versus commercial responsibilities; and the effects of reading and viewing on real-life behavior. Yet again

the indictment occurred at a time of perceived social and moral crisis for the nation. Rising concern about the effects of new media and technology on youths was fueled by a series of highly publicized murders in the late 1990s and early years of the following decade committed by and against youths. Because comic books are a medium that many consider to be for children, youths were again at the center of the debate. Not only was the explosive popularity of manga among young readers in Japan a point of contention but also its reputation abroad as an emerging national art.

The manga trial also introduced some entirely new issues that were specific to its historical moment: how to determine the legal concept of "community standards" (*shakai tsūnen*) and how to police obscenity in the borderless age of the Internet; the state of contemporary publishing trends, particularly after the much-vaunted "liberation of pubic hair" (*hea kaiki*) in the early 1990s after the unfettered publication of nude photo collections; and the relationship of domestic obscenity laws to new and proposed legislation, such as the 1999 Child Pornography/Prostitution Law, prefectural healthy youth regulations, and the international Cybercrime Treaty, which targets cyberporn among other Internet crimes. While the prosecution upheld the state's right and obligation to regulate obscenity and to maintain the "minimum degree of sexual morality," the defense attempted to argue for the irrelevance of the very notion in the twenty-first century.

The trial also diverged from its predecessors as the first targeting the medium of manga. Like the first indictments against literature and film in the *Chatterley* and *Black Snow* trials, this one too engendered a serious debate about medium specificity that addressed the relative obscenity of prose, photography, and film but added manga into the mix and led the judges to assert a revised hierarchy that could impact future prosecutions of all these media. The ways that this trial revisited, diverged from, and refined the earlier trials' debates demonstrates that notions of art and obscenity have both changed and not changed much over the past half century.

The Manga *Honey Room:* It's No *Lady Chatterley*

The tremendous change in the concept of obscenity itself during the fifty-odd years since the *Chatterley* charges is readily apparent if one compares the objectionable passages cited by the prosecutors in the two cases (see the epigraph to part 1 and fig. 8.1). Both depict anal sex, but Lawrence's allusive prose is a far cry from the graphic images and monosyllabic grunts of the manga. *Honey Room* is no *Chatterley,* or *Peanuts* for that matter. It is part of

a specialized popular genre of erotic manga called *eromanga* or *ettchi manga* (dirty comics) that account for approximately 9 percent of manga sales.[2] As with many other arts in Japan, erotic manga possess their own detailed classification system segmented based on subject matter, such as *bishōnen* (beautiful young boy-boy love); S/M; *Loli-con* (Lolita complex), featuring prepubescent girls; and their young-boy equivalent *Shota-con;* or segmented based on readership, with ladies' comics (*redi komi*) aimed at female readers and *eromanga* for males in their late teens and twenties. Typifying the genre are female characters with gigantic eyes and even larger breasts, trussed up in costumes with zippered crotches and piercings, who appear in scenes of violent, and sometimes ecstatic sex that often includes rape, torture, and narcotics forcibly shoved up vaginas.

Fig. 8.1 From "Carnival, Carnival" (Beauty Hair 2002, 63).
Reproduced with the permission of Shōbunkan Publishing.
© 2002 by Shōbunkan Publishing.

In the United States, the term "comics" typically brings to mind serialized newspaper strips like *Peanuts* and *Doonesbury*, or superhero comic books. Such associations have fueled the impression that comic books are for kids, notwithstanding the recent popularity of the graphic novel, a term that itself reveals a perceived need (or, as some have accused, an "insecure pretension—the literary equivalent of calling a garbage man a 'sanitation engineer'"[3]) to distinguish between a novelistic, literary form meant for adults and its predecessors. The notion that comics themselves are a childish, debased art form has further encouraged their strict censorship. In the United States, censoring comics in the name of "the children" dots the history of the medium in a series of crusades led by PTA associations, church groups, and conservative politicians.[4]

In Japan, manga have traditionally occupied a more diverse and prominent place. "Manga" refers to hand-drawn panel art ranging in length from a single-panel comic to a several-hundred-page book that might itself be part of a thirty-plus volume series, its publishers include the largest commercial publishing houses and small amateurs (*dōjinshi*), its audiences encompass everyone from elementary schoolchildren to the elderly, and its genres span educational textbooks to pornography. By 1993, almost 40 percent of all printed publications in Japan were manga, and manga have recently evolved into cell-phone downloads with great success.[5] Notwithstanding manga's diversity, even in Japan the impression that "comics are for kids" remains difficult to dispel, and the medium has provoked much censure and attempted censorship, from the mid-1950s Movement to Abolish Bad Books (Akusho Tsuihō Undō) led by mothers' groups to the 1990s Harmful Comics Movement (Yūgai Komikku Undō) and recent calls to include comics in antipornography legislation. Not until *Honey Room*, however, would a manga too gain the dubious distinction of becoming the object of a sensational criminal trial that would ultimately be heard by the nation's highest court.

Honey Room is a 144-page paperback volume published in May 2002 by Shōbunkan, a midsize publisher specializing exclusively in erotic manga started in 1993 by Kishi Motonori. The book contains eight manga by Beauty Hair (Byūtī Hea), a pen name used by Suwa Yūji that plays on the romanized word for pubic hair. The title *Misshitsu* (蜜室) is translated into English on the cover as "honey room," a pun on its usual meaning of "locked or hidden room," that, according to the publisher, was meant to spice up the title from the "typical and uninteresting to one that was sexy, sweet, and

dripping."[6] The doubled meaning is an apt one for a book whose pages are filled with exploding bodily fluids and women confined against their will. The cover (fig. 8.2, right side) shows an image that does not appear in the book proper, although it is representative of the raped and tortured female characters who appear inside: a young female with gigantic, soulful eyes and even more gigantic breasts that spill out of her skimpy bodice with her panty-clad crotch exposed as she fearfully backs up against a bathroom wall while something seemingly approaches from off frame.

Only the cover and the first four pages are all color and on glossy, high-quality paper. The book is a standard A5 size and includes a relatively small (about a half inch long by quarter inch high) standardized mark on the cover and another smaller one on the spine indicating that it is an "adult comic" (*seinen komikku*). The designation is part of a voluntary self-censorship system that was adopted by publishers in January 1991 to forestall threats of state regulation and indicates to booksellers that selling the

Fig. 8.2 *Honey Room* cover images (Beauty Hair 2002). Reproduced with the permission of Shōbunkan Publishing. © 2002 by Shōbunkan Publishing.

book to minors under the age of eighteen may be a violation of prefectural youth ordinances. Copies of the book sold for 920 yen (about $7) each at thirty-five bookstores. In the back of *Honey Room* ads appear for two other Shōbunkan anthologies, a manga about young teens at "Sailor Clothes Campus" and another about "the forbidden adulterous crime of incest." A table of contents indicates the starting page number for each of the book's stories, although only four pages of the entire book are given page numbers.

The eight stories are completely formulaic, with each precisely sixteen pages long, except for the final story, which consists of two parts that are sixteen pages each. They begin with two to three pages of background story, followed by eleven to thirteen pages of explicit sexual depiction, and end with a half or single page wrap-up of the story. (Not coincidentally, the one exception, "New Heroine," which begins immediately with explicit sex scenes, was the one chosen to appear first in the book, likely both as an enticement for impatient readers as well as to capitalize on the full effect of the all-color pages.) Each of the stories has a full- or nearly full-page and sometimes even a two-page climactic display of explosive orgasms. So hyperbolic are these depictions of male and especially female orgasm that they could belong just as easily in the pages of an apocalyptic sci-fi fantasy. The pages literally overflow with images and text. Like the photographs in *Realm* in which the unbounded motion of the actors' bodies exceeded the frames, here too the action is not bounded by the frame, nor are the frames even depicted in their entirety. Instead, the characteristic bleeding technique of Japanese manga[7] is used, particularly in the sexually explosive scenes. The stories' other common feature is their conspicuously rapid and happy denouements, the abrupt "happy end" (*happī endo*) that has been a noted feature of ladies' comics as well.[8] For example, in the penultimate panel of "New Heroine," a failed stuntwoman turned adult video star sanguinely comments after her first performance, in which she plays a woman who is raped while strung up by ropes to the ceiling: "It's a little bit different from what I'd dreamed, but I was really happy I got to play the lead."[9]

The two most objectionable stories, according to the prosecutor and ultimately also the judges, were the volume's final ones, which escalate the violence quotient significantly. In the last story, "Crawling About" (Haizurimawaru), a naïve girl sneaks out for a "date" that results in her being kidnapped, tortured (including cigarette burns and brutal beatings), and gang-raped. Although her "date" was aided at first by a geeky young neighborhood male friend of the female protagonist's, in the end the boy

helps her to get revenge by poisoning the men and gaining her release. Even more problematic was the story "Mutual Love" (Sōshi sōai), which features a submissive prostitute, who, after enduring brutally sadistic sex with a client that includes his whipping her face with a belt and stomping on her vagina repeatedly, confesses her own pleasure on the story's final page.

Although the manga contains many such scenes of rape and torture, it also contains images of women relishing their sexual desire. For example, on the inside cover (fig. 8.2, left side), a significantly less misogynist image appears: one of an intelligent-looking professional wearing eyeglasses and a business suit who has disrobed to masturbate on the couch of what can be imagined to be her own, very realistic-looking office. One story, "Fortune at a Stroke" (Ikkaku senkin), is about the randy female boss of a design company who turns her male employees into sex slaves that is told from the perspective of a young, new apprentice who successfully manages to displace his more experienced colleagues and attain the eponymous "fortune at a stroke." In many of the stories appear such female characters who unabashedly enjoy sex that they themselves have aggressively initiated ("Innocent"); high-school girls who soon overcome any reticence and enjoy "perverted" oral or anal sex ("Carnival, Carnival" and "Body Issues"); and those who enjoy it at the hands of sadistic men, even if it is of the violent, masochistic variety ("Mutual Love"). Only the final story, "Crawling About," features an unremittingly tortured female who plainly does not enjoy being raped and tortured, as is clearly indicated by a close-up of her painfully swollen and raw genitals with a caption that reads, "The vagina is red and swollen, and the anus is torn."[10]

Depictions of female pleasure and pain are at the core of the manga and they were also at the center of the trial debates. The volume's diversity of plots dispels any assumption that the stories are exclusively ones of male sexual domination and female submission, although these kinds abound as well. The book's combination of both types made interpreting it purely as either misogynist domination or feminist liberation tricky for feminist critics in both the pro- and anticensorship camps.

Feminist Interpretations: Identifying with the Rapist or Rape Victim?

The question of how these ambivalent representations might fuel or subvert misogynistic beliefs and practices is one that was engaged by all parties in the trial, and one that occupies most scholarly discussions of the genre as well.[11] At the trial, both sides adopted the mantle of the feminist. Like the

prosecutors in the Nikkatsu and "Yojōhan" trials, the *Honey Room* prosecutor squarely aligned himself with the antiporn feminist camp. In the indictment, he criticized the stories for "making women into the objects of male pleasure," citing in particular the masochistic woman's suffering in "Mutual Love" and the gang rape of a woman threatened with a cutter knife in "Crawling About." On the other side, defense witness manga critic Fujimoto Yukari aligned herself with the anticensorship feminist camp. In her testimony, Fujimoto claimed that Beauty Hair's detailed drawings of genitalia were an attempt "to convey intimacy and heated temperatures with depictions of open, flowering female genitals during scenes of mutually pleasurable sex" in contrast with the "closed and raw ones in scenes of rape and sexual harassment."[12]

How could the very same material invite two such completely opposite conclusions? For the prosecutor, scenes of masochistic women and sadistic men that make "women into the objects of male pleasure" were objectionable on feminist grounds because they would lead to real harm of real women. His position echoed the antipornography feminists' oft-quoted slogan, "Pornography is the theory, and rape the practice."[13] For defense witness Fujimoto, such scenes would instead allow a reader to detect the manga artist's aversion to the rape and abuse of women, while his depictions of pleasurable sex bespoke his endorsement of consensual "good" sex. Both positions relied on the common, but often unspoken, assumption in feminist interpretations of pornography that depictions of female pleasure are potentially liberatory whereas depictions of their pain (and torture and rape) are misogynist. Notwithstanding their divergent conclusions, both hinged on determining if the female characters were experiencing pleasure or pain, with female genitalia as the barometer of that pleasure or pain.

Not coincidentally, the story that brought the indictment and the one that would be found most problematic by the judges—"Mutual Love"—is the only one that reveals a masochistic woman's pleasure at the hands of a brutal man to be genuine. It is seemingly the most indefensible, particularly on feminist grounds, because the sexual offender is not punished for his brutality in the end, and the woman revels in it. The story at first potentially invites a reading of the prostitute's pleasure as sheer performance when she theatrically begs her sadistic client to beat and kick her, dutifully proclaiming herself his "lewd, masochistic slave, my master's toy." But at the very end of the story, she admits her pleasure to her sympathetic pimp while tweaking her pierced nipple: when he asks, "Yumi-chan, why do you struggle

so against that client? If you don't want to . . . ," she responds, "It was the best. . . . Mutual sex with him is the best."[14] Because this revelation appears outside the context of the diegetic performance, the sex act with her client, the reader is inclined to interpret it as genuine and the story as irredeemably misogynist since it depicts male violence perpetrated against women as justifiable, even desirable.

In part, the two sides' divergent conclusions depended on another unspoken assumption—the question of whom the reader identified with, the rapist or rape victim?[15] As the sole female witness at the trial, Fujimori offered testimony from the implicit perspective of a female reader identifying with the pleasured or pained female protagonist. But for the judges, the primary question was not how the few to nonexistent female readers would interpret the stories but the effects on an exclusive male readership, including a very specific segment of that population in particular: the nerdy young male *otaku.*

Identifying with the *Otaku* or the Demonic Phallus Incarnate?

In *Honey Room,* the male characters generally fall into one of two stereotypes that have been identified as staples of pornographic anime: the "demonic phallus incarnate" and the "comic voyeur," usually an *otaku,* who offer two very different possibilities for a (male) reader's vicarious identification. Half the works feature young male characters in their teens or early twenties who appear to be *otaku,* the nerdy young men who avidly consume manga and anime, or, in other words, the prototypical manga audience. As Susan Napier has noted, this "helpless male figure is a way of working through a host of sexual uncertainties in a nonthreatening way. The demon, on the other hand, displaces the anxieties of the 'normal' viewer, allowing him to enjoy vicarious sexual satisfaction without the need to identify on a deep level with his demonic substitute."[16]

In *Honey Room,* identifying with the *otaku* rather than with the demon is particularly attractive since the female character often enacts her revenge with the help of this young male, who not only saves the girl in the end but also usually gets the girl. Unlike the anime version of the *otaku,* who is of the frustrated and passive Peeping Tom variety, the peeping *otaku* in *Honey Room* are often abundantly rewarded with sex by the buxom protagonist. Even in the final, most brutal story, "Crawling About," in which an *otaku* boy initially conspires to kidnap his neighborhood friend and even

participates in her rape at one point, in the end he is fully redeemed as her savior. The role of violent sex aggressor is completely displaced onto the demonic phallus and the comic voyeur is safely restored. In the story's final pages, just before resolving to save her, he is depicted as this paralyzed and impotent childlike voyeur, hunched over with his arms protectively covering his genital area. In contrast, just several pages earlier stood a brawny broom-wielding brute dominating the frame in a parallel placement that highlights the two alternative points of identification (fig. 8.3).

Of particular note is the fact that every story in *Honey Room* that features a demonic phallus incarnate also features the redemptive figure of the *otaku,* with only "Mutual Love," the genesis for the indictment, again

Fig. 8.3 Demonic phalluses and impotent *otaku* voyeurs in "Crawling About" (Beauty Hair 2002, 135 [*left*] and 143 [*right*]). Reproduced with the permission of Shōbunkan Publishing. © 2002 by Shōbunkan Publishing.

serving as the important exception. That this work provoked the charges is unsurprising, for it lacked all the usual elements that could mitigate its depictions of cruel and violent sex: it held no possibility of a feminist critique, the ending was far from the age-old model of "punishing the evil and rewarding the good," and there is no redemptive figure with whom to identify; no *otaku*-savior appears, and neither the sadistic john nor the violated woman, who is complicit in her own violation, offers a safe position of identification.

The Indictment

Unlike in the previous indictments, where the catalyst remains at the level of speculation, the origin of the *Honey Room* charges is quite clear: a letter written by a concerned father who discovered an erotic manga in his teenage son's room. In fact, the discovered manga was not *Honey Room* but another Shōbunkan anthology published three months later, in August 2002. This volume, *Himedorobō Best Collection,* reprinted fifteen of the best erotic manga by various artists that had previously appeared in Shōbunkan's monthly magazine *Himedorobō.* This collection included Beauty Hair's story "Mutual Love." The story had thus appeared three times in print prior to the indictment: first in the August 2001 edition of the monthly *Himedorobō,* which had a circulation of approximately 45,000; next in *Honey Room* (May 2002), which sold 20,544 copies; and finally in the August 2002 *Himedorobō Best Collection,* which sold about 15,000 copies. After discovering this volume in his son's room, the concerned father singled out Beauty Hair's story as the most objectionable and sent it along with a letter of complaint to his Diet representative, Hirasawa Katsuei, a conservative, LDP politician in the House of Representatives since 1996, who then forwarded it to the police in mid-August 2002.[17]

It is tempting to attribute the indictment solely to the machinations of the conservative LDP, which, as we will see below, has traditionally led the charge in the Diet to introduce a host of strict media regulations. But Hirasawa is no antiporn campaigner and is instead best known for his tough stance on North Korea security issues. (Interestingly, however, as David Leheny's 2006 *Think Local, Fear Global* points out, surprising links exist between conservative international security policies and those concerning issues of domestic sexual morality. Or, as Yama Ryōkichi, head of the Ethics Committee of the Japan Magazine Publishing Association, put it, *ero-guro-tero,* or "erotic, grotesque [or violent], and terrorist," is the new unholy trinity.)[18] In fact, as

head of the Tokyo police unit monitoring obscene publications during the early 1990s, Hirasawa had advocated that article 175 be invoked only very selectively. As the head *Honey Room* defense lawyer speculated, Hirasawa was instead likely "just doing a nice service for one of his constituents."[19]

Rather than any politically motivated attack, targeting *Honey Room* was largely a result of a series of coincidences. After receiving the letter, the police launched an investigation of *Himedorobō Best Collection,* but this volume contained works by fifteen manga artists. As the prolonged Nikkatsu trial had proven with its nine defendants and four lawyers, narrowing the indictment to a single artist and single publisher was highly advisable. With his scandalous pen name, Beauty Hair offered an ideal target. Because the letter had singled out his story as particularly objectionable and, according to the police, a subsequent, anonymous phone call identified his work as "particularly egregious" (*toku ni hidoi*), even for erotic manga,[20] the trial could be characterized as generated by concerned citizens rather than by the police. After comparing *Honey Room* with three of Shōbunkan's other Beauty Hair anthologies and with fifteen to twenty other comic books on the market, the police decided to target *Honey Room.* In his trial testimony, the policeman in charge of the investigation claimed this choice was based on the police's assessment that "genitalia and scenes of sexual intercourse, etc., are drawn in detail and realistically" in *Honey Room,* whereas the others "were not sufficiently plain or detailed and were lacking in reality" (*WKS*, 247, 252, 253). Moreover, the self-censorship maskings (*keshi* or *amikake*), the white or gray rectangular and triangular marks that are meant to obscure genitalia and the very edges of sexual penetration, employed in *Honey Room* were less conservative than those in *Himedorobō.* Not only did *Honey Room* use 10 percent lighter masking but also its higher-quality paper rendered these even less effective in obscuring the images underneath.

In an unprecedented move, the police arrested, on October 1, both Shōbunkan's president and editor in chief, Kishi Motonori and Takada Kōichi, as well as the manga artist himself. In contrast with previous manga-related incidents, which ended with fines or pending indictments, the defendants' handcuffed entrance into the courtroom was shocking.[21] In the end, Shōbunkan's president stood as the lone defendant, with Beauty Hair and Takada each given a summary verdict and fine of 500,000 yen (approximately $4,000).

At the lower court trial, four reluctant witnesses were forced to testify for the prosecution after the defense team strategically objected to having

the damaging testimony they had given during the investigation phase submitted as evidence: the president of the Publishing Ethics Association (Shuppan Rinri Konwakai), a voluntary self-censorship organization to which Kishi's company did not belong (prompting the association's president to call Shōbunkan "an outlaw" during the investigation);[22] both the manager and the comics section chief of Tōhan, an agency that had distributed and sold the book; and, most damaging to the defense, the manga artist Beauty Hair himself. In addition to these, both prosecution and defense attorneys successfully petitioned to have the head of the Tokyo Public Safety and Morals Division, Maniwa Yoshikazu, who had led the investigation, testify as well.

For the defense's side, a host of stock witnesses appeared: in his third appearance at an obscenity trial, legal scholar Okudaira Yasuhiro, who had become something of a requisite defense witness, insisted again that the state has no right to regulate free expression; manga critic Fujimoto, as we saw above, offered a close exculpatory reading of the manga from a feminist and female perspective; sociologist Miyadai Shinji disputed the scientific validity of any copycat theory that linked reading erotic manga and sex crimes; psychologist Saitō Tamaki testified that the copycat theory was especially inapplicable in the case of *otaku* readers; and finally, in a unique twist, a conservative defense witness, Sonoda Hisashi, the head of the powerful Osaka Investigative Committee to Promote the Healthy Development of Youths (Osaka Seishōnen Kenzen Ikusei Shingikai), who asserted that the book should be prosecuted but not under the obscenity law. At the appeal trial, the defense succeeded in also calling the esteemed older manga artist Chiba Tetsuya to attest to the increasing importance of manga both in Japan and abroad. Although the father whose letter generated the investigation did not himself appear as a prosecution witness, his letter neatly distills the prosecutor's key objections, hitting all the time-honored favorites of the censor: the crisis of contemporary youths and the ill effects of sexual and violent material on them, the illegitimacy of the medium, and an attack on the greedy commercialism of the publisher.

Censoring Readership: "Save the Children, Censor Comics"

Youths were once again the linchpin of the censor's case. In his letter, the concerned father lamented the current state of youths in contemporary Japan and foresaw their utter ruin if publications like "Mutual Love" were allowed unchecked. In his final lines, he hyperbolically claimed that "if we

continue like this, there is no future not just for my son but for all of Japan's children." Most centrally, he invoked the familiar specter of the young reader committing copycat crimes, writing, "Children who learn about sex from unhealthy, perverted, erotic-grotesque books about rape and incest will become sex criminals."[23] In his closing, the prosecutor similarly asserted a link between violent sexual representations and sex crime, although he provided no hard data:

> That having such manga in the public will harm the majority of youths who have not been trained by society is something we have all known for a long time. These youths will have sexual desires stimulated by a manga like *Honey Room* that will inevitably lead them to sex crimes. The bad influence it will have on unsocialized youths is impossible to calculate. (*WKS*, 259)

As with other pop-culture media, such as the 1950s Sun Tribe films, the fear that manga would incite its young readers to copycat behavior, or even crime, was a typical justification used to censor it. In 1949, police targeted manga for contributing to a rise in youth crime and even for inciting financially desperate readers to steal manga themselves. In the 1970s, a PTA-led crusade was prompted by the trend among middle school children to imitate the manga *Shameless School* (*Harenchi gakuen*) characters' penchant for exposing their schoolmates' bottoms by pulling down their school uniforms.[24]

During the *Honey Room* investigation and trial, the police and prosecutor stressed the potential ill effects of exposing unsuspecting passersby, especially youths, to such salacious content. The police report complained that the manga was "sold at regular bookstores, where even housewives and children can enter" (*WKS*, 56). During his questioning of all four hostile prosecution witnesses, the prosecutor repeated an almost rote recitation of the following questions: "Is its content such that you could read it in front of people?" "If you were to read it in a place with other people, don't you think it would cause people to avert their eyes?" and "Is its content such that you would show it to youths?" (*WKS*, 136; cf. 67, 143, 153, 158). Each witness attempted to dodge such questions by pointing out that the book was not intended for children, as evidenced by the "adult comics" mark on its cover. The judges nonetheless pressed for a clear response from recalcitrant

witnesses on this point, as in the chief judge's following exchange with the president of the Publishing Ethics Association:

> *Judge:* What if youths were to see it?
> *Witness:* As I said above, it's not made for youths to see.
> *Judge:* But what if they did see it?
> *Witness:* I'd guess they'd be excited. Young youths. But it's not made
> for youths so . . . (*WKS*, 139–140)

The preoccupation here with the potential harm done to youths and to "young youths," in particular, suggests the endurance in Japan of the equivalent of England's mid-nineteenth-century Hicklin principle, which based obscenity judgments on the harm done to the most vulnerable reader. As one Japanese scholar pointed out in his 2002 book, which is aptly subtitled *"Youths, the Toy of Adults,"* youths continue to serve as the de facto tool for censorship advocates in Japan.[25]

Employing rhetoric about uncritical youthful readers was at once an age-old strategy of the censor and an attack to which the medium of comics was especially susceptible. Despite the fact that manga in general, and *Honey Room* in particular, are far from childish in terms of content or form, manga were still perceived by many to be a "childish medium" geared toward young readers because of their relative legibility and accessibility. For example, the father who wrote the letter asserted that *Honey Room* was for children, willfully disregarding the labels marking it an "adult comic." He wrote, "If it were a magazine geared toward adults, I might understand. But the cover of this book is crafted like a childish one usually read by children and is made so that youths can easily buy it over the counter. It is altogether clear that youths are its targeted market. This is extremely evil and shrewd."[26]

In a panel discussion about the trial that appeared in a medical journal in the summer of 2004, leading manga literary critic Yonezawa Yoshihiro (and founding member of Komike, host of the largest annual amateur manga convention) noted the persistent tendency to equate comics with children's reading materials and attributed the impulse to censor them to this fact: "In the 1990s, there was still a feeling that comics are for kids. Out of shock over the fact that the form is childlike while the content is adult came an attempt to regulate."[27] Again what is evident is the perennial classificatory impulse

of the censors. Here, however, rather than a clash between highbrow literary form and lowbrow content, as with *Chatterley, Dannoura,* and "Yojōhan," it was the disjuncture between the "childlike" form of manga and the adult pornographic content that provoked the censors.

The impulse to censor manga stemmed not just from an abstract discomfort with jumbled taxonomies but also from a concrete lack of basic knowledge about the current state of the industry. As the policeman leading the investigation admitted in his testimony, as of 2002 manga were not even included in the one hundred fifty to two hundred publications surveyed monthly by the Tokyo Public Safety Division. The defense lawyer pursued this line of questioning in an attempt to expose the policeman's ignorance:

> *Q:* In that case, what was your impression upon finding out that publications with depictions like *Honey Room* were being distributed?
>
> *A:* In all honesty, I was shocked.
>
> *Q:* What shocked you in particular?
>
> *A:* The abundance of depictions of genitalia and whatnot—that's what surprised me.
>
> *Q:* In that case, what was your perception of the state of manga?
>
> *A:* I had utterly no knowledge of comics until that point. (*WKS,* 252)

The prosecution's reliance on "save the children" rhetoric was not simply a factor of its ignorance or a strategic ploy. It was also a reflection of the historical moment of the trial, a time of a perceived heightened crisis surrounding youths that resulted in a boom in proposed legislation to protect them. Beginning in 1991, prefectural youth regulations, including "harmful book" (*yūgai tosho*) designations for works that "significantly retard the healthy growth of youths or stimulate sexual feelings of youths," were strengthened across the nation, and in 2000 "harmful environment" (*yūgai kankyō*) laws enforcing curfew restrictions and where contraceptives and sex toys can be sold were proposed by the LDP.[28] As early as the *Chatterley* trial, a legal scholar had voiced his optimism that if such youth regulations were introduced, article 175 would become obsolete and Japan would start distinguishing between the rights of adults and those of youths.[29] But, based on the *Honey Room* charges, clearly the existence of youth regulations failed to change much of anything. Instead, the prosecutor indicted the defendants

for an adult comic under obscenity laws while employing a rhetoric that still depended largely on the dangers of youth readers.

Defending the Readership: For the Eyes of Adults and *Otaku* Only

To rebut the impression that immature youths or unsuspecting passersby would be irrevocably harmed by exposure to works like *Honey Room,* the defense advanced three distinct arguments. First, it claimed that erotic manga were never meant to be read by youths and cited voluntary self-censorship zoning mechanisms: labeling them "adult comics" designated for those over age eighteen, sealing them in vinyl bags to disallow the common practice of reading while standing at the racks (*tachiyomi*), and placing the bookshelves where they were placed out of reach of children in accordance with prefectural youth regulations. The publisher Shōbunkan was depicted as particularly cooperative, having been one of the first to institute such policies at its own considerable expense (two to five yen per bag). According to Kishi, Shōbunkan also presented bookstores with complimentary bookshelf plates reading "Shōbunkan Adult Comics."[30] (Such self-censorship mechanisms may have placated the state censor, but they could also serve to pique a reader's sexual curiosity and sales. In fact, one of the first uses of sealed bags, for a manga billed as a "secret series" in mid-1989, may have dissuaded *tachiyomi,* but it also titillated potential customers, and the manga became a best seller.[31])

Second, the defense argued that the manga was never intended to be read "in public" at all. The eminent legal scholar Okudaira identified this assumption of public context as the dangerous logic underlying all obscenity judgments:

> I think that the constitutional points of debate have gone astray because the standard has been based on an argument about what is inappropriate for the family hearth. . . . In the case of publications like *Honey Room,* it is entirely inappropriate to treat it as a regular publication and to ask, "Can you read it at the family hearth?" "Can you read it out loud?" or "Can you read it in a place where it could be seen by others?" Even if you call that "community standards," they do not exist only amid the family hearth. Reading is extremely individual. . . . If you judge all publications or all communication based on whether it is okay for them to occur in the public sphere, then freedom of speech will become severely limited. (*WKS*, 213–214)

As I argued above in the case of the "Yojōhan" trial and as Okudaira charges here, prosecutors often implicitly appealed to an outdated mode of reading aloud by the family fireside rather than recognizing contemporary reading to be a silent and solitary activity. By characterizing *Honey Room* as individual adult reading material, the defense attempted to refute the impression that impressionable youths were its audience. But, despite the fact that the book was labeled an adult comic and in theory should have been sold only to readers over the age of eighteen, the fact that the letter writer's sixteen-year-old son had it in his possession largely undermined any such defense in practice.

The *Otaku* Defense

In seeming recognition of this contradiction, the defense offered a final and intriguing, if not spectacularly misguided, argument. If the young person was the rhetorical linchpin of the prosecutor's case, then the *otaku* was the defense's. In its formulation, *otaku* were sexually immature male computer geeks, or as cyberpunk sci-fi writer William Gibson has colorfully put it, a "pathological-techno-fetishist-with-social-deficit."[32] This *otaku* reader, who the defense claimed was the primary consumer of erotic and violent manga, anime, and video games, was at the crux of the defense, especially in the testimony of Saitō Tamaki, a psychologist specializing in *otaku* and an extreme subgroup of this population, *hikikomori,* or youth shut-ins who withdraw completely from society.

The defense advanced classic arguments for the safety-valve theory of media, whereby fictional depictions act as a safe substitute for the actual thing, or as manga critic Fujimoto put it in her testimony, a "gas release" for sexual desire. But most intriguingly, Saitō limited the ability to sublimate manga and anime to the select population of *otaku*. He argued, "For *otaku,* manga won't stir feelings of sexual arousal toward real women. They dissolve sexual desire with pictures and anime. . . . A special characteristic of *otaku* is that they will not try to do anything to real women."[33] In other words, in the case of reclusive, socially awkward *otaku,* such desires were not necessarily unacceptable but inactionable.

According to Saitō, the inability of *otaku* to act upon their sexual desires was as much a factor of their reclusive natures as it was specific to the media of manga and anime, which require "special training." He claimed, "To feel sexually aroused from the altered depictions in manga requires training. People unaccustomed to it will rarely feel aroused" (*WKS,* 202). In

an exchange with the head defense lawyer, Saitō elaborated on his theory of manga reception, distinguishing clearly between the identification processes of *otaku* and non-*otaku* readers:

Q: To begin from the conclusion, is it possible that people who read *Honey Room* will be led to commit sex crimes or sexually deviant acts?

A: I feel that it would be impossible.

Q: To start from the beginning then, would an average person, a regular, healthy, normal person, be unduly sexually stimulated by reading *Honey Room*?

A: I believe it is an extremely low possibility, or nonexistent. . . . For my *hikikomori* patients, the truth is that exposure to media, such as sexual information on the Internet, pornographic anime, or erotic games, will rarely lead even to the sex act in actuality, much less sex crimes.

Q: Are the two-dimensional characters of these media established to be *people* or *like people*?

A: If you compare the actual drawn pictures to a real woman, it is clear that the drawn pictures have distinct exaggerations and *déformés*. Normally, it would be very difficult to feel sexual arousal for this without a certain kind of training or study. To put it plainly, if a person who was entirely unused to reading manga or seeing anime suddenly saw them, I believe it would be very unlikely for them to become directly aroused.

Q: What about for *otaku*? Don't they need for a real person to exist before they can become sexually aroused?

A: The two-dimensional images of comics, anime, and games are all expended on masturbation fantasy. Before they might desire a real woman, it is over. In other words, I am certain that the expression [in manga, anime, etc.] is of the type that desire is satisfied with masturbation.

Q: Let's say that taking care of it by yourself [by masturbating] was insufficient. Is it not possible that it would then induce them to turn to the direction of wanting to try it on a real woman?

A: The vector leading toward real women and the vector of desire leading toward two-dimensionally drawn comics and anime are different. (*WKS*, 203–205)

Saitō's argument is premised on the belief that untrained audiences, which he defined as adults and non-*otaku,* are unable to identify with the unfamiliar characters of manga (or anime) and therefore unable to be aroused.

On the one hand, there is much to agree with in his testimony. Intuitively, we know that investment in a text, be it emotional, sexual, or psychological, is often intensified by, if not predicated on, some kind of identification. As Susan Napier has argued, the elaborate cosplay (costume play) avid fans engage in at anime and manga conventions suggests a strong desire to adopt alternative personas that transcend national and gendered identities; fandom and identification often go hand in hand.[34] Adult readers unfamiliar with the representational strategies of manga (or anime) might be less likely to identify with their characters, particularly when those characters are so much younger. (The fact that the manga included underage characters was not, however, pursued as a line of argument by the defense, for somewhat obvious reasons.)

On the other hand, Saitō's testimony invited a guilty verdict by bringing *otaku* to the fore. First, this defense would be unsuccessful if the judges, who likely did not self-identify as *otaku,* found themselves nonetheless aroused by *Honey Room.* Moreover, Saitō's safety-valve thesis was limited to *otaku* and did not extend to non-*otaku* youths and adults, who were the state's concern as well. Second, the proposition that sexual arousal depends on identification and familiarity, rather than on estrangement and fantasy, is disputable. As many a psychoanalyst has noted, sexual desire (and its commodified packaging in a capitalist society) are predicated on distance from the mundane, or even the attainable, and instead focus on a fantastical object.[35]

Most crucially, Saitō's argument failed to acknowledge that *otaku* were perhaps not as harmless as they appeared. He claimed the "vectors" of desire leading to flesh-and-blood women in the real world and those leading to two-dimensional characters in manga remained utterly distinct for *otaku.* But whether the realms of representation and reality were safely removed from each other was questionable in many people's minds. Indeed, any image of the harmless *otaku* was shattered by the highly publicized "*otaku* murderer" Miyazaki Tsutomu. When Miyazaki was arrested for killing four young girls in the late 1980s, his apartment ostensibly revealed an extensive collection of pornographic manga and anime, as well as horror and snuff films. The police photo of his room of floor-to-ceiling bookshelves was repeatedly reproduced in the media as the de facto explanation for his

perverse crimes, confirming the fear that *otaku*s' pop-culture obsessions would lead to the "abnormality that lurked behind the solitude" of "the friendless and wordless Miyazaki, with anime and manga as his friends," as one of the early headlines put it.[36]

The fear that unsocialized youths, or, even worse, criminal social deviants like Miyazaki, would read *Honey Room* was, after all, at the heart of the prosecutor's arguments. The defense itself unwittingly contributed to this impression by emphasizing that *otaku* were the intended readers and that they were far from "normal." As the defense repeatedly stressed, *Honey Room* was not meant for youths under eighteen, as clearly indicated by its "adult comic" mark. And as both Saitō and another defense witness noted, nor was it meant for "*normal grown-ups and adults,* who would hardly be aroused" (*WKS,* 192; italics mine). If neither vulnerable youths nor "normal adults" was its audience, then what was left were childish adults or "sexually infantile" *otaku*. The prospect of these readers identifying with their *otaku* counterparts in the stories or, worse, with the demonic phallus incarnate did little to reassure the censor's fears.

Erotic manga, and particularly *Loli-con* comics featuring sex with prepubescent girls, generated the concern not just that crimes would be committed by child or childish readers but also that sex crimes would be committed *against* children, as in Miyazaki's case. Although not a *Loli-con,* even *Honey Room* could be charged with encouraging sexual violence against minors since its female characters range from their teens to their late twenties. (And the age of the characters in the "Sailor Clothes Campus" issue advertised in *Honey Room* appear to be thirteen at best.) To forestall accusations of encouraging underage sex, the manga includes an exculpatory postscript at the bottom of the table of contents that states, "The characters that appear in this manga are all over eighteen years of age." In a similar attempt to discourage charges of copycat crime (as well as those of libel), Shōbunkan's other adult manga magazines include postscripts that read, "The enclosed works are fiction and bear no relation to actual people, organizations, incidents, etc. Nor are they things that instigate crimes."[37] Such exculpatory notations reveal the persistent belief in a perceived link between the realms of reality and representation, even among the artists and publishers themselves. Just as a half century earlier the *Chatterley* defense had argued against prosecution because adultery had been decriminalized just prior to the novel's publication, here too the work was protected by claims that it did not violate contemporary child pornography laws.

Child prostitution and pornography legislation is an area of law that is particularly subject to confusion between the registers of reality and representation. In Japan, the 1999 Law for Punishing Acts Related to Child Prostitution and Child Pornography and for Protecting Children (Jipohō, for short) forbids both prostitution and "the production, sale, or intended sale of child pornography," with sentences set at a maximum fine of three hundred thousand yen fine and/or a three-year prison term. Child pornography is defined as (1) "photos, electronic records, . . . or any method of depiction that allows one to visually perceive that they are figures of minors" who are "engaged in sexual intercourse or acts with another person"; (2) sexually arousing images of a "minor touching someone's genitals or having their own genitals touched"; or (3) "naked or partially clothed minors."[38] The premise of the law is to prevent harm to actual children in the act of filming them, or the "harmful effects on the bodies and minds of minors who are depicted in child porn," as the law puts it.[39] Since its inception, however, there have been persistent attempts to expand the prosecutable material to include fictional representations of children, especially in anime, manga, and video games.

The anti–child pornography campaign has been spearheaded by LDP politicians, like former minister of justice Moriyama Mayumi, and by popular music celebrity turned UNICEF spokeswoman Agnes Chan. When calling for revising the law in February 2008 to include criminalizing the possession of pornography, UNICEF tellingly noted that Japan has been repeatedly criticized by the international community for being, along with Russia, the only G8 nation not to do so, and for being "the number one producer and exporter" of child porn. UNICEF also called for expanding the definition of child pornography to include " 'quasi-child porn' that realistically depicts the sexual poses or abuse of children whether or not the depicted subjects actually exist or not."[40] In other words, quasi child porn (*jun-jidō poruno*) would include fictional representations of fictional characters if they were "realistically" depicted to look underage.

From the obscenity provisions of the Meiji Criminal Code to prewar adultery laws to twenty-first-century child pornography legislation, the applicable laws themselves may have changed, but the premise is the same: criminal acts in reality and representations of criminal acts in fiction are equally subject to the laws of the state. As Okudaira testified, for this reason freedom of expression in Japan has traditionally been tenuous at best:

Until now, expression has been treated just as if it had the same power as physical objects. . . . For example, arguments to abolish the emperor system and physical acts to eradicate the emperor system were regulated by the same area of law: treason and lèse-majesté. This stems from people having long thought of physical actions and expression as the same. . . . The "nonpublic nature of the sex act" is a question of actions. . . . But when you then believe that depicting sex acts should also not be public, then you equate the freedom to have sex with the freedom to depict sex acts and, little by little, that difference gets eradicated. Then, logically if you must regulate the former, you must regulate the latter too. (*WKS*, 215–216)

Laws that equate thought crimes and criminal acts depend on collapsing distinctions between the registers of representation and reality, as Okudaira suggests. Just as the Criminal Code juxtaposes criminally obscene acts (like flashing in article 174) with regulating obscene media in article 175, youth regulations related to harmful books and environments also regulate both real-life behaviors and representational media. Alternatively, the equation of the two realms is based on the sense that there exists a causal link between representation and reality, as adherents to the copycat crime theory suggest. The assumption that vulnerable readers will uncritically identify with and imitate unscrupulous characters, from the adulteress Lady Chatterley to the homicidal Jirō to the castrating murderess Abe Sada, lurks behind many of Japan's obscenity proceedings. In the *Honey Room* trial, by drawing attention to the abnormal psychology of *otaku*, the defense only exacerbated the impression that the media consumed by this deviant group require especially tough policing, particularly with the specter of the *otaku* murderer looming.

Otaku as Ambassador, Japan's Poster Boy for Soft Power
This defense backfired not just because it brought to the fore the dubious image of the innocuous *otaku* as reader but also perhaps because it drew attention to the fact that manga and *otaku* were now being considered ambassadors of Japanese culture internationally. As in the earlier obscenity trials, the *Honey Room* defense brought to bear the eyes of the international community to argue for relaxing domestic censorship lest Japan again be regarded as antimodern and its reputation as the leading producer of manga be harmed. Manga critic Fujimoto most blatantly warned of the setbacks a

guilty verdict would have on Japan's international repute as what she called a manga superpower (*manga taikoku*):

> Japanese manga has garnered attention both domestically and abroad for its high level of achievement and for its international competitive power. . . . Before Japan became a manga superpower, America was at the leading edge of the comics scene. But Japan's manga has outpaced American comics over the past fifty years. One of the biggest reasons is said to be the establishment of the [U.S.] Comics Code in 1955. Because of these regulations, American comics have stalled, their development has narrowed, and comics have been marginalized. When the code was established, there was a very strong impression that comics were for kids. So they made all the expressions harmless for children. But, because of this, they were deprived of their possibilities as a deep medium that was of interest to adults as well. (*WKS*, 236–237)

Here Fujimoto was clearly appealing to the soft power potential of manga and to a rhetoric of international competition that again featured Japan and the United States as antagonists, but this time as engaged in a cultural rather than military battle.

At the appeal trial, one of the few items of evidence allowed by the judges was, in fact, a testament to the international import of *otaku:* a catalog from the exhibit "OTAKU: persona = space = city" staged at the Japan pavilion of the 2004 Venice Biennial 9th International Architecture Exhibition, which had opened just two days before the start of the High Court trial. This catalog was submitted by the defense as proof that manga and anime were regarded as art by the international community, even appearing at the high-profile Venice event touted as "the Olympics for art" by the Japan Foundation, the sponsor of the event.[41] The defense likely hoped that the exhibit would act as a corrective to the impression of *otaku* as social deviants and displace the image of Miyazaki Tsutomu and his room overstuffed with *otaku* paraphernalia.

The exhibit itself tackles this unspoken assumption in its displays of "bedrooms of *otaku*" that feature a life-size model and a series of eighteen photos and miniature re-creations. As the exhibit card acknowledged, just as there is a stereotypical image of the "*otaku* body" as "either chunky or all skin and bones, with a look of being indifferent to fashion," there exists a stereotypical image of their bedrooms: "surrounded by electronic

equipment—computers, videos, and the like—with stacks of manga magazines and video software piled high by the bed." The exhibit photos and replicas confirm, rather than dispel, this stereotype. On the one hand, these rooms look no different from the serial murderer Miyazaki's and could therefore fuel the charges against *Honey Room* and prejudice against *otaku*. On the other hand, this was precisely the point of both the exhibit and Saitō's testimony: many *otaku* obsessively consume erotic and violent media, but not all become serial murderers. In an interview, the pop-*otaku* (*poku*) artist Murakami Takashi likewise stressed just how normal Miyazaki's room was:

> When Miyazaki's room was revealed to the public, the mass media announced that it was *otaku* space. But, it was just like my room. Actually, my mother was very surprised to see his room and said, "His room is like yours. Are you okay?" Of course I was okay. In fact, all my friends' rooms were similar to his, too. The only way that Miyazaki was "different" from us was that he videotaped dead bodies of little girls he killed.[42]

The question in the *Honey Room* trial was which image would prevail: the *otaku* murderer linking manga with criminality, as suggested by the oft-reproduced image of Miyazaki's bedroom, or the "*otaku* ambassador" linking manga with soft power, as suggested by Fujimoto's testimony and the Venice catalog. These two extremes appeared side by side at a 2008 exhibit at the Kyoto International Manga Museum that could have been titled "Otaku Pride and Prejudice." A reproduction of the photo of Miyazaki's overstuffed room with a display card explaining the incident's role in propagating a negative image of *otaku* was followed by the "OTAKU" catalog and schoolgirl figurine[43] from the Venice exhibition with another card testifying to the international repute of *otaku* culture. In what was likely not entirely coincidence, the next three panels were devoted to the "god of manga" (*manga no kamisama*) Tezuka Osamu, as if to definitively rehabilitate manga and *otaku*.

For the defense, the increasing domestic and international attention to manga proved their legitimacy as an artistic medium. Most central to this defense at the appeal trial was the testimony of the single defense witness allowed by the judges, the manga artist Chiba Tetsuya (b. 1939), a senior professor of manga at Kyoto Seika University most famous for his popular boxing series *Tomorrow's Joe* (*Ashita no Jō*) in the late 1960s. Chiba testified

under the understanding that he would not hesitate to acknowledge that *Honey Room* was lewd (*iyarashii*), and in fact in the trial did just so, and added that he did not approve of children reading it.[44] Nevertheless, it was a coup for the defense to enlist Chiba since he was the 2002 recipient of the imperially awarded Purple Ribbon.[45] The mere presence of a respected elderly manga artist like Chiba at the trial lent gravitas to the medium of manga and to *Honey Room* by association.

Paradoxically, however, as we saw especially in the *Chatterley* and Nikkatsu Roman Porn trials, such legitimacy often encouraged stricter policing, and indictments were fueled by the reputable status of translators, publishers, or distributors. Again, at a time when a medium was gaining critical recognition internationally and, in this case, the attention of the Japanese government as a worthy cultural export in the wake of the 2000 white paper on education that defined manga and anime as Japan's key art industries,[46] it became the object of a sensational criminal trial. As the Venice exhibit website noted, "*otakus*' hobbies of manga, anime, and games . . . are exceptional among Japanese contemporary culture in that they are remarkably successful in transcending international borders."[47] In other words, *otaku* and manga were depicted as cultural ambassadors of sorts representing contemporary Japanese culture to the world at large, as graphically symbolized by an enormous sign marking the entrance to the Japan pavilion: GIAPPONE/OTAKU.

The fact that manga (and *otaku*) were symbols of national importance only fueled the state's desire to police them. The concerned father who initiated the charges identified the publisher's crimes as twofold: he criticized the publisher for his "sheer profit motive" and for the hubris of "publishing it not as an underground publication but publicly with the publisher's information clearly visible on the book as if a challenge to the authorities."[48] The inclusion of this information was not optional, of course, but required by law and was even a practice initially instituted by the government censors themselves to facilitate regulation.[49] But his comment suggestively hints that had such books remained underground, rather than being distributed through authorized channels, he would have had no objection.

The police concurred with the concerned father on this point, writing in their initial investigation report that Shōbunkan's erotic manga were "obscene pictures just like underground books sold at the underground video stores of Shinjuku's Kabukichō. Compared to underground video shops, where a limited group of adult males make purchases, these are sold

at regular bookstores, where even housewives and children can enter, and are therefore even more evil than underground video shops."[50] Again, the rhetoric of vulnerable women and children prevailed, and the legitimacy of distribution routes was problematic. According to this police-scripted "confession," Kishi's crime was all the greater because the book had been distributed through legal distribution channels rather than illegally underground. While not one of the big five publishing companies of the magnitude of Kōdansha or Shūeisha, Shōbunkan is one of the many legitimate, midsize companies that was established in the wake of the exodus of the majors from publishing risqué magazines after the Harmful Comics Movement of the early 1990s. Ironically, the targeting of a manga can be considered a somewhat perverse testament to its emerging legitimacy as a medium of consequence.

Comparable Obscenity

The perception that sexually explicit materials had been excessively legitimated in general society propelled the offense in the eyes of the prosecutor and, as we will see, in the eyes of the judges. While the prosecutor attacked *Honey Room* for being at the vanguard, a particularly egregious example of a much larger problem, the defense argued Shōbunkan was merely trying to compete commercially in a publishing industry that included much more hard-core manga, not to mention unexpurgated nude photos, anime, videos, and games. In this respect, the arguments rehearsed the issues of commercialism and competition familiar from the Nikkatsu trial, but the manga trial was forced to accommodate a new context: the 1990s "liberation of hair" and the explosion of the Internet. To prove that *Honey Room* was merely an insignificant part of this larger trend, the defense submitted a load of comparable materials, including early 1970s sex educational manga by Tezuka, the god of manga.[51]

From Hokusai to *Hea*

Most provocatively, the defense also attempted to legitimate *Honey Room* by depicting it as having lofty antecedents rooted in Japanese cultural and literary traditions of free sexual expression. The defense echoed Ienaga Saburō's testimony in the *Realm* trial, which, as the media headlines put it, boldly claimed: "No Sex Taboos in Ancient Japan!"[52] Manga were aligned with a host of "national treasures": the twelfth-century "Scrolls of Frolicking Animals and Humans" (Chōjūjinbutsu giga), in particular the famous "frog-rabbit sumo" picture scrolls that are credited with being the prototype

for manga's speech bubbles;[53] Genji picture scrolls (*emaki-mono*); early nine-teenth century sketches by ukiyoe master Hokusai (1760–1849), or *Hokusai manga;* and especially Edo-period erotic ukiyoe (*shunga*).

In the past trials the defense had argued that *shunga* were not particu-larly stigmatized or censored during the Edo period, which was character-ized as a bastion of free sexual expression prior to contact with the West. In contrast, in the *Honey Room* trial the defense pointed to the unfettered publication of unexpurgated *shunga* in contemporary Japan, especially col-lections published by the major publishing house Kawade Shobō in the mid-1990s. One of the volumes submitted, for example, *Embracing Komachi/ Venus* (1802), is a collection of fourteen erotic woodblock prints by the famed ukiyoe artist Kitagawa Utamaro (1753–1806).[54] The two-page full-color prints feature sex scenes between partially undressed men and women, who invariably have their genitals exposed in full glory: exaggeratedly large penises are shown either poised to penetrate or penetrating splayed vaginas, with both male and female genitalia and pubic hair clearly visible (fig. 8.4). The text inscribed in the background ranges from grunts of pleasure and pillow talk to gossip about famous actors and playboys of the day.[55]

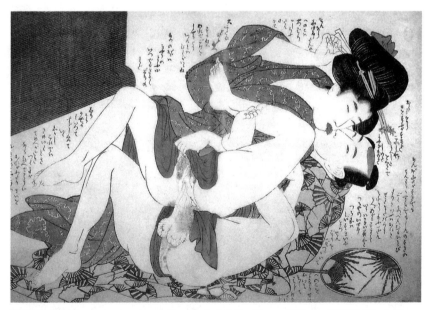

Fig. 8.4 Utamaro's unexpurgated shunga *Embracing Komachi/Venus* (1802) (Hayashi and Lane 1996, 2:18–19). Reproduced with the permission of Kawade Shobō Shinsha Publishing. © 1996 by Kawade Shobō Shinsha Publishing.

The defense argued altogether plausibly that the depictions in *Honey Room* had their antecedents in such comparably explicit *shunga* with their contorted poses and fairly detailed genitalia replete with wrinkle lines and pubic hair. Not only were manga likened to *shunga* prints in terms of their content and style, but also both media were depicted as crucial training grounds for inexperienced artists, in an echo of the claims made about Nikkatsu Roman Porn.[56] But the defense's attempt to legitimate an erotic manga like *Honey Room* as on a par with the lofty genre of ukiyo-e was decidedly contrary to the state's project. As the police told the editor in chief of Shōbunkan during the investigation, in the police's eyes ukiyo-e were "cultural property" (*bunkazai*) (*WKS,* 60). The police were praising ukiyoe's status as a cultural ambassador that depended not on the more lowbrow subgenre of *shunga* but instead on the internationally famed highbrow prints like Hokusai's Great Wave and Mount Fuji series. Even the Kawade publication of *shunga* could claim to be a scholarly enterprise based on its inclusion of lengthy introductions by the avid collector of Edo prints Hayashi Yoshikazu, as well as an English-language one by Edo scholar Richard Lane. That erotic manga were not ukiyo-e or even *shunga* was precisely the point. While the two sides may have shared a desire to elevate the medium of manga to the status of new national mascot, *Honey Room* made for a controversial poster boy.

If, according to the defense, *Honey Room* deserved to be exempt from prosecution because of its affinity with the venerable tradition of *shunga,* then it was even less suspect because of its distance from realistic photography or film, or what it called the spate of "nude photo collections that are flooding the streets . . . and videos and photos that reproduce the genital area as is."[57] But what had brought the indictment was precisely an unfavorable contrast between such nude photos and *Honey Room*. In his initial letter of complaint, the father wrote, "I am well aware that nude photos have been liberated, but selling this kind of detailed depiction of genitals—is this not against the law? . . . I feel confident that Japan is an ethical country where sales can be prohibited by prefectural regulations. . . . I demand a ban."[58] Here he is referring to the so-called hair controversy (*hea ronsō*) of 1991 that was spurred by the publication of a series of nude photo collections by the mainstream Asahi Press.[59]

In February of 1991, photographer Shinoyama Kishin published his first collection of "hair nudes" in *Waterfruit,* featuring actress Higuchi Kanako (aged thirty-two), and in November, his more scandalous collection

Santa Fe, featuring teen idol Miyazawa Rie (aged seventeen) at the peak of her popularity as a fresh-faced J-pop and television drama star.[60] The latter collection, which quickly sold 1.5 million copies, includes some seventy-five pictures (mostly color) of Miyazawa posed nude and clothed among the cholla cacti–filled desert landscape of New Mexico. In fact, the collection is a lot less scandalous than the phrase "hair controversy" might suggest. In many of the photos (though not all, since she is fully clothed in some), her naked breasts or buttocks are visible, but with two exceptions, her genitalia and pubic hair are discreetly hidden by clever framing tactics or the demure placement of her hands. In the one photo in which her pubic hair is clearly visible, she sits totally nude in the middle of a sunny field of flowers, her long, curly head of hair flowing over the tops of her breasts, kneeling with her legs firmly pressed together so that only the uppermost triangle of her pubic hair is visible. Nonetheless, the photos were shocking enough to cause an uproar in the media and among the general public, with a November 1994 *Yomiuri* newspaper survey indicating the disapproval of 67 percent of respondents.[61]

In an odd coincidence, Hirasawa, the Diet member who forwarded the concerned father's letter to the police, had played a key role in the policy shift to "liberate hair" in the 1990s. At the time, he was the head of the police unit in charge of monitoring obscene publications, and in a book he wrote in 1999, *The Japanese Police* (*Nihon no keisatsu*), he advocated police restrain from calling for the application of article 175 against Shinoyama's books in recognition of the changing times. He wrote,

> Shouldn't the concept of obscenity reflect the perspective of contemporary society? It is not right to mechanically apply laws without even considering the changing times. Now is an age when with the Internet, all the world's information can instantly enter into people's homes. At a time when you can see not just pubic hair but also the entire [genital] area, the police alone cannot define what constitutes obscenity. . . . It should be determined by the people. . . . The police should be not at the vanguard but instead at the rearguard trailing a bit behind the trends of public opinion. (*WKS*, 244–245)

Ironically, whereas the two procensorship individuals responsible for initiating the *Honey Room* indictment—the concerned father and Hirasawa—both professed a tolerance for nude photography, the defense lodged an

attack against it and against the medium of photography in general. Again the obscenity trial set off a fierce debate about the respective powers of media, this time updating the discussion to include manga.

Realistic Mimetic Photography versus Deformed Artistic Manga

Like their predecessors who had demonized other works and media as comparably more obscene, the *Honey Room* defense team also criticized photography and video that depict filmed live things. For example, they pled for a reduced sentence based on the "considerable difference evident if you compare the degree of obscenity of manga to that of live filmed media."[62] As lawyer Yamaguchi Takashi characterized it, the defense's strategy, like the prosecutor's own, was predicated on notions of realism: "I made the argument that pornographic films are more arousing than manga because of sounds. . . . And actual sexual activity has sounds."[63] Again, the defense subscribed to the realist rhetoric of the censor.

First and foremost, the defense claimed that manga's "fabricated and fictionalized" creations ensured that sexual arousal would remain in the realm of fantasy, as we saw above with the testimony of psychologist Saitō Tamaki, who also claimed, "Although the pictures in *Honey Room* are close to life-size in scale, they are undeniably altered a good deal. Unless you are accustomed to the depictions used in Japanese manga and anime, it is difficult to feel reality in the pictures . . . and it is very difficult to arouse sexual desire toward real women directly from them." Similarly, in their opening statements the defense lawyers argued that manga "characters are nothing more than a part of a fictional conceptual existence. No matter how detailed the depiction, they are no more than the image of genitals, or symbols, and cannot be regarded as the same as the genitals of living humans" (*WKS*, 208, 132). Lurking here is an implicit argument that once again held photography and feature films, as realistic representations of "real people and things," to be the most potentially arousing and obscene media.

Defendant Kishi most explicitly argued this point: "With photos of a woman's genitals, a hundred out of a hundred men would likely be aroused. Pictures, on the other hand, are creative works made from an individual's own mental picture. They are not drawn based on models and even if there is an attempt to approximate a living person, they remain merely elaborate figures" (*WKS*, 25). When asked by the prosecutor if the depictions of genitalia in *Honey Room* contravened the regulations of the Publishing

Ethics Association, the association president too responded by pointing to this distinction, arguing, "In the case of photography, there is a model used and so you know that they are genitals, but in the case of illustrations or manga, they are drawn from the imagination and so I don't think you can say that they are actually genitals." The judges pursued this point with the recalcitrant witness, asking him,

> Q: When you say that you don't know if they are genitals or not, is your point that you don't know if they are depictions of genitals or not?
>
> A: In the case of photos and videos, they are the real thing just as they are. But in the case of manga, they're not the real thing, right? They're drawn to resemble them, but I'm just not sure about saying that they are genitalia. In the case of manga, since they're not real genitals, I just don't know. (*WKS*, 137–138)

With these circuitous claims, the defense attempted to maintain a distinction between realism and reality, distinguishing between realistic-looking fictional depictions of genitals and real genitals. The prosecutor himself was not unaware of this distinction. As he acknowledged in his cross-examination of Kishi, "Yes, they are not real genitals. This is obvious since they are representations. But in the end, by drawing something that resembles genitals, it makes one associate it with genitals and the sex act, yes? . . . And based on that, does it not sexually stimulate readers?" (*WKS2*, 68–70).

For the defense, the inherent fictionality of the images drawn by a manga artist not only meant that they were distant from reality or "the real thing as it is" (*sono mama honmono*) but also ensured that the work achieved the level of high art and the manga illustrator that of artist. Summing up this perspective in a news conference after the lower court guilty verdict, Kishi compared "the ease of taking photographs with the many hours it takes to draw even a single panel of a comic" (*WKS2*, 105). Implicitly, manga's artistry was privileged over photography's mimetic realism because of the existence of an authorial consciousness that sculpts the manga. Manga, as art that is the product of the artist's imagination, constituted creative artistry, not mere reproductive mimicry like photography.

But claiming that manga in general, and especially *Honey Room*, lacked realism and possessed artistry was, in light of the manga artist's own testimony, a dubious proposition. Beauty Hair had repeatedly admitted that

his work was not artistic but instead realistic and lewd: during the police investigation, he stated, "I don't think of my work as artistic so I drew depictions of pubic hair and private parts in detail"; at the trial, he claimed he tried to draw things "as realistically and lewdly as possible" and that "achieving reality" was his aim. Even defendant Kishi had testified to the skillful realism of Beauty Hair's erotic manga.[64] As in the *Chatterley* trial where a prosecution witness criticized translator Itō Sei for "depicting the scenes too skillfully," here too the artist's skill was both its strength and its downfall; as Kishi complained, "There is a terrible contradiction when you get nabbed by the police if you perfect your technique too much."[65] Perfected realism was dangerous in the censors' minds because it invited the possibility that readers would confuse the fictional and factual realms. Realism could also paradoxically work against the artist's own status as creator. In this case, it did not elevate the work to the level of art or Beauty Hair to that of artist but instead relegated him to the status of mere scribe who copied reality onto the page. Like a translator transcribing another's original literary work or a genre director who followed a studio's generic formula, a realistic manga artist working in the confines of a formulaic genre could be accused of lacking the authorial intent to create something that contained enough artistic or philosophical merit worthy of constitutional protection.

Authorial Integrity and Criminal Culpability

The defendants further undermined any claims of artistic or authorial integrity by pointing to a division of labor that again left the business executives, not the artist, in control of the final product. In an echo of the defense at both the *Chatterley* and Nikkatsu trials, Beauty Hair fingered Takada, Shōbunkan's editor in chief, as responsible both for dictating the content and for censoring the work as necessary to avoid criminal charges.[66] Again, the formulaic nature of the genre dictated its content, and the genre of erotic manga, by definition, intended to arouse, as Beauty Hair had admitted; as the reporter covering the case put it, "Lewdness is erotic manga's essence" (*WKS2*, 276).

The publisher, in turn, pointed to increased competition and pled commercial necessity to explain why he had reduced the color density of the manga's maskings. These tiny, transparent white or gray rectangular and triangular marks indeed fail to mask much at all, particularly in the glossy all-color opening pages. As the defendant himself implied in his testimony and as a major publishing industry executive admitted, their use is really

just "subterfuge" (*gomakashi*) to appear as if publishers are complying with police regulations.[67] Even totally opaque masks, however, arguably reveal more than they conceal, as film theorist André Bazin has famously argued about the American pinup. He wrote, "At any rate, it is only too obvious that the veils in which the pin-up girl is draped serve a dual purpose: they comply with the social censorship of a Protestant country . . . but at the same time make it possible to experiment with the censoring itself and use it as an additional form of sexual stimulus."[68] Eroticism, in other words, often depends upon *not* showing and instead inviting the viewer to re-create these hidden images in their imaginations.

Censored manga can be said to doubly require such reader input. The viewer is actively enlisted to "fill in the blanks" of both what is absent in the frames themselves because of self-censorship devices like masking or coding images (i.e., the substitution of a fish mouth for a breast or a bat for a penis) and what is absent between the frames in this inherently "laconic text."[69] As manga artist Chiba Tetsuya explained in the High Court trial when asked how manga differed from photography and *shunga,* "Manga are expressed by the movement of the panels. And there's a story. You look while imagining, the parts that are not drawn, or shall we call them the space between the lines?"[70] As in the previous trials, in the judges' minds, this invitation to read the invisible "space between the lines" or behind faint maskings was no testament to the artistry of the medium but rather evidence of its obscenity.

The Verdicts

Of all the landmark postwar obscenity trials, *Honey Room* stands as the only one in which the defendant was consistently convicted and the work consistently found obscene. In the *Chatterley* trial, the lower court had issued its infamous split verdict convicting the publisher but not the translator based on the reasoning that the translation itself became obscene only upon being marketed as such. In the Sade trial, the High Court reversed the lower court's not-guilty verdict. In the *Black Snow* trial, the film was deemed not obscene by the lower court as a "time art," and though this was reversed by the High Court, the defendants were acquitted because of Eirin's seal of approval. For the same reason, all defendants were exonerated in the Nikkatsu Roman Porn trial.[71] In the *Dannoura* trial, the lower court deemed the work not obscene, although this was overturned by the High Court on appeal. In the "Yojōhan" trial, the editor and publisher were found guilty at all three stages, but the work itself and its original author were exculpated

to a degree. And in the *Realm* trial, both the work and the defendants were exonerated at each stage.

In contrast, in the case of the manga, the work itself was found obscene and the defendant-publisher Kishi was convicted at all three phases of the trial. In the lower court verdict of January 13, 2004, Kishi was sentenced to a one-year prison term with a stay of sentence for three years' probation, having already served forty-four days in detention during the investigation phase. The High Court verdict of June 16, 2005, overturned the prison sentence but not the guilty verdict, and instead fined him 1.5 million yen (approximately $13,750).[72] On June 14, 2007, the Supreme Court tersely dismissed the defense's appeal and let both the fine and guilty verdict stand. What about the manga *Honey Room* itself, the genre as a whole, the publisher-defendant's role in its production, and the context of its production and reception led to this unmitigated condemnation?

For the courts, again the guilty verdicts hinged on a complex understanding of the specificity of the medium in question, both its potential effects and its audience. The judges were again guided by a sense of perceived crisis surrounding youths and the contemporary publishing industry, one that was especially fraught in the new borderless age of the Internet. What was entirely new to the *Honey Room* trial was the judges' reliance on conservative international laws and norms concerning child pornography and prostitution. How this trial rehearsed and revised the familiar key issues from prior proceedings as well as introduced entirely new ones suggests both whence this verdict came and where obscenity trials might head in the future.

Judging the Medium of Manga—Realism, Artistry, and Motion

In this first trial of a manga, the *Honey Room* judges redefined the hierarchy of obscene media established in the previous trials that had rhetorically positioned film at the apex, photography a close second, and prose as the least potentially obscene. Notwithstanding this theoretical ranking, however, we saw how time and time again, prose was charged with transcending the powers of printed text and achieving the qualities of a moving image that "appeared as if before the eyes of viewers." After the *Honey Room* guilty verdict, one commentator complained, "These judges don't understand a thing about prose. The imaginative power of prose is such that it beats its wings inside one's head and is more powerful than photography

or pictures."[73] In fact, the verdicts in these earlier trials concurred with this assessment entirely.

For the courts, while images were potentially obscene because of their visuality and visibility, prose was suspect precisely because of its textuality and invisibility. As a medium combining text and still images, *Honey Room,* like Ōshima's *Realm,* was subject to accusations on both counts. But, as we recall, *Realm* had been exculpated largely because the text and image sections were separated and there existed a third version—the film—that combined the two. In contrast, *Honey Room* intermixed text and image on a single page. For the judges, the question was what media did the medium of manga most closely resemble, and where did it rank in the hierarchy of obscene media?

Honey Room was a hybrid medium in multiple senses: as a combination of text and image, it straddled the media of literature (or prose) and drawings; as a collection of still images, it straddled those of drawings and film; and because of its detailed, realistic drawing style, the images were not squarely characterized as hand-drawn art but instead likened to photography. The question in the minds of the judges was how the individual panels of manga compared with still images like ukiyoe prints and photography, and how the successive still images of manga compared with the moving ones of film.

On the one hand, the judges asserted that manga were, as the defense had claimed, distinct from and thus less potentially obscene than photography and live-action film. In the lower court verdict, they conceded, "We agree that manga pictures are not photographs or [film] images, and because they are hand drawn with lines and dots, there is a difference between the real-world thing, and the picture is deformed so sexual stimulus is potentially mitigated."[74] In principle, manga as a medium was deemed distinct from photographic realism because of its use of a hand-drawn, *déformé* style that created distance between real-life objects and their representations.

On the other hand, the judges argued that because manga contain realistic visual images like photography, they are potentially more obscene than prose. They wrote, "But, on the other hand, as with photos, manga's methods also depict scenes of sexual intercourse and sex play just as they appear, and can thus directly appeal to the reader's vision. Compared with prose, which is limited to printed information, we can conclude that manga have a potentially stronger sexual impact on readers based on this method of depiction" (*MLC,* "Honken manga no kōsei, naiyō tō ni tsuite"). In sum,

while manga's use of the unrealistic drawing technique of *déformé* might be a mitigating factor, the medium's inherently suspect visual images imbued it with an immediacy and realism that rendered it potentially more obscene than prose.

The judges reasoned that if manga in general are suspect because of their use of realistic images that appeal to vision, then *Honey Room* was all the more so because the artist himself had admitted that realism and eroticism, not artistry, were his goal. The judges wrote,

> As the manga artist himself testified, no model was used, but he strove to depict them as realistically and lewdly as possible, so the depictions of genitals and couplings are by no means very distant from the real thing but instead appeal to people's emotions and senses and stir up their imaginative powers. Therefore, we recognize that the depictions possess enough truthfulness to life and vividness that they bear a close resemblance to actual sex acts and scenes.

Not only was the visual quality of the manga problematic but also its aurality heightened its obscenity in their minds: it had "not just figural depictions but also characters' exclamations, onomatopoeia, and mimetic sounds that imparted the whole with a sense of presence and increased the sexual stimulus." Also, *Honey Room*'s drawing technique was much more realistic than the other "comparably explicit" erotic manga submitted by the defense: unlike those, *Honey Room* depicted body parts that were "very close to reality," especially the genitals, which were "exaggerated and drawn larger than other body parts." The lower court judges concluded, "*Honey Room* belongs to a class of a much higher level of reality and verisimilitude than the other manga submitted, because even though they employ no masking, they use *déformé*" (*MLC*, "Honken manga no kōsei, naiyō tō ni tsuite").

In sum, according to the judges, the work's excessive realism and eroticism rendered it irredeemably obscene. The artist's own testimony came back to haunt the defense, for he had admitted that his aim was not realism in the service of "art" but in line with the commercial goals of the publisher. As the High Court judges noted, Beauty Hair created the work at the behest of the editor in chief, who had told him to "draw something lewd" (*ettchi na mono*); they further noted, "As the manga artist himself stated, he drew pubic hair and regions as detailed and real as possible in order to impart sexual stimulus to readers" and "does not consider it an artistic work" (*MHC*,

"'Misshitsu' ga mangabon de aru koto ni motozuku shuchō ni tsuite").
Paradoxically, what damned the work in the judges' eyes was both its artistic
richness as a finished product and the artistic poverty behind its conception.

Because the intent behind producing the manga was admittedly erotic,
the judges most definitively rejected the defense's attempts to equate manga
with the lofty artistic genre of ukiyoe or even *shunga*. The lower court judges
carefully distinguished between the two, insisting on the historical appeal of
ukiyoe and *shunga* as opposed to the purely prurient appeal of erotic manga:

> Ukiyoe, as works by famed ukiyoe artists, and Edo and Meiji-period
> *shunga,* as historical culture that appeals to nostalgia for the past, are
> things that pique one's interest. Even sex instruction books contribute
> to achieving a fulfilling sex life primarily among married couples. Their
> content and purpose are distinct from those of the manga in this case,
> which appeals entirely to readers' prurient interests. (*MLC,* "Honken ni
> tekiyō subeki shakai tsūnen ni tsuite")

Even *shunga* were credited with piquing viewers' interest in their nation's
past, and sex manuals with stimulating their married sex lives. These two
lofty aims had, we should recall, been cited to exculpate sexually explicit
material in past trials: both the sex manual *Perfect Marriage* by Van de Velde
cited in the *Chatterley* trial and the "historical picture scroll" of *Dannoura.*

Historically speaking, *shunga*'s original purpose, as advertisements for
prostitutes of the floating world of Edo, had more in common with erotic
manga than the judges admitted. Originally, they were commodities that
titillated prospective customers, who went on to purchase a prostitute if
they could afford it, or that substituted as masturbatory material for those
poorer customers who could not. In fact, in his testimony psychologist Saitō
pointed to this by citing the controversial Japanese title of Timon Screech's
book, *Shunga: Katate de yomu Edo no e* (*Shunga:* Edo pictures read with one
hand, 1998).[75] But by crediting *shunga* in the verdict with the sanctioned
dual purposes of fueling nostalgia and procreation, the judges elevated
shunga to the status of a national treasure serving the nation in two respects,
as highbrow historical culture and as a procreative aid.

Whereas *shunga* were canonized, the erotic manga *Honey Room* was
demonized as purely prurient in both intent and effect. In addition to
Beauty Hair's testimony, the judges cited also the content and proportions
of the manga itself, following the revised criteria for defining obscenity

established in the 1980 "Yojōhan" Supreme Court verdict. They criticized the manga's emphasis on genitals "that are drawn enlarged and in detail with just that part filling up an entire panel or even almost an entire page." Moreover, the book contained an overwhelming proportion of such depictions, calculated by the judges to the precise mathematical figure of 82.6 percent of the pages. Additionally, the fact that the publisher published only erotic manga and admitted in the investigation that his aim was "to satisfy the sexual desire of male [readers]" proved, in the minds of the judges, "that the work has no artistic or philosophical intent" and led the judges to conclude that such "profit seeking merited their severe condemnation" (*MLC*, "Honken manga no kōsei, naiyō tō ni tsuite"; "Ketsuron"). Unlike the Nikkatsu defendants, who had argued that the production of pornographic films sustained a larger domestic film culture in the name of national film preservation, here the defendant could not invoke any such extenuating circumstances. Instead, in the *Honey Room* trial, dirt for money's sake was precisely just that.

Although the judges did not explicitly compare manga with film, they did consider how motion functioned in the medium of manga to determine whether and how the reader would interpret each panel's isolated scenes in the context of the whole. Again the question was, could the isolated images of sex be subsumed under some greater message (philosophical, artistic, political, etc.) of the entire work?

In the case of *Honey Room,* the judges concluded that the narrative, composed of a string of isolated spectacles of sex, was as a whole overridingly immoral and indefensible. In other words, the manga's many spectacles, problematic in their own right, punctuated an even more problematic narrative:

> This manga is not merely something that depicts a collection of isolated scenes of genitals or sex, like the still images of photographs. Rather, in addition to possessing manga's unique characteristics, such as its division into panels and its use of speech bubbles emanating from the characters, this manga is endowed with a narrative that has a plot with sex scenes mixed therein. More specifically, in addition to "New Heroine," in stories like "Mutual Love" and "Crawling About" too, the male violently rapes the female, and in the former the woman even says that those kinds of actions are a form of love. Or, in "Innocent," in which the female patient in the psychiatric hospital tempts the doctor to perverted sex

acts, and in other stories too where immoral sexual acts readily occur in high schools and in the workplace. Each and every one is violent, sadistic, and amoral and can only be said to be far from reality. (*MLC,* "Honken manga no kōsei, naiyō tō ni tsuite")

At the same time that the judges objected to realistic depictions of the sex spectacle, they also criticized the unrealism of the narrative. But when they criticized the implausibility of the narrative setups for unrealistically depicting misogynist and immoral sex acts occurring in everyday environments like high schools and the workplace, the judges were likely pointing instead to their undesirability in an ideal world.

Here again we see hints of a procensorship feminist argument in which the sadistic violence inflicted upon female characters (and their enjoyment and validation of it) fuels censorship. Ultimately, the judges remained unswayed by Fujimoto's attempt in her testimony to redeem the narrative as a feminist one and were perhaps influenced by the manga artist's own admission that "even [he] was surprised at Fujimoto's remarks" (*WKS,* 239). Although the judges reluctantly agreed with her that "in seven out of nine of the stories, the manga artist depicted consensual sex" and that "it is not as if there is not some room to consider that the works reflect a certain consciousness on the part of the artist toward sex and women," they concluded that "the story in each is limited," citing as an example the very brief background story about the stuntwoman that serves only to introduce the sex acts.

According to the judges, the problem was that the narrative was merely in the service of spectacle: "Even the panels that don't include sexual depiction are tools to develop the sex scenes or mere postscripts that wrap up the story's conclusion . . . and serve the function of increasing the sexual stimulus of the sex scenes themselves. . . . The story part of the manga serves only the function of increasing the sexual stimulus" (*MLC,* "Honken manga no kōsei, naiyō tō ni tsuite"). Unlike *Black Snow,* where the moving images could be subsumed under a politicized narrative that mitigated sexual content, the manga was judged to be unable to forestall sexual arousal because the larger narrative itself was a misogynist, violent, amoral, and apolitical one.

The question was again one of form as much as content. But unlike their predecessors, these judges deemed manga to be potentially more obscene than still images precisely because manga resemble a "time art" like film, with the average manga reader scanning pages at a rapid rate of about

three to four seconds per page.[76] It seems that manga were characterized as more filmic than photographic because of their forward propulsion from panel to panel and inclusion of a narrative or plot, which itself entails forward momentum. Narrative, after all, propels readers through space and time, whereas spectacle is a freezing of that motion, a punctuation mark that allows one to revel in the still image and moment. In the verdict, the judges repeatedly drew an unfavorable comparison between the innocuous still shots of photography and the dangerous forward-moving momentum of manga as a narrative art made up of a succession of panels.[77] They wrote, "This manga is not *merely* something that depicts a collection of isolated scenes of genitals or sex, like the still images of photographs." Similarly, they concluded, "More than a photograph that shoots only a single scene of sexual intercourse or sex play, this collection imparts a larger degree of stimulus on readers because it has a story and greater presence" (*MLC,* "Honken manga no kōsei, naiyō tō ni tsuite"; italics mine).

And again, this motion was equated with a realistic "presence" (*rinjōkan*) that resulted from integrating objectionable isolated still scenes (or spectacle) into a forward-moving plot (or narrative). Moving images coupled with a "moving" story lent the work a presence that was dangerous and obscene. Once again, rhetorically film and moving images were implied to be the most potentially obscene medium of all, even when the object on trial was not itself a film.

A Revised Hierarchy for Obscene Media?

How did the judges' condemnation of the medium of manga as a quasi-filmic art correspond to the hierarchy of media articulated by the other verdicts? As a film, *Black Snow* had been exculpated largely as a "time art" that mitigated film's inherent realism because it disallowed the spectator's lingering, prurient gaze. The stillness of the photographic images in Ōshima's *Realm,* in contrast, mitigated their obscenity because viewers would fixate on them and sense the unrealism of their presentational qualities. With the manga *Honey Room,* however, the images were deemed simultaneously stilled and in motion, too realistic but not artistic enough.

The problem was that the manga's isolated stilled images invited not skepticism about their reality but sheer arousal: as the High Court judges wrote, Beauty Hair's "elaborately drawn" and "detailed" depiction "becomes extremely vivid and appeals to the emotions and senses of the reader and stirs up their imaginations" (*MHC,* " 'Misshitsu' ga mangabon de aru koto

ni motozuku shuchō ni tsuite"). Unlike the staged and performative photos of *Realm* that revealed their unreal qualities, the manga's realistic images incited its readers' imaginations. Moreover, the fact that these images were contained in a printed and bound volume, not in a true "time art" like film that compelled viewers to watch the images at a fixed speed, allowed readers to pause and fixate on them at will. When readers paused at will on an image from the manga, they would see something that was "realistic" with "the power to press in upon them." The fact that the reader could linger over these moving solitary images in solitude guaranteed they would be in the service of prurient desire. Even when these individual images or panels were set into motion by the reader-cum-viewer and read in the context of the larger story, the larger narrative failed to redeem them. Rather, viewers would move from panel to panel and from one dialogue bubble to the next only to find that the story in which they were subsumed was one that was as indefensible on political grounds as it was on feminist ones.

In conclusion, not only did the manga's lack of a grand political or philosophical narrative fail to mitigate the obscenity of the isolated images but also the very form of the manga contributed to its obscenity. Its obscenity depended precisely on this dangerous combination of motion and stasis: the kinetic motion within and between the individual panels, the propulsion through an objectionable narrative, and the static, bound nature of these individual panels as well as their collection into a bound book.

Readership and Reception:
Kids, Crime, and Comics

The fact that the manga was a printed volume fueled the judges' assumption both that readers would use it for masturbatory purposes and that the manga would have a dangerous "afterlife" in two senses of the word: as a text that could be recirculated repeatedly after its initial sale and as one with potential repercussions in real life. First, even if the manga was clearly marked an adult comic and booksellers faithfully adhered to voluntary zoning regulations designed to restrict youths' access at the time of sale, it could easily circulate subsequently among susceptible youths (to wit, the sixteen-year-old boy whose possession was the genesis for the indictment), not to mention sexual deviants. Second, but not unrelated to this first point, the judges worried that a manga like *Honey Room,* with its graphic images of the torture and rape of young women, would potentially transform these "unsocialized youths" (to borrow the phrasing of the prosecutor) into sex

criminals. To justify their guilty verdict, the judges implicitly invoked this first kind of afterlife to convict the publisher while quite explicitly invoking the second.

Manga were particularly susceptible to this first charge because recirculation is especially common, prompting many commentators to put circulation figures for manga at three times the number of sales.[78] Following that formula, the 20,544 copies of *Honey Room* sold might have reached over 61,500 readers. Alternatively, based on the fact that the objectionable story "Mutual Love," the catalyst for the indictment, had been published in three different volumes, for a total circulation of around 80,500, that particular work alone potentially reached over 240,000. In addition to instituting detailed zoning restrictions for selling adult materials, in the early 1990s special sealed trash receptacles for "harmful reading materials" (*yūgai posuto*) were installed at train stations so that commuters could dispose of such materials without fear of making them accessible to underage youths or unsuspecting passersby.[79] Despite such attempts to restrict access, in practice manga circulation was especially difficult to regulate.

In anticipation of this objection, the defense introduced the conservative defense witness Sonoda, who called for the prosecution of *Honey Room* and other such material as "harmful books" under child-protection ordinances.[80] (Conveniently for the defense, such charges would apply to offending booksellers rather than to the publisher-defendant.) Like this defense witness, the judges too were clearly concerned about the effects of such a manga on youths, as seen in their cross-examination of a witness who conceded its ill effects on "young youths."

But the judges did not, and could not, rely solely on this rhetoric of the young reader in the verdict because, as they themselves noted, the comic was being prosecuted under obscenity laws, not youth regulations. Accordingly, the judges dismissed Sonoda's testimony as irrelevant since his expertise was limited to what would arouse and harm children. In fact, they asserted their concern was not keeping the book from those who should not see it (i.e., youths) or even from those unsuspecting passersby who did not want to see it, but from precisely those readers who wanted to see it. The High Court judges wrote, "It is true that this manga was made so that it would not catch the eyes of those who did not want to see it or be shown it. But . . . since this does not constitute a regulation for those people who want to see it, it therefore cannot avoid . . . the crime of distribution" (*MHC*, " 'Hanpu' kōi ni gaitō shinai to no shuchō"). Here the judges reveal the extent of

their conservative ambitions. They quite baldly declared their intent to perform a clinical role, just as their predecessors had in the *Chatterley* Supreme Court verdict. In the twenty-first-century context, however, this seemingly unabashed assault on the rights of adults required some legal finessing on the part of the judges.

Their claim that such censorship was not in violation of the constitutional provision for free expression depended on linking the act of reading obscene manga to criminality. The judges admitted that they were effectively expanding the provisions of article 175 by crediting it with the "legal benefits" (*hogo hōeki*) of crime prevention. They wrote, "The direct purpose of article 175 was not intended to maintain particular legal benefits, like preventing sexual crimes and prostitution or promoting the healthy development of youths," but it nonetheless "indirectly contributed" to these legal benefits (*MHC*, "Keihō 175-jō no hogo hōeki ni kansuru shuchō ni tsuite"). To bolster this claim, they argued that readers would be incited by the manga to commit egregious copycat sex crimes against girls and women.

Another Statistics War: Erotic Manga as Safety Valve or Boiler Room?

To prove that reading sexually explicit manga was linked to sex crimes, the judges used the defense's own statistics against them. In a seeming contradiction, the defense had cited both the lack of social science proving any connection between criminal activity and media representations of crime and simultaneously a barrage of crime statistics to prove there existed a negative correlation between the two. While the defense advanced the safety-valve theory of media, whereby representations offered a harmless fictional outlet for satisfying unacceptable desires, the judges countered with the copycat theory, whereby publications inflamed and incited these very desires in real life. In other words, the question was, were erotic manga a safety valve or a boiler room?

Both sides agreed that the late 1990s marked a precipitous escalation in both the quantity and degree of explicit erotic manga published, although neither cited any hard statistics. According to the defense, during this period crimes of rape and forcible obscenity committed by youths were down considerably: by 2002, juvenile suspects constituted only about a third of the 1980 number. The defense argued further that the decline in the number of obscenity investigations (from a peak in 1983 of 2,388 to just 881 in 1998, and a mere 483 in 2002) led the defendant Kishi to believe that he

was operating within the limits of the law when he published *Honey Room* in 2002. Kishi may have miscalculated, but he was justified in presuming his innocence based on "considerable reason" (*sōtō na riyū*), which, as we saw above in the *Black Snow* trial, had led to the defendants' acquittal because Eirin had approved the film. The defense's contention that the state's failure to prosecute comparably explicit manga for obscenity constituted "considerable reason" would seem to be of an entirely different order than the expressed endorsement of a film by a self-censorship regulatory agency like Eirin. But, considering the lack of a corollary authoritative prepublication censorship system for printed works, such monitoring offers perhaps the only, though imperfect, gauge for publishers attempting to tread the fine line of the permissible and impermissible.

Interpreting the decline in obscenity charges as proof of the state's endorsement of explicit material was not, however, acceptable to the judges. The decline was attributed in the verdict instead to a much more practical reason: the twofold increase in the prosecution of violent crime—murder, robbery, and rape—from 1997 to 2002 showed "nothing more than the fact that the authorities were busy with investigating heinous crimes" (*MLC*, "Keihō 175-jō no hogo hōeki"). Far from a sign of approval, the state's failure to prosecute proved only what the head lawyer for the U.S. *Chatterley* case had warned: "The government does not have time to prosecute everything that ought to be prosecuted."[81]

Crucially for the judges, these statistics evidenced a cause-effect relationship between the rise in erotic manga publications and the rise in violent crime at the turn of the twenty-first century. The judges admitted the defense's statistics were accurate and attested to a huge decline in obscenity crimes among youths aged fifteen to nineteen in the 1990s. They were not, however, interested exclusively in the negative effects on youths but on adults as well. Marshaling their own statistics, the judges pointed to an increase in the cumulative number of sex crimes committed by adults *and* youths, with a peak that conveniently coincided with the year of *Honey Room*'s publication, 2002. Although investigated sex crimes steadily decreased by almost 40 percent from 1975 to 1986, by 1995 the numbers had crept back up by almost 30 percent. In 2000, the year that all had agreed marked the emergence of completely unexpurgated (maskless) manga, there was an incredible 88 percent jump in the number of sex-crime investigations, and again in 2002 another sharp rise of 18 percent (*MLC*, "Keihō 175-jō no hogo hōeki").

Although social science research has repeatedly failed to prove a measurable connection between media representations of violence or sex and real-life behavior, statistics were marshaled here to prove both claims and counterclaims. At times, the two sides relied on different data sets to yield different "objective" results, but even when citing the same set of data, they reached entirely opposite conclusions. As in the *Chatterley* trial, the defense's scientific and statistical testimony invited yet another numbers war. Social science lives on in obscenity determinations, serving the defense or prosecution of a work equally well by offering a cloak for ideology in the "objective" language of science. The grim fate of ostensibly neutral hard science when it fails to uphold a desired ideology is illustrated by the fate in the United States of *The Report of the Commission on Obscenity and Pornography—September 1970,* which had been submitted as defense evidence in the Nikkatsu Roman Porn trial. When the report found "no evidence that exposure to such material was harmful to individuals," its findings were overwhelmingly rejected by the Senate and by President Nixon, who dismissed the report's scientific findings in favor of "centuries of civilization and 10 minutes of common sense" that "tell us otherwise" and warned that "the warped and brutal portrayal of sex . . . , if not halted and reversed, could poison the wellsprings of American culture and civilization."[82]

The same rhetorical move seen here—from objective science to subjective but unassailable morality—would be made by the judges in the *Honey Room* trial. After concluding a discussion of their highly objective statistical evidence that "proved" the copycat theory of crime, the judges launched into a moralistic polemic:

> Of course, we cannot entirely attribute the rise of sex crimes to increased sexual expression in society, but even so, the rise in sex crimes suggests a slackening of sexual order and the decay of sexual morality in society. As such, we can easily presume a definite relationship between the two. Accordingly, as reflected by these kinds of recent trends in sex crimes, the maintenance of sexual order, of the minimum degree of sexual morality, and of healthy sexual morality is an urgent issue requiring legal protection especially now. (*MLC,* "Keihō 175-jō no hogo hōeki")

The age-old invocations of the censor are reiterated in yet another age of perceived crisis; the era of "moral decadence" (*dōtoku no taihai*) has again

returned. But this time, the object on trial was not figured as a symptomatic reflection of that decadence but as its very cause.

Obscenity Law in the Borderless Age of the Internet: International Norms Revisited

According to the judges, the explosion of unexpurgated erotic manga was only partly to blame for this precipitous decline in morality. There was another, new root cause: the Internet. The judges wrote:

> Even domestically in Japan recently there has been a flood of varied sexual expression and it has become possible for even the general populace to obtain such works relatively easily. The content too has become increasingly extreme. In light of the fact that this trend is even more intensified by the spread of the Internet, we must say that the changes in society wrought by these types of sexual expression inevitably constitute a threat to sexual order and to its foundational minimum degree of sexual morality as well as to the maintenance of healthy sexual morals. (*MLC,* "Keihō 175-jō no hogo hōeki")

As with the immediate postwar publication boom and its concomitant "flood" (*hanran*) of unhealthy publications, again the spate of readily accessible explicit publications in the twenty-first century justified a reassertion of the courts' clinical function in the interest of maintaining not just a "minimum degree of sexual morality" but, tellingly, also "healthy sexual morals."

Of note, according to the judges these morals would be determined by the court based on the legal concept of "community standards." From the time of the *Chatterley* Supreme Court verdict, these standards were not a question of "legal interpretation" (*hō kaishaku*) based on "compiling the opinions of individuals who make up society or any kind of mean average," but instead a "legal fact" (*hōritsu no jijitsu*) based on the judges' determination of a "group consciousness that transcended these."[83] As such, testimony that lobbied either for or against the work based on an individual witness's standard of decency was deemed irrelevant.

Likewise, the defense's pleas that community standards had changed in the age of the Internet and had rendered the 1880 Meiji Criminal Code irrelevant were themselves deemed irrelevant. In his opening statement, Kishi had pointed out, "There are ten million people [in Japan] who can access the Internet, where they can see [unexpurgated] naked bodies" (*WKS,* 25;

cf. 35). Even the conservative Sonoda acknowledged the "Internet's huge effect on people's conceptions of obscenity because of its ability to transcend national borders and to connect directly to another nation's culture."[84] In an echo of prior trials, the defense called for Japan to loosen its obscenity regulations based on international norms or risk embarrassment in the eyes of the international community on both aesthetic and legal grounds.

The key difference in the manga trial was how the explosive popularity of the Internet made such local and national deviations nearly impossible to maintain in the face of globalization and new technologies. In a 1995 speech, the eminent British philosopher Bernard Williams likened the Singaporean government's persistent attempts to restrict free speech in the global era to opening the windows with the aim of swatting at the flies.[85] In using this metaphor, he was suggesting the folly of trying to swat at flies gathering around a honey pot that had been left by an open window. In the case of *Honey Room,* as the defense implied, the moral guardians were now undertaking the truly herculean and quixotic task of trying to keep the flies out of the honey when the house no longer had walls, much less windows.

While the defense called forth the eyes of the international community in order to situate Japan in line with more liberalized Western artistic and legal societies, the judges conspicuously introduced another set of international norms to assert the need to police national borders all the more tenaciously in this age of the Internet: the international push to regulate cyberporn. The lower court judges cited the November 2001 Cybercrime Treaty (Saibā Hanzai ni Kansuru Jōyaku)—the first such international treaty on criminal offenses committed through the Internet—and noted that it was "signed by Japan as well as by G7 nations and by the majority of Western nations." They also cited the Japanese Diet's unanimous passage of the Ministry of Justice proposal to expand article 175 to include "so-called cyberporn, or obscene electromagnetic records" in September 2003. The introduction of this treaty and supporting domestic legislation was highly strategic on the part of the judges. It proved that Japan was aligned with other developed nations in the fight against cyberporn. (In fact, Japan was leading the charge as one of the key drafters of the treaty alongside the United States, Canada, and South Africa.)[86] According to the judges, these cyberporn regulations represented "the consensus of our nation's legal scholars" to continue to apply and even to expand the provisions of article 175 to prosecute obscenity in contemporary Japan (*MLC,* "Keihō 175-jō no hogo hōeki"). This conspicuous introduction of new evidence by the judges

suggests both their ultimately conservative aims and the perceived need by all parties in the trial to enlist the international community on their side.

There are several reasons why the judges' introduction of the Cybercrime Treaty was controversial. First, judges are charged with ruling on evidence supplied by the trial lawyers, not with introducing new evidence of their own.[87] Second, the treaty was initially designed to prevent the spread of child pornography (along with other objectionable racist or illegal materials) on the web. But nowhere else in the trial was *Honey Room* explicitly accused of being child pornography showing sexualized images of children, although, as mentioned above, the verdict did criticize the fact that some of the sex acts take place in high schools. Nor were erotic manga linked to crimes committed *against children* per se, with the only crime statistics cited by the judges being those for obscenity crimes in general. Third, *Honey Room* was a bound, printed volume, not a manga distributed on the web, at least not initially.

To understand why the judges risked the legally dubious proposition of introducing this treaty as evidence, it is crucial to look at how the treaty itself addresses the implicit question at the heart of the trial: the real-life dangers of representational media, particularly for youths. Evident throughout the treaty is the typical slippery rhetoric of the censor targeting representations in the name of reality. The treaty's definition of child pornography encompasses visual depictions of sex acts involving both actual minors (defined as under eighteen or under sixteen, depending on the nation) and those "appearing to be a minor," as well as "realistic images representing a minor engaged in sexually explicit conduct." Moreover, these regulations are designed to apply equally to real and simulated conduct and to images of real and simulated children. Like Japan's UNICEF petition to regulate quasi child pornography, the treaty applies even to "pictures which are altered, such as morphed images of natural persons, or even generated entirely by the computer." As the framers of the treaty admit, there is a distinction of note here between real and simulated children:

> The protected legal interests are slightly different. [The former] focus more directly on the protection against child abuse. [The latter] aim at providing protection against behaviour that, while not necessarily creating harm to the "child" depicted in the material, as there might not be a real child, might be used to encourage or seduce children into participating in such acts, and hence form part of a subculture favouring child abuse.

But any gap between real and imagined children is readily explained away by invoking the copycat theory of crime: "It is widely believed that such material and online practices, such as the exchange of ideas, fantasies and advice among paedophiles, play a role in supporting, encouraging or facilitating sexual offences against children."[88] Clearly, the aims of the treaty were not only to prevent *real* harm to *real* children in the act of filming or photographing them, but also to prevent *potential* harm done to *real* children by readers and viewers who consume sexualized images, whether based on real or simulated children.

The treaty offered the judges a perfect opportunity to invoke the hot-button issues of censorship—kids and copycat crime—while aligning themselves with international standards. Like the treaty, the *Honey Room* judges claimed to be concerned not with child readers but with child victims of copycat sex crimes committed by adult readers of the manga. We should recall here how much the concerns that precipitated the trial—the letter from the concerned father of a sixteen-year-old reader—had morphed by the time of the verdict into another danger entirely: the image of adult pedophiles consuming sexualized images of youths and subsequently harming youths, like the *otaku* murderer.

For a nation like Japan that has often been the target of severe international criticism for prostitution and pornography, the Cybercrime Treaty and the *Honey Room* trial offered a particularly useful means to reform its international image. In doing so, Japan could claim membership among the developed, enlightened nations of the G8 rather than remaining, as one critic has accused, "along with Russia" one of the "only two that do not criminalize the possession of child pornography."[89] Bringing up the treaty in the verdict simultaneously allowed the judges to imply a few seemingly contradictory things: they could announce that they too were joining the international fight against porn in order to combat Japan's own negative international image as "the number one producer and exporter of child porn" (as UNICEF charged), and they could displace that blame onto the Internet. This time the "flood" of pornography came not from imported translations but from the nebulous and originless Internet. In other words, Japan could ally itself with the international community against porn while implicitly fingering those other nations as the perpetrators.

The judges selectively embraced some international norms while rejecting others to justify a crackdown on sexually explicit representations. Again, international cultural norms of sexual liberation were deemed inappropriate

to the nation's "healthy sexual morality." The impetus to accept conservative international legal norms like the Cybercrime Treaty converged with both external international pressures and internal domestic pressures. As David Leheny has pointed out, the application of international norms in Japan is often skewed to satisfy the distinctly local concerns of an increasingly conservative Japanese domestic policy. The judges cited and adapted the Cybercrime Treaty as needed in the verdict (disregarding both legal protocol and the fact that the manga may be porn but is not cyberporn) to suit a conservative agenda. Domestic calls to revise Japan's child-prostitution laws to crack down on both human trafficking and pornography, including manga and anime, similarly cite these international norms.[90] These were recently bolstered by the May 2008 U.S. Supreme Court ruling that deemed pornography using computer-generated children is not protected under the First Amendment, in a reversal of its earlier 2002 verdict.

The judges' claim that *Honey Room* and other salacious materials available on the Internet were a threat to sexual order and healthy sexual morals implied that these things were intact, under assault perhaps, but intact. Again the judges relied on the notion of the "minimum degree of sexual morality" established almost fifty years earlier in the Supreme Court *Chatterley* verdict of 1957. Suggestively, however, for the first time in the course of the postwar obscenity trials, this minimum standard was not correlated to any unchanging "principle of the nonpublic nature of sex." In the 1960s and 1970s, in the face of the miniskirt boom, the sexual revolution, and the liberation of pornography, claiming the existence of any such principle had become a bit of a stretch that required some creative rhetorical acrobatics. In the twenty-first century, it was an utterly untenable assertion.

By reiterating in the *Honey Room* trial the court's right and duty to police sexual morality, the judges were attempting not to maintain any existing boundary that defined the minimum degree of morality but to reassert one that had been obliterated and then some. Although they claimed that the manga was unacceptable "even for today's healthy societal standards," their use of the qualifier "even" suggests that today's standards were potentially far from ideal health (*MLC*, "Honken ni tekiyō subeki shakai tsūnen ni tsuite"). As the judges admitted, such excessive depictions were not limited to the one manga *Honey Room* but were evident also in numerous contemporaneous publications. It would seem that not despite but rather because of the disjuncture between the courts as society's legal moral guardians and society itself, there was a perceived need to reassert the clinical function of

the courts. The judges in the *Honey Room* trial were not quite as bold as their counterparts in the *Chatterley* Supreme Court trial, who had admitted that the "law and the courts do not necessarily always uphold societal realities, but instead, taking a critical stance against vice and depravity, must perform a clinical role."[91] But when the *Honey Room* judges claimed that maintaining sexual morality was "an urgent issue requiring legal protection especially now" with the precipitous rise in sex crimes that coincided with the explosion of unexpurgated sexually explicit materials and the spread of the Internet, they too were taking a scalpel to society in an moment of urgent crisis surrounding public morality (*MLC,* "Keihō 175-jō no hogo hōeki").

Yet again policing the border of the permissible and impermissible was all the more essential at a moment when borders—both categorical ones of obscene/pure and geographical ones of national/global—were indeterminate. Just as in the earlier moments of perceived threats—the early postwar years, when the flood of foreign publications and personnel threatened Japanese morality (and especially female purity), as reflected in the *Chatterley* and *Black Snow* trials; the 1970s, when American capitalist decadence threatened the purity and survival of the national film industry, as seen in the Nikkatsu trial, or when irreverent publishers and filmmakers threatened the sanctity of the Japanese literary and film canons by republishing pornographic classics and by creating Japan's first hard-core film in line with the international liberation of porn, as reflected in the *Dannoura,* "Yojōhan," and *Realm* trials—in the twenty-first century borderless Internet age, again corruption and decadence lingered at Japan's doors. But this time, paradoxically, it required that the judges fling the doors open to international judicial norms in order to let out the flies gathering in its own "honey room."

The perceived need to police the borders of the Internet stems precisely from its unpoliceability. In an ironic twist, the banned manga *Honey Room* is readily available on the web with a little bit of technological savvy, as are the original letter written by the concerned father, hundreds of pages of the complete trial records covertly recorded and transcribed by a dedicated attendee, the trial verdicts, and countless bloggers' own records and responses. The proliferation of material and its ready and free access at the touch of a button, rather than buried in often out-of-print bound "complete trial records" that can be found only sequestered away in a musty library, suggest that rapidly changing technologies and newly emerging media are proving how quixotic a task censorship is today. Truly the honey runs.

Abbreviations Used in Citations and Sources

AS	*Ai no korīda saiban zenkiroku*
CS	*Saiban*
ISZ	*Itō Sei zenshū*
KWS	*Kenryoku wa waisetsu o shitto suru: Nikkatsu poruno saiban o sabaku*
MHC	*Kishi Motonori v. Japan* (Tokyo High Court, no. 458, June 16, 2005)
MLC	*Japan v. Kishi Motonori* (Tokyo District Court, no. 3618, January 13, 2004)
MS	*Misshitsu* lower court trial record
NKBD	*Nihon kindai bungaku daijiten*
NKZ	*Nagai Kafū zenshū*
NPS	*Nikkatsu poruno saiban*
WKS	*Waisetsu komikku saiban*
WKS2	*Hakkin shobun: "Waisetsu komikku" saiban kōsaihen*
YS	*Yojōhan fusuma no shitabari saiban zenkiroku*

Notes

Preface

1 Senuma 1956, 49.

2 Hamano 1976, 116.

3 Rubin 1984; K. Hirano 1992. See also Peter High's thorough examination of prewar and wartime film censorship *The Imperial Screen: Japanese Film Culture in the Fifteen Years' War, 1931–1945* (*Teikoku no ginmaku: Jūgonen sensō to Nihon eiga*), first published in Japanese in 1995 and in English in 2003, and Makino Mamoru's monumental account *A History of Japanese Film Censorship* (*Nihon eiga ken'etsu-shi*, 2003).

4 See Richard H. Mitchell's *Censorship in Imperial Japan* (Princeton: Princeton University Press, 1983), which spans Meiji through World War II, and Gregory Kasza's *State and the Mass Media in Japan* (1988).

5 Koppes 1992, 643–649.

Introduction

1 Nafisi 2003, 24–25.

2 Treat 1994.

3 LaCapra 1986, 7, 16.

4 In addition to those works and scholars noted in the preface, film censorship studies in both Japan and the West have deeply influenced my approach, particularly scholarship by film scholars Lea Jacobs (1991) and Annette Kuhn (1988) on early Hollywood and by film theoreticians Christian Metz (1986) and André Bazin (1972) on the productive nature of censorship and the ties between censor and artist, and work by Aaron Gerow (1996, 2000) and Hase Masato (1998) on the need to consider how Japanese censors regulated reception not just content or production.

5 To get a sense of the divergent perspectives offered by censorship scholars from liberal and conservative camps in Japan, see Odagiri Hideo and Fukuoka Seikichi, *Shōwa shoseki, zasshi, shinbun hakkin nenpyō* (Tokyo: Meiji bunken, 1965–1967); Matsuura Sōzō, *Senryōka no genron dan'atsu* (Tokyo: Gendai jānarizumu shuppankai, 1969); Iwasaki Akira, *Senryō sareta sukurīn* (Tokyo: Shin Nihon shuppansha, 1975); Etō Jun 1981, 1982, 1989; and Katō Norihiro, *Amerika no kage* (Tokyo: Kawade shobō shinsha, 1985).

6 The trial of *In the Realm of the Senses* has received the most attention by far. In English, see Grindon 2001, Alexander 2003, and Lawson 1992 for a translation of Ōshima's statements in court; in Japanese, see Gerow 2000. For an overview of the *Chatterley* trial, see Kockum's book (1994) on Itō Sei,

Rubin 1988 on the role of the Occupation in the trial, and Sherif 2009 on its relationship to the Cold War.

7 Ōshima 1976, 157.

Part I: East Meets West, Again

1 Lawrence 2000, 173; Itō Sei 1950, 2:49.

2 Rembar 1968. After D. H. Lawrence privately published *Chatterley* in Italy in 1928, British and U.S. customs soon began confiscating all imported copies. This ban was upheld for thirty years, during which time a few individuals were successfully prosecuted for "possession of an obscene book" in both nations. In June 1959, when Grove Press published an unexpurgated edition of *Chatterley* and attempted to distribute it through the U.S. mail, the novel was seized by the Postmaster General. In the censorship trial that ensued, the New York court ruled in favor of the publisher, a judgment that was unanimously upheld by the New York Court of Appeals in 1960. In England, Penguin Books was charged for publishing a complete edition in 1960 but was also found not guilty (Craig 1963, 146–163).

3 *CS*, 1:38.

4 *NKBD*, 4:280. On the Yoshida cabinet, see Dower 1993, 15. On Red Purges, see Dower 1999, 272–273, and K. Hirano 1992, 252–253.

5 U.S. scholars fiercely debate the impact of Occupation censorship measures on the arts (see Rubin 1988, 167–187; Mayo 1991; Rubin 1985). For a brief sketch of these positions, see Dower 1999, 618–619n6. Despite the tendency to unfavorably contrast the invisibility of Occupation-style censorship with the visible Japanese-style one, as Abel's work (2005, 155) points out, in fact Japanese censors discontinued their own form of invisible censorship—the practice of using *fuseji,* or *x*'s and *o*'s, to mark out censored portions—back in late 1936.

6 *AS*, 2:345–346.

7 *CS*, 1:49.

8 *NKBD*, 4:281.

9 Rubin 1988, 168. Most notable were the 1938 trial of Ishikawa for *Living Soldiers* (see Hamano 1976, 114–127) and the 1908 trial of Ikuta Kizan's "The City" ("Tokai," 1908) for obscenity, the latter of which has been called the Lady Chatterley trial of the Meiji period (Rubin 1984, 83).

10 On the Criminal Code and article 175, see Beer 1984, 59, 336; Rubin 1988, 170; Masaki 1983, 489. For an informative overview of obscenity regulation in Japan, see Beer 1984, 335–361.

11 Maki 1964, 6–7; for the original Japanese, see *CS*, 2:282. The 1951 case involved a humorous newspaper piece about sex and genitals entitled "The Scent of Amorous Tales" (Kōshoku banashi no kaori) (*AS*, 1:13).

12 Beer 1984, 129.

13 For the debate over the constitutionality of article 175, see the first and twenty-fourth issues of *Jurisuto* (Wagatsuma and Miyazawa 1952b, 1; 1952a, 2).

14 Dower 1999, 379–380. See pp. 346–360, 374–404 for a detailed discussion of the Occupation officials' involvement in scripting the postwar Constitution. In contrast, Kyoko Inoue (1991) argues that the Constitution is also not a purely foreign document, pointing to the practical difficulties involved in translating it back into Japanese.

15 This is not to imply that Western translations were exempt from censorship. In the 1890s, there was a brief backlash against foreign literature in favor of rediscovered Japanese classics like Saikaku (Keene 1998, 55–75), and in the early 1900s naturalist fiction by writers like Zola and Maupassant was banned, as were all enemy translations during World War II. For a timeline and list of censored works from 1868 to 1944, see Rubin 1984, 279–283. On enemy translations, see Kasza 1988, 247.

16 Tsubouchi S. 1983, 3.

17 Critic Nakamura Mitsuo used the word *sakoku* here to draw a parallel between Japan's two centuries of isolation from the outside world during the Edo period (1600–1868) and wartime Japan (Rubin 1988, 169).

18 Dower 1999, 182, 189–190. In 1946 alone, four translated works appeared on the top-ten best-seller list, including Van de Velde's *Perfect Marriage,* discussed below.

19 Masaki 1983, 488. On Masaki's background and role in these incidents, see ibid., 481–490, and Asahi Shinbunsha 1978, 1:299–307.

20 Okudaira 1962, 2, 4.

21 Abe 1997, 190.

22 On the Placard Incident, see Masaki 1983, 487. On the Kyoto Incident, see Desser 1988, 32; *AS,* 2:214.

23 Desser 1988, 32. On Cold War culture and politics in Japan, see Sherif 2009.

24 Dandō 1957, 47; Asahi Shinbunsha 1978, 1:123.

25 *CS,* 1:385.

26 Ibid., 14. *Saiban* was initially published in the journal *Chūō kōron* in late 1951 as the Tokyo District Court trial was winding down. In July of 1952, during the High Court appeal, Itō published an expanded edition through Chikuma shobō. In 1997, to celebrate the publication of Itō's complete, unexpurgated translation, Itō Sei's son, Itō Rei, published a revised edition through Shōbunsha. All references to this 1997 edition are cited as *CS* (short for *Chatterley saiban*) in the notes, and parenthetically in chapters 1 and 2.

Chapter 1: Lady Chatterley's Censor

1 One prosecution witness had read a pirated edition in China in the late 1930s, and defense witness Aono Suekichi testified that he had eagerly read

Itō's prewar translation in combination with the English-language original so as to construct an uncensored version (*CS,* 1:324, 369).

2 Itō Rei 1985, 177.
3 Itō Rei 1996, 564.
4 Dower 1999, 180–181.
5 For a list of the objectionable passages, see *CS,* 1:38.
6 Itō Sei 1950, 1:214, and Lawrence 2000, 133. See the passage cited at the opening of part 1 of the present volume, where Itō uses *penisu,* and also *koshi* (waist or pelvic region) for Lawrence's old-fashioned "loins."
7 *CS,* 1:48–50. Cf. *ISZ,* 18:42–43. For print-run counts, see Asahi Shinbunsha 1978, 1:123. By the time of the bust in June, sales had reached two hundred thousand (Oyama 1982, 277).
8 See legal scholars Hirano R. 1952, 16–17, and Baba et al. 1957, 221; Oyama 1982, 277.
9 Lawrence 2000, 146; Itō Sei 1950, 1:236.
10 A former judge attributed the success of the prosecution solely to the translation's inexpensive price (Baba et al. 1957, 217). For a discussion of Van de Velde's best-selling work, see Asahi Shinbunsha 1978, 1:12–20.
11 Oyama 1982, 269–270.
12 Dower 1999, 581n46.
13 Rembar 1968, 99.
14 *CS,* 1:110; cf. Oyama 1982, 261–262.
15 *CS,* 1:379–380. According to another Publishing Code Practice Committee member, author Miyamoto Yuriko, the decision to discontinue indictments in the name of harm to public safety stemmed from ideological, not practical, reasons because it was too reminiscent of prewar censorship (Miyamoto 1980, 419).
16 For more on literature of the flesh, see Slaymaker 2004.
17 Rubin 1988, 170.
18 Ibid., 172.
19 *AS,* 2:345–346.
20 Ladenson 2006, 140.
21 Oyama 1982, 278. Cf. Itō Rei 1985, 181–184.
22 Tsuda 1995, 52. I thank Itō Rei for sharing a copy of these privately published memoirs.
23 I thank Jonathan Abel for pointing out the potential pun.
24 On the slow-moving repatriation process, see Dower 1999, 48–53.
25 *ISZ,* 15:159–162.
26 On Kamei's film, see K. Hirano 1992, 172–175, 54–55. For more on the return of the "living war dead" and unfaithful wives in reality and in fictional

depictions, see Dower 1999, 58–62, 339–345. On Wyler's hit film, see Schilling 1998.

27 Lawrence 2000, 295.

28 Hirano R. 1952, 14.

29 McCarthy 1964, vii–x.

30 Film scholar Richard Maltby (1986) similarly argues, in his aptly titled article "'Baby Face,' or How Joe Breen Made Barbara Stanwyck Atone for Causing the Wall Street Crash," that 1930s Hollywood censors often scapegoated female protagonists/actresses.

31 Levy 2006, 93, 178–179.

32 See, for example, Mori Atsuo, who explains that he hides his copy under his desk, fearing that his children might read it (*CS,* 1:138).

33 *YS,* 2:35–46, 143; *AS,* 1:330. In the British *Chatterley* trial, the defense called a twenty-one-year-old female witness.

34 Kendrick 1987. On the vulnerable viewer, see Couvares 1996, 1–15. On the Hollywood censors' concern with growing urban immigrant populations, see Jacobs 1990.

35 Yanagida 1951, 86. The phrase "Mii-chans and Haa-chans" specifically evokes a female readership since the expression derives from popular female names, such as Miyoko or Hanako (*Taishū bunka jiten,* ed. Ishikawa Hiroyoshi [Tokyo: Kōbundō, 1991], s.v. "MiiHaa," 768).

36 Shively 1982.

37 On censorship-dodging strategies in the *Bovary* trial, see LaCapra 1986, 41–62. On Hollywood, see Jacobs 1991, 114–115.

38 Tsubouchi S. 1983, 2, 16.

39 Rubin 1988, 169. Interracial fraternization was forbidden in a March 22, 1946, GHQ order (K. Hirano 1992, 159); cf. Dower 1999, 411–412. On the censorship of puppet plays, see Shively 1982.

40 Yanagida 1951, 87–88.

41 Asahi Shinbunsha 1978, 1:89. In the fashion of the I-novel, this novel features a protagonist with a similar name (Ishinaka Ishijirō), occupation (novelist), and birthplace (Tōhoku). The police censors objected specifically to the episode entitled "Elegant Tales from Tsugaru" (Tsugaru furyūdan), which appeared in September and October of 1948. The offending story was based on folktales from Tsugaru, in Japan's northern Aomori prefecture, and depicts a virgin and the chief priest of a Buddhist temple who perform a ceremony worshipping the phallus, ostensibly in accord with regional folk beliefs (ibid., 90–92).

42 Miyamoto 1980, 418–419; Oyama 1982, 274–275.

43 Asahi Shinbunsha 1978, 1:124–125.

44 Inoue 1991, 316–317, 329.

45 Polemical attacks on the Japanese postwar Constitution as an alien charter can be traced from the calls from conservatives for constitutional revision in the 1950s and 1960s (Fukui 1968, 41–70) to Etō Jun's *The Shackles of the 1946 Constitution* (*1946-nen kenpō no kōsoku*) (Tokyo: Bungei shunjū, 1980).

46 Dower 1999, 351–360; 387–390; Hidaka 2003, 206.

47 McCullough 1990, 379.

48 *CS,* 1:240; Oyama 1982, 271–273. In a letter dated October 12, 1949, from Frieda Lawrence to her husband's biographer, she wrote that she had been promised authentic Japanese silk fabrics as a present if she allowed translation rights (Itō Rei 1985, 177).

49 The judges refused to allow the GHQ letter as evidence of U.S. rule because there was no national ban on *Chatterley* there since obscenity was determined by individual states (408).

50 Gluck 1993, 66.

51 Schilling 1998.

52 Itō Rei, interview by author, Tokyo, October 19, 2002.

53 Masaki 1983, 318.

54 Itō Rei 1985, 179–180.

55 Descriptions of Itō tend to depict him as an unpopular novelist and sedate (*jimi*) intellectual prior to the trial (Asahi Shinbunsha 1978, 1:224–226; Oyama 1982, 263).

56 Rubin 1984, 170.

57 For a bleak view of the subordination of literature to politics in wartime, see Keene 1998, 906–909. For a more measured and yet essentially similar assessment that also takes into account writers' practical considerations, see Rubin 1984, 272–278. For a brief sketch in English of *tenkō bungaku,* see Keene 1998, 846–905; in Japanese, see Tsurumi Shunsuke, *Tenkō kenkyū* (Tokyo: Chikuma shobō, 1991).

58 Dower 1999, 238. For more on writers' war responsibility debates (*bungakusha no sensō sekinin ronsō*), see Usui et al. 1972, 2:115–167.

59 Itō's wartime story is reprinted in Itō Sei 1943, 32; for his opinions on wartime censorship of translations, see also "Eigo to hon'yaku," in *ISZ,* 15:159–162.

60 Kockum 1994, 185–186. Although this diary was not published during the war, scholars believe it was intended for publication. A second wartime diary, which contains no such patriotic utterances, was discovered among Itō's posthumous papers, which some take as evidence that Itō had written the nationalistic version merely as insurance against a run-in with the wartime authorities (Itō Rei, interview by author, Tokyo, October 19, 2002).

61 Keene 1998, 675–676; Kockum 1994, 174–196.

62 Itō Sei 1957, 77.

63 Ibid., 71, 72, 77.

64 *ISZ,* 16:286–291.

65 Itō Rei 1985, 170, 181.

66 On the "people's literature debate" (*kokumin bungaku ronsō*), see Usui et al. 1972, 2:109–189 and Alan M. Tansman, *The Writings of Kōda Aya, a Japanese Literary Daughter* (New Haven: Yale University Press, 1993), 62–67.

67 See Etō 1981, 1982, 1989.

68 Masaki 1983, 278.

69 For example, postwar courtrooms were rearranged to put defense and prosecution lawyers' seats at the same level and to allow defendants to sit in front of the defense lawyers' table to facilitate communication; prosecutors no longer wear the same clothing as judges, and judges no longer wear colored collars over their robes to indicate rank; and legal terms were revised to avoid any bias for the prosecution, such as "indictment" (*kiso*) instead of "public prosecution" (*kōso*) (*CS,* 1:35, 95, 29–30).

70 Muramatsu 1968, 430.

71 Gluck 1993, 64.

72 Ibid., 80.

73 Rubin 1988, 171. See, for example, when the defense exposed prosecution witness Eirin chair Watanabe Tetsuzō's attachment to the discredited Meiji Imperial Rescript (*CS,* 1:186, 188–189). In the *Realm* trial, in an interesting reversal, the prosecutor adopted this same tactic to depict one of the defense witnesses—the liberal historian Ienaga Saburō—as reactionary for using imperial era names to refer to dates (*AS,* 1:249).

74 Gluck 1993, 80.

75 Masaki 1983, 279.

76 Cf. Lawrence 1951, 168–169.

77 Kawakami 1950, 150–151, 155. This volume, which has essays on Lawrence by well-known critics, including Kobayashi Hideo, was republished by Oyama in November 1950, just after the formal indictment.

78 Cf. the introduction to the Penguin Classics edition of *Chatterley* and Lawrence's own essays (Lawrence 2000, xiii–xxx, 303–335).

79 Tamura 1948, 18, 16; translation modified slightly from Rubin 1985, 83.

80 Kawakami 1950, 153.

81 Masaki 1983: 271, 284; see pp. 304–309 for a reproduction of these graphs and Masaki's statement in court.

82 Itō Sei 1951, 105; 1957, 80; *ISZ,* 18:44; Itō Sei 1951, 95, 96.

83 *ISZ,* 13:410. Cf. Itō's 1935 essay " 'Chatarei fujin no koibito' ni tsuite," ibid., 417–419.

84 The used copy of *Chatterley* that I bought at a Tokyo bookstore fortuitously included this questionnaire, having been overlooked by readers for over fifty years.

85 Oyama 1982, 274–276.

86 On the lie detector experiments and related testimony, see *CS*, 1:381–385, 312–315.

87 *ISZ*, 18:474–476.

88 Dower 1999, 184.

89 Information on the statistics boom is based on Heine 2002; 2003, 765–778.

90 Barshay 1988, 241; Dower 1999, 499. For a general discussion of the turn to science in the wake of defeat, see Dower 1999, 490–496.

91 Keene 1998, 683.

92 See also the fascinating Rorschach experiments conducted on authors in Kataguchi Yasufumi, *Sakka no shindan: Rōru shahha tesuto ni yoru sōsaku shinri no himitsu o saguru* (Tokyo: Shibundō, 1966).

93 Schilling 1998.

94 Dandō 1957, 51; cf. Wagatsuma and Miyazawa 1952a, 2.

95 *ISZ*, 18:44.

96 Maki 1964, 8. For the original Supreme Court verdict, see *Oyama v. Japan*, 11 Keishū 997 (Sup. Ct., G.B., March 13, 1957).

97 Huxley 1963, 6–7.

98 Ibid., 9, 6.

99 Masaki 1983, 297.

100 Baba et al. 1957, 220.

101 Dandō 1957, 55.

102 Baba et al. 1957, 218–219. See Frank Upham's *Law and Social Change in Postwar Japan* (Cambridge, MA: Harvard University Press, 1989) for a discussion of Japanese judges' tendency to make broad policy-related decisions; cf. Mark Ramseyer's analysis of the tight imbrication of the ruling Liberal Democratic Party and the courts in postwar Japan in "The Puzzling (In)Dependence of Courts: A Comparative Approach," *Journal of Legal Studies* 23 (2) (June 1994): 721–747.

Chapter 2: The Legacy of *Chatterley*

1 Yamaguchi Takashi, interview by author, Tokyo, May 29, 2008.

2 *AS*, 2:382.

3 The experiments the *Realm* defense lawyers cited were not specific to the book or film *Realm* but instead ones conducted in the United States and published in the journal *American Psychiatry Medicine* that measured the effects of textual and visual pornography on subjects' state of arousal (see the testimony of psychologist Kobayashi Tsukasa, ibid., 125–162).

4 L. Williams 1989, 1–33.

5 *YS,* 2:311; cf. the testimony of authors Inoue Hisashi and Kaikō Takeshi (*CS,* 1:213, 255).

6 Chong 2001, 23–26.

7 Lawrence 1951, 169. It is unclear who actually wrote this letter from "Lawrence," although scholars speculate that it was a supporter of Itō's, if not Itō himself. Oketani Hideaki attributes authorship to Itō based on stylistic similarities (in discussion with the author, February 16, 2002). Itō Sei's son, Itō Rei, speculates that it was either Tanaka Seijirō, a friend of Itō's who later translated Graham Greene, or Senuma Shigehiko, a close friend and literary critic, or Nishimura Kōji, the translator of Lawrence's *The Plumed Serpent* (Itō Rei, pers. comm., July 17, 2003). I am skeptical that Itō wrote this letter because its self-aggrandizing tone clashes with the self-deprecating tone in his other writings.

8 See Douglas 1966 on the fundamental human impulse to conduct rituals of purity and pollution to create orderly taxonomies.

9 Rubin 1984, 83–93.

10 Again the manga trial was the exception, with the defense adopting a more cautious approach, likely because of the perceived illegitimacy of manga in general and erotic manga in particular.

11 *YS,* 2:314.

12 Keene 1993, 246; Ueda 1967, 199. Cf. Ueda 1967, 1–24 and Matsumoto 1970, 35–53.

13 Itoh and Beer 1978, 212.

14 For example, see Ōshima's closing arguments in the *Realm* trial (*AS,* 2:298–300) and the testimony of defendant Satō Yoshinao and defense witness Kanai Mieko in the "Yojōhan" trial (*YS,* 1:53; 2:33).

15 *YS,* 2:244.

16 *AS,* 2:373; cf. *YS,* 2:250.

17 *MS,* Okudaira's testimony in the *Honey Room* lower court trial, eleventh session; cf. Miyadai's testimony in the fourth session.

18 For a detailed discussion of Nihonjinron, see Dale 1986.

19 *CS,* 1:177. Cf. *YS,* 1:153.

20 *YS,* 1:213–214.

21 Hirano R. 1952, 18.

22 Both the publisher and translator of Sade were found guilty at all three stages, by the Tokyo District Court on October 16, 1962 (see the verdict reprinted in Ishii and Shibusawa 1963, 2:360–375), by the Tokyo High Court on November 21, 1963, and finally by the Supreme Court on October 15, 1969 (for the Supreme Court verdict, see *Ishii et al v. Japan,* 23 Keishū 1239; for a translation, see Itoh and Beer 1978, 183–217).

23 Masaki 1983, 319.

24 Asahi Shinbunsha 1978, 1:124.

Part II: Pinks, Pornos, and Politics

1 This may explain the tendency of commentators to describe these films with verbatim cursory plot summaries. Compare, for example, the summaries of *Black Snow* by Ian Buruma (*Behind the Mask: On Sexual Demons, Sacred Mothers, Transvestites, Gangsters, and Other Japanese Cultural Heroes* [New York: New American Library, 1985], 57) and Robert Firsching ("Black Snow [1965]: Review Summary," *New York Times,* http://movies.nytimes.com/movie/249642/Black Snow-Yuki/overview). *Love Hunter* was released on DVD in December 2007, *The Warmth of Love* in December 2005, and *Black Snow* in December 2007.

2 Kuwahara 1993, 123. For a similarly flippant homage to censorship's unanticipated positive effects, see Flaubert's preface to *Madame Bovary,* which he dedicates to the defense lawyer whose "magnificent defense" lent the work "an unexpected authority" (LaCapra 1986, 53).

3 For a compelling argument about how prosecuted literary works came to enter the Western literary canon, see Ladenson 2006.

4 Information here and below on the formation of Eirin is derived from *Eirin: 50-nen no ayumi* (Tokyo: Eirin, 2006), 38–44, Eirin's privately published fiftieth-year commemorative anniversary history. I thank Eirin's former president, Ide Magoroku, and current secretary-general, Kodama Kiyotoshi, for sharing a copy with me. For information on Eirin's current organization, members, policies, etc., see Eirin's website at http://www.eirin.jp/. For the history of Eiren, see Eiren's website at http://www.eiren.org/aboutus/history.html.

5 Eirin 2006, 185–186. Cf. the strikingly similar Hays Code's mission statement (Maltby 1993, 48).

6 Eirin 2006, 39–40.

7 Ibid.; Beer 1984, 340 (italics mine).

8 Endō 1976, 330; cf. 333.

9 On censors' prewar corruption, see K. Hirano 1992, 101. On postwar accusations of corruption, see Sakata 1977, 215. According to one source, around 1971 their monthly salary was only eighty thousand yen (Kuwahara 1993, 209; cf. Kobayashi 1956, 160–164).

10 In Japanese, these organization names are Seishōnen Bunkazai Taisaku, Seishōnen ni Yūgai Naru Eiga Shuppanbutsu tō Taisaku Senmon Iinkai, and Seishōnen ni Taisuru Eiga no Eikyō Tokubetsu Iinkai. On Hatano's study, see Nozue 1967, 42.

11 Alternatively, they were called Seishōnen Hogo Aigo Jōrei (Kobayashi 1956, 77–79; Endō 1976, 331). For a list of prefectures with these ordinances and the applicable penalties, see MEXT 2006.

12 Information on this scandal and its repercussions is derived from Kuwahara 1993, 42–45; Endō 1976, 331; and Eirin 2006, 52–53.

13 For a list of what constituted an "adult film" and a "recommended" youth film, see Eirin's May 1955 directive for "Films Geared to Adults," reprinted in Kobayashi 1956, 172–174. In 1958, the rating name was changed to the more definitive "adult films" (*seijin eiga*). In 1976, the new rating "R" was introduced disallowing spectators under age sixteen without a parent, and in 1998 the current system of four rating categories (G, PG-12, R-15, and R-18) was established.

14 Ishihara 1981, 334, 348. On the Akutagawa Prize debates, see Usui et al. 1972, 2:291–327, and Asahi Shinbunsha 1978, 1:326–334.

15 Kuwahara 1993, 46; Kobayashi 1956, 124; Asahi Shinbunsha 1978, 1:329. Zenkoku Chiiki Fujin Dantai Renraku Kyōgikai (Chifuren) was established on July 9, 1952. On Ishihara, see Raine 2001, Shamoon 2002, and Sherif 2005. On the Sun Tribe film scandal and its aftermath, see Kuwahara 1993, 45–56, and Eirin 2006, 56–69.

16 Asahi Shinbunsha 1978, 1:332. The Antiprostitution Law was enacted on May 24, 1956, and put into effect in April 1957.

17 Eirin 2006, 58; Anderson and Richie 1982, 265; Eirin 2006, 59.

18 Asahi Shinbunsha 1978, 1:330–331. On the Tachikawa base protests, see Desser 1988, 32–33.

19 Information on Eirin's reorganization is taken from Eirin 2006, 61–63; Kuwahara 1993, 45–58.

20 Violators were subject to fairly hefty fine systems set by local prefectures, for example a fifty-thousand-yen fine in Tokyo (Ōtsuka 1967, 67).

Chapter 3: Dirt for Politics' Sake

1 Aoki 1969, 90.

2 Eirin 2006, 114; Hanrei Taimuzu 1967, 194.

3 Ōbayashi 1981, 120. For the debate over the legality of indicting on the basis of such reconstructed evidence, see Hanrei Taimuzu 1967, 192, 195–197; Ōtsuka 1967, 70.

4 Eirin 2006, 71. Endō even appeared as a defense witness in the *Realm* trial.

5 Satō S. 1965, 34, 37. Kuwahara 1993, 115. For the Directors Guild (Nihon Eiga Kantoku Kyōkai) mission statement, see http://www.dgj.or.jp/english/.

6 On Takechi Kabuki, see Lee 2003, 12–24; for a brief overview of Takechi's life and film career, see Sharp 2001.

7 The only prior exception, noted by the lower court judges in the *Black Snow* verdict, was the conviction of "a rogue company that publicly exhibited a film composed of clips of film scenes that had been passed by Eirin along with those that had not, as if it were an Eirin-approved film" (Hanrei Taimuzu 1967, 194).

8 For the operative August 1959 Eirin regulations, see Eirin 2006, 187–188. For Takechi's comments to the media, see Kuwahara 1993, 104 and Endō 1973, 272.

9 On Takechi's clashes with Eirin over *Day Dream,* see Kuwahara 1993, 105; Endō 1973, 280–281; Eirin 2006, 110–113.

10 Nozue 1967, 43.

11 Eirin 2006, 113.

12 Robert Firsching, "Black Snow (1965): Review Summary," *New York Times,* http://movies.nytimes.com/movie/249642/Black Snow-Yuki/overview.

13 Takechi 1967, 268. For Takechi's theater writings, see his *Tradition and Extinction (Dentō to danzetsu)* (Tokyo: Fūtōsha, 1969).

14 Endō 1973, 343.

15 For the prosecutor's charges, see ibid.; Aoki 1969, 90.

16 Eirin 2006, 191.

17 For the Mothers' Society comments, see Kuwahara 1993, 114–115. On the Tokyo Mothers' Society's tight-knit relationship with the police, see *NPS,* 30 and Takechi 1967, 213–214.

18 Hanrei Taimuzu 1967, 193; Aoki 1969, 90.

19 Uematsu 1966, 22; cf. Uematsu 1969 and 1970.

20 Eirin 2006, 115–116, 229; *NPS,* 170–171.

21 Endō 1973, 331.

22 Eirin 2006, 113; Endō 1973, 295–296.

23 Takechi 1967, 265.

24 Former Eirin employee Endō remarks that the length of the script for *Red Chamber* was only one-third that of typical screenplays, with only forty-three scenes (Endō 1973, 285; cf. 272). *Black Snow* contained a scant thirty-nine scenes.

25 Satō S. 1973, 37.

26 Endō 1973, 323–324; Takechi 1967, 224–225; Kuwahara 1993, 112.

27 Takechi 1967, 270.

28 Ibid.

29 Satō Shigechika (1965) similarly writes, "The boy's peeking at the Japanese prostitutes and American GIs having sex is not a substitute for the sex act but something that emasculates him so that his sexual energy has no outlet" and leads to his later acts of violence (35).

30 On the relationship between hate speech and state censorship in the West, see Butler 1997.

31 Hanrei Taimuzu 1967, 201.

32 The novel *Black Rain* was serialized in *Shinchō* between January 1965 and September 1966.

33 For an account of the censorship of the A-bomb, see Braw 1991. On Occupation censorship of the A-bomb in films, see K. Hirano 1992, 59–66.

34 As Richard Burt points out in his fascinating article on the very public Nazi exhibitions of avant-garde "degenerate art" in the late 1930s, Hitler was interested in a quite visible form of censorship as a display of power, unlike the Occupation officials (Burt 1994, 216–259).

35 Satō S. 1965, 34.

36 K. Hirano 1992, 56–57. Criticism of the Occupation was, of course, forbidden, but as Edward Fowler writes in his essay "Piss and Run: Or How Ozu Does a Number on SCAP," some directors employed clever ruses, such as the image of an American flag–patterned futon that a defiant boy pees on nightly in Ozu's 1947 film *Record of a Tenement Gentleman,* to get around this directive (in Washburn and Cavanaugh 2001, 273–292).

37 The strategy of using sound to obscure objectionable sounds was famously adopted to achieve a paradoxically stimulating effect in the 1956 Sun Tribe film *Crazed Fruit.* At the final stage of inspections, Eirin called for the deletion of the ripping of a girl's skirt in a scene of the quasi date rapes that are de rigueur in this genre, insisting that the on-screen visual depiction of the skirt ripping be deleted but allowing the accompanying sound effect to remain (Kuwahara 1993, 50).

38 Takechi 1967, 259; cf. 263; Endō 1973, 304–305.

39 Takechi 1967, 261, 259–260.

40 Hase 1998; deCordova 1990, 102.

41 Takechi 1967, 266.

42 Ibid.

43 Endō 1973, 305.

44 Maki 1964, 11–12, 6.

45 Cited by the defense in the lower court *Black Snow* trial (Takechi 1967, 236–237).

46 Itoh and Beer 1978, 185–186.

47 Hanrei Taimuzu 1967, 202.

48 Ibid.

49 Hanrei Jihō 1969, 22. In contrast with this assessment, the scientific study cited in the *Realm* trial found that a lengthy scene of a person running could have the same, if not greater, agitating an effect on spectators as outright pornography (*AS,* 2:125–162).

50 Hanrei Taimuzu 1967, 202.

51 Rembar 1968, 25.

52 Itoh and Beer 1978, 217, 186.

53 Mishima, cited in Saitō M. 1975, 73.

54 Hanrei Taimuzu 1967, 202; Aoki 1969, 92.

55 Hanrei Jihō 1969, 23.

56 Hanrei Taimuzu 1967, 199.

57 Hanrei Jihō 1969, 20–21.

58 The first VCRs for home use were designed and built in the mid-1960s, contemporaneous with the *Black Snow* trial, but were not widely available until the late 1970s. It was not until 1987 that one in two families owned a VCR in Japan (Kuwahara 1993, 254).

59 Takechi 1967, 237.

60 Mishima 1973, 160–161; Kuwahara 1993, 125.

61 Of the thirteen shots that make up this scene, three last for forty or more seconds each: a forty-second long shot tracking Shizue's run around the base fence, a fifty-four-second stationary shot of the barbed wire chain-link fence, and a forty-six-second tracking close-up shot of her running.

62 Takechi 1967, 189–190, 199–200, 178; cf. 200.

63 Ibid., 198–199. Ogawa was strategically rewriting film history when he characterized montage as a purely Western innovation, ignoring the fact that its pioneer was the Russian director and film theorist Eisenstein, who in turn had identified the "basic nerve" of ancient Japanese culture, especially its use of Chinese characters, with embodying the "pure cinematographic element . . . montage" (Eisenstein 1949, 44).

64 Takechi 1967, 195, 189.

65 Hanrei Taimuzu 1967, 202.

66 Ibid., 199. Although TV broadcasting began in Japan in 1953, at first TVs were too expensive for most individual families, at one hundred forty thousand yen for a fourteen-inch black and white, while the average salaryman's monthly paycheck was only about ten thousand yen. TV ownership jumped considerably in 1959 for the occasion of the televised wedding ceremony of Crown Prince Akihito and his commoner bride Michiko, which attracted fifteen million viewers, and it eventually reached 90 percent of the population by the time of the 1964 Olympics (Schilling 1998).

67 Ōtsuka 1967, 67. Cf. Maeda S. 1967, 126.

68 For supporters of the film as a unique "time art," see Takechi 1967: 284–285. For its detractors, see Maeda S. 1967, 127; Hanrei Taimuzu 1967, 192.

69 Hanrei Jihō 1969, 21; cf. 19–22 passim.

70 Ibid., 22.

71 Aoki 1969, 92.

72 Hanrei Jihō 1969, 22.

73 Maeda S. 1967, 128.

74 Aoki 1969, 90.

75 Hanrei Jihō 1969, 20, 24.

76 Hanrei Taimuzu 1967, 201. For a strident critique of the court's tendency to kowtow to Eirin, see Uematsu 1969, 15.

77 Hanrei Jihō 1969, 24–25, 26.

78 Eirin 2006, 118–119.

79 Fujiki 1972, 60.

Chapter 4: Dirt for Money's Sake

1 Sharp 2008, 123. I use "Nikkatsu Roman Porn" rather than following Sharp's "Nikkatsu Roman Porno" in an attempt to naturalize the English and to match Nikkatsu studio's own terminology on its website (http://www.nikkatsu.com/en/library.html).

2 Indictment reprinted in full in *NPS*, 13–19. Citations of *Nikkatsu poruno saiban*, film critic Saitō Masaharu's account of the trial, are hereafter given parenthetically in the text throughout this chapter.

3 See the trailer for *Love Hunter* included in the DVD's "Special Features" (Yamaguchi S. 1972).

4 Rembar 1968, 180.

5 de Grazia 1992, 417–443.

6 Satō T. 1976, 324; Eiren 2010; Schilling 1998. By 1964, audiences were at only 431 million, less than 40 percent of the all-time high in 1958, and the nationwide number of theaters was down to 4,927 from a peak of 7,457 in 1960.

7 Eiren 2010.

8 Satō T. 1976, 327.

9 Domenig 2002; Eirin 2006, 191; Kuwahara 1993, 127.

10 Kuwahara 1993, 166–169; Eirin 2006, 124–125. This avant-garde film was the perfect candidate for anticensorship advocates, such as Grove Press (the defendant in the U.S. *Chatterley* trials), which distributed the film and published both the screenplay and a memoir by the film's director in the United States in 1968.

11 Eirin 2006, 191, 194. In 1965, imported adult films represented just 12 out of a total 245 adult films, in 1970, 33 out of 254, and in 1971, 71 out of 296.

12 Kuwahara 1993, 68–71. On Eirin's difficulty regulating imported films, see Sakata 1977, 148–150; Endō 1976, 330–331; Kuwahara 1993, 40–41.

13 Eirin 2006, 87–90.

14 Kuwahara 1993, 139–142, 145.

15 Domenig 2002; Sharp 2008, 124–125.
16 "Nihon eiga" 2005; Kuwahara 1993, 173.
17 On Nikkatsu's financial crisis, see Matsushima 2000, 30 and Tsubouchi Y. 2000, 289. The Purima company, Nikkatsu's codefendant, went bankrupt in July 1974 during the Nikkatsu trial because of legal expenses and the decline in Pinks.
18 Sharp 2008, 123; Yamane 1983, 20. According to some commentators, "roman" refers instead or also to "romantic," an attempt to entice both male and female audiences (Weisser and Weisser 1998, 15; Richie 2001, 210).
19 Matsushima 2000, 32–33.
20 Ibid., 44–45. Although the first all-color Pink was released in 1967, it was not until 1973 that most were shot in color. For more on the distinctions between Pinks and Roman Porn, see Sharp 2008, 128–129.
21 Yamane 1983, 18.
22 On Nikkatsu's financial woes, see Tsubouchi Y. 2000, 289; on Nikkatsu Roman Porn's financial success, see Satō S. 1973.
23 Tsubouchi Y. 2000, 288.
24 Uematsu 1970, 83.
25 Endō 1973, 369; Kuwahara 1993, 180.
26 Tsubouchi Y. 2000, 288.
27 In the Nikkatsu Porn Video Incident, the defendant, Nikkatsu's video operations chief Suzuki Heisaburō, was found not guilty in the Tokyo lower court verdict of November 1975. Three of the four indicted films were judged not obscene based on the court's recognition that there were equally explicit materials on the market among magazines, feature films, and videotapes. The fourth film was judged obscene, but the defendant was exculpated for selling it because he believed with "sufficient reason" that it was not obscene. The High Court reversed the ruling in 1978 and fined the defendant two hundred thousand yen, refuting the lower court's use of the existence of other equally explicit materials as legitimate evidence of community standards. The appeals court also criticized the lower court ruling for exculpating the defendant based on assertions of good faith, asserting that mere awareness of the tapes' content, which contain "bold, plain, and persistent depictions of sexual scenes," is enough to determine criminal intent. The verdict was upheld by the Supreme Court in 1979 (*AS,* 1:30–32; Kuwahara 1993, 182, 229–230).
28 Yamane 1983, 32n.
29 Ibid.
30 See the *Sunday Mainichi* (February 20, 1972), *Shūkan yomiuri* (February 19, 1972), and *Shūkan bunshun* (February 21, 1972), cited in Tsubouchi Y. 2000, 288–289.

31 *NPS,* 188–193. Policeman Hosojima would also suspiciously just "happen
to" purchase Ōshima's book *In the Realm of the Senses* while off duty one day
and precipitate charges.
32 *Sunday Mainichi* (January 23, 1972), cited in Tsubouchi Y. 2000, 288 (italics
in original).
33 Endō 1973, 380.
34 Anderson and Richie 1982, 241–245.
35 "Dankon wa kābinjū ni narieruka" (Can a penis become a carbine), Saitō M.
1972, 93. On Nikkatsu New Action, see Schilling 2007.
36 *KWS,* 14. Saitō's sequel account of the Nikkatsu trial, *Kenryoku wa waisetsu
o shitto suru,* is hereafter cited parenthetically in the text throughout
this chapter.
37 For an English-language translation of Japanese copyright law, see Copyright
Research and Infomation Center, http://www.cric.or.jp/cric_e/clj/clj.html.
38 I thank Alex Zahlten for pointing out this connection.
39 Hanrei Jihō 1978, 42.
40 One of the more amusing title changes was for *Love Hunter,* which had
originally been called *First Frost Wet the Forest* (*Hatsushimo ga mori o
nurashita*) (Yamane 1983, 32).
41 In his testimony, Purima executive Watanabe made a similar claim in an
attempt to exculpate himself, crediting the "author" (*sakka*) Umezawa with a
"creator's philosophy" (*sakka no shisō*) (*KWS,* 105).
42 Cf. *NPS,* 151. The prosecutor put it even more bluntly in his initial
questioning of Nikkatsu staff and actors when he asked them, "Aren't the
films made at Nikkatsu all nothing more than pussy films [*omanko eiga*]?"
(ibid., 58). Yamaguchi would shockingly cite this verbatim in his opening
statement in court.
43 Eiga Geijutsu 1973, 96.
44 Yamane 1983, 89.
45 Kuwahara 1993, 150–151.
46 On prewar film regulations, see Endō 1976, 329. On the JCP leader
Miyamoto Kenji's "necessary critique of cultural decadence," see *NPS,* 3–8,
32, 269–274.
47 Endō 1973, 385.
48 *KWS,* 53. Cf. the testimony of film critic Ogi Masahiro (ibid., 90) as well
as a contemporaneous article by film critic Iwasaki Akira titled "The Debate
against Roman Porn" and the testimony of Nikkatsu filming chief Yoshikawa
Akira (*NPS,* 62–63, 124–125).
49 *KWS,* 45. Cf. criminal law scholar Miyazawa Kōichi's testimony on West
Germany's successful 1973 experiment in liberating porn (ibid., 82–86).

50 Kurosawa himself explicitly linked the underappreciated *Rashōmon* to ukiyoe, lamenting, "Why is it that Japanese people have no confidence in the worth of Japan? Why do they elevate everything foreign and denigrate everything Japanese? Even the woodblock prints of Utamaro, Hokusai, and Sharaku were not appreciated by Japanese until they were first discovered by the West" (Kurosawa Akira, *Rashōmon,* ed. Donald Richie [New Brunswick, NJ: Rutgers University Press, 1994], 121).

51 Endō 1973, 375–376.

52 Satō T. 1976, 324.

53 *NPS,* 92, 77–78; Satō S. 1973, 41–42.

54 Jonathan Crow, "Tatsumi Kumashiro," *New York Times,* http://movies .nytimes.com/person/98267/Tatsumi-Kumashiro/biography.

55 Kuwahara 1993, 128–129. On Wakamatsu, see Sharp 2008, 79–122.

56 Kuwahara 1993, 126.

57 Endō 1973, 327.

58 Ibid., 387, 381; cf. Miura's defense testimony cited in *NPS,* 153.

59 Endō 1973, 388.

60 On Eirin's tendency to revise its regulations, see ibid., 389, and cf. *NPS,* 177. For a reprint of the May 1972 revised regulations, see Eirin 2006, 134. An example of the "chilling effect" occurred in 1973 when Eirin chief Takahashi pulled two films from the theaters (a bad girl [*sukeban*] film by defendant Kondō and a Nikkatsu Roman Porn by Kumashiro Tatsumi) after the police objected to their sexually graphic and violent content (Kaku Renbō 1973, 113–114).

61 Endō 1973, 383.

62 Kobayashi 1956, 27, 97, 127; Sakata 1977, 59–60, 248. Cf. the 1996 interview with an Eirin representative in Weisser and Weisser 1998, 33–34.

63 Endō 1973, 381.

64 See, for example, Hanrei Jihō 1978, 39.

65 Kōtō Saibansho Keishū 1980, 517–518. Cf. Hanrei Jihō 1978, 48–49.

66 Hanrei Jihō 1969, 26.

67 Hanrei Jihō 1978, 48.

68 Kōtō Saibansho Keishū 1980, 517, 518–519.

69 Hanrei Jihō 1978, 44.

70 Hanrei Jihō 1978, 43 (italics mine); Kōtō Saibansho Keishū 1980, 519.

71 Hanrei Jihō 1978, 49.

72 Ibid., 42.

73 Kōtō Saibansho Keishū 1980, 516.

74 Hanrei Jihō 1978, 47; Kōtō Saibansho Keishū 1980, 516.

75 *KWS,* 136. Nikkatsu producer Miura, on the other hand, wisely claimed in his testimony that it was "entirely acted" (*NPS,* 152). Despite all the

prosecutor's rhetorical charges of realism, when asked by the defense in the first trial session if he was claiming that the actual sex act was filmed, the prosecutor denied this, undoubtedly because of the difficulty he might have proving it (Eiga Geijutsu 1973, 97–98).

76 Maki 1964, 19–20.

77 Hanrei Jihō 1978, 48.

78 Kōtō Saibansho Keishū 1980, 524. The focus on vision here and throughout the verdict is striking (Cf. Hanrei Jihō 1978, 49–53).

79 Hanrei Jihō 1978, 49.

80 Kōtō Saibansho Keishū 1980, 522.

81 Kuwahara 1993, 254.

82 This is not to characterize 1988 as the "end of porn" or of Nikkatsu Porn, especially considering the "Roman Porn Returns" line that debuted in February 2010 (http://www.roman-returns.com/roman.html). For descriptions of Nikkatsu's many spin-off brands and subsidiaries created in the 1970s and 1980s, see Weisser and Weisser 1998, 30; Sharp 2008, 129; Kuwahara 1993, 254–255; and Domenig 2002.

83 *NPS,* 180. For a discussion of other factors that led to the end of Nikkatsu Roman Porn, see Sharp 2008, 129–130; Matsushima 2000, 329–330; and Domenig 2002.

84 Statistics taken from Endō 1976, 332; Domenig 2002; and Eiren 2010. In 1975, foreign films occupied 55.6 percent of the market, fluctuating above and below the 50 percent mark until 1986, when they steadily retained the lead until 2005.

85 Kuwahara 1993, 242.

Part III: The Canon under Fire

1 The works indicted alongside *Dannoura* were translations of two Western pieces—*Gamiani,* the nineteenth-century classic French erotic novel written by Alfred de Musset (which had been translated into Japanese by a prosecution witness for the *Chatterley* trial), and the British novel *True Love* (*Torū rabu*) by John Smith—as well as two Edo-period works, *Ukiyoe Cards Color Edition* (*Genshoku-ban ukiyoe kādo*), ukiyoe picture cards depicting various sexual positions on the front side and their names and explanations on the reverse, and *Zoku Dannoura* (ca. 1725), a quasi sequel to *Dannoura* that depicts the imagined sex lives of well-known historical figures, such as Empress Kōken (718–770) and the poet Fujiwara Teika (1162–1241).

2 *NPS,* 291.

3 For a characterization of these literary styles, see Twine 1991, 18–19, 61–68, 59–61.

Chapter 5: Pornographic Adaptations of the Classics

1 *YS*, 1:143–144 (*Yojōhan fusuma no shitabari saiban zenkiroku* is hereafter cited as *YS* in notes and parenthetically in chapters 5 and 6).

2 What makes this even more speculative is the fact that I was unable to access the volume published by Matsukawa and have instead relied on information about the work provided in the verdict (reprinted in its entirety in *YS*, 1:143–148) and, for comparison, on a later 1963 version (Inada 1963). According to Yoshiko Samuels, the charges against *The Safflower* were initiated by the Occupation officials (Rubin 1984, 179n12).

3 *YS*, 1:147.

4 Information on senryu is taken from Keene 1976, 525–532, and Miner, Odagiri, and Morrell 1985, 81–85.

5 For references to the classics in *The Safflower*, see Inada 1963, 37, lower paragraph, line 3 (subsequent citations of this volume are abbreviated as page number, upper or lower, to refer to the top or bottom paragraphs, followed by the line number). Cf. ibid., 38, lower, 13; 60, lower, 9.

6 Keene 1976, 531.

7 On bans of *The Safflower*, see Jō 1999, 54–55; on Umehara, see Abel 2007, 341–367.

8 Kōmyōji 1968, 29–31.

9 On Rai's twenty-two-volume *Nihon gaishi* (*Private History of Japan*, 1829), see Kurozumi Makoto's article "*Kangaku:* Writing and Institutional Authority," in Shirane and Suzuki 2000, 215.

10 McCullough 1988, 425, 469. Although *Heike* refers to her death as occurring in 1191, just six years after the battle at Dannoura, *Dannoura* depicts her as living for a full thirty years more, until the year 1213, when she "dies alone and lonely at the age of fifty-eight" (Kōmyōji 1968, 8).

11 Kōmyōji 1968, 137–140.

12 A fascinating issue that I omit here for lack of space is the ways the work may have been charged because of its libelous (and in this case potentially treasonous) obscenity involving the imperial family.

13 In the District Court trial (1970–1974) verdict of March 16, 1974, only the translations *Gamiani* and *True Love* were found obscene, and the publisher was fined two hundred thousand yen. On appeal, the not-guilty verdicts for *Dannoura* and its sequel were reversed by the High Court on February 6, 1975. The publisher was fined an additional fifty thousand yen, a decision that was subsequently upheld by the Supreme Court on March 23, 1976.

14 Kōmyōji 1968, 4. The republished "original" text was actually an Edo-period version that had been translated from its original Sino-Japanese *kanbun* into a mixed Japanese-Chinese (*wakan konkō*) literary style.

15 *AS,* 1:24–25. On pp. 23–26, Uchida offers an overview of the *Dannoura* trial and reprints portions from the verdicts.

16 On the key role paratexts played in the U.S. *Ulysses* trial, see Brook Thomas' fascinating article "*Ulysses* on Trial: Some Supplementary Reading," in Burt 1994, 125–148.

17 Jō 1989, 286–288; Itō Sei 1951.

18 *CS,* 2:332.

19 Maki 1964, 12–13.

20 Ishii and Shibusawa 1963, 2:168–170, 174.

21 Ibid., 30–36, 118–119; Itoh and Beer 1978: 216–217.

22 *AS,* 1:24.

23 Ibid.

Chapter 6: Kafū

1 Nagai 1995, 182.

2 On Kafū's "immaculate" style and "maculate" content, see Seidensticker 1965, 76. On his earliest skirmishes with the censors, see Rubin 1984, 117–125.

3 Oketani 2002, 2. Most notably, a salacious version of Kafū's 1916–1917 novel *Rivalry* (*Udekurabe*), a tale of rivalry among Shimbashi geisha, was republished in 1946 and soon became a top-ten best seller (Dower 1999, 190; for an analysis and translated excerpt, see Seidensticker 1965, 85–90, 244–252). For interpretations of Kafū as cultural critic, see Hutchinson 2001; Snyder 2000; and Oketani 1976, 197–281; for Kafū as dilettante, see Seidensticker 1965 and Keene 1998, 386–440.

4 Kumashiro 1973.

5 Letter from Kafū to the editor of *Bunmei,* June 17, 1916, cited in Tsuge 1997, 89.

6 For a brief sketch of the antipornography feminists, see L. Williams 1989, 16–23. The defense occasionally articulated this concern as well; see Maruya's closing testimony from "average housewife" Mizusawa Kazuko (*YS,* 2:254, 148, 150–151).

7 *NKZ,* 12:183–187.

8 *NPS,* 278.

9 Beer and Itoh 1996, 470. The defendants were found guilty at all three stages, by the lower court on April 27, 1976 (*Satō et al. v. Japan,* verdict reprinted in full in *YS,* 2:316–341), by the High Court on March 20, 1979 (32 Kōtō Saibansho Keishū 71), and finally by the Supreme Court on November 28, 1980 (34 Keishū 433; for a partial translation of the Supreme Court verdict, see Beer and Itoh 1996, 468–471).

10 Natsukawa 1983, 327. Hachisukaze suggests Kafū's name because the Chinese character for "fū" is read "kaze" in its Japanese pronunciation.

11 Ibid., 322. Kafū adopted the pen name Koikawa Kanemachi in homage to *gesaku* writer Koikawa Harumachi (1774–1789) and to his hometown in downtown Edo, Koishikawa Kanatomi-machi. His pen name Kinpu Sanjin is derived from the Chinese readings of the characters for "Kanatomi" town.

12 For Kafū's admissions that he wrote the story and his fears that he would be arrested, see Kafū's diary entries and letters cited in Nagai 2000, 322, and in Tsuge 1997, 80, 81, 83, 89.

13 Natsukawa 1983, 328.

14 Ibid., 322.

15 *NKZ*, 17: 83–154.

16 Natsukawa 1983, 328.

17 *NKZ*, 12:186.

18 May 24, 1959, special issue of *Shūkan myōjō*, cited in Tsuge 1997, 81–82. As with Kafū's own playful denials, the protagonist of his 1937 "Strange Tales from the East" (Bokutō kidan) employs similarly clever linguistic play when apprehended by the police (Seidensticker 1965, 281–284).

19 Satō Y. 1973, 91.

20 *YS*, 2:209. For a full reprint of the 1950 *Safflower* and "Yojōhan" trial verdicts, see *YS*, 1:143–148.

21 Nagai 1995, 177.

22 Rubin 1984, 190–193.

23 Omoshiro Hanbun 1979, 287.

24 Miyatake 1929, 1; cf. Yoshiyuki 1972, 98, 79.

25 Seidensticker 1965, 82.

26 Satō Y. 1973, 21.

27 Saitō A. 1997, 63.

28 For a detailed analysis of the found-manuscript device in Kafū's works, see Snyder 2000, 131–153.

29 Nagai 1995, 177.

30 Ibid.

31 "Edo period" entry in a 1932 almanac, cited in Gluck 1998, 282.

32 Seidensticker 1965, 168–169.

33 Nagai 1995, 177. Alternatively, this line could be interpreted as, "There are no torn-off places in the beginning" (*hajime no hō wa chigirete nashi*), but the use of the contrastative "wa" particle still suggests that subsequent portions may be illegible (Natsukawa 1983, 334).

34 Nagai 1995, 178.

35 Laqueur 2003, 304. For a fascinating discussion of the perceived somatic nature of reading in the context of early-modern England, see "The Physiology of Reading: Print and the Passions," in Adrian Johns' *The*

Nature of the Book: Print and Knowledge in the Making, 380–443 (Chicago: University of Chicago Press, 1998).

36 Kornicki 1998, 99, 104.

37 Satō Y. 1973, 94.

38 On postwar debates about the classics and classical language, see Odagiri, Inagaki, and Nakamura 1963, 178–192, and Haruo Shirane, "Curriculum and Competing Canons," in Shirane and Suzuki 2000, 220–249.

39 Maeda A. 1989, 396–399.

Part IV Trying Text and Image

1 Jameson 1992, 1 (italics in original).

2 Cavell 1979, 45.

3 LaCapra 1986, 7, 16.

4 Other film adaptations of the Abe Sada incident include *A History of Bizarre Women in the Meiji, Taisho, and Showa Periods* (*Meiji, Taishō, Shōwa ryōki onna hanzai-shi,* 1969; directed by Ishii Teruo, Tōei), *The True Story of Abe Sada* (*Jitsuroku Abe Sada,* 1975; directed by Tanaka Noboru, Nikkatsu), and the musical *Sada* (1998; directed by Ōbayashi Nobuhiko, Shōchiku). For critical studies, see William Johnston, *Geisha, Harlot, Strangler, Star: A Woman, Sex, and Morality in Modern Japan* (New York: Columbia University Press, 2005), and Christine L. Marran, *Poison Woman: Figuring Female Transgression in Modern Japanese Culture* (Minneapolis: University of Minnesota Press, 2007).

5 *AS,* 1:73, 436 (*Ai no korīda saiban zenkiroku* is hereafter cited as *AS* parenthetically throughout chapter 7).

Chapter 7: A Picture's Worth a Thousand Words

1 Ōshima 1976, 49–51.

2 For a list of the obscene passages, see *AS,* 1:35.

3 Gerow 2000, 193.

4 *KWS,* 78–79.

5 *AS,* 1:59. The book was published on June 15 (with a second print run just five days later), charged with obscenity on July 28, and officially indicted on August 15. After much delay, the film finally passed customs on September 24, and a heavily expurgated version was screened in Japan on October 16.

6 Scholes 1985, 427.

7 On prewar film censorship, see Gerow 2001.

8 Gunning 1989, 31–45.

9 L. Williams 1989, 184–186.

10 Gunning 1989, 34–35.

11 Couvares 1996, 2.

12 L. Williams 1989, 30.

13 Ibid., 48, 51–53.

14 Ōshima's previous projects, especially his 1965 short film *Diary of Yunbogi*
 (*Yunbogi no nikki*) and his 1967 *Manual of Ninja Martial Arts* (*Ninja bugei-
 chō*), more closely resembled the early exhibition practices described by
 Gunning. In the former film, Ōshima incorporated a series of photographic
 stills, and in the latter, he created a film of over two hours entirely by filming
 a succession of manga panels.

15 The objectionable photos, counting from the front of the book (since its
 pages were unnumbered), were nos. 4, 8, 9, 10, 11, 12, 14, 16, 18, and 20,
 which aligned genitals, and nos. 13 and 21, which suggested fellatio.

16 Ōshima 1976, 144.

17 Photos 8 and 10, respectively. Even photo 14 (fig. 7.3), not mentioned by
 the prosecutor as embodying motion, could be argued to do so using this
 standard because it shows Sada's arms outstretched, captured as she makes the
 motion to strangle Kichi.

18 This is clearly true for photo 9, in which Kichi's face is not even visible to the
 camera. The exceptions are photo 16, in which Sada's face is barely visible,
 spilling outside the top of the frame, and photo 10, in which both Sada's and
 Kichi's facial expressions are equally sedate.

19 L. Williams 1989, 194, 101–102.

20 *Japan v. Ōshima et al.* (Tokyo Dist. Ct., Oct. 19, 1979) (lower court verdict
 reprinted in full in *AS*, 2:414–427). This not-guilty verdict was upheld by the
 High Court on June 8, 1982.

21 I thank Thomas Looser for suggesting this.

22 For the most rigorous (and lyrical) analysis of the function of voyeurism in
 the film, see Heath 1981, 145–164. See also Turim 1998, 125–156.

23 Ōshima 1976, 45–46, 49.

24 Jacobs 1991, 119–121.

25 Comolli 1985, 121–142.

26 Yomota 1983, 183. In this fascinating essay, Yomota's aim is not to demonize
 still photographs but to redeem them from their lowly position akin to "dregs
 left gathered in the bottom of a wine bottle" (189).

27 Barthes 1977, 65.

Chapter 8: Japan's First Manga Trial

1 With the exception of two high-profile Mapplethorpe trials, but these were
 initiated by the publishers rather than by the state prosecutor. First, in 1992,
 a museum catalogue of a Mapplethorpe exhibit from the Whitney Museum

in New York was disallowed entry into Japan under article 21 of the Customs Law, as a "work that would harm morals," a ban that was ultimately upheld by the Japanese Supreme Court in 1999, albeit with a three-two split verdict. Next, in 1999, the art book *Mapplethorpe,* a newly translated Japanese version of an edition published in the United States by Random House that had been sold without a problem in Japan since 1994, was confiscated by customs. After the publisher sued, the courts wavered, first finding for the state at the lower court and then for the publisher in the High Court, but, in February 2008, the Supreme Court ultimately ruled in favor of the publisher. The verdict was championed as the "end of obscenity" in Japan, but this claim was perhaps premature since the work was exonerated largely because it was deemed highbrow artistry.

2 Statistics based on 1996 figures (Kinsella 2000, 45). Allison (2000, 51–79) offers one of the only detailed English-language analyses of erotic manga based on selected magazines from the early 1980s. Cf. Schodt 1983.

3 Daniel Raeburn, *Chris Ware* (New Haven: Yale University Press, 2004), 24.

4 For a history of comics censorship in the United States, see Hajdu 2008.

5 Allison 2000, 56. Shōbunkan's subsidiary Group Zero handles cell phone erotic manga (*keitai eromanga*), which, in 2008, were generating about two hundred million yen in annual revenue with their biggest hit, "Teen's Love: Nothing to Do but Sex," reaching over two hundred thousand downloads (Kishi Motonori, interview by author, Tokyo, May 27, 2008).

6 Kishi Motonori, interview by author, Tokyo, May 27, 2008. The pun is achieved by substituting the very similar looking and homophonous Chinese character for "honey" (*mitsu* 蜜) for "hidden" (*mitsu* 密). Although the cover transcribes its title as "Missitsu," I follow the conventional romanization of "Misshitsu."

7 Matt Madden, *99 Ways to Tell a Story: Exercises in Style* (New York: Chamberlain 2005), 43.

8 Jones 2002, 18.

9 Beauty Hair 2002, 16.

10 Ibid., 129.

11 This has become a lively debate among Western scholars of Japanese pop culture, although, in the end, not as divergent as one might expect. The majority of commentators attempt to recuperate select genres of erotic comics by pointing out ways that the texts offer potentially powerful feminist statements despite their overtly misogynist content. See Buckley 1991, Allison 2000, Napier 2001, Jones 2002, Orbaugh 2003, and Shamoon 2004. The broader question about the feminist or misogynist possibilities of pornography is a highly debatable and complex one that, because of a lack

of space, I leave aside to instead focus on how the parties at the trial engaged this issue.

12 *WKS,* 255, 233–234. Citations from the journalist Nagaoka's account of the lower court trial, *"Waisetsu komikku" saiban,* are hereafter cited parenthetically in the text as *WKS.*

13 Robin Morgan's 1974 essay "Theory and Practice: Pornography and Rape," cited in L. Williams 1989, 16.

14 Beauty Hair 2002, 109, 112.

15 Such an either-or approach to reader identification fails to recognize the fluidity of identification possibilities identified by Carol Clover (1992) in her seminal study of horror films.

16 Napier 2001, 345, 364n14.

17 The events leading to the charges in this case are known for two reasons: (1) the original letter of complaint was posted on the web, intact with Hirasawa's name on it ("Letter of Complaint to Hirasawa Katsuei" 2002), and (2) during his testimony as a witness at the lower court trial, the police investigator in charge of morals in the Tokyo Police Public Safety Division surprisingly revealed Hirasawa's name as the politician responsible for jump-starting the investigation (*WKS,* 243–246).

18 Yama Ryōkichi, interview by author, Tokyo, May 30, 2008.

19 Yamaguchi Takashi, interview by author, Tokyo, May 29, 2008.

20 *WKS,* 246; Kishi Motonori, interview by author, Tokyo, May 27, 2008.

21 The earliest criminal charges against manga included *Manga erojenika* in November 1978 after the editor in chief appeared on a late-night television program about "the boom of third-rate dramatic comics" and the arrest of the editor in chief of *Bessatsu yūtopia: Kuchibiru no yūwaku* in February 1979. In the early 1990s, amateur magazines (*dōjinshi*) became the target, most notably in an investigation of seventy-four people involved in the Minīzu Kurabu group in February 1991 (*WKS,* 10–11, 16–18).

22 *WKS,* 133. The Publishing Ethics Association was established in June 1985 to serve thirty-five small to medium-size publishers not belonging to the larger hundred-member Japan Book Publishers' Association (Nihon Shoseki Shuppan Kyōkai) or to the Japan Magazine Association (Nihon Zasshi Kyōkai) (Hashimoto 2005, 10). Another major self-regulating organization is the Publishers' Association on Book Distribution (Shuppan Ryūtsū Taisaku Kyōgikai, or Ryūtaikyō), with ninety-eight members, including Michi Shuppan, owned by Kishi's wife. This last organization was the only one to publicly come to Shōbunkan's defense (Ryūtaikyō 2005). Kishi did not belong to any of these, partly out of a personal disdain for such groups, but also in part perhaps because he would not have been accepted by the more

mainstream ones (Kishi Motonori, interview by author, Tokyo, May 27, 2008; Yama Ryōkichi, interview by author, Tokyo, May 30, 2008).

23 "Letter of Complaint to Hirasawa Katsuei" 2002.

24 On manga thefts and the *Shameless School* incident, see Orbaugh 2003, 106 and Hashimoto 2002, 285. For a history and time line of manga censorship, see Komikku Hyōgen no Jiyū o Mamoru Kai 1993, 134–155.

25 Hashimoto 2002.

26 "Letter of Complaint to Hirasawa Katsuei" 2002.

27 Nagaoka et al. 2004; cf. Fujimoto's testimony, cited in *WKS,* 237, and Komikku Hyōgen no Jiyū o Mamoru Kai 1993, 85.

28 *WKS,* 189; Komikku Hyōgen no Jiyū o Mamoru Kai 1993, 159. In April 2002, for the first time, a prison sentence (of up to six months) was attached to the crime of selling harmful books to minors in Ishikawa prefecture. In 2000, the Proposed Legislation to Regulate Harmful Environments to Protect Youths (Seishōnen Yūgai Shakai Kankyō Taisaku Kihon Hōan) failed to gain traction, but again in 2004 similar legislation was proposed in the form of two laws: Law to Foster Healthy Youths (Seishōnen Kenzen Ikusei Kihon Hōan), which would nationalize prefectural youth regulations, and the Proposal to Self-Regulate Harmful Environments to Protect Youths (Seishōnen Yūgai Kankyō Jishu Kisei Hōan) (Hashimoto 2005, 9–10). Critics of this kind of legislation call them media purification laws (*media jōka hō*), alluding to Nazi policies (Yama Ryōkichi, interview by author, Tokyo, May 30, 2008; " 'Takaichi shian' ni kikikan hyōmei: Shuppan Rōren ga kinkyū shūkai," *Shinbunka,* May 15, 2008.

29 Hirano R. 1952, 14, 18.

30 *WKS,* 31–34; Yama Ryōkichi, interview by author, Tokyo, May 30, 2008; Kishi Motonori, interview by author, Tokyo, May 27, 2008. Tokyo Youth Regulations require that shelves with "unhealthy" (*fukenzen*) books be separated from other shelves by at least two feet, or, if separated by a partition, more than eight inches; be placed high up on shelves at a minimum height of five feet, with only the book spines visible; or, alternatively, be placed in vinyl bags (*WKS2,* 174) (the journalist Nagaoka's 2005 sequel account of the High Court *Honey Room* trial is hereafter abbreviated as *WKS2*).

31 Buckley 1991, 173–174.

32 William Gibson, *Idoru* (New York: Putnam, 1996), 115.

33 *WKS,* 239, 202. For an English-language translation of Saitō's scholarship on *otaku,* see Saitō T. 2007.

34 Napier 2007, 159–167. This is not to imply that it is impossible for audiences to identify with characters who do not resemble them. As Carol Clover's work (1992) has illustrated, young male horror fans identify

alternately with the homicidal male killer, the female and male victims, and finally, the avenging "final girl." But even here the ability to slide in and out of these identifications that transcend gender often depends on a spectator's ability to feel a sense of affinity with the victims' own psychology to a degree, such as an adolescent boy spectator's ability to identify with the bullied heroine of *Carrie* (20).

35 See Allison's (2000, 154–155) discussion of the Frankfurt school.

36 "Kodoku ni hisomu ijōsa. Tomo wa anime, bideo. Miyazaki, tsukiai sake mukuchi," *Asahi shinbun,* August 11, 1989. The media obsessively reported on the precise numbers of Miyazaki's *otaku* collection. For critics who claim Miyazaki and manga were merely scapegoats, see Ōtsuka Eiji and Azuma Hiroki in Noguchi Hiroshi, "Bōhatsu suru 'amai sekai' zōshoku shikei shikkō 'Miyazaki Tsutomu' kara Akihabara jiken made no 20-nen," *Aera* [June 30] 2008, 93). For this photo, see the Kyōshin Insatsu website at http://www .kyoshin.net/aide/c74/index.html.

37 *Himedorobō,* January 2007.

38 In Japanese, the law is called Jidō baishun, jidō poruno ni kakawaru kōi tō no shobatsu oyobi jidō no hogo nado ni kansuru hōritsu. For a complete text of the law, see e-Gov 2006. For an English translation of select portions of the law, see INTERPOL 2006.

39 See INTERPOL 2006, articles 15, 16.

40 For a copy of the UNICEF petition, see UNICEF 2008; for a critique against proposed revisions, see Yamaguchi 2008 and "Jidō poruno 'mottemo dame' e," *Tokyo shinbun,* March 12, 2008.

41 The Japan Foundation subsequently sponsored an exhibition of the Japan pavilion from the Venice exhibition at the Tokyo Metropolitan Museum of Photography from February 22 to March 13, 2004. For a virtual tour, see Morikawa 2004.

42 Murakami 2000.

43 The figurine, created by Ōshima Yūki, known for his Lolita-esque creations, is a young schoolgirl straddling the miniaturized city of Akihabara. According to rumors on the web, the figurine can be stripped naked and put in the provocative pose of a nude schoolgirl with only a rucksack on her back, or *hadaka randoseru* (HK-DMZ.plus 2004, "Ōshima Yūki no figua," October 9, 2004, Akiba blog, http://blog.livedoor.jp/geek/archives/7820319.html).

44 *WKS2,* 246, 252; Chiba 2005.

45 Chiba's testimony also drew the attention of the mass media and a broader manga fan base to the comparably low-profile *Honey Room* trial, necessitating a move to a larger courtroom for the day of his testimony (*WKS2,* 223–226, 229). One blogger put the count at about a hundred people, although only fifty-two were allowed into the courtroom (NOLIA, "Saibanshō e itte mita

17," February 17, 2005 [11:58 p.m.], http://www87.sakura.ne.jp/%7Ecou/
matu.htm#matu02).

46 Since 2000, tremendous resources have been expended on manga and
anime, including the creation of manga departments at private and public
universities (e.g., at Kyoto Seika University in 2000 and at the first public
university, Tokyo University of the Arts, in 2008); the steady introduction
of university courses on *otaku* culture (e.g., at the University of Tokyo as
of February 2000); the inclusion of manga as an "art" subject in Ministry
of Education Junior High School Curriculum Guidelines of 2002 and the
introduction of manga in textbooks for Japanese language and social studies;
and the establishment of the Kyoto International Manga Museum in 2006
(Japan Echo 2008; Kyoto International Manga Museum, http://www
.kyotomm.jp/english/about/mm/).

47 Morikawa 2004.

48 "Letter of Complaint to Hirasawa Katsuei" 2002.

49 The Kyōhō Reform of 1722 was the first to require the names of the author/
artist and the publisher, and the edict was repeated in the Kansei Reforms
of 1790, when single-sheet prints also required the censor's seal of approval
(*kiwame*). In 1875, prints were required to show also the addresses as well as
the date of publication (Thompson and Harootunian 1991, 44, 59, 62, 88).

50 *WKS,* 56. Although ostensibly written by Kishi, its legalistic language
suggests that Kishi was coerced by the authorities, as he claimed in the trial
(*WKS2,* 45–59).

51 For example, Tezuka's 1970–1972 "Marvelous Melmo" (Fushigi na Merumo),
about a young girl who could advance or regress her age at will by eating
candy, and his 1970 "Yakkepachi's Maria" (Yakkepachi no Maria), about a
boy's inflatable doll named Maria. When the Fukuoka Children's Welfare
Committee deemed the latter too explicit, the magazine in which it ran,
Shōnen junia, was labeled "harmful" (Hashimoto 2005, 96).

52 Cited in *KWS,* 223.

53 Chiba 2005.

54 Hayashi and Lane 1996. Yamaguchi Takashi, interview by author, Tokyo,
May 29, 2008. According to Yamaguchi, *shunga* volumes submitted included
number 2 (*Kitagawa Utamaro: Ehon Komachi-biki,* 1996), number 21
(*Suzuki Harunobu: Fūryū Edo hakkei, hoka,* 1998), and number 24 (*Torii
Kiyonaga: Sode no maki, hoka,* 1999). Interestingly, they did not submit
volume 1 by Hokusai, perhaps in an attempt not to sully the originator of
the term "manga" and perhaps because, although all the volumes depict
exaggeratedly enlarged penises, none are quite as conspicuously gigantic as
those depicted by Hokusai.

55 Hayashi and Lane 1996, 2:44–46.

56 See, for example, Kishi's testimony at the fourth and ninth sessions and Yamaguchi's closing statement at the eleventh session (available online in the transcribed trial record titled *Shōbunkan saiban bōchō kiroku,* hereafter abbreviated as *MS* in the notes), Chiba 2005, and Kishi's testimony, cited in *WKS2,* 63.

57 Sonoda's testimony, cited in *WKS,* 192; cf. Yamaguchi's opening, ibid., 38.

58 "Letter of Complaint to Hirasawa Katsuei" 2002.

59 For a summary of this debate, see Allison 1998, 208–210; 2000, 147–151.

60 Shinoyama 1991. In addition to these two nude photo collections of female actresses, another, entitled *White Room* (1991) features the male actor Motoki Masahiro.

61 Allison 2000, 195n3. Allison notes the use of the foreign word *hea* (in katakana) in this debate, rather than the native term *inmō* (195n2), yet again suggesting the tendency to displace crass sexual explicitness and permissiveness onto the West.

62 *WKS2,* 276. Cf. *MS,* Yamaguchi's closing argument in the tenth session.

63 Yamaguchi Takashi, interview by author, Tokyo, May 29, 2008.

64 *WKS,* 93; *MS,* Beauty Hair's testimony at the third session; *WKS2,* 210–211. Cf. Chiba 2005, 254.

65 Chiba 2005, 273–274.

66 *MS,* Beauty Hair's testimony at the third session; *WKS,* 34–35, 93, 158–159. In fact, as editor in chief Takada revealed, the procedures and standards for applying masking are so pro forma that he delegates it entirely to his staff (Takada Kōichi, interview by author, Tokyo, May 27, 2008).

67 *WKS2,* 66–67; Yama Ryōkichi, interview by author, Tokyo, May 30, 2008.

68 Bazin 1972, 159.

69 Buckley 1991, 187–188; Allison 2000, 56.

70 Chiba 2005.

71 In August 2007, in a seeming repeat of the Nikkatsu trial, a self-regulatory agency for adult video, Biderin (Nihon Bideo Rinri Kyōkai, or Nihon Ethics of Video Association, established in 1972), was threatened with an obscenity indictment. In contrast with the state's earlier resounding endorsements of Eirin as an effective self-regulating body, the Biderin incident resulted in the organization's dissolution after thirty-six years in operation. In its stead was established a new organization, the Japan Motion Pictures Regulation Committee (Nihon Eizō Rinri Shinsa Kikō, or Eizōshin for short), headed by the liberal constitutional scholar Shimizu Hideo, the defense witness who had lamented Japan's lagging human rights record in the Nikkatsu trial. Presumably, this new organization will become the adult video equivalent of Eirin, but whether it too will run afoul of the law remains to be seen

("Biderin, 36-nen no rekishi ni maku," *Asahi shinbun,* June 22, 2008, http://www.asahi.com/showbiz/tv_radio/TKY200806210118.html).

72 The maximum allowable fine was 2.5 million yen, but the judges determined that Kishi had suffered enough of a monetary penalty between his court costs and the financial damage to his company during the investigation and trial phases.

73 In *Tosho shinbun* (February 7, 2004), cited in *WKS2,* 121.

74 *Japan v. Kishi Motonori* (Tokyo Dist. Ct., no. 3618, January 13, 2004), "Honken manga no waisetsusei ni tsuite." The *Honey Room* lower court verdict is given hereafter as *MLC* parenthetically in the text and notes. The High Court judges concurred with the lower court judges that, in theory, manga were less potentially obscene than photography and live-action film but dismissed the relevance of such comparisons in practice because "the issue here is not a relative comparison between actually filmed representations and manga representations" (*Kishi Motonori v. Japan* [Tokyo High Ct., no. 458, June 16, 2005], referred to hereafter as *MHC* parenthetically in the text and notes).

75 As Screech warns the squeamish reader in the preface to his considerably more staid English-titled version, *Sex and the Floating World: Erotic Images in Japan, 1700–1820,* they "will have to tolerate a discussion of masturbation, for it is the central practice that accounts for the genres here discussed" (Screech 1999, 7). Cf. Buckley 1991, 165–168.

76 Buckley 1991, 188; Schodt 1983, 18.

77 That manga panels do not actually move was made painfully obvious by Ōshima's experimental film *Manual of Ninja Martial Arts,* a 135-minute feature film composed exclusively of filmed manga panels.

78 Kinsella 200, 43.

79 For photos of these receptacles for "harmful book" materials, see Wikipedia, "Yūgai tosho," http://ja.wikipedia.org/wiki/%E6%9C%89%E5%AE%B3%E5%9B%B3%E6%9B%B8 and at http://f.hatena.ne.jp/images/fotolife/B/Blueforce/20061117/20061117120521.jpg.

80 *WKS,* 193–197; *MS,* Sonoda's testimony at the sixth session.

81 Rembar 1968, 99.

82 Nixon 1970.

83 *MLC,* "Honken ni tekiyō subeki shakai tsūnen ni tsuite"; *MHC,* "Waisetsu no igi, gutaiteki handan kijun hōhō ni tsuite no shuchō ni tsuite"; Yamaguchi Takashi, interview by author, Tokyo, May 29, 2008. For the *Chatterley* Supreme Court verdict on "community standards," see Maki 1964, 9.

84 *MS,* Sonoda's testimony at the sixth session; see also Nagashima's testimony at the second session; *WKS,* 190–191.

85 B. Williams 1996, 12–13.

86 Despite Japan's leading role, Asia as a whole has been paternalistically categorized by the movement's spearheading organization, the Council on Europe, as a reluctant participant at best (Kirk 2009). As of August 2011, the treaty has yet to be ratified by the Japanese Diet.

87 Yamaguchi Takashi, interview by author, Tokyo, May 29, 2008. They are, however, allowed to introduce relevant information that is considered "common knowledge" (*kōchi no jijitsu*).

88 Council of Europe 2001, article 9, no. 2; nos. 100–102; no. 93.

89 Hansen 2008. In this essay, titled "Japan's Fight against Modern-Day Slavery," Scott Hansen, a secretary at the U.S. Embassy in Tokyo, lambastes Japan for its failure to criminalize the possession of pornography, especially manga and anime, and explicitly ties this to the spread of human trafficking and particularly child prostitution.

90 UNICEF 2008; Yamaguchi Takashi, interview by author, Tokyo, May 29, 2008; Hansen 2008.

91 *Chatterley* Supreme Court verdict, cited in Baba et al. 1957, 220.

Works Cited

Abe Kōbō. 1997. "Chatarei hanketsu to Tokubetsu hoan hō (Dantai tō kisei hō) ni tsuite." In *Abe Kōbō zenshū,* 3:190. Tokyo: Shinchōsha.

Abel, Jonathan E. 2005. "Pages Crossed: Tracing Literary Casualties in Transwar Japan and the United States." PhD diss., Princeton University. ProQuest (3169722).

———. 2007. "The *Ero-Puro* Sense: Declassifying Censored Literature from Interwar Japan." *Japan Forum* 19 (3): 341–367.

Alexander, James R. 2003. "Obscenity, Pornography, and the Law in Japan: Reconsidering Oshima's *In the Realm of the Senses.*" *Asian-Pacific Law & Policy Journal* 4 (1): 148–168.

Allison, Anne. 1998. "Cutting the Fringes: Pubic Hair at the Margins of Japanese Censorship Laws." In *Hair: Its Power and Meaning in Asian Culture,* ed. Alf Hiltebeitel and Barbara D. Miller, 195–218. Albany: SUNY Press.

———. 2000. *Permitted and Prohibited Desires: Mothers, Comics, and Censorship in Japan.* Berkeley: University of California Press.

Anderson, Joseph L., and Donald Richie. 1982. *The Japanese Film: Art and Industry.* Exp. ed. Princeton: Princeton University Press.

Aoki Hisashi. 1969. "Saiban to sōten: Eiga 'Kuroi yuki' jiken." *Hōgaku seminā* 160 (July): 90–92.

AS. Uchida Takehiro, ed. 1980–1981. *Ai no korīda saiban zenkiroku.* 2 vols. Tokyo: Shakai Hyōronsha.

Asahi Shinbunsha, ed. 1978. *Besutoserā monogatari.* Vol. 1. Tokyo: Asahi Shinbunsha.

Baba Hideo et al. 1957. "Hōritsuka no mita Chatarei saiban." *Chūō kōron* (May): 208–223.

Barshay, Andrew E. 1988. *State and Intellectual in Imperial Japan: The Public Man in Crisis.* Berkeley: University of California Press.

Barthes, Roland. 1977. "The Third Meaning: Research Notes on Some Eisenstein Stills." In *Image, Music, Text,* trans. Stephen Heath, 52–68. New York: Hill and Wang.

Bazin, André. 1972. "Entomology of the Pin-Up Girl." In *What Is Cinema?* 2:158–162. Berkeley: University of California Press.

Beauty Hair [Suwa Yūji]. 2002. *Misshitsu: Honey Room.* Tokyo: Shōbunkan.

Beer, Lawrence Ward. 1984. *Freedom of Expression in Japan: A Study in Comparative Law, Politics, and Society.* Tokyo: Kodansha International.

Beer, Lawrence Ward, and Hiroshi Itoh. 1996. *The Constitutional Case Law of Japan, 1970 through 1990*. Seattle: University of Washington Press.

Braw, Monica. 1991. *The Atomic Bomb Suppressed: American Censorship in Occupied Japan*. Armonk, NY: M.E. Sharpe.

Buckley, Sandra. 1991. "'Penguin in Bondage': A Graphic Tale of Japanese Comic Books." In *Technoculture*, ed. Constance Penley and Andrew Ross, 163–196. Minneapolis: University of Minnesota Press.

Burt, Richard, ed. 1994. *The Administration of Aesthetics: Censorship, Political Criticism, and the Public Sphere*. Minneapolis: University of Minnesota Press.

Butler, Judith. 1997. *Excitable Speech: A Politics of the Performative*. New York: Routledge.

Cavell, Stanley. 1979. *The World Viewed: Reflections on the Ontology of Film*. Cambridge, MA: Harvard University Press.

Chiba Tetsuya. 2005. "Kōsoshin shōnin Chiba Tetsuya," February 17, 2005. http://www.geocities.co.jp/AnimeComic-Tone/9018/shoubun-kouso.html (accessed August 23, 2011).

Chong, Doryun. 2001. "Witness and Anti-Witness: War, Rememorations, and Art in Contemporary Japan." Unpublished paper.

Clover, Carol J. 1992. *Men, Women, and Chain Saws: Gender in the Modern Horror Film*. Princeton: Princeton University Press.

Comolli, Jean-Louis. 1985. "Machines of the Visible." In *The Cinematic Apparatus*, ed. Teresa de Lauretis and Stephen Heath, 121–142. London: Macmillan.

Council of Europe. 2001. "Convention on Cybercrime," November 23, 2001. CETS No.: 185. http://conventions.coe.int/Treaty/Commun/QueVoulezVous.asp?NT=185&CM=8&DF=5/27/2009&CL=ENG (accessed August 29, 2011).

Couvares, Francis G., ed. 1996. *Movie Censorship and American Culture*. Washington, DC: Smithsonian Institution Press.

Craig, Alec. 1963. *Suppressed Books: A History of the Conception of Literary Obscenity*. Cleveland: World Publishing.

CS. Itō Sei. 1997. *Saiban*. Ed. Itō Rei. 2 vols. Tokyo: Shōbunsha.

Dale, Peter N. 1986. *The Myth of Japanese Uniqueness*. New York: Palgrave Macmillan.

Dandō Shigemitsu. 1957. "Chatarei saiban no hihan." *Chūō kōron* (August): 45–56.

deCordova, Richard. 1990. "Ethnography and Exhibition: The Child Audience, the Hays Office and Saturday Matinees." *Camera Obscura*, no. 23 (May): 90–107.

de Grazia, Edward. 1992. *Girls Lean Back Everywhere: The Law of Obscenity and the Assault on Genius*. New York: Random House.

Desser, David. 1988. *Eros Plus Massacre: An Introduction to Japanese New Wave Cinema*. Bloomington: Indiana University Press.

Domenig, Roland. 2002. "Vital Flesh: The Mysterious World of Pink Eiga." In *Udine Far East Film IV Edition*. Udine, Italy: Centro Espressioni Cinematografiche. http://web.archive.org/web/20041118094603/ http://194.21.179.166/cecudine/fe_2002/eng/PinkEiga2002.htm.

———. 2004. "The Anticipation of Freedom—Art Theatre Guild and Japanese Independent Cinema" (June 28, 2004). *Midnight Eye: The Latest and Best in Japanese Cinema*. http://www.midnighteye.com/features/art-theatre-guild .shtml.

Douglas, Mary. 1966. *Purity and Danger: An Analysis of the Concept of Pollution and Taboo*. New York: Routledge.

Dower, John W. 1993. "Peace and Democracy in Two Systems: External Policy and Internal Conflict." In *Postwar Japan as History*, ed. Andrew Gordon, 3–33. Berkeley: University of California Press.

———. 1999. *Embracing Defeat: Japan in the Wake of World War II*. New York: Norton.

e-Gov. 2006. Jidō baishun, jidō poruno ni kakawaru kōi tō no shobatsu oyobi jidō no hogo nado ni kansuru hōritsu. Law no. 106. Last updated June 18, 2006. http://law.e-gov.go.jp/htmldata/H11/H11HO052.html.

Eiga Geijutsu. 1973. "Nikkatsu poruno saiban: Dainikai kōhan." *Eiga geijutsu*, no. 9 (October): 91–96.

Eiren (Shadanhōjin Nihon Eiga Seisakusha Renmei). 2010. "Kako dētā ichiran (1995-nen–2010-nen)." http://www.eiren.org/toukei/data.html.

Eirin. 2006. *Eirin: 50-nen no ayumi*. Ed. "Eirin 50-nen no ayumi" Hensan Iinkai. Tokyo: Eirin Kanri Iinkai.

Eisenstein, Sergei. 1949. "The Cinematographic Principle and the Ideogram." In *Film Form: Essays in Film Theory*, trans. and ed. Jay Leyda, 28–44. New York: Harcourt, Brace & World.

Endō Tatsuo. 1973. *Eirin: Rekishi to jiken*. Tokyo: Perikansha.

———. 1976. "Eirin: Sono kinō to mondai." *Jurisuto sōkan sōgō tokushū (Gendai no masukomi)*, no. 5 (June): 329–333.

Etō Jun. 1981. *Ochiba no hakiyose: Haisen, senryō, ken'etsu to bungaku*. Tokyo: Bungei shunjū.

———. 1982. "Senryōgun no ken'etsu to sengo Nihon." *Shokun!* 14 (2) (February): 34–109; 14 (12) (December): 224–267.

———. 1989. *Tozasareta gengo kūkan: Senryōgun no ken'etsu to sengo Nihon*. Tokyo: Bungei shunjū.

Fujiki Hideo. 1972. "Eirin jiken o meguru hōritsu mondai." *Jurisuto*, no. 504 (May): 56–61.

Fukui, Haruhiro. 1968. "Twenty Years of Revisionism." In *The Constitution of Japan: Its First Twenty Years, 1946–67*, ed. Dan Fenno Henderson, 41–70. Seattle: University of Washington Press.

Gerow, A. A. 1996. "Swarming Ants and Elusive Villains: *Zigomar* and the Problem of Cinema in 1910s Japan." *CineMagaziNet! On-Line Research Journal of Cinema,* no. 1 (Autumn). http://www.cmn.hs.h.kyoto-u.ac.jp/NO1/SUBJECT1/ZIGOMAR.HTM.

Gerow, Aaron. 2000. "Ōshima to iu sakka, kankyaku to iu waisetsu: *Ai no korīda* saiban to poruno no seiji." *Yurīka* 32 (1) (January): 188–197.

———. 2001. "The Word before the Image: Criticism, the Screenplay, and the Regulation of Meaning in Prewar Japanese Film Culture." In Washburn and Cavanaugh, *Word and Image in Japanese Cinema,* 3–35.

Gluck, Carol. 1993. "The Past in the Present." In *Postwar Japan as History,* ed. Andrew Gordon, 64–95. Berkeley: University of California Press.

———. 1998. "The Invention of Edo." In *Mirror of Modernity: Invented Traditions of Modern Japan,* ed. Stephen Vlastos, 262–284. Berkeley: University of California Press.

Grindon, Leger. 2001. "In the Realm of the Censors: Cultural Boundaries and the Poetics of the Forbidden." In Washburn and Cavanaugh, *Word and Image in Japanese Cinema,* 293–317.

Gunning, Tom. 1989. "An Aesthetic of Astonishment: Early Film and the (In) Credulous Spectator." *Art & Text* 34 (Spring): 31–45.

Hajdu, David. 2008. *The Ten-Cent Plague: The Great Comic-Book Scare and How It Changed America.* New York: Farrar, Straus and Giroux.

Hamano Kenzaburō. 1976. " 'Ikite iru heitai' jiken." In *Ishikawa Tatsuzō no sekai: Hyōden,* 114–127. Tokyo: Bungei shunjū.

Hanrei Jihō. 1969. *Murakami et al. v. Japan* (Tokyo High Ct., September 17, 1969). *Hanrei jihō,* no. 571 (November): 19–26.

———. 1978. *Japan v. Nikkatsu Co. et al.* (Tokyo Dist. Ct., June 23, 1978). *Hanrei jihō,* no. 897 (October): 39–53.

Hanrei Taimuzu. 1967. *Japan v. Murakami et al.* (Tokyo Dist. Ct., July 19, 1967). *Hanrei taimuzu,* no. 210 (November): 191–202.

Hansen, Scott. 2008. "Japan's Fight against Modern-Day Slavery (Part II)." *American View* (Spring). Tokyo: Embassy of the United States. http://tokyo.usembassy.gov/e/p/tp-20080416-72.html.

Hase Masato. 1998. "The Origins of Censorship: Police and Motion Pictures in the Taishō Period." Trans. Angela Turzynski-Azimi. *Review of Japanese Culture and Society* 10 (December): 14–23.

Hashimoto Kengo. 2002. *Yūgai tosho to seishōnen mondai: Otona no omocha datta "seishōnen."* Tokyo: Akashi shoten.

———. 2005. *Hakkin, waisetsu, shiru kenri to kisei no hensen: Shuppan nenpyō.* Ishikawa, Japan: Shuppan media paru.

Hayashi Yoshikazu and Richard Lane, eds. 1996. *Teihon ukiyoe shunga meihin shūsei: Kitagawa Utamaro (Ehon Komachibiki).* Vol. 2. Tokyo: Kawade shobō shinsha.

Heath, Stephen. 1981. "The Question Oshima." In *Questions of Cinema,* 145–164. Bloomington: Indiana University Press.

Heine, Laura. 2002. "Statistics in Postwar Japan." Lecture presented at the Center for Japanese Studies, University of California, Berkeley, March 1, 2002.

———. 2003. "Statistics for Democracy: Economics as Politics in Occupied Japan." *positions: east asia cultures critique* 11 (3) (Winter): 765–778.

Hidaka Shōji. 2003. "Senryō, kenpō, retorikku—Matsukawa jiken to Hirotsu Kazuo." In *Nihon bungaku shi.* Vol. 14, *Nijū seiki no bungaku 3,* 205–209. Tokyo: Iwanami shoten.

High, Peter B. 2003. *The Imperial Screen: Japanese Film Culture in the Fifteen Years' War, 1931–1945.* Madison: University of Wisconsin Press.

Hirano, Kyoko. 1992. *Mr. Smith Goes to Tokyo: The Japanese Cinema under the American Occupation, 1945–1952.* Washington, DC: Smithsonian Institution Press.

Hirano Ryūichi. 1952. "Chatarei saiban hihyō." *Jurisuto,* no. 4 (February): 12–19.

Hutchinson, Rachael. 2001. "Occidentalism and Critique of Meiji: The West in the Returnee Stories of Nagai Kafū." *Japan Forum* 13 (2): 195–213.

Huxley, Aldous. 1963. *Literature and Science.* Woodbridge, CT: Ox Bow Press.

Inada Saburō, ed. 1963. *Haifū Suetsumuhana.* Tokyo: Uozumi shoten.

Inoue, Kyoko. 1991. *MacArthur's Japanese Constitution: A Linguistic and Cultural Study of Its Making.* Chicago: University of Chicago Press.

INTERPOL. 2006. Law for Punishing Acts Related to Child Prostitution and Child Pornography, and for Protecting Children. Last updated spring 2006. http://www.interpol.int/public/Children/SexualAbuse/NationalLaws/csaJapan.asp.

Ishihara Shintarō. 1981. "Taiyō no kisetsu." In *Kaseki no mori; Taiyō no kisetsu,* 334–366. Tokyo: Shinchōsha.

Ishii Kyōji and Shibusawa Tatsuhiko. 1963. *Sado saiban.* 2 vols. Tokyo: Gendai shichōsha.

Ishikawa Tatsuzō. 1999. *Ikite iru heitai.* Tokyo: Chūō kōron.

ISZ. Itō Sei. 1972–1974. *Itō Sei zenshū.* 24 vols. Tokyo: Shinchōsha.

Itō Rei. 1985. *Itō Sei shi funtō no shōgai.* Tokyo: Kōdansha.

———. 1996. "Kaiteiban e no atogaki." In *Chatarei fujin no koibito,* trans. Itō Sei. Tokyo: Shinchōsha.

Itō Sei. 1943. "Kansei." In *Tsuji shōsetsu shū,* ed. Nihon Bungaku Hōkokukai, 32. Tokyo: Hakkōsha Sugiyama shoten.

———, trans. 1950. *Chatarei fujin no koibito.* 2 vols. Tokyo: Oyama shoten.

———. 1951. " 'Chatarei fujin no koibito' no sei byōsha no shisō." *Gunzō* (December): 94–106.

———. 1957. "Hikoku Itō Sei to watashi." *Chūō kōron bungei tokushū* 7 (712) (May): 70–80.

———, trans. 1996. *Chatarei fujin no koibito.* Tokyo: Shinchōsha.

Itoh, Hiroshi, and Lawrence Ward Beer. 1978. "The de Sade Case." In *The Constitutional Case Law of Japan: Selected Supreme Court Decisions, 1961–70*, 183–217. Seattle: University of Washington Press.

Jacobs, Lea. 1990. "Reformers and Spectators: The Film Education Movement in the Thirties." *Camera Obscura* 22 (January): 28–49.

———. 1991. *The Wages of Sin: Censorship and the Fallen Woman Film, 1928–1942*. Madison: University of Wisconsin Press.

Jameson, Frederic. 1992. *Signatures of the Visible*. New York: Routledge.

Japan Echo. 2008. "Anime Goes Academic: Universities Launch Animation Courses" (February 6, 2008). *Trends in Japan*. http://web-japan.org/trends/07culture/pop080206.html.

Jō Ichirō. 1989. *Katsuji no erogotoshitachi*. Tokyo: Chūseikisha.

———, ed. 1999. *Hakkinbon: Meiji-Taishō-Shōwa-Heisei; Jō Ichirō korekushon*. Tokyo: Heibonsha.

Johns, Adrian. 1998. *The Nature of the Book: Print and Knowledge in the Making*. Chicago: University of Chicago Press.

Jones, Gretchen. 2002. "'Ladies' Comics': Japan's Not-So-Underground Market in Pornography for Women." *U.S.-Japan Women's Journal*, no. 22:3–31.

Kaku Renbō [pseud.]. 1973. "Poruno jigoku ni yūshi tessen o mita!" *Eiga geijutsu*, no. 9 (October): 113–114.

Kasza, Gregory J. 1988. *The State and Mass Media in Japan, 1918–1945*. Berkeley: University of California Press.

Kawakami Tetsutarō. 1950. "Chatarei fujin no koibito." In *Rorensu senshū: Bessatsu, Rorensu kenkyū*, 149–155. Tokyo: Oyama shoten.

Keene, Donald. 1976. *World within Walls: Japanese Literature of the Pre-Modern Era, 1600–1867*. New York: Holt, Rinehart, and Winston.

———. 1993. *Seeds in the Heart: Japanese Literature from Earliest Times to the Late Sixteenth Century*. New York: Holt.

———. 1998. *Dawn to the West: Japanese Literature of the Modern Era*. New York: Columbia University Press.

Kendrick, Walter M. 1987. *The Secret Museum: Pornography in Modern Culture*. Berkeley: University of California Press.

Kinsella, Sharon. 2000. *Adult Manga: Culture and Power in Contemporary Japanese Society*. Honolulu: University of Hawai'i Press.

Kirk, Jeremy. 2009. "Countries Move Forward on Cybercrime Treaty." *PC World* (March 11, 2009). http://www.pcworld.com/article/161067/countries_move_forward_on_cybercrime_treaty.html.

Kobayashi Masaru. 1956. *Kinjirareta firumu: Eirin nikki*. Tokyo: Shun'yōdō.

Kockum, Keiko. 1994. *Itō Sei: Self-Analysis and the Modern Japanese Novel*. Stockholm: Institute of Oriental Languages, Stockholm University Press.

Komikku Hyōgen no Jiyū o Mamoru Kai, ed. 1993. *Komikku kisei o meguru batoru roiyaru: Shigaisen.* Tokyo: Sō shuppan.

Kōmyōji Saburō, trans. 1968. *Dannoura yagassenki.* Tokyo: Misaki shobō.

Koppes, Clayton R. 1992. "Film Censorship: Beyond the Heroic Interpretation." *American Quarterly* 44 (4) (December): 643–649.

Kornicki, Peter. 1998. *The Book in Japan: A Cultural History from the Beginnings to the Nineteenth Century.* Leiden: Brill.

Kōtō Saibansho Keishū. 1979. *Satō et al. v. Japan* (Tokyo High Ct., no. 6, March 20, 1979). Kakyū Keishū 32:71–105.

———. 1980. *Japan v. Nikkatsu Co. et al.* (Tokyo High Ct., no. 9, July 18, 1980). Kakyū Keishū 34:514–525.

Kuhn, Annette. 1988. *Cinema, Censorship, and Sexuality, 1909–1925.* New York: Routledge.

Kuwabara Takeo. 1950. *Bungaku nyūmon.* Tokyo: Iwanami shoten.

Kuwahara Ietoshi. 1993. *Kirareta waisetsu: Eirin katto-shi.* Tokyo: Yomiuri shinbunsha.

KWS. Saitō Masaharu. 1978. *Kenryoku wa waisetsu o shitto suru: Nikkatsu poruno saiban o sabaku.* Nagoya: Fūbaisha.

LaCapra, Dominick. 1986. *"Madame Bovary" on Trial.* Ithaca: Cornell University Press.

Ladenson, Elisabeth. 2006. *Dirt for Art's Sake: Books on Trial from "Madame Bovary" to "Lolita."* Ithaca: Cornell University Press.

Laqueur, Thomas W. 2003. *Solitary Sex: A Cultural History of Masturbation.* New York: Zone Books.

Lawrence, D. H. [pseud.]. 1951. "Itō Sei e." *Gunzō* (September): 168–169.

Lawrence, D. H. 2000. *Lady Chatterley's Lover; A Propos of "Lady Chatterley's Lover."* Ed. Michael Squires. London: Penguin.

Lawson, Dawn, trans. 1992. *Cinema, Censorship, and the State: The Writings of Nagisa Oshima, 1956–1978.* Cambridge, MA: MIT Press.

Lee, William. 2003. "Artistic Direction in Takechi Kabuki." *Asian Theatre Journal* 20 (1): 12–24.

Leheny, David. 2006. *Think Global, Fear Local: Sex, Violence, and Anxiety in Contemporary Japan.* Ithaca: Cornell University Press.

"Letter of Complaint to Hirasawa Katsuei." 2002. http://www.geocities.co.jp/AnimeComic-Tone/9018/letter.html (accessed August 31, 2011).

Levy, Indra. 2006. *Sirens of the Western Shore: Westernesque Women and Translation in Modern Japanese Literature.* New York: Columbia University Press.

Maeda Ai. 1989. "Kotoba to shintai." In *Kindai dokusha no seiritsu,* 395–400. Tokyo: Chikuma shobō.

Maeda Shinjirō. 1967. "Geki eiga ni taisuru waisetsu-sei no handan to jishu kisei." *Hanrei jihō,* no. 498 (December): 125–128.

Maki, John M., trans. and ed. 1964. "Obscenity and Freedom of Expression (The *Lady Chatterley's Lover* Decision)." In *Court and Constitution in Japan: Selected Supreme Court Decisions, 1948–60,* 3–37. Seattle: University of Washington Press.

Makino Mamoru. 2001. "On the Conditions of Film Censorship in Japan Before Its Systematization." Trans. Aaron Gerow. In *In Praise of Film Studies: Essays in Honor of Makino Mamoru,* ed. Aaron Gerow and Abé Mark Nornes, 46–67. Victoria, BC: Trafford; Yokohama: Kinema kurabu.

———. 2003. *Nihon eiga ken'etsu-shi.* Tokyo: Pandora.

Maltby, Richard. 1986. "'Baby Face,' or How Joe Breen Made Barbara Stanwyck Atone for Causing the Wall Street Crash." *Screen* 27 (2) (March–April): 22–45.

———. 1993. "The Production Code and the Hays Office." In *Grand Design: Hollywood as a Modern Business Enterprise,* 37–72. New York: Scribner's.

Masaki Hiroshi. 1983. *Masaki Hiroshi chosaku shū.* Ed. Ienaga Saburō et al. Vol. 1, *Kubi nashi jiken, Purakādo jiken, Chatarei jiken.* Tokyo: Sanseidō.

Matsumoto, Shigeru. 1970. *Motoori Norinaga, 1730–1801.* Cambridge, MA: Harvard University Press.

Matsushima Toshiyuki. 2000. *Nikkatsu roman poruno zenshi: Meisaku, meiyū, meikantoku-tachi.* Tokyo: Kōdansha.

Mayo, Marlene J. 1991. "Literary Reorientation in Occupied Japan: Incidents of Civil Censorship." In *Legacies and Ambiguities: Postwar Fiction and Culture in West Germany and Japan,* ed. Ernestine Schlant and J. Thomas Rimer, 135–161. Washington, DC: Woodrow Wilson Center Press; Baltimore: Johns Hopkins University Press.

McCarthy, Mary. 1964. "Foreword." In *Madame Bovary,* by Gustave Flaubert, trans. Mildred Marmur, vii–xxiii. New York: Penguin Books.

McCullough, Helen Craig, trans. 1988. *The Tale of the Heike.* Stanford: Stanford University Press.

———, trans. 1990. *Classical Japanese Prose: An Anthology.* Stanford: Stanford University Press.

Metz, Christian. 1986. *The Imaginary Signifier: Psychoanalysis and the Cinema.* Trans. Celia Britton. Bloomington: Indiana University Press.

MEXT. Ministry of Education, Culture, Sports, Science and Technology. 2006. "Yūgai toshorui no shitei tō ni kansuru shitei." Last updated November 2006. http://www.mext.go.jp/b_menu/shingi/chukyo/chukyo0/toushin/07020115/021.htm.

MHC. Kishi Motonori v. Japan (Tokyo High Ct., no. 458, June 16, 2005). "Kōsoshin hanketsubun." http://www.geocities.co.jp/AnimeComic-Tone/9018/shoubun0616hanketsu.html (accessed August 31, 2011).

Miner, Earl, Hiroko Odagiri, and Robert E. Morrell. 1985. *The Princeton Companion to Classical Japanese Literature.* Princeton: Princeton University Press.

Mishima Yukio. 1973. "Erochishizumu no byōsha wa doko made yurusareru ka." In *Bunshō dokuhon,* 160–161. Tokyo: Chūō kōron.

Miyamoto Yuriko. 1980. "'Chatarē fujin no koibito' no kiso ni tsuyoku kōgi suru." In *Miyamoto Yuriko zenshū,* 16:418–422. Tokyo: Nihon shuppansha.

Miyatake Gaikotsu, ed. 1929. *Omoshiro Hanbun,* no. 1 (June).

MLC. Japan v. Kishi Motonori (Tokyo Dist. Ct., no. 3618, January 13, 2004). "Dai-ichiban hanketsu." http://picnic.to/%7Eami/news/etc/040122hanketsu .txt (accessed August 31, 2011).

Morikawa Kaichirō, ed. 2004. *OTAKU: persona = space = city.* Tokyo: Japan Foundation. http://www.jpf.go.jp/venezia-biennale/otaku/j/index.html.

MS. Shōbunkan saiban bōchō kiroku (January 13, 2004). http://www.geocities.co.jp/ AnimeComic-Tone/9018/shoubun-index.html (accessed August 31, 2011).

Murakami Takashi. 2000. Interview by Mako Wakasa, Murakami Studio, Brooklyn, NY, February 24, 2000. Trans. Mako Wakasa and Naomi Ginoza. *Journal of Contemporary Art.* http://www.jca-online.com/murakami.html.

Muramatsu Takeshi, ed. 1968. *Shōwa hihyō taikei.* Vol. 3, *Shōwa 20 nendai.* Tokyo: Banchō shobō.

Nafisi, Azar. 2003. *Reading Lolita in Tehran: A Memoir in Books.* New York: Random House.

Nagai Kafū [Kinpu Sanjin]. 1995. "Yojōhan fusuma no shitabari." In *Naze "Yojōhan fusuma no shitabari" wa meisaku ka,* ed. Yagiri Takayuki, 177–185. Tokyo: San'ichi shobō.

Nagai Kafū. 2000. *Danchōtei nichijō.* Ed. Isoda Kōichi. Vol. 2. Tokyo: Iwanami bunko.

Nagaoka Yoshiyuki, Yonezawa Yoshihiro, Yamaguchi Takashi, and Fujimoto Yukari. 2004. "Zadankai: Hajime no 'waisetsu' komikku saiban." *Medical Tribune* (June). http://www.medical-tribune.co.jp/ss/2004-6/ss0406-3.htm (accessed September 25, 2005).

Napier, Susan J. 2001. "The Frenzy of Metamorphosis: The Body in Japanese Pornographic Animation." In Washburn and Cavanaugh, *Word and Image in Japanese Cinema,* 342–365.

———. 2007. *From Impressionism to Anime: Japan as Fantasy and Fan Cult in the Mind of the West.* New York: Palgrave Macmillan.

Natsukawa Bunshō. 1983. "Hikō—Yojōhan fusuma no shitabari." *Kokubungaku kaishaku to kanshō* 38 (5): 319–351.

"Nihon eiga: Mondaishi sareta sakuhin oyobi sono shūhen-shi nenpyō" (September 25, 2005). http://www.geocities.jp/okumiki555/yokubou-.htm (accessed August 31, 2011).

Nixon, Richard. 1970. "381—Statement About the Report of the Commission on Obscenity and Pornography (October 24, 1970)." In *The American Presidency Project,* ed. John T. Woolley and Gerhard Peters. Santa Barbara, CA. http:// www.presidency.ucsb.edu/ws/index.php?pid=2759.

NKBD. Nihon Kingaku Bungakkan, ed. 1977. *Nihon kindai bungaku daijiten,* s.v. "Chatarei saiban," 4:280–281. Tokyo: Kōdansha.

NKZ. Nagai Kafū. 1992. *Nagai Kafū zenshū.* 30 vols. Tokyo: Iwanami shoten.

Noguchi Hiroshi. 2008. "Bōhatsu suru 'amai sekai' zōshoku: Shikei shikkō 'Miyazaki Tsutomu' kara Akihabara jiken made no ni-jūnen." *Aera* (June 30): 93.

Nozue Shun'ichi. 1967. "Eiga rinri no jishu kisei." *Jurisuto,* no. 378 (September): 38–44.

NPS. Saitō Masaharu. 1975. *Nikkatsu poruno saiban.* Nagoya: Fūbaisha.

Ōbayashi Miho. 1981. "Nihon waisetsu saiban hihan josetsu." *Kinema junpō* 816 (July): 117–126.

Odagiri Hideo, Inagaki Tatsurō, and Nakamura Shin'ichirō. 1963. "Koten to genbundan." *Gunzō* (November): 178–192.

Oketani Hideaki. 1976. *Tenshin, Kanzō, Kafū.* Tokyo: Ozawa shoten.

———. 1994. *Itō Sei.* Tokyo: Shinchōsha.

———. 2002. "Danchō tei nichijō shiori-roku: Sengo no Kafū sanjin."

Okudaira Yasuhiro. 1962. "'Waisetsu bunsho hanpu hanbai zai' (Keihō 175-jō) ni tsuite." *Hōsei ronshū* (Nagoya Daigaku), no. 20:1–48.

Omoshiro Hanbun. 1979. "Kettei-ban, Nosaka Akiyuki." *Omoshiro Hanbun: Half Serious* 14 (1).

Orbaugh, Sharalyn. 2003. "Creativity and Constraint in Amateur Manga Production." *U.S.-Japan Women's Journal,* no. 25 (December): 104–124.

Ōshima Nagisa. 1976. *Ai no korīda = L'empire des sens.* Tokyo: San'ichi shobō.

Ōtsuka Ki'ichirō. 1967. "Eiga no jishu kisei to waisetsusei nintei kijun—Chatarē hanketsu, Kuroi yuki hanketsu ni tsuite." *Jurisuto,* no. 378 (September): 65–70.

Oyama Hisajirō. 1982. *Hitotsu no jidai: Oyama shoten shishi.* Tokyo: Rokkō shuppan.

Raine, Michael. 2001. "Ishihara Yūjirō: Youth, Celebrity, and the Male Body in Late-1950s Japan." In Washburn and Cavanaugh, *Word and Image in Japanese Cinema,* 202–225.

Rembar, Charles. 1968. *The End of Obscenity: The Trials of Lady Chatterley, Tropic of Cancer, and Fanny Hill.* New York: Random House.

Richie, Donald. 1987. "The Japanese Eroduction." In *A Lateral View: Essays on Contemporary Japan,* 144–157. Tokyo: Japan Times.

———. 2001. *A Hundred Years of Japanese Film: A Concise History, with a Selective Guide to Videos and DVDs.* Tokyo: Kodansha International.

Rubin, Jay. 1984. *Injurious to Public Morals: Writers and the Meiji State.* Seattle: University of Washington Press.

———. 1985. "From Wholesomeness to Decadence: The Censorship of Literature under the Allied Occupation." *Journal of Japanese Studies* 11 (1) (Winter): 71–103.

————. 1988. "The Impact of the Occupation on Literature, or, Lady Chatterley and Lt. Col. Verness." In *The Occupation of Japan: Arts and Culture; The Proceedings of the Sixth Symposium,* ed. Thomas W. Burkman, 167–187. Norfolk, VA: General Douglas MacArthur Foundation.

Ryūtaikyō (Shuppan Ryūtsū Taisaku Kyōgikai). 2005. "Shōbunkan saiban, kōso kikyaku, yūgai hanzai ni kōgi suru" (June 16, 2005). http://d.hatena.ne.jp/kitano/20050616 (accessed August 31, 2011).

Saikō Saibansho Keishū. 1981. *Satō et al. v. Japan* (Supreme Ct. Second Petty Bench) 34 Keishū 6:433–480.

Saitō Ayako. 1997. "So Kinky, So Tough." In "Nagai Kafū," special issue, *Yuríka* 29 (3) (March): 63–65.

Saitō Masaharu. 1972. "Dankon wa kābinjū ni narieruka—Nikkatsu roman poruno no tenkai." *Eiga hyōron* 29 (8) (August): 92–95.

Saitō Tamaki. 2007. "Otaku Sexuality." Trans. Christopher Bolton. In *Robot Ghosts and Wired Dreams: Japanese Science Fiction from Origins to Anime,* ed. Christopher Bolton, Istvan Csicsery-Ronay Jr., and Takayuki Tatsumi, 222–249. Minneapolis: University of Minnesota Press.

Sakata Ei'ichi. 1977. *Waga Eirin jidai.* Tokyo: Kyōritsu tsūshinsha.

Satō Shigechika. 1965. "Takechi Tetsuji to arugoragunia—'Kuroi yuki.' " *Eiga hyōron* 22 (8) (August): 34–36.

————. 1973. "1972-nen Nihon eiga sōkessan: Nikkatsu poruno aru nomi." *Eiga hyōron* 30 (2) (February): 40–44.

Satō Tadao. 1976. "Nihon eiga no jōkyō." *Jurisuto zōkan sōgō tokushū: Gendai no masukomi,* no. 5 (June): 324–328.

Satō Yoshinao, ed. 1973. "Yojōhan fusuma no shitabari saiban." Special issue, *Omoshiro Hanbun: Half Serious,* no. 23 (October).

Schilling, Mark. 1998. "Celluloid Dreams, American Movies in Japan." In *Partnership, Prosperity, Potential—50 Years of American Business in Japan.* Tokyo: American Chamber of Commerce Japan.

————. 2007. *No Borders, No Limits: Nikkatsu Action Cinema.* Godalming, Surrey, UK: FAB Press.

Schodt, Frederik L. 1983. *Manga! Manga! The World of Japanese Comics.* Tokyo: Kodansha International.

Scholes, Robert. 1985. "Narration and Narrativity in Film." In *Film Theory and Criticism,* ed. Gerald Mast and Marshall Cohen, 390–404. 3rd ed. New York: Oxford University Press.

Screech, Timon. 1999. *Sex and the Floating World: Erotic Images in Japan, 1700–1820.* Honolulu: University of Hawai'i Press.

Seidensticker, Edward. 1965. *Kafū the Scribbler: The Life and Writings of Nagai Kafū, 1879–1959.* Stanford: Stanford University Press.

Senuma Shigeki. 1956. "Gendai sakka hikkachō." *Shinchō,* no. 67 (September): 48–52.

Shamoon, Deborah. 2002. "Sun Tribe: Cultural Production and Popular Culture in Post-War Japan." *E-AsPac.* http://mcel.pacificu.edu/easpac/2002/shamoon .php3.

———. 2004. "Office Sluts and Rebel Flowers: The Pleasures of Japanese Pornographic Comics for Women." In *Porn Studies,* ed. Linda Williams, 77–103. Durham: Duke University Press.

Sharp, Jasper. 2001. "Tetsuji Takechi: Erotic Nightmares" (March 10, 2001). *Midnight Eye: The Latest and Best in Japanese Cinema.* http://www .midnighteye.com/features/focus_takechi. shtml.

———. 2008. *Behind the Pink Curtain: The Complete History of Japanese Sex Cinema.* Godalming, Surrey, UK: FAB press.

Sherif, Ann. 2005. "The Aesthetics of Speed and the Illogicality of Politics: Ishihara Shintarō's Literary Debut." *Japan Forum* 17 (2) (July): 185–211.

———. 2009. *Japan's Cold War: Media, Literature, and the Law.* New York: Columbia University Press.

Shinoyama Kishin. 1991. *Santa Fe.* Tokyo: Asahi Press.

Shirane, Haruo, and Tomi Suzuki, eds. 2000. *Inventing the Classics: Modernity, National Identity, and Japanese Literature.* Stanford: Stanford University Press.

Shively, Donald H. 1982. "Tokugawa Plays on Forbidden Topics." In *Chūshingura: Studies in Kabuki and the Puppet Theater,* ed. James R. Brandon, 23–57. Honolulu: University of Hawai'i Press.

Slaymaker, Douglas. 2004. *The Body in Postwar Japanese Fiction.* New York: Routledge.

Snyder, Stephen. 2000. *Fictions of Desire: Narrative Form in the Novels of Nagai Kafū.* Honolulu: University of Hawai'i Press.

Takechi Tetsuji. 1967. *Sabakareru erosu.* Tokyo: Tokuma shoten.

Tamura Taijirō. 1948. "Nikutai ga ningen de aru." In *Nikutai no bungaku,* 11–18. Tokyo: Kusano shobō.

Thompson, Sarah E., and H. D. Harootunian. 1991. *Undercurrents in the Floating World: Censorship and Japanese Prints.* New York: Asia Society Galleries.

Treat, John Whittier. 1994. "Beheaded Emperors and the Absent Figure in Contemporary Japanese Literature." *PMLA* 109 (1) (January): 100–115.

Tsubouchi Shōyō. 1983. *The Essence of the Novel.* Trans. Nanette Twine. St. Lucia, Queensland: Department of Japanese, University of Queensland.

Tsubouchi Yūzō. 2000. "1972—'Hajimari no owari' to 'Owari no hajimari': Daisankai Nikkatsu roman poruno tekihatsu sareru." *Shokun!* 32 (4) (April): 284–289.

Tsuda Masayoshi. 1995. *Tsuisō—Chatarei no hōchō.* Tokyo: Takahashi Print.

Tsuge Teruhiko. 1997. "'Yojōhan fusuma no shitabari' kōchū, kaidai." In "Nagai Kafū," special issue, *Yurīka* 29 (3) (March): 66–89.

Turim, Maureen. 1998. *The Films of Oshima Nagisa: Images of a Japanese Iconoclast.* Berkeley: University of California Press.

Twine, Nanette. 1991. *Language and the Modern State: The Reform of Written Japanese.* New York: Routledge.

Ueda, Makoto. 1967. *Literary and Art Theories in Japan.* Cleveland: Press of Western Reserve University.

Uematsu Tadashi. 1966. "Eiga 'Kuroi yuki' to Eirin shinsa." *Toki no hōrei,* no. 558 (February): 22–25.

———. 1969. "Nandemo shite yarō—Eiga 'Kuroi yuki' jiken no kōsoshin." *Toki no hōrei,* no. 676 (May): 10–15.

———. 1970. "Eiga 'Kuroi yuki' gojitsudan." *Toki no hōrei,* no. 700–701 (January): 78–83.

UNICEF (Zaidan Hōjin Nihon UNICEF Kyōkai). 2008. "Kodomo poruno mondai ni kansuru kinkyū yōbōsho" (February 27, 2008). Tokyo: UNICEF. https://www2.unicef.or.jp/jcuApp/websign/websign_input.jsp.

Usui Yoshimi et al., eds. 1972. *Sengo bungaku ronsō.* 2 vols. Tokyo: Banmachi shobō.

Wagatsuma Sakae and Miyazawa Toshiyoshi, eds. 1952a. "1952-nen no kaiko." *Jurisuto,* no. 24 (December): 2–9.

———. 1952b. "Sōkan no kotoba." *Jurisuto,* no. 1 (January): 1.

Washburn, Dennis C., and Carole Cavanaugh, eds. 2001. *Word and Image in Japanese Cinema.* Cambridge: Cambridge University Press.

Weisser, Thomas, and Yuko Mihara Weisser. 1998. *Japanese Cinema Encyclopedia: The Sex Films.* Miami: Vital Books.

Williams, Bernard Arthur Owen. 1996. *Censorship in a Borderless World.* Singapore: Published for the Faculty of Arts and Social Sciences, National University of Singapore, by G. Brash.

Williams, Linda. 1986. "Film Body: An Implantation of Perversions." In *Narrative, Apparatus, Ideology: A Film Theory Reader,* ed. Philip Rosen, 507–534. New York: Columbia University Press.

———. 1989. *Hard Core: Power, Pleasure, and the "Frenzy of the Visible."* Berkeley: University of California Press.

WKS. Nagaoka Yoshiyuki. 2004. *"Waisetsu komikku" saiban.* Tokyo: Michi shuppan.

WKS2. Nagaoka Yoshiyuki. 2005. *Hakkin shobun: "Waisetsu komikku" saiban kōsaihen.* Tokyo: Michi shuppan.

Yamaguchi Takashi. 2008. "'Jidō poruno hō kaisei' kyōfu no shinario." *SPA!* May 27, 24–29.

Yamane Sadao, ed. 1983. *Kannō no puroguramu pikuchua: Roman poruno, 1971–1982 zen eiga.* Tokyo: Firumu ātosha.

Yanagida Kenjūrō. 1951. "Geijutsu to nikukan to no mujun." *Gunzō* (August): 84–88.

Yomota Inuhiko. 1983. "Suchīru shashin kara katsujinga e." In *Eizō no shōkan: Esse shinematogurafikku,* 181–204. Tokyo: Seidosha.

Yoshiyuki Junnosuke, ed. 1972. *Omoshiro Hanbun: Half Serious,* no. 1 (January).

YS. Maruya Sai'ichi, ed. 1976. *Yojōhan fusuma no shitabari saiban zenkiroku.* 2 vols. Tokyo: Asahi shinbunsha.

Filmography

Fujii Katsuhiko (director). 1972. *OL nikki: Mesuneko no nioi* (Diary of an office lady: Scent of a she-cat). Nikkatsu, 69 min.

Kondō Yukihiko (director). 1973. *Ai no nukumori* (The warmth of love). Nikkatsu, 2005. DVD, 69 min.

Kumashiro Tatsumi (director). 1973. *Yojōhan fusuma no urabari* (The world of geisha; lit., Behind the papering of the four-and-a-half-mat room). Nikkatsu, 2003. DVD, 73 min.

Ōshima Nagisa (director). 1976. *Ai no korīda* (In the realm of the senses). Argos Films and Ōshima Productions. Videocassette, 104 min.

———. 2000. *Ai no korīda (kanzen nō-katto ban)* (In the realm of the senses [uncut complete version]). Argos Films and Ōshima Productions. DVD, 108 min.

Takechi Tetsuji (director). 1965. *Kuroi yuki* (Black snow). Daisan Productions. Videocassette; Nikkatsu, 2007. DVD, 89 min.

Umezawa Kaoru (director). 1972. *Jokōsei geisha* (High school geisha). Nikkatsu.

Yamaguchi Sei'ichirō (director). 1972. *Koi no karyūdo: Rabu hantā* (Love hunter). Nikkatsu, 2007. DVD, 73 min.

Interviews

Ide Magoroku (former president of Eirin) and Kodama Kiyotoshi (secretary-general of Eirin). Interview by author. Eirin offices, Tokyo, May 26, 2008.

Itō Rei. Interview by author. Tokyo, October 19, 2002.

Kishi Motonori (president of Shōbunkan publishing), Takada Kōichi (Shōbunkan editor in chief), and Nagaoka Yoshiyuki (freelance journalist). Interview by author. Shōbunkan publishing offices, Tokyo, May 27, 2008.

Yama Ryōkichi (chief of general affairs at Shogakukan publishing and head of the Ethics Committee of the Japan Magazine Publishing Association). Interview by author. Shogakukan office, Tokyo, May 30, 2008.

Yamaguchi Takashi (head defense lawyer in the *Honey Room* trial). Interview by author. Link Law offices, Tokyo, May 29, 2008.

Index

and, 128–129; as precedent, 85–86,
114, 116; and prior Eirin scandals,
81–84; prosecution, 87, 92–94, 103,
112, 114; prosecution supporters,
86–87, 94, 110; role of Eirin,
78–79, 80, 84, 85–86, 92, 93–94,
114–115, 141–142, 144, 145, 265;
role of police, 85; role of the Tokyo
Mothers' Society, 88, 92; verdicts,
103–115, 119, 125, 144, 145, 148,
219, 254. See also *Black Snow*

censored subjects: adultery, 21, 24,
28–31, 34, 35–36, 50–51, 62, 64,
124, 226, 242–243; anal sex, 21,
222, 227; divorce, 33–34, 53–54,
62; emperor, 1, 16, 17, 160, 243;
"fraternization," 36; genitalia, 61,
88, 142, 148–150, 170, 191, 201,
207–208, 232, 236, 242, 248–253,
257, 259, 261, 276n11; girl-girl
sex play, 118, 197; impotence,
28–30, 62, 90, 96, 230; incest, 89,
93, 119, 126, 234; masturbation,
118, 149, 227; murder, vii, 93,
95–96, 103, 149, 195, 218, 243,
245; oral sex, 170, 197, 207, 227,
298n15; orgasm, 21, 23, 55, 90,
101, 103, 169–170, 210, 226; orgy,
119, 125, 127, 198, 200, 203, 213;
pederasty (Loli-con), 223, 240–242
passim, 249, 269–271; prostitution,
vii, 26, 86, 88, 89–90, 105–106,
169–170, 222, 227, 228; pubic
hair, 121–123 *passim*, 138, 207,
222, 224, 248–250, 253, 257; rape,
82, 89, 93, 97, 104, 106, 138,
157, 195, 223, 226–230 *passim*,
234, 259, 262, 264–265, 287n37;
sadomasochism (S/M), 26, 95–96,
105, 210–211, 227, 228–229, 260

Chiba Tetsuya, 233, 245–246, 254
child pornography laws, 222, 242,
255, 269–271. *See also* Cybercrime
Treaty; Law for Punishing Acts
Related to Child Prostitution
and Child Pornography and for
Protecting Children (1999)
commercialism: and paratexts, 162,
272; as attack in *Black Snow* trial,
92, 114–115; as attack in *Chatterley*
trial, 19, 23–24; as attack and
defense in manga trial, 233, 246,
247, 253, 257, 259; as attack
and defense in Nikkatsu Roman
Porn trial, 118, 119, 131–133
passim, 135–137 *passim*, 141–142,
146–147; as attack in "Yojōhan"
trial, 175
Constitution (Meiji), 38, 39
Constitution (postwar): and
Constitutional Problem
Investigation Committee and,
39; and Eirin, 80; and freedom
of assembly, 17; and freedom of
expression (Article 21), 6, 11, 12,
14–15, 17, 19, 37, 237; newness of,
37–39 *passim;* no-war clause (article
9), 99; Occupation's authorship of,
14–15, 39–40, 47, 73–75 *passim*,
277n14, 280n45; public welfare
clauses, 38, 40, 65; relationship to
Meiji Constitution, 38; relationship
to Meiji Criminal Code (Article
175), 14, 38–39, 41, 73–74, 221;
role in *Chatterley* trial, 37–42,
46–48, 51–52, 65, 70; role in
subsequent trials, 73; staying power
of, 6, 15
copyright laws: and Nagai Kafū, 173,
180; during Occupation period, 40;
revised in 1970, 129

128–129, 133–34, 154; prosecution: 125–137 *passim*, 140–141, 149, 291n42, 292–293n75; prosecution supporters, 128, 135–136; prosecution witnesses, 117, 126–127, 130–133, 143, 151, 152; role of Eirin, 78–79, 84, 115, 116, 119–120, 125, 128–129, 130–133 *passim*, 141–146, 147; role of Japanese Communist Party (JCP), 117, 118, 136; role of Nikkatsu studio labor union, 117, 118, 123, 135–136, 147; role of police, 125–126, 127; verdicts, 84, 119, 144–152, 219, 254; and Western "liberation" of porn, 121–122, 124–125, 127, 137–141, 145–146, 152; and "Yojōhan" trial, 133–134, 152, 171, 175, 180. See also *Diary of an Office Lady: Scent of a She-Cat (OL nikki, Mesuneko no nioi)*; *High School Geisha (Jokōsei geisha)*; *Love Hunter (Koi no karyūdo: Rabu hantā)*; *The Warmth of Love (Ai no nukumori)*

Nikkatsu Studio: and Big Five studios, 128; and Dainichi, 123, 147; as defendant in Nikkatsu Roman Porn trial, 2, 116, 118, 120, 125–128, 129–130, 132–135 *passim*, 135–136; as defendant in Nikkatsu Roman Porn Video trial, 125, 129; as distributor of *Black Snow*, 85, 93, 129, 141–142; finances of, 120–121, 123–124, 137–139, 146–147, 152; Sun Tribe scandal and, 128

Nishimura Kōji, 19, 283n7

Nosaka Akiyuki, 5, 70, 72, 154, 171, 175, 177–179, 181–182, 185–187, 191; "The False Charges of Sex in the Four-and-a-Half-Mat Room" ("Yojōhan iro no nureginu"), 178; *The Pornographers (Erogotoshi-tachi)*, 178

nude art, 14

obscenity: as animalistic and irrational, 30, 51, 60–63; definitions of, 14, 21, 55, 59, 61–63 *passim*, 68, 105–106, 122, 168, 190–192, 250, 258–259; gauged scientifically, 52–57, 59–60, 68–70, 264–266; linked to politics, 8, 16–17, 65, 91–92, 96–97; and literary style, 159, 163–165, 185; and modernity, 7, 13, 35, 41–42, 47–51 *passim*, 73–74, 140, 174–177 *passim*, 243; and the "principle of the nonpublic nature of sex" (*sei kōi no hikōzensei no gensoku*), 34–35, 148–149, 191, 204, 243, 271; and reader identification, 31–34, 61, 83, 113, 227–231, 239–243, 301n34; and sense of shame, 10, 21, 30, 105–106, 170, 184; as taboo, 8, 18, 74, 247; in "undeveloped" nations, 148–149, 204, 270; versus rationality, 57–60, 68–69, 71–72

obscenity laws: in contemporary Japan, 222, 267–272, 298–299n1, 304n71; in Meiji-period Japan, 13–14, 71, 74; in Occupation-period Japan, 25, 26, 36; in postwar Japan, 6, 7, 10, 14–15; in premodern and early modern Japan, 7, 75, 247, 248; in the West, 10, 31, 73–74, 119, 121–122, 138–139, 170, 291n49. *See also* Article 175; Hicklin principle

Occupation-period censorship, 12–13; of the A-bomb, 100; critiqued in

trial, 175, 178, 181, 188–189. *See also* obscenity

Press Law (1909), 13

prewar censorship, vii–viii, 6, 13–14; and artists' responses, 43–45, 49; corruption of public morals (*fūzoku kairan*), 38; echoes of in postwar, 17, 26, 38–39, 136, 177–178, 278n15; of film, 79–80, 102; *hatsubai kinshi* (suppression of sales), 6, 39; and Nagai Kafū, 167–168, 178; 1925 Peace Preservation Law and, vii

"principle of the nonpublic nature of sex" (*sei kōi no hikōzensei no gensoku*). *See under* obscenity

prostitution: and 1956 Antiprostitution Law, 83, 90; and contemporary antiprostitution legislation, 222, 242–243, 264, 270–271; in postwar Japan, vii, 26, 31, 36, 83, 86, 88; and *shunga,* 258

Publication Law (1893), 13, 38

Publishing Code Practice Committee (Shuppan Kōryō Jissen Iinkai), 25, 278n15

publishing industry: and commercialism, 22, 23, 175, 246, 253, 257, 259; in early postwar, 12, 20, 24–25, 26; in Edo period, 303n49; and "hair nudes," 249–250; in the 1990s, 222, 247, 248, 255; and manga, 224, 247; and self-censorship, 225, 237, 251–252, 253–254; and self-regulatory organizations, 12, 25, 26, 231, 233, 265, 278n15, 300n22; and *shunga,* 248

Publishing Morals Committee (Shuppan Butsu Fūki Iinkai), 12–13, 26

pulp magazines (*kasutori zasshi*), 20, 21, 24, 25–26, 37, 52, 55–56, 71

Purima Company, 118, 129, 130, 290n17

Rai San'yō, 159

Realm trial, 272; compared to *Black Snow* trial, 215, 219; compared to *Chatterley* trial, 74, 195; compared to *Dannoura* trial, 216–217; compared to Nikkatsu Roman Porn trial, 208, 219; compared to "Yojōhan" trial, 192, 200, 204; defense, 32, 74, 195, 208, 212, 215, 218–219, 247; defense arguments on screenplay, 68, 202–203, 204; and "dirt for politics' sake," 98; gender arguments in, 195, 209–211; indictment, 197–198, 199, 200; as a precedent, 217; precedents for, 151–152, 154, 204, 215; prosecution, 191–192, 197, 219; prosecution on photographs, 205–211 *passim;* prosecution on screenplay, 96; 200–202, 203–205; role of police, 291n31; scientific evidence in, 68, 282n3; verdicts, 195, 211–217, 219–220, 255. See also *In the Realm of the Senses* (book); *In the Realm of the Senses* (film)

The Record of the Night Battles at Dannoura, 2, 72, 75, 154–155, 159–163, 258; advertisements, 162; antiwar message, 72; paratexts, 161–162, 216–217; style, 160–162, 163, 165, 294n14; and *The Tale of Heike,* 159–161, 294n10

The Record of the Night Battles at Dannoura trial (1970–1976), 2, 154–155, 159–163, 294n12; compared to "Yojōhan" trial, 185; historical context of, 165, 272; objects on trial, 293n1; as precedent,

World War II: artists' responsibility for, 44–46; and *Chatterley* trial, 28–29, 42–46 *passim*, 49–51, 72; emperor's responsibility for, 17; and kamikaze pilots, 50; and "living war dead" veterans, 28–29; and militaristic propaganda, 57, 72; scientific evidence, 57, 72; war crimes and, 41, 51

Yamaguchi Sei'ichirō, 5, 117, 118, 119, 134, 149, 291n42
Yamaguchi Takashi (head lawyer in manga trial), ix, 67, 251
"Yojōhan fusuma no shitabari" ("Underneath the Papering of the Four-and-a-Half-Mat Room"), 78, 154–55, 167, 169–170, 172–173, 180–181, 183–184; antiwar message of, 177–178; and Kantō earthquake, 181, 183; as "native" Edo-period *gesaku*, 75, 154, 167, 172, 176–179, 181–183, 189–190; paratexts, 188–189; sales of, 154–155, 156, 175; style of, 163, 170, 185
"Yojōhan" trial (1948–1950), 166; role of Kafū as author, 155, 156, 171, 172–174; role of police, 172, 173; and the *Safflower* trial, 156–157, 172; verdicts, 168, 174; and "Yojōhan" trial (1973–1980), 154–155, 174, 175, 188
"Yojōhan" trial (1973–1980), viii, 75, 154–155, 163, 165, 166,

167, 272; anti-Western/antiwar stance of defense in, 73–76, 176–178, 183; compared to *Chatterley* trial, 5, 70, 72–76 *passim*, 168, 177; compared to *Dannoura* trial, 154; defendants, 5, 70, 154, 171, 187; defense, 175, 176–180, 181–183 *passim*, 185–186; defense witnesses, 32, 175, 181–182, 186; prosecution, 168, 169–170, 174–175, 183–184, 186–187; and *Realm* trial, 204; role of Kafū as author, 171, 174–176, 189–191; verdicts, 168–169, 171, 188–191, 204, 254–255, 295n9; and "Yojōhan" trial (1948–1950), 154–155, 174, 175, 188
Yoshida Sei'ichi, 40, 175
Yoshiyuki Junnosuke, 179
Youth Protection Ordinances (Seishōnen Hogo Ikusei Jōrei), 81, 222. *See also* youth protection organizations and laws
youth protection organizations and laws, 31, 81, 88, 92, 222, 226, 233–237 *passim*, 243, 262–264, 285n13, 301n28, 301n30; in United States, 121. *See also* Eirin, rating system; "harmful" (*yūgai*) media designations; mothers' societies

Zenkōren. *See* Japan Association of Theatre Owners

Studies of the Weatherhead East Asian Institute
Columbia University

Selected Titles

Redacted: The Archives of Censorship in Postwar Japan, by Jonathan E. Abel. University of California Press, 2012.

Occupying Power: Sex Workers and Servicemen in Postwar Japan, by Sarah Kovner. Stanford University Press, 2012.

Empire of Dogs: Canines, Japan, and the Making of the Modern Imperial World, by Aaron Herald Skabelund. Cornell University Press, 2011.

Russo-Japanese Relations, 1905–17: From Enemies to Allies, by Peter Berton. Routledge, 2011.

Realms of Literacy: Early Japan and the History of Writing, by David Lurie. Harvard University Asia Series, 2011.

Planning for Empire: Reform Bureaucrats and the Japanese Wartime State, by Janis Mimura. Cornell University Press, 2011.

Passage to Manhood: Youth Migration, Heroin, and AIDS in Southwest China, by Shao-hua Liu. Stanford University Press, 2010.

Imperial Japan at its Zenith: The Wartime Celebration of the Empire's 2,600th Anniversary, by Kenneth J. Ruoff. Cornell University Press, 2010.

Behind the Gate: Inventing Students in Beijing, by Fabio Lanza. Columbia University Press, 2010.

Postwar History Education in Japan and the Germanys: Guilty Lessons, by Julian Dierkes. Routledge, 2010.

The Aesthetics of Japanese Fascism, by Alan Tansman. University of California Press, 2009.

The Growth Idea: Purpose and Prosperity in Postwar Japan, by Scott O'Bryan. University of Hawai'i Press, 2009.

National History and the World of Nations: Capital, State, and the Rhetoric of History in Japan, France, and the United States, by Christopher Hill. Duke University Press, 2008.

Leprosy in China: A History, by Angela Ki Che Leung. Columbia University Press, 2008.

Kingdom of Beauty: Mingei and the Politics of Folk Art in Imperial Japan, by Kim Brandt. Duke University Press, 2007.

Mediasphere Shanghai: The Aesthetics of Cultural Production, by Alexander Des
 Forges. University of Hawai'i Press, 2007.
Modern Passings: Death Rites, Politics, and Social Change in Imperial Japan, by
 Andrew Bernstein. University of Hawai'i Press, 2006.
*The Making of the "Rape of Nanjing": The History and Memory of the Nanjing
 Massacre in Japan, China, and the United States,* by Takashi Yoshida. Oxford
 University Press, 2006.

(Complete list at: http://www.columbia.edu/cu/weai/weatherhead-studies.html)

ABOUT THE AUTHOR

Kirsten Cather earned her BA in Japanese from Connecticut College in 1991 and her MA and PhD (2004) in Japanese literature with a secondary specialization in film from the University of California, Berkeley. She is an associate professor of Japanese literature and film in the Department of Asian Studies at the University of Texas at Austin. *The Art of Censorship in Postwar Japan* is her first book.